The Contextual Nature of
Design and Everyday Things

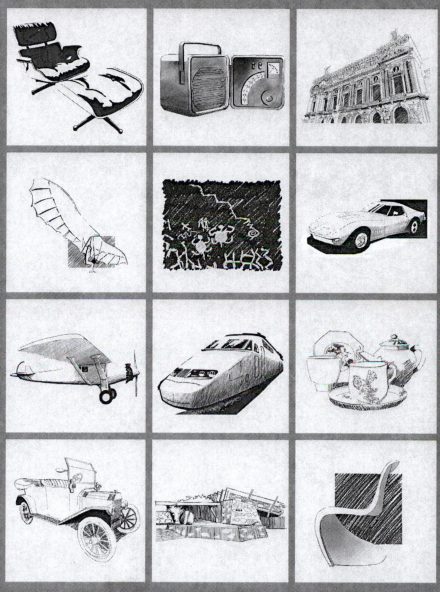

Second Edition Jacques Giard

Kendall Hunt
publishing company

All images courtesy of the author.

Kendall Hunt
publishing company

www.kendallhunt.com
Send all inquiries to:
4050 Westmark Drive
Dubuque, IA 52004-1840

ISBN 978-1-4652-9662-7

Printed in the United States of America

TABLE OF CONTENTS

LIST OF IMAGES

Images have been provided as a quick way to connect some of the course material found in the text to the worlds of design and everyday things. These images complement the visual material that appears in the online course videos and serve as a kind of appetizer to this visual material, which is much more extensive. All images are by the author.

LIST OF DIAGRAMS

FOREWORD TO SECOND EDITION

The second edition of The Contextual Nature of Design and Everyday Things builds upon the first edition. However, it differs in three important areas. First, additional information has been added to most of the chapters. Second, illustrations and diagrams have replaced the photographs found in the first edition. Last, the graphic graphic layout now has two columns instead of one, making reading easier. Otherwise, the book remains an invaluable aid in understanding the course material for the design of everyday things.

FOREWORD TO THE FIRST EDITION

There are benefits to teaching at a university. One of these is the development of new courses. I was given that opportunity with IND 316 20th Century Design I and IND 317 20th Century Design II. Both courses are a required part of the undergraduate industrial design curriculum at Arizona State University and have been offered for at least 10 years. During that period, the course material was presented chronologically, which isn't at all unusual for history courses in architecture, art and design.

The opportunity to reconsider the chronological approach to the two courses came in 2013. The author and his colleagues were of the opinion that exploring the history of industrial design thematically rather than chronologically would make more sense to students. Situating an artifact in its context or theme provides a more comprehensive picture of how these same artifacts of design came into being in the first place.

The thematic direction of the course material was first developed for the online versions of both courses. Over 100 different scripts were researched, written, and made into short videos. Once completed, the web design team in the Herberger Institute for Design and the Arts proceeded to build the online courses.

The idea for a course textbook was discussed not long thereafter. There was already ample written material because of the scripts that had been developed previously. So began the process of creating a course textbook. That said, the book provides additional information in the form of essays by well-known designers and experts. These can be found in a section at the end of the book and are part of the readings required for the course.

As a general rule, the writing of a textbook isn't a solitary affair. This book is no exception to that rule. Several individuals were involved. Without doubt, the most important person was Nancy Gray, who is an accomplished designer, a lecturer in the W. P. Carey School of Business, and a colleague at Arizona State University. The two of us worked closely on the initial thematic structure for the course and the development of the course material. Two other persons also need to be recognized. One is Professor Prasad Boradkar who, as coordinator of the industrial design program at Arizona State University, supported our efforts to create a thematic direction in the two courses. The other is my wife, Mercedes. Not only did she tolerate my long hours at the computer and did so with remarkable patience, but she was always there when I needed her advice, counsel, support and love.

HOW TO USE THIS BOOK

This book has been written purposely for two courses: IND 316 20th Century Design I and IND 317 20th Century Design II. Both courses are offered by Arizona State University, either face-to-face or online. The information found in the book complements both versions of these courses, and goes beyond the material provided in the courses.

The book has 12 chapters. Chapters 1 and 2 provide general information about design. Every student enrolled in either IND 316 or IND 317 should make a point of reading both chapters. For students already familiar with the material, the chapters will provide a refresher. For students taking an industrial design history course for the first time, the reading of the chapters is highly recommended because an assumption is made that all students enrolled in either IND 316 or IND 317 have an understanding of basic design theories and principles.

Chapters 3 through 7 are meant for IND 316. Each chapter deals with one of the five themes of the course, which are A Worldview of Design, Design and the Natural World, Design and Economics, Design and Technology, and Design and Transportation. Chapters 8 through 12 are meant for IND 317. Similarly, each chapter deals with one of the five themes of the course, which are Design and Communication, Design and Education, Design and Material Culture, Design and Politics, and Design and Society. Online students may notice that the content of the book mimics closely the content of the scripts of the online videos. This approach was deliberate on my part and provides the students with important information such as names of designers or dates of events, which can't always appear on the online videos.

There are also sketches scattered throughout many of the chapters. These serve as simple visual aids to connect a known artifact to the content in the chapter. That said, both the face-to-face and online versions of the course provide significantly more images on the same topic. Not to be forgotten are the readings and viewings for both courses. Most of these appear either as full-text versions of the article or as a link to an article or a video to be viewed.

In the end, please consider the book as your learning companion as you undertake IND 316 and IND 317. It will be there to answer many of your questions as you explore the world of 20th-century design.

NOTE: The Readings and viewings appear at the end of the book. These are very important to your success in the course.

AUTHOR BIO

Jacques Giard is Professor of Industrial Design at Arizona State University. His forty-year career spans both design practice and design education in the United States and Canada as well as visiting professor at various universities in the United Kingdom, Korea and Mexico. He is the former director of the School of Industrial Design at Carleton University in Ottawa, Canada, and the School of Design at Arizona State University.

Professor Giard has an undergraduate education in furniture design and a graduate degree in industrial design (engineering). He earned his PhD in cultural studies from Concordia University in Montreal, Canada, and continues to research the phenomenon of everyday things as reflections of context.

Professor Giard is the author of *Design FAQs* and *Designing: A Journey Through Time*, and co-editor with Professor Stuart Walker of *The Handbook of Design for Sustainability*.

INTRODUCTION

The history of design is the history of everyday things—big and small—beginning with the earliest stone tools to the most recent building. The history of industrial design is somewhat narrower; it's the history of everyday things normally from around 1750 when mechanization began to take command, to borrow from the British historian Siegfried Gideon. This is the period in Western history when machines began to displace artisans or craftsmen. It's also when the concept of design for industry began, which would eventually lead to what we know today as industrial design.

Books on industrial design history aren't rare. There are many types, from academic texts such as *Mechanization Takes Command* by Siegfried Gideon, already mentioned, to the many books by Nicholas Pevsner as well as John Heskett's well-known book entitled *Industrial Design*. There are also numerous so-called coffee table books on industrial design and industrial designers. Several publishers, such as Taschen, are known for this type of book. And then there are a few books on industrial design that don't fit easily into either of these two categories. *Design for the Real World* by Victor Papanek is such a book as are Jonathan Woodham's wonderful book *Twentieth-Century Design* and Penny Sparke's *An Introduction to Design and Culture: 1900 to the Present*. These books can be found in the bibliography at the end of this book.

The textbook, *The Contextual Nature of Design and Everyday Things*, sits in the last category. It's not a book meant for design scholars in academia; neither is it a coffee-table book. It differs from the former because it doesn't explore industrial design history in a scholarly fashion; neither does it deal with industrial design as a series of stand-alone artifacts or as a stable of superstar designers like coffee-table books.

Instead, the textbook explores the history of design and industrial design thematically and as part of the industrial design curriculum at Arizona State University. Why is the thematic direction taken? Because the history of design and industrial design never occurred out of context. The full understanding of any artifact is enhanced with an equal understanding of its context. The original Volkswagen Beetle makes the point. It can be studied as an innovative design concept with leading edge engineering and effective streamlined styling executed by Ferdinand Porsche, a brilliant designer. These three factors—innovation, styling, and personality—are often the basis for the design appreciation of the Beetle. However, this direction often omits or ignores many contextual factors, such as the politics of the time or the social structure of the country or unintended consequences. In the case of the Beetle, these three factors played a significant role in its design and development, as you will learn in the theme on Design and Politics.

Exploring the history of design and industrial design thematically doesn't mean that artifacts and designers will be excluded. Such won't be the case. Artifacts and designers will always be present, but they will always be situated in context because that's how the designing activity occurred in the first place. And what are some of these contexts or themes? There are 10 in all, including economics, technology, politics, and transportation, to name but four. In each theme, design and industrial design will be explored within the essential framework of the theme. Consequently, design and industrial design will become parts of a larger picture, as they should be.

Exploring design and industrial design thematically is effective but can at times appear somewhat

repetitive. This could certainly be the case with Alexander Graham Bell, the inventor of the telephone. He will appear in the theme Design and Communication. This is only obvious given the importance of the telephone in the development of communication devices. Bell's name will also appear in Design and Politics because it was the ease of cross-border travel between Canada and the United States that allowed Bell to develop his inventions. Ease of cross-border crossing derives directly from a political context.

The book begins with two introductory chapters on design. Each chapter provides basic yet important information that creates the foundation for the 10 chapters that follow. Chapter 1 sets the stage by demystifying the two words central to the textbook: design and designing. It does so by confirming that design and designing are human activities and that people all over the world are designers and engage in design and designing most every day. We also learn that design and designing are universal activities and occur everywhere that humans live. And we will be made aware that design and designing aren't recent human activities but date back some 3.4 million years. Chapter 1 will also introduce the concept of People/Place/Process or the 3Ps as well as *The Designing Triad*. The latter is a simple framework that helps demystify the designing process.

Chapter 2 follows with nine basic design principles that underpin most situations found in industrial design. At first glance, the world of industrial design may appear to be complex. Closer observation, however, will show definitive patterns, many of which can be perceived as principles for design and designing. The design principles begin with the phenomenon that design is essentially the process that creates the artificial world from the natural. From there, other principles are explained including the classification of everyday things (Tool, Structure, and Sign), designs as human extensions, and innovation-push/demand-pull. The chapter ends with reflections about good design.

Chapters 3 through 12 present the 10 themes that were mentioned earlier. These begin with Chapter 3, A World View of Design, in which design is framed in the so-called bigger picture. The chapter may appear somewhat short because most of the course material is delivered by way of a video and a collection of essays in the section called Readings and Viewings.

Chapter 4 is about design and the natural world. The relationship between the two may first appear to be tenuous but there's a strong connection beginning with the fact that everyday things can only exist as material objects because of the bounty found in nature. Nature's place in design goes well beyond being a source of material, however. Nature is also apparent in everyday things by way of symbolism, such as we find in applied decoration of natural subjects as well as the concepts of Organic Architecture and Arcology as practiced by Frank Lloyd Wright and Paolo Soleri, respectively. And then there's biomimicry, where the biological systems found in nature become the source of ideas for industrial design.

Design and Economics is the theme for Chapter 5. Economics may at first appear somewhat out of place in a course about industrial design history. After all, some people, many of them designers, believe that economics has little to do with industrial design and is far removed from industrial design and the world of everyday things. But it isn't. The reality is quite the opposite and simple to explain: design exists as a means of creating a surplus of one commodity or other, and economics is the operating engine of this surplus. In the end, effective industrial design is far more than creating objects for museums; it's the creation of objects for markets. This has been the case going back hundreds of years, even before the Industrial Revolution.

Design and Technology, the topic of Chapter 6, is an obvious theme for the study of industrial design history. The evolution of the making processes as well as the materials used go hand in hand with the evolution of everyday things. The chapter covers a great deal of ground. It begins with an overview of sources of artificial power including mechanical, steam, and electric. Power is important because it's power that created the Industrial Revolution, and, as we know, it's the latter that gave birth to industrial design. The chapter continues with sections on various making processes, from additive to subtractive and from one-off to mass customization. It ends with a summary of materials important to industrial design, especially wood, metal, and plastic.

Chapter 7, Design and Transportation, is an equally obvious theme for industrial design history. The chapter provides an overview of major developments in three sectors of transportation: automobile, rail, and aviation. Industrial design played a role in all

three sectors, either directly or indirectly. For example, the Streamlined Decade of the 1930s in the United States was a showcase for the role of industrial design. It began with the aerodynamic development of the Douglas DC-3, which influenced not only the streamlined design of the locomotives of the day but also the styling of automobiles of the same era.

Design and Communication is the theme of Chapter 8. As an area of study communication is an important component of industrial design history. It's a complex one as well because there are many facets to communication. One facet is human communication and the visual language. The latter is a design tool commonly used by industrial designers and with which ideas and concepts are communicated. For example, we recognize a chair because of the visual language that signifies "chair," not necessarily by a label or tag that says "chair." But communication is also about the world of technology. We may take our smartphones for granted but its design is the result of developments in communication technology going back to at least Alexander Graham Bell and even before.

The education of industrial designers is underpinned by a certain body of skills and knowledge that has evolved since around the 1800s. This is the theme of Chapter 9. As we've already discovered, designing is a human activity. Everyone designs. But an industrial designer, much like an architect or an engineer, is educated in the art and science of design in a rather specific and deliberate way. Formal design education began during the Industrial Revolution and evolved from there with contribution from schools in France and Germany. It came to America in the early part of the 20th century, gradually found its place in American culture, and expanded throughout the country. More recently, industrial design education has flourished in southeast Asia in places such as Japan, Korea and China.

Industrial designers have always had a fascination with material objects. So have anthropologists but from a different perspective, that of human culture. Chapter 10, Design and Material Culture, deals with these two different perspectives. The chapter begins by categorizing most artifacts into one of three groups: tools, structures, and signs. It proceeds from there to explore these categories by way of short case studies of several everyday things and artifacts. It ends with the description of a product classification system called *productology*.

Chapter 11 deals with the place of politics in design. At first glance, these two topics appear to be mutually exclusive and lacking totally of any connection. Design has everything to do with the creation of the artificial world, whereas politics deals with governance. However, the two are indeed connected because it's governance or politics that allows for the artificial world to be designed in one of several possible ways. What are some of these ways? Design can occur in a top-down political model much like it can occur in a bottom-up model. Case studies of several well-known everyday things will be used to show how politics were always present in the background of the design process.

The last chapter, Design and Society, is focused on design as a reflection of shifts in society. This we know to be the case because design never occurs out of context. In fact, everyday things are mirrors and reflect the societal values of the era in which they were created. This is why archeologists can tell us so much about past cultures by studying artifacts from those same cultures. The chapter will begin with brief descriptions of two societal constructs: individual/group and guilt/shame followed by some broad overviews of several important shifts in society and show how these shifts were reflected in everyday things of the era. These shifts begin with Beaux-Arts to Industrialization and end with Modernism to Postmodernism with several other shifts in between.

Many of the chapters will also include readings and viewings. In combination, these will provide additional information to the course material. Many of the readings are excerpts from Carma Gorma's excellent book *The Industrial Design Reader*. The other readings are taken from journal articles. Each one complements the chapters in which the readings are part. The viewings play a similar role to the readings. They too complement the chapters in which the viewings are found and provide important insight to industrial design history, especially those videos that come from corporate archives. In combination, the chapters, readings, and viewings provide background material that allows us to study and understand design, more particularly industrial design, as a contextual manifestation of human needs and wants, which goes well beyond the appreciation of everyday things as mere material objects.

CHAPTER 1

TO DESIGN IS TO BE HUMAN

Humans evolved principally because of the development of the human brain. With it came our ability to think. It was perhaps the one physiological feature that most differentiated us from other animals. Thinking made it possible for our ancestors to evolve beyond the animal-like behavior of the hunter-gatherer and rise to the level that it has today in the arts, humanities, and sciences. The ability to think changed almost everything for the human race. It not only permitted humans to understand the world but to also consider and propose changes to it. In other words, the capacity of the human brain to think made it possible for a person to contemplate an existing situation and to imagine a preferable one.

That said, thinking alone doesn't create stone tools or log houses or jumbo jets. Preferred situations only become a reality when they're materialized. Therefore, something else other than thinking *per se* needs to happen. And that something else is doing. Artifacts—stone tools, log houses, jumbo jets, and all other things artificial—are the result of a thinking activity combined with a doing activity. In other words, thinking leads to doing. Today, thinking and doing, in combination, is called designing.

The French philosopher René Descartes was correct when he declared, "*I think; therefore, I am.*" He connected thinking to being human. However, he could just have easily said "I design; therefore, I am." Like thinking, designing is an activity fundamental to

human evolution. It's not, as is sometimes heard, a very recent activity undertaken only by gifted individuals so that we may have cool things in our lives. This is what some people in the popular design media would like us to believe. In reality, everyone designs, and design occurs wherever humans live.

DESIGNING IS UNIVERSAL

Designing isn't only a human activity but it's also a universal activity. It occurs everywhere humans reside. Moreover, designing isn't unique to the developed world. In fact, it's how humans have forever adapted to changes in their context. Every artifact that we have today exists because our ancestors began designing some three million years ago and never stopped. Consequently, there's a kind of design DNA between today's everyday thing and those of the past. For example, there's a connection between a Swiss Army knife and a three-million-year-old stone tool. The former may be technologically more sophisticated than the stone tool but it's nevertheless nothing more than a refined version of it.

At one extreme, designing can be reactive such as the need to address misfits; at the other extreme, designing can be proactive such as the need to invent and innovate to the point of change for the sake of change. In either case, it's still designing. In his book, *Notes on the Synthesis of Form*, Christopher Alexander

1

wrote extensively about this continuum in designing. In it, Alexander explained that in unselfconscious cultures such as tribal cultures the changes in design in everyday things occur usually as the result of the recognition of a misfit. In other words, a spear once made of a certain wood is now made of a different wood because the wood previously used is no longer available. The need for this change in design is an external one to the person and not precipitated by a need to change for the sake of change. This designing process is very different from what occurs in self-conscious cultures where changes in design often occur because of self-referencing. That is to say, there appears to be a need for many everyday things to reflect the individual, which partially explains fashion design. The skirt that we own may be barely worn but we nevertheless discard it because it has gone out of fashion. In this case, the design change is internal and comes from the person. This kind of change is most often a change for the sake of change.

THE 3PS OF DESIGN

Designing three million years ago was very different from designing today. This should come as no surprise given the evolutionary changes that have occurred in design in the intervening years—from primitive axes to computer chips. Despite these changes, three factors have always underpinned designing. These are people, place, and process or the 3Ps of design. Designing has always included these three factors. Let's begin with people.

People are an intrinsic part of designing. After all, what reason is there to design other than for a human need or want? Admittedly, the first artifacts were strictly utilitarian and served a direct human need for subsistence, but even the least utilitarian artifact of today such as a sculpture serves a human want. There's always a human dimension to an artifact much like there is to designing.

The second factor is place. Place impacts designing because designing never occurs in a vacuum. It always occurs in place or context. The context may not be obvious at first but it's always there. Modernism is such an example. Its fundamental premise was based on a rational designing process, but the rationale was northern European—Germany, Austria, the Netherlands,

and Scandinavia. Although labeled as the International Style by some scholars, Modernism was regional by the very nature of its place of origin.

The third factor is process. Process has always been part of designing. Generally speaking, designing doesn't occur by some form of black magic or other unexplained phenomena. Intention is always involved in designing. Moreover, the designing process can be either explicit or implicit. Even accidental discoveries can be considered as an unintended consequence and therefore a kind of designing process. To no one's surprise, process has also evolved over time. It's much more complex today than it ever was in the days of hunter/gatherers.

THE DESIGNING TRIAD

People play three distinct roles in the designing process. Examine almost any artifact and you will soon discover that people can be designers, makers, and users. These three roles or players constitute the Designing Triad. Two other elements are also present in the Triad. One is context—after all, designing always occurs in context; the other is the artifact itself.

Although the designer, maker, and user are constants in all designing activities, the interrelationship among the three players hasn't always been the same. It has evolved and changed over time. Initially, the three players were essentially one and the same person. This occurred in the so-called Age of Needs (a period between 3.4 million BCE to about 10,000 years ago).

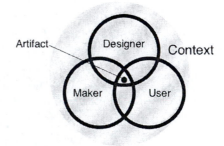

Diagram I: The Designing Triad, which shows how the Designer, Maker and User interact to create an Artifact in Context.

Hunter-gatherers were designers, makers, and users all rolled into one. If spears were needed for hunting, an industrial designer wouldn't be hired to design them; neither would a manufacturer be found to make them. Hunter/gatherers did the designing, the making, and the using as one integrated activity.

The interrelationship among the three players changed with the advent of agriculture and the domestication of animals. This was the Age of Surplus and happened about 10,000 years ago. Growing food instead of foraging for it not only provided a steady source but also created a surplus on occasion. Much the same happened with the domestication of livestock. It too could create a surplus. Hunting was no longer the only way to get meat. This surplus—grain, spices, fish, meat, and even artifacts—resulted in a commodity. One commodity could be exchanged for another. The exchange, or trade, of surplus generated a new design phenomenon: a user of an artifact who didn't necessarily have to be its designer and maker. In other words, a person didn't have to be able to design and make a basket in order to own and use one. You could trade your surplus for the basket. Today's market economy is based totally on the trading of one kind of surplus for another. Watch an intercontinental freight train go by. What you see is a series of flat cars with containers full of stuff—that is, one person's surplus being exchanged for another person's surplus. The nature of surplus may be different today compared to what it was 10,000 years ago but the concept of surplus isn't. It's the same.

The Designing Triad went through yet another change when designers and makers split. This division had its beginning as early as the Renaissance where there was a first recognition of an individual as the designer. Leonardo da Vinci is a good case in point. The split became even more amplified with the Industrial Revolution when machines began displacing the makers. Until then, the designer/maker—or artisan—was solely responsible for the creation of everyday artifacts albeit almost exclusively meant for the nobility. We see the latter especially well in the Renaissance and Baroque eras. The Chateau de Versailles is an excellent example of the design exuberance of the artisans of the day. These artisans possessed both designing and making skills. You couldn't separate the two. Industrialization changed all of that. Machines could now make

everyday things, which displaced the making function for the designer/maker. Moreover, industrialization put into question the role of the designer because machines could now replicate what the designer had created in the past. It appeared that designers were no longer needed.

With industrialization, the number of users also began to grow rapidly. This was the beginning of what was to become the middle class, and makers—manufacturers to be more specific—were sprouting everyday and everywhere. The same couldn't be said for designers, however; they seemed to be out of the loop. The change to a more active role in designing occurred with the realization that industrialization was an opportunity and not a threat to designers. This approach was best illustrated, first, by designer/makers such as Michael Thonet and Josiah Wedgwood, and then by the early Modernists, who embraced the machine age. By extension, the recognition of the designer as an entity independent from the user and maker led to the notion of self in the designing process. Slowly, the names of designers began to appear more frequently. Today, few people bat an eyelash when a designer's name is connected directly to an artifact such as a Chanel suit or an Eames chair or an Aalto vase or a Dell computer. Each one of these everyday things is defined by the name of a person. This period became known as the Age of Self.

Designing continues to change. As we move forward into the millennia, it's intriguing to observe that designers, makers, and users, who had become isolated from each other in the Age of Self, are once again becoming one. User involvement and ownership appear to be the driving forces in this change, which, at least in part, is a reaction to the prescriptive model of Modernism. The latter placed control of the designing process solely in the hands of the designer. Users were merely the recipients of the designer's output. Today, users are getting more control of the designing process by participating in it, a process known in business circles as codesign.

This higher degree of user participation is attributable to two relatively recent socioeconomic developments, both of which are displacing the industrial age. The first development is the Information Age, which occurred with the intensification of knowledge creation and the resulting glut of information. People now

know more and more about almost everything. The second development is the Digital Revolution, a period defined by information leaving the analog domain and shifting to a digital one. Both developments have empowered users. Not only are they better informed but with systems like the Internet and devices like smartphones they also have the means to communicate. When combined, information and communication can be extremely powerful as was witnessed with the Arab Spring. Despite the military backing, rulers and dictators were summarily removed from power because of smartphones and social media.

Chapter 2 provides an overview of several important principles in design. These aren't formulae or hard-and-fast rules but a set of design lessons learned over several centuries.

NOTE: There are no readings or viewings for chapter 1.

CHAPTER 2

A FEW NOTABLE DESIGN PRINCIPLES

INTRODUCTION

For some people, design and designing are shrouded in mystery. The presence of everyday things—who designed them and how they got here in the first place—is unknown and never fully understood. A new tablet is launched by Samsung and appears on the market as if by magic. It seems to have come out of nowhere but is now found everywhere—in a local store, on television, or on a web site. Despite the presence of millions of tablets as well as a thousand other everyday things, most people don't quite understand the process that created them. Even less is the understanding of certain design principles that underpin each and every one of these everyday things. This chapter will address a few of these notable design principles.

FROM NATURAL TO ARTIFICIAL

Our cities, our transportation systems, our houses, and our everyday things are all artificial. We live in an artificial world almost every day of our lives. Yet many people don't realize that designing makes this artificial world possible.

The artificial world exists simultaneously with the natural world. The latter is the world of lakes, rivers, oceans, forests, deserts, and mountains. It's the bounty that we are given as humans. More importantly, the natural world is the only source of material from which we can design and make our artificial world.

The designing process, that is, converting the natural into the artificial, began over three million years ago when rock, a natural material, was chipped deliberately into a tool, an artificial thing. As basic as this first act of designing was, it would evolve and eventually provide the panoply of everyday things that we have today. A complex product such as the Boeing 787 Dreamliner follows, at least in principle, the same designing and making principles as the stone tool. Every part and piece of the 787—from the metal in the landing gear and turbines of the jet engines to the composite plastics in the fuselage and wings—comes from the natural world albeit with a great deal of processing. The metal in the landing gear, for example, originally came from ore found in the earth much like the plastic used in the fuselage came from oil pumped from the ground.

The designing of our artificial world is totally dependent on the bounty found in the natural world. In the end, there's nowhere else for us to go but to the natural world for material with which to design and make our everyday things. It's all that we were given and all that we have.

TOOL, STRUCTURE, AND SIGN

There are just too many everyday things for us to count. In any one day, a person will come into contact with several hundreds if not thousands of everyday things. Some are small such as a ballpoint pen; others are larger like a bicycle. Others are larger still like the Statue of Liberty. Despite the number and variety, all everyday things or artifacts generally fall into one of three categories. They can be tools, structures, or signs. They can also be either mobile or immobile.

If artifacts are mobile, they generally fall into the category of tools. Therefore, tools are mobile everyday artifacts that address human needs and wants. The term may create confusion because the common use of the word tool generally refers to such things as hammers and screwdrivers or to kitchen tools such as knives and can openers. For our purpose, however, the meaning of tool will be broader and will embrace a much larger range of artifacts, both large and small. For example, the typical car is a tool because it conforms to the definition: a car is a mobile everyday artifact that addresses human needs and wants of transportation. Chairs are also tools; they're tools meant for sitting.

Structures are also everyday artifacts that address human needs and wants. They differ from tools because they're immobile. Houses, buildings, and bridges are structures as are bus shelters and fences. If the everyday artifact is immobile and serves human needs and wants, it's a structure.

Signs are a third category of artifacts; they don't fit neatly into the categories of tools or structures but they're nevertheless artifacts. For example, the letter A is a sign. It's a graphic composition of three simple lines, and has an explicit meaning. However, there are signs with implicit meanings. Most people looking at a Ferrari sports car would read certain messages beyond the fact that it's a car. Most likely they would assume that a Ferrari costs a great deal of money and that the person who owns it must be wealthy. In the end, signs are a combination of visual design elements that constitute the visual language either explicit or implicit in everyday artifacts.

DESIGNS ARE HUMAN EXTENSIONS

Artifacts exist to serve human needs and wants. This fact we've already discovered. However, artifacts, especially those classified as tools, serve human needs and wants in a particular way: they're often forms of human extensions. That is, these artifacts exist as a way of extending human capacities of one kind or another.

Generally speaking, there are three levels or types of human extensions. The first level is composed of artifacts that extend muscular extensions. For example, wheels, as we find on bicycles, wagons, and automobiles, are artificial extensions of the human leg. Tools, like shovels and spades, extend the muscular capacity of the hand to move sand or dirt as well as the muscular capacity of the arms to lift. A combination of the wheel, the shovel, and a few other devices such as hydraulic cylinders gives you something like a backhoe, which is nothing more than a highly efficient extension of basic human muscular capacity.

The second level of human extensions is connected to human senses, especially hearing, sight, and smell. The cell phone that you use every day may at first appear to be nothing more than a cool example of sophisticated technology. In reality, however, it's an artificial extension of our ability to hear. No matter how refined the technology, a cell phone is nothing more than an extension of the human ear. It allows one person to hear another person hundreds even thousands miles away. The same principle applies to radar like we find on airplanes. The radar is an extension of human sight. When next on a flight home think of the radar on the airplane as it descends through dense clouds. The pilots can see where they're going because of radar, which can see through the clouds in a way that humans can't. And while on that same airplane, think for a minute about the smoke detectors in the lavatories. They're better than the human nose at detecting smoke.

The third and last level of human extensions is our capacity to think. The abacus, which goes back to the Sumerian civilization some 5,000 years ago, was one of the earliest devices that replicated the human capacity to think or calculate. It allowed people to do basic arithmetic more quickly and efficiently. Today, we have

all forms of computing devices—calculators, computers, computer-aided manufacturing, and robots. Each one essentially does the same thing: it extends the human capacity to think.

INNOVATION-PUSH/ DEMAND-PULL

Which comes first, the chicken or the egg? Children often ponder this question. So do some consumers when thinking of everyday artifacts. Does the designer's idea for a new everyday thing come first or is it the market demand for a new everyday thing? The answer is both, but not always to the same degree. For example, most everyday artifacts are based on incremental changes from one model to the next. The automobile is a good example. Every year manufacturers release a new model. But these new models rarely offer anything radically different from last year's model. This phenomenon is called demand-pull; that is, it's the market demand that pulls or defines the new artifact.

That wasn't the case with the Sony Walkman when it was launched in 1979. No one had ever seen let alone used a small, portable device that allowed individuals to play their own music whenever and wherever they wanted. Not surprisingly, it took some doing for people to get accustomed to it and to feel comfortable to buy it. The Walkman was novel and unfamiliar to people. This type of product phenomenon is called innovation-push. In other words, the innovation needs to be pushed onto the market before it's accepted. What about the iPod, you may ask? Is it demand-pull or innovation-push? As innovative as it is, the iPod is an example of demand-pull. There's no doubt that the iPod is innovative, but the idea of a small, portable music player is now an old concept even if the digital technology in the iPod is recent.

The majority of everyday artifacts launched on the market are demand-pull. One reason explains this: it's easier to sell something that people already know than something they don't. As the British art critic Eric Newton once quipped, *"It's not that people know what they like; they like what they know."* Consequently, manufacturers and retailers reduce their risk in the marketplace with demand-pull products. Innovation-push is just the opposite. The business risk is extremely high, perhaps around 90% failure rate in some product sectors. Nevertheless, the financial rewards for a successful innovation-push product can be immense.

THE VISUAL LANGUAGE

Few if any everyday artifact have labels or nametags to identify them. Yet we never mistake a spoon for a chair or an automobile for a church. Why is that? It's because everyday artifacts all have visual characteristics that we read and understand and recognize as a spoon, a chair, an automobile or a church. And we read them because they communicate via a visual language.

The visual language has two components. They are design elements and design principles. Design elements are like the words or vocabulary of the visual language. They are the visual devices that designers use to determine what we perceive as the look of the everyday thing. They normally include line, color, shape, form, texture, and space.

Design principles are also part of the visual language but act more like the grammar found in a written language. In other words, the design principles provide designers with the means to express a visual message more effectively. The design principles most often used are variety, unity, balance, emphasis, rhythm, and scale.

When you next look at a spoon, a chair, an automobile or a church, ask yourself why you recognized it to be what it is. More than that look closely at the combination of design elements and design principles and study how they were used to create the requisite visual language appropriate to a spoon, a chair, an automobile, or a church.

THE LAW OF PROXIMITY

When next in a department store have a look at the watches. There seems to be an infinite selection of models. There are watches for women, men, and children. There are basic, inexpensive models and upscale, expensive ones. There are all types of sports and chronometer models as well as designer watches such as

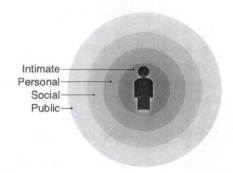

Intimate —
Personal —
Social —
Public —

Diagram 2: The Law of Proximity, which is based on Edward T. Hall's Law of Proxemics. The latter is about people-to-people interaction; the former is about people-to-product relationship. Both laws are conditioned by the spatial bubbles that we all inhabit.

Swatch. Irrespective of their variety, these watches all do the very same thing: they tell time. Therefore, why do we have all these different models for a product with essentially the same function? The same phenomenon occurs with frames for eyeglasses. Anyone who has to select a frame for a pair of prescription glasses faces a challenge of limitless choice. There are metal and plastic frames. There are also combinations of metal and plastic. Some frames are decorated; others aren't. Then there are designer frames. Like watches, frames have but one function: to hold two pieces of prescriptive glass in front of your eyes. Therefore, why so many choices?

The Law of Proximity partially explains the variety of designs in many everyday artifacts. Simply put, the law states that the closer an everyday artifact is to the user in normal use, the greater the variety of designs. That's why there are so many models of watches and frames for glasses. When in use, these artifacts are close to us physically; they become an extension of who we are and allow each one of us to create our own selves.

The reverse is equally true; that is, the further an everyday artifact is to the user in normal use, the fewer the variety of designs. There may be an infinite variety of sunglasses in the market place but there are a great deal fewer models of welding goggles. The reasons for this are quite simple. Welding goggles are often purchased by the employer and not the employee or user; they're also

meant for a workplace and not for personal use. Consequently, the choices are limited. Much the same occurs for office clocks. Like watches, they're also time-keeping devices. Unlike watches, however, they don't belong to the individual user. There's no self-identity associated with the office clock. As a result, they're available in fewer models.

PAST TIMES ARE PASTIMES

If asked, many people think that MP3 music files on their smartphones represent the state of art of today's music technology. In reality, they're nothing more than a refined version of Edison's invention of recording cylinders made of wax. Considered from this perspective, most everyday things connect to past in one way or another. They do so almost as if there's a design DNA.

The connection to the past exists in several other ways as well. Certain architectural styles such as the Renaissance were connected to the past styles of classic eras such as Rome and Greece. The same goes for Gothic architecture and its revival as Neo-Gothic. Looking back to one era or another brought a certain level of human satisfaction by validating the present with evidence from the past. What's called retro design follows in a similar pattern. It too is an example of designing the present by retrieving something from the past. This is clearly the case with the New Beetle and the New Mini. Both cars connect, at least visually, to past models of the same car.

There's another way to connect with the past that isn't at first apparent but equally noteworthy. It's especially relevant in the context of past times and pastimes such as we find with outdoor activities like camping, fishing, and hunting. It should be noted that there's a multi-million dollar industry associated with these outdoor activities. Think of Cabela's, REI, and Patagonia. Yet each one of these activities—camping, fishing, or hunting—was part of a day-to-day lifestyle some 200 years ago. This is how people survived, by way of camping, fishing, and hunting. In no way were any of these activities a pastime then. Today, the situation has changed totally; these activities are considered a pastime and are no longer necessary for human

survival. Much the same can be said for sailing. When our European ancestors reached the shores of the country for the first time, it was by way of tall ships. Today, sailboats are rarely used for trans-oceanic travel. However, they certainly exist as a pastime. In fact, the sailing industry is huge. These examples aptly demonstrate that even with the most sophisticated products in camping, fishing, hunting, and sailing, there's still a connection to the past. Past times are indeed pastimes.

DESIGN IS ABOUT EXPERIENCE

Several years ago, I had the distinct pleasure of having lunch with Tony Lapine, the chief designer at Porsche, the company that makes high-performance sports cars. While discussing all manner of car stuff I asked a somewhat naïve question, "What is the difference between a Mercedes-Benz sports car and the Porsche?" Frankly, I expected an answer filled with technological information such as top speed, weight-to-power ratio, or acceleration from 0 to 60. His answer totally surprised me. Lapine turned to me and said, "If you want to look 10 years older, buy a Mercedes; if you want to look 10 years younger, buy a Porsche."

In hindsight, what Lapine and Porsche had discovered appears self-evident: people buy and use all manner of artifacts for the experience that these provide. Designers, of course, tend to not see artifacts in quite the same way. Their fascination is more about the materiality imbedded in the artifacts. They admire the innovative use of material or an ingenious detail or a novel form. As meaningful as these may be, users see things differently from designers. Their concerns is much more about the toast and not so much the toaster.

GOOD DESIGN

As I discovered when lunching with Mr. Lapine, discussions about design can be about many things. Ours began about measurable variables such as performance and ended on the topic of experience. This is not at all unusual. However, one topic appears to be almost inevitable: what is good design? As relevant as this question is it's also fraught with all manner of pitfalls because it's so subjective.

The subjectivity implicit in asking and answering what is good design is perhaps the proverbial slippery slope, but it's also the clue for a better comprehension. As long as we persist on believing that a person stating that this or that product is a good design is actually referring to the product, we err. The person is not talking about the product. To the contrary, the person is talking about herself. Statements about good or bad design are autobiographical. Most importantly, good design, or beauty, resides in the person, not in the product. The comments made by the person are about the person, not about the product. Once understood, this concept allows us to comprehend better terms such as right and wrong or good and bad or like and dislike. In the end, it becomes clear that there is no such thing as a good or bad product; there are only products that we perceive as good or bad.

SUMMARY

Most everyday artifacts go well beyond some narrow utilitarian function. Watches are more than just time-keeping devices much like automobiles are more than vehicles that get us from A to B. Everyday artifacts have more complex meanings. They provide myriad clues about human culture. If anything, they're mirrors and reflect who we are. To quote Henry Ford in Penny Sparke's delightful book, *An Introduction to Design & Culture in the Twentieth Century*, "*A piece of machinery, or anything that's made, is like a book, if you can read it.*"

The information in chapters 1 and 2 is an abridged version of material found in *Designing: A Journey Through Time*, the course textbook for DSC 101 Design Awareness. The latter explores these and other topics in greater depth.

NOTE: There are no readings or viewings for chapter 2.

CHAPTER 3

A WORLD VIEW OF DESIGN

INTRODUCTION

I don't know about you but when I read a magazine I usually flip through the many pages and articles in order to get an overview or sense of the content. I do much the same when I get a new book—even an e-version. I first look at the table of contents and see what the main chapters are. In many ways, getting a bird's eye view of something appears to be human nature. This chapter takes a similar approach. It provides an overview of industrial design and its presence in our everyday world. The overview of design and industrial design is already familiar for some of you, especially the design majors in the course. That said, this portion of the course offers nuances and details that may be unfamiliar to you.

For other students in the course, almost everything in this theme will be new and revealing. Some of you may have only become familiar with the term industrial design since coming to the university. For others still, perhaps those of you who have completed DSC 101 Design Awareness, this theme will reinforce certain perceptions and beliefs that were already present but perhaps not yet confirmed. Be it as it may, there's something for everyone.

READINGS AND VIEWINGS

The theme begins by asking that you view the full-length video *Objectified*. The latter is an excellent documentary on the state of contemporary industrial design. I can hear the groaning already because there are those of you who have already seen the video. It's old news for you. If you took DSC 101, you have certainly seen it. On that note, I can tell you that I have seen the video over a dozen times. And each time that I do I discover something new. I can guarantee you that you will as well.

To those of you who have not viewed *Objectified*, take the time to savor it. This you can do because you need not watch it all in one sitting. This is especially the case for online students. Not only can you watch the video in segments but you can also go back to certain bits and watch these more than once.

Objectified will be the only full-length video in this theme. The remainder of the course material will be in the form of one shorter video and three readings. The video is an interview with Jonathan Ive and Marc Newson, both designers of note. Moreover, both appeared in *Objectified*.

The three readings connect the practice of industrial design as discussed in *Objectified* to the discourse in industrial design history—past and present. In combination, the video and readings create a kind of comparison between practice, on the one hand, and theory and ideology, on the other. The first reading is from Victor Margolin, a well-known American design historian. In his article, *Design, the Future and the Human Spirit*, Margolin begins by positing a dichotomy, of sorts. On the one hand, Margolin perceives designers

as agents of change; on the other hand, he sees design-ers as people who never seem to be at the center of change, at least not at a global level. For Margolin, this dichotomy is an important one, especially when con-sidered in the context of the sciences of the artificial as explored by Herbert Simon. From Simon's perspective, the world is becoming increasingly artificial and it's design that's driving the process. Consequently, why is it that designers don't appear to be in the driver's seat? This is an excellent question, indeed. Margolin touches upon several exceptions, going back to William Morris in the 19th century and his social agenda to Tomas Maldonado in Italy in the 1970s to Bruce Mau, who has been the driving force behind Massive Change.

Margolin also mentions Victor Papanek, the American designer who saw well beyond the material world of artifacts. His book, *Design for the Real World*, opened the eyes of designers to the realization that challenges in design didn't reside only with the tradi-tional areas of products such as furniture, appliances, and automobiles. Papanek also made it abundantly clear that design had its place in areas such as the devel-oping world and the environment, and in sectors such as the handicapped and the aging population. Equally revealing is the fact that Papanek was making this com-mentary in the early 1970s, an era when few designers were aware of the developing world, the environment, the handicapped, or the aging population.

The third reading is the essay from Sigmund Freud. How, you may ask, is Freud, the Austrian psychoanalyst, connected to design? The connection exists but very much in a global way, a way in which the intervention of society onto nature affects the human condition. As expected, Freud's musings are somewhat broad and philosophical. Nevertheless, they situate design—that is, courses of action changing an existing situation into a preferred one—in a much larger con-text and show how significant the impact of design can be on the human condition.

A World View of Design provides a broad perspec-tive of design. It also makes the point that design and nature are interconnected, even if not always in the most obvious way. The Natural World, the next theme, will shed more light on this connection between design and nature.

NOTE: Readings for chapter 3 are found in the back of the book.

CHAPTER 4

DESIGN AND THE NATURAL WORLD

INTRODUCTION

Everyday things, whether simple or complex, can't exist without the Natural World. After all, where do we get the materials from which we make everyday things? In a nutshell, what we know about design and the Natural World comes down to this: humans come into a Natural World and then go on to create an Artificial one. The latter intervention or process is what we call designing.

Everything in our world is either natural or artificial. And if it's artificial, then it was designed. This fact is especially important to industrial designers because designing is what industrial designers do. We also know that we can't create an Artificial World, that is, one that's material, without using the resources provided to us in the Natural World. Our natural resources are all that we have. Moreover, these resources are finite. This fact is equally important to industrial designers.

Placed in an historical context, we also know one more thing: both the Natural World and the Artificial World have been intertwined since the beginning of human history. You can't separate one from the other easily. Look around: the physical presence of all everyday things is due to the bounty of the Natural World. Remove the Natural World from the picture and everyday things can't exist. Therefore, what's the place of design and industrial design in the Natural World?

DESIGN AND HUMAN EVOLUTION

Designing is the human capacity to devise the means to change an existing situation into a preferred one. We also know that our earliest ancestors regularly changed an existing situation to a preferred one by making simple tools. Simple tools were necessary because they were directly connected to survival. Simple tools such as stone tools served one purpose: survival and little else. Over time, designing made the development of more elaborate stone tools possible such as tools meant for cutting. These would eventually give us more sophisticated blades made of bronze and steel. The chef's knife found in today's modern kitchens is a direct descendant of the early stone tools, albeit a far distant cousin.

In the Age of Needs, the process of artifact creation occurred in a way that was simpler if compared to the design of today's chef's knife. As a case in point, it's impossible to see the iron ore in the knife's steel blade. There have been too many processes between the iron ore, as found in the ground, and the refined steel of the blade. The connection to nature is no longer direct and isn't evident. That wasn't the case with the stone tool. We could easily tell that the tool is made of stone even if its new purpose was to be a knife.

In the Age of Surplus, we saw the beginning of tools that went well beyond needs for cutting, scraping, and pounding. For example, the concept of surplus

meant that there now existed a need to not only protect the surplus but also carry it and store it. These added requirements led to a new range of artifacts not seen in the Age of Needs. The amphora was one of these new artifacts. These were large containers used to store liquids such as olive oil or wine. The amphora protected the liquid from the environment; it also allowed for the shipping of the liquid, thereby encouraging trade.

With the need for different tools for different purposes came the discovery of different materials, all originating from nature. The amphora just mentioned was made of clay. Clay's connection to a natural material is somewhat obvious. Even when fired, clay retains a close visual and textural connection to its natural source. This connection isn't as obvious, however, with glass bottles. Bottles and jars occur in almost infinite variety of shapes and forms; all are made from silica found in sand. But the presence of sand isn't immediately obvious when looking at a glass jar. Glass is several steps removed from its natural state, all by way of one artificial process or other.

The need to store, protect, and transport surplus has remained much the same over time. What has changed, however, is the design of the containers. Wilhem Waggenfeld, who was a master at the Bauhaus, designed glass containers in the 1920s. These were simple rectilinear glass boxes based on early Modernist design principles. Even today, the lowly plastic sandwich bag is nothing more than a container. Nevertheless, it has a design DNA that connects it to the clay amphora. That said, the connection between plastic and nature appears to be very tenuous, indeed. After all, the plastic used in sandwich bags is an extremely refined material and derives from petroleum, which, of course, comes from nature.

As can be surmised from these few examples, our artificial world originates from the bounty provided by our natural world. And nature's bounty certainly appeared to be infinite until recent times. For most of human history, the use and subsequent depletion of the natural resources for the purpose of survival was never a matter of concern. The world's population was small and our natural resources appeared limitless. Moreover, only a few people such as kings, pharaohs, and emperors consumed a great deal of material. Most people had barely enough to sustain life. The situation began

to change with the Industrial Revolution principally because production suddenly moved from the level of individual human capacity to the level of machine capacity; that is, from one-off production by artisans to mass production by machines. Over time, and as we shall see, machine capacity would only increase as would the acquisition of everyday things by people. People also began to travel more, their homes became larger, and everyone wanted the highest standard of living possible. Once this pattern of consumption moved beyond the so-called developed world of Europe and North America, material consumption began to grow exponentially.

Fortunately, not everything was out of control, so to speak. There have been several designers over these past 150 years or so who have shown concern for what we today call our ecological footprint. Horatio Greenough was one of these as were Adolf Loos, Paolo Soleri, and Victor Papanek. These individuals stand out as exemplars of people who showed a direct concern about the interconnection between the Natural and Artificial worlds. Their stories are found next.

IT ALL BEGINS WITH THE INDUSTRIAL REVOLUTION

The Industrial Revolution was the first step to what would eventually lead to our age of consumption. Industrialization accelerated the making of everyday things and created what we today call the middle class, which was often associated with material possessions and the lifestyle that these provided. The increased production and consumption benefited manufacturers and consumers alike. Generally speaking, the direct impact from these changes was good. There was, however, two important impacts: the depletion of natural resources and pollution. There appeared to be little concern for either. Both appeared to be the price to pay to become industrialized. Today's age of consumption is the amplification of a pattern that developed over 100 years ago.

Over that same period of time, from the late 19th to the late 20th centuries, several designers were keenly aware of the impacts of industrialization on the Natural World. In their individual ways, they each contributed

to a perception of an artificial world that was less detrimental to the Natural World. Four of these individuals will be examined more closely; they are Horatio Greenough, Adolf Loos, Paolo Soleri and Victor Papanek.

Horatio Greenough (1805–1852)

Horatio Greenough was an American sculptor and author; he wrote extensively about art and architecture. His connection to the Natural World and design was his belief that the beauty and goodness found in the Natural World was the direct result of a form that was appropriate to its function. From his perspective, the forms found in animals and plants were a reflection of the functional requirements imposed upon them. Greenough stated it best when he wrote, "*The law of adaptation is the fundamental law of nature in all structure.*" In other words, the design of everyday things should somehow conform to rules similar to the rules that create designs in nature. Carma Gorman, the American design historian, expressed a similar sentiment when she wrote that Greenough "*. . . argued that beauty in architecture and design was a result of fitness to function.*" It should be noted that Greenough was connecting form to function but doing so well before the American architect Louis Sullivan uttered that same combination of words. As we know, "form follows function" became the founding premise of Modernism. There's more about Greenough and his ideas in Readings and Viewings.

Adolf Loos (1870–1933)

The Austrian architect Adolf Loos was what we today would call a closet environmentalist. In his seminal article of 1910 entitled *Ornament and Crime*, Loos railed against the waste of material and capital involved in unnecessary decoration. Loos was emphatic when he wrote, "*Ornament is wasted effort and therefore a waste of health. It has always been so. But today it means a waste of material as well, and the two things together mean a waste of capital.*"

Loos' reference to health was, in part, because of the inhumane conditions in certain work places of the era. The ornamentation that was required for everyday things often placed the workers in dangerous situations.

For example, people who made hats—hats were very popular in the late 19th and early 20th centuries—had to use mercury. Mercury can be lethal and can affect the brain. As a result, many workers became mentally unstable over time, a situation that gave us the saying "mad as a hatter."

But it's Loos' reference to waste—health as well as material—that makes a point about sustainability because he perceived that together the two created a waste of capital. Little did Loos know that the triple-bottom line of sustainability is now based on similar elements. That is, health is about the human or cultural aspects of sustainability; material is about the environmental aspects; and capital is about the economic aspects. These three—culture, environment, and economics—are the pillars of sustainability.

Paolo Soleri (1919–2013)

The years after World War II were years of prosperity in America. This is when the country was in its biggest period of economic growth. Expansion was occurring everywhere. Housing construction was booming and car manufacturers couldn't keep up with demand. The American dream was alive. The state of the environment wasn't a social concern whatsoever.

One person who saw things differently was Paolo Soleri. Soleri was an Italian architect and had trained under Frank Lloyd Wright. Like Wright, he also had a love for Arizona. Soleri's perception of architecture was somewhat different from Wright's, however. Soleri was of the opinion that architecture couldn't be separated from the environment. The two—architecture and the environment—evolved together.

Wright didn't quite see architecture and the environment in the same integrated way. For example, he perceived the development of cities as a decentralized concept. This concept he called Broadacre City. The idea was to provide each family with a one-acre lot on which to build a house. By doing so, the population of a city wouldn't be concentrated in a densely populated center but spread out. Soleri didn't agree with this design direction. If anything, he was of the opposite opinion. For Soleri, architecture occurred in a symbiotic relationship with the Natural World. It was an integral part of the ecology of place. He called this

principle arcology, a combination of the words architecture and ecology. For any given amount of land, arcology encouraged the centralization of buildings with the rest of the land remaining untouched. This approach was the opposite of Wright with Broadacre City.

Arcosanti, the building complex in Cordes Junction, Arizona, is the living laboratory for Soleri's concept of arcology. He located all the buildings—living quarters, studios, and workshops—in a limited area situated on a very large piece of land. Although Soleri died in 2013, his Arcosanti project continues to evolve.

Victor Papanek (1923–1998)

Victor Papanek shocked the industrial design community when he wrote in his book, *Design for the Real World*, that there were few professions as dangerous as industrial design. This was in the mid-1970s, no less. What Papanek was objecting to was the almost immoral practice of industrial designers, who in many cases were designing things that people didn't need, purchased with money they didn't have, in order to impress people who didn't care. This practice would eventually become known as consumerism. And for Papanek, industrial designers were the culprits who were responsible for wasting material as well as being involved in malpractice.

But there were other issues that Papanek considered relevant and important but that the design community was ignoring. The environment was one of these as was the concern for the developing world. Papanek felt strongly about both. However, he was making these pronouncements in the 1970s when the industrial design community was more focused on the newest car model or the latest gadget. The environment and the developing world were unknown territories for the design community. There was no interest for either, and certainly no possible potential for business or the economy. Fast forward 30 years and the picture had changed totally. Papanek saw what most of us didn't. Today, the early environmental actions from Greenough, Loos, Soleri, and Papanek have been encapsulated into one term: sustainability.

THE NATURAL WORD: A SOURCE OF VISUAL IMAGERY

The Natural World provides designers with the material for the so-called Artificial World. It can also be a source of another aspect of design. The period beginning with the Industrial Revolution is identified with the rise of the machine and industrialization. Over this same period of 150 years or so, the Natural World had another presence in design. This presence was more visual and symbolic, therefore more obvious to the eye. The presence of nature first appeared as applied decoration and, as we shall see, proceeded over time to become more exuberant with Art Nouveau. Nevertheless, nature was the source of visual imagery for both design and designers. Inspiration from nature would lead ultimately to biomimicry, where the biological systems that underpin nature are used as the source for new designs.

THE NATURAL WORLD AND THE INDUSTRIAL REVOLUTION

The Industrial Revolution totally changed the making of the everyday thing. Machines could now easily out-produce the manual worker. More everyday things could be made in less time and at a lower cost. Not surprisingly, the Industrial Revolution became known as the Machine Age, and the Machine Age came with its own visual language. In one word, it was mechanistic. If anything, it lacked any direct visual connection to the Natural World. So did, for that matter, many of the everyday things that were made by these same machines.

An obvious first step for addressing this mechanistic look was applied decoration; that is, reduce the machine esthetic by using colors, shapes, and forms derived from nature and applying these to everyday things. This visual direction occurred not only in the many machine-made artifacts but also with the machines themselves. What would have been expanses of cast iron devoid of anything but the rough steel surface became scrolls, eagles, and other decoration. Of course, applied decoration was nothing

Courtesy of Jacques Giard

Image 1: The highly decorated chalice was typical of religious artifacts in the Middle Ages.

new. It had its place in many historical objects such as religious vessels going back to the Middle Ages. Going back even further in history to the time of the Romans, we know that a great deal of decoration on everyday things had to do with storytelling because most people couldn't read.

Returning to the Industrial Revolution, many everyday things were heavily decorated. Such was certainly the case with the makers of crockery and pottery. English companies such as Royal Doulton applied one kind of decoration or other often using imagery found in nature such as flowers and birds.

Josiah Wedgwood, whose company also produced crockery and bears his name, was an advocate for this decorative approach because he believed that the artisan had a place in industry. Moreover, Wedgwood's reputation for including the arts in the making of everyday things is apparent in the words of former British Prime Minister William Gladstone, which appear on the

Courtesy of Jacques Giard

Image 2: Applied decoration was often found on everyday objects such as we see with this Wedgwood tea service.

showroom wall at the Wedgwood factory in England. Commenting on Wedgwood's contribution, Gladstone said, "*Wedgwood was the greatest man who ever, in any country, applied himself to important work of uniting art with industry.*"

The applied decoration found on items for the home became particularly important in the 1800s as the middle class was quickly growing in size. Generally speaking, it served three important purposes. First, applied decoration helped differentiate one company's product from those of another company. It could be said that it was an early form of branding. Second, applied decoration helped connect the consumer to the everyday thing. In other words, it made the everyday thing appear to be an extension of the consumer's values. Last, applied decoration made the everyday thing appear to be hand-made rather than machine-made. Hand-made objects were often considered superior to ones made by machine.

As good as applied decoration became and as widespread as its use was, it was nevertheless superficial, a kind of band-aid approach. Applied decoration of scenes from nature wasn't addressing the fundamental issue of machine production and its connection to or impact on nature and humanity. For some designers, the machine was nothing less than a direct threat to design as a human activity. The most prominent and among the most vocal of these designers was no doubt William Morris.

William Morris was an advocate of the crafts. For him, everyday things resulted from a process that included people in both the designing and making. In other words, everyday things should be imbued with human and natural values. This premise formed the basis for the Arts and Crafts Movement in the late 19th and early 20th centuries in England. It should therefore come as no surprise that the visual or design language used by Morris and his colleagues was inspired by nature. Think of it, what better antidote is there for the inhumanity of machines than the organic designs taken of nature? In part, this attitude explains the use of plant imagery in the wallpaper designed by Morris.

By the late 1800s, the mechanistic character of design had been alleviated to some degree by applied decoration. Despite the efforts of Morris and others, however, the machine age continued its march forward. Steam

trains were now common as were steam-powered ships, which had replaced sailing vessels. Clearly, the products of industrialization were becoming more and more part of everyday life. It's in this same era, the late 19th century, that a monument to industrialization was created, at least indirectly so. That monument was the Eiffel Tower. The Eiffel Tower was designed and erected in 1889 to celebrate the centennial of the French Revolution. Its designer, Gustave Eiffel, was an engineer. To no one's surprise, the tower had a mechanistic look to it. Equally to no one's surprise, especially in a city such as Paris, the tower proved to be a lightning rod of discontent. Many critics considered it an unacceptable blight in a city defined by classical architecture. To one group of artists, designers, and architects, the Eiffel Tower exemplified an esthetic devoid of human content or feeling and therefore unacceptable. The group rallied against such an esthetic and precipitated a movement called as Art Nouveau.

Henri van de Velde, a Belgian painter, architect, and designer, is considered one of the founders of Art Nouveau. Somewhat like Morris, he wasn't a champion of the machine age, at least not as it existed. Unlike Morris, however, he and his followers could see design opportunities in industrialization if there was a human content. Hector Guimard, the French architect and designer, was an exemplar of the design direction advocated by van de Velde and the Art Nouveau Movement. It's Guimard's design for the Paris Metro that best demonstrates the connection between object and nature. In a built environment filled with concrete and rectilinear stone buildings, Guimard's cast-iron lamp standards and entrance signs to the Paris Metro

Courtesy of Jacques Giard

Image 3: Hector Guimard, the French architect and designer, used natural shapes and forms in his design for the Paris Metro signs.

provided a visual exploration of what natural design could be. The light fixtures and Metro signs—even complete Metro entrances—were a departure from the surroundings. With their green color, they were like large plants thriving in a concrete jungle.

Design—even those everyday things made by machine—didn't have to look mechanistic. They could exude a visual quality more easily associated with nature than with machines. Van de Velde commented on Guimard's designs and its connection to nature when he said, "*. . . we do not see . . . clearly recognizable motifs which are only interpreted and regularized by a geometric ornamental convention. But neither is it merely withered and graceless floral or animal skeletons that Mr. Guimard draws. He is inspired by the underlying movements, by the creative process in nature that reveals to us identical formulas through its numerous manifestations. And he assimilates these principles in the formation of his ornamental contours . . .*"

A design direction similar to Art Nouveau in Europe was also taking place in America. Louis Comfort Tiffany was one of its leaders. Like Guimard, his designs, especially his lamps and vases, were based on shapes and forms found in nature. And like Guimard, he didn't avoid the use of new materials and new techniques. In fact, he developed new techniques in glass, especially an iridescent glass. Also like Guimard, Tiffany made no attempt to copy nature visually, but was inspired and stimulated by nature's organic designs as we see in these glass lamps that bear his name. Tiffany was among many designers who used the formal qualities of nature as an inspiration. Tapio Wirkkala, the Finnish designer, was also inspired by nature, particularly what he found in the Finnish woods. A well-known vase, the Chantarelle Vase, was designed based on the form of the chanterelle mushroom.

It's also in Finland, in Helsinki to be exact, that we find the Temppeliaukio Church, often known as the Rock Church. It provides yet another design direction with a concern for nature. At first glance, the church is barely visible. All you see is a copper dome, which has oxidized over time and blends in with the surrounding rock and vegetation. The church is a large excavation and built from solid rock. It's as if the architects are saying, "How little can we do to change a natural place into an artificial one?"

Image 4: Taliesin West, located in Scottsdale, Arizona, served both as Frank Lloyd Wright's winter home and his school of architecture.

Frank Lloyd Wright, the American architect, had his own take on the place of nature in design. We see this with Taliesin West, in which local materials are used in the construction of the buildings in order to make them appear as being "of the place." Wright called this design direction organic architecture. Organic architecture is a design direction that attempts to harmonize the built environment with the natural environment. For Taliesin West, the natural environment was the base of the McDowell Mountains in Scottsdale, Arizona. A quick hike in the mountains would allow you to discover the stone that's found there. A tour of Taliesin West would show you that same stone in evidence in the buildings.

Two other examples of symbolism of nature in design are found in the design of vehicles. The first is with the Chrysler Airflow, a car designed and built in the 1930s, and a product of the Streamline Era in the United States. The connection to nature wasn't so much in the streamline design itself but with how the car was described in the advertising produced for it in 1934. "*You have only to look at a dolphin, a gull, or a greyhound to appreciate the rightness of the tapering, flowing contour of the new Airflow Chrysler.*" Clearly, the message is that there's goodness in a natural form.

The second example are the designs of Luigi Colani. Colani's exploration with design from nature was in a domain that he called biodynamic, which was based on rounded, organic form. Colani's choice of words in his description of biodynamic was revealing. He spoke of the earth and other heavenly bodies as being round; furthermore, these same bodies moved in round or elliptical orbits. This phenomenon of roundness wasn't limited to stars and planets but also occurred at the microscopic level. For Colani, this natural presence of the circle or sphere was justification enough to design using only round shapes and forms. In fact, the use of rectilinear shapes and forms used by most of his contemporaries eluded Colani.

Now and then, the presence of nature has been used in a different way or even misplaced. Such was the case with the short-lived era known as Flower Power in San Francisco in the 1970s. It was an era when graphics of stylized flowers appeared everywhere, especially on Volkswagen minivans, which was a preferred vehicle of the hippy crowd. Perhaps a more flagrant example of misplaced aspects of nature was the questionable use of wood paneling on American station wagons and other similar vehicles beginning in the 1960s. In all fairness, real wood had been used on some station wagons between World War I and World War II. The postwar use of wood, however, was merely a clever paint job. There was no wood whatsoever but steel made to look like wood.

BIOMIMICRY: LEARNING FROM THE NATURAL WORLD

Design is imbedded in the Natural World. Look around. Could the design of a flower be any better? How about the design of a bird? Or that of a whale? Is it possible to improve on these designs? The Natural World has been a source of inspiration for design for thousands of years. The earliest cave drawings were of natural subjects. So were many of the subjects of the petroglyphs found in many parts of the American Southwest. These too were derived from the Natural World. Leonardo da Vinci was also inspired by what he found in the Natural World. He produced countless visual studies of the human body that showed an understanding and appreciation of the Natural World and what it could provide in the form of ideas. The Natural World also served designers well when it came the time for new visual forms or visual language. We saw this with Hector Guimard and the entrances to the Paris Metro as well as with Louis Comfort Tiffany and the lamps that used motifs from nature.

Design based on the Natural World can go well beyond visual imagery however. It can do so when the under-lying biological system is taken into

consideration. This approach is known as biomimicry, and Velcro is a perfect example. Velcro is based directly on the biological system found in cockleburs. Cockleburs have spines with microscopic barbs. It was this biological system of adhesion that inspired George de Mestral, the Swiss engineer, to invent Velcro.

Today, the application of biomimicry is occurring in many facets of industrial design. Take the latest high-speed bullet train from Japan. The external design of the train was inspired by the shape of a bird's head and beak. The chief engineer of the train project was an avid birdwatcher and was intrigued by the shape of the kingfisher, a bird that can dive into water with very little splash. He mimicked that concept when designing the shape of the bullet train because it too has to "dive" through a fluid, in this case, air.

Birds aren't the only source of ideas for biomimicry. The human body is equally a rich domain for ideas. For example, a scratch on your arm will first bleed, but will soon stop as the blood coagulates and then creates a scab. This is a very natural process. There are now plastics that will perform in a similar way. That's, when the plastic is cut or fractured it will "bleed" resin in order to heal the fracture. Clearly, this is a biomimicry concept.

SUMMARY

The Artificial World of design cannot exist without the Natural World. A coexistence clearly exists between the two. Societies of the past may not have always acknowledged this coexistence but we have come to learn that the abuse of the Natural World comes with consequences. What was once considered to be fog in London was in reality smog created from the uncontrolled burning of coal. As the creators of everyday things, there is a lesson to be learned: designers can either be part of the problem or part of the solution. They cannot, however, be both.

NOTE: Readings for chapter 4 are found in the back of the book.

CHAPTER 5

DESIGN AND ECONOMICS

Cowritten with Nancy Gray

INTRODUCTION

There are times when design and economics seem to be mutually exclusive. That is, there doesn't appear to be a direct connection between the two. If anything, design and economics exist in separate worlds. Is that true? Is design something superficial, subjective, easily copied, and not really capable of generating economic value? Until recently, this is how a majority of economists and policy makers have viewed design. And to be fair, design hasn't done a stellar job of making its economic role visible. Why bother, or so quip many designers. This is the defense that they cite for their ambivalence towards economics. However, design is more than just a form of self-expression in the context of creating yet another cool thing. It's a professional activity that's practiced overwhelmingly in the context of business. Apple and Apple stores are an example of this. Therefore, there's value for designers (and those who work with and purchase design services) to be skilled in articulating the economic relevance of design. Otherwise designers will remain what the American designer, George Nelson, termed "exotic menials."

The unease that designers have in dealing with design as an economic proposition is in great part due to the meaning of design itself. Most designers—this is certainly the case with industrial designers—define design as something directly connected to the formulation or prescription that ultimately leads to the creation of an artifact. Josef Albers, the Bauhaus master, certainly defined design in such terms when he said that designing was "...to *plan and to organize, to order, to relate and to control.*" In the 1960s, it was Bruce Archer, the British engineering designer, who defined design as "...a *goal-seeking activity, in which a model or prescription is formulated in advance of embodiment of an artifact, which is offered as an apt and original solution to a given problem.*" In the same vein, Charles Eames, the American designer, referred to design as "...*as a plan for arranging elements to accomplish a particular purpose.*" These three definitions resonate with most designers because each makes a connection to what designers do. As broad as these definitions may be—after all, each one can easily embrace everything from a spoon to a building—they remain narrow when compared to the definition offered by Herbert Simon.

Simon comes to design from a perspective that is quite different from designers such as Albers, Archer and Eames. Moreover, he is one of the few scholars to consider design as an activity of significance. However, his interest was not so much the narrow world of artifacts but the much broader context of the artificial world that we create. And if the world is increasingly artificial, then designers must be involved. Simon's now well-known definition of design addresses issues broader than the formal or aesthetic aspects of an everyday thing. In Simon's words, "*Everyone designs who devises courses of action aimed at changing existing*

situations into preferred ones. The intellectual activity that produces material artifacts is no different fundamentally from the one that prescribes remedies for a sick patient or the one that devises a new sales plan for a company or a social welfare policy for a state. Design, so construed, is the core of all professional training; it is the principal mark that distinguishes the professions from the sciences."

At this point, it would be helpful to place the human act of designing into some historical and broader perspective. To do so, we need to go back some 10,000 years at the beginning of what's called the Age of Surplus. Without going into the details, the Age of Surplus was a time in history when individuals and groups began to create a surplus of one thing or another and to exchange it with other individuals. Think of Marco Polo and the Silk Road, for example. The surplus of Chinese silk and spices was making its way to Europe. In other words, one person—a designer/maker in China—exchanged his surplus for the surplus of another individual person or group in order to acquire something that he didn't have. This exchange of surplus is known today as trade. It was part of an economic concept even then, and the early designer/maker was part of this economic concept. Over time, the skills of the designer/maker became more and more refined as we find with the artifacts of the Baroque period.

The situation changed dramatically with the advent of the machine in the Industrial Revolution. Quite suddenly, machines, not artisans, were making things. The artisans' role, when it existed, was much more associated with the applied decoration of artifacts. To no one's surprise, design wasn't perceived as being important to the economic progress being experienced by Europe and America. Neither did it help that design was mostly taught in schools of art. Over the next century, design continued to be more or less as an expression of self and culture. This was certainly the case with the design directions of the Arts and Crafts Movement, Art Nouveau, and Art Deco. Even Modernism was predicated on form follows function, in which form came after the function, which had often determined by someone other than the designer.

Nevertheless, several designers did have a strong sense of the economic content implicit in design. Four of these designers make the point extremely well. One

is William Morris, who integrated business in his design explorations; a second is Peter Behrens, who is considered to be the first corporate designer; there's also Raymond Loewy, whose early successes came during the Great Depression in the United States; and more recently we have James Dyson, who built a multinational company based on the design of an improved vacuum cleaner.

William Morris (1834–1896)

As a designer, William Morris was active at the height of industrialization in England. But he objected to certain aspects of industrialization. He was of the opinion that everyday things that people had in their homes should be designed and made by people, not by machines. In other words, everyday things required human content. Even today, many designers are of the same opinion. What made William Morris different is that he developed several businesses to do what he believed in.

Morris' foray into business began in 1861 when he founded Morris, Marshall, Faulkner & Company. This he did principally with the partners Edward Burne-Jones, Dante Gabriel Rossetti, and Philip Webb. The burgeoning middle class was an obvious market for Morris and decorated artifacts, which had become highly fashionable and much in demand. By 1875, Morris assumed total control of the company, which was renamed Morris & Company. A retail store was opened two years later on Oxford Street in London. In the years that followed, Morris & Company became a household name, especially with the upper class, whose members were Morris' regular clients. Wallpaper patterns and tapestries were the company's strong point. But the company was also commissioned to undertake stained glass windows, which were most often designed by Morris and his colleague, Edward Burne-Jones.

By the 1880s, however, Morris' attention had shifted. His interest was much more about writing poetry and becoming involved in politics. Moreover, his political leanings—he was a socialist and concerned with the working class—created a personal dilemma for Morris because the clients of Morris & Co. were members of the rich, upper class. He therefore disengaged himself from the company, leaving it to his daughter and others to run. The company continued to be active until 1940. Despite Morris' close attachment to design

as a kind of artistic expression, he realized that design had a business dimension. Designing and making were part of this business dimension but so was retailing. Morris did all three exceptionally well.

Peter Behrens (1868–1940)

The story of Peter Behrens and AEG, a very large German company, is quite different from that of Morris. If Morris created what we today call a start-up company, Behrens was one of the earliest designers to work for industry and set the stage for an executive position that would become known as Chief Design Officer or CDO.

Behrens was one of the early leaders in the Modernist movement in Germany. His education and training in painting, illustration, and bookbinding gave him a broad perspective of design in Germany in the early 1900s. This multidisciplinary background proved to be particularly valuable with Behrens' involvement with the Deutscher Werkbund, an organization established to promote good design in Germany. He regularly collaborated with colleagues such as Joseph Maria Olbrich, Josef Hoffmann and Richard Reimerschmid, all prominent designers and architects.

The Deutscher Werkbund also included industrialists. One of its mandates was the improvement of the design of everyday objects and products in order to raise the level of popular taste in Germany. Behrens' rational and logical approach to design opened the door for him to become directly involved with AEG, the German equivalent of General Electric. Behrens relationship with AEG began in 1907 when he was hired to be its artistic consultant. The term design consultant didn't exist in those years. It should also be noted that Behrens was never an employee of AEG. Nevertheless, Behrens had control of what we today would consider to be the design function of the company. For example, Behrens designed AEG's corporate identity and many of its products such as clocks and kettles. Behrens was even responsible for the design of certain buildings such as the AEG turbine factory in Berlin.

Companies like Apple, Braun, and McDonald's owe a great deal to Behrens because of his pioneering work in the development of corporate design including corporate visual identity.

Raymond Loewy (1893–1986)

The case of Raymond Loewy is different from both Morris and Behrens. Nevertheless, it connects design to an economic situation and shows that the two are never far apart. The interconnection of Loewy, design and business begins at one of the darkest economic moments in America: The Great Depression of 1929. The American economy had crashed in a very serious way.

In that same year, Loewy, who had moved to America from France, was asked to redesign the Gestetner mimeograph machine. Because of the economic downturn no one—corporations as well as individuals—was buying anything. Redesigning the machine was considered a way to entice people to buy once again and get the economy up and running. As Loewy would write in the book *Industrial Design*, "*Success finally came when we were able to convince some creative men that good appearance was a salable commodity, that it often cut costs, enhanced a product's prestige, raised corporate profits, benefited the customer and increased employment.*"

Time Magazine was of a similar opinion when it wrote that Loewy "*. . . made products irresistible at a time when nobody really wanted to pay for anything.*" Despite the rise of the new design language of Modernism in Europe, Loewy looked to the language of business to sell the idea that good design was good business.

James Dyson (b. 1947)

The last short case study of design and economics is James Dyson, the English inventor, designer and businessman behind the Dyson vacuum cleaner, which has become a highly successful product worldwide. Dyson's story is one of determination, something that he learned early in life as a long-distance runner. He combined this personality trait with a strong education in art, industrial design and engineering. Determination proved to be invaluable for Dyson because it's rumored that he developed thousands of models and prototypes of his vacuum cleaner using cyclonic separation before he arrived at the final concept.

As inventive as cyclonic separation may appear to be the real business strategy was to address the disposable vacuum bags. The latter was a multi-million dollar

market because almost all vacuum cleaners used disposable bags. Dyson's business idea was to get rid of disposable vacuum bags. Initially, he attempted to sell his concept of cyclonic separation, that is, no disposable bag, to a manufacturer. He wasn't successful. The existing market for disposable vacuum bags was too lucrative. It appeared that no one wanted to place this market in jeopardy. In the end, Dyson had no choice but to go on his own, which he did in 1993. The rest is history, as they say. By 2005, Dyson vacuum cleaners had become the market leader in the United States.

SUMMARY

Morris, Behrens, Loewy and Dyson make the point: Good design can't exist without a strong business connection. In fact, that very point was made at a business conference that I attended some years ago. The keynote speaker was Dieter Rams, who was then the chief designer at Braun, the German manufacturer of small appliances and a leading corporate voice of good design in business. In his presentation, Rams took care to connect the principles of good design to the company's product line. To do so, Rams showed many of these products at the conference. At one point, a businessman in the audience asked, "But where are the Dieter Rams in America?" A designer in the audience quickly answered, "That's the wrong question. What we should be asking is where are the Max Brauns?" You see, Max Braun was one of the founders of Braun. And without a Max Braun you can't have a Dieter Rams or good design. And without a Steve Jobs you can't have a Jony Ive at Apple. To succeed, design and business have to work in partnership.

CONNECTING DESIGN AND ECONOMICS

Connecting design to economics begins by going back to Herbert Simon and his definition of design. As mentioned previously and as a gentle reminder, Simon defined design in these words *"Everyone designs who devises courses of action aimed at changing existing situations into preferred ones."* But Simon also went on to say *"The intellectual activity that produces material artifacts is no different fundamentally from the one that prescribes remedies for a sick patient or the one that devises a new sales plan for a company or a social welfare policy for a state. Design, so construed, is the core of all professional training; it is the principal mark that distinguishes the professions from the sciences."*

In other words, design is a thought-process that's foundational to a very wide range of professional practices. So why is design at times overlooked in the bigger picture of economics and business? Perhaps the article *Creating Economic Value by Design* (one of the readings for this theme) is a good place to start. John Heskett, its author, begins to provide an answer to the question by digging a bit deeper into Simon's definition of design. By doing so, we discover that Simon partially answers the question by pointing out that the economy works on three levels: (1) the individual, (2) the market, and (3) the business. As Heskett explains, this situation is indeed unfortunate for designers because traditional economics is interested in markets only. Little if any attention is paid to either businesses or individuals. Yet these two factors—how goods and services are created for the market place and how they're used—are probably the most salient to designers. Clearly, the situation poses a dilemma for designers.

Heskett unpacks the dilemma by going back to its roots in Neo-Classical economic theory, which has its basis in markets in the traditional sense; that is, specific places in towns or villages. This is where people gathered to buy and sell goods and services. Today, markets exist across the globe and are complex, impersonal and intangible. Global stock markets are a good example. They're very different from a farmers' market; nevertheless, they remain the core means for exchanging goods and services. In part, this is why Neo-Classical theory has become the mainstay of economic thought in the modern world.

In Neo-Classical theory, supply and demand exist in a context of scarcity. Simply stated, the price of any unit is directly connected to its scarcity leading to the known market behavior of higher prices when demand increases or supply is reduced, or both. Consequently, and as explained by Heskett, the price of each unit—good or service—decreases as the quantity that's made increases.

Many of you have likely heard the term "economies of scale"—made possible by increased manufacturing capabilities. Supply is connected to demand—what people are prepared to pay. Demand increases as larger quantities become available at lower prices. Equilibrium is the point where supply and demand intersect. This intersection determines the price that customers are prepared to pay.

As stated by Heskett, Neo-Classical theory is exceedingly more sophisticated than the simplistic relationship of supply, demand, scarcity and economies of scale. Still, Heskett gleans three notable factors that impact design:

- Price is the major determinant of value (which ignores other factors including quality and design).
- Goods appear on the market without consideration for how they got there. Firms have no role in this theoretical description. They passively accept the price determined by the market.
- Markets are depicted as static.

Economic theory aside, most of us know that many companies act as price-setters. They do so knowing that there are some people who are willing to pay more for products of superior quality, including superior design. Apple is one such company. Overall, its products—iPods, iPads, and laptops—are more expensive than its competitors. Nevertheless, Apple is an extremely successful business and a leader in the market. The same phenomenon exists for the Dyson vacuum cleaner mentioned above. Dyson's vacuum cleaners were introduced in Great Britain in 1993 and were twice the price of their cheapest competitors. Yet the superior performance of the product gained the company market leadership in the United Kingdom in two years, and subsequently in other markets. The well-known Vespa scooter is a third case in point. When the original design for the Vespa was changed to visually reflect Japanese scooters, European Vespa clubs protested loudly to Piaggio, the manufacturer of the scooters. The company responded with a Modern Vespa, one that mirrored the original. The brand is now quite recognized, successful, and sells for almost twice as much as its competitors. Do you think these competitors took notice? Of course they did. Yamaha and Honda now sell models that resemble Vespa's design.

Heskett next focuses on Neo-Classic economic theory and the explanation for goods and services, which occur in terms of two main functions of production: labor and capital. While these can explain cost, they can't help designers understand those elements important to design such as what, why, or how goods and services are produced. Neither can cost alone determine how quality might influence value. Neo-Classic economic theory is about the measurable and explains what exists; it isn't fundamentally concerned with speculating about what might be. A main criticism is that it focuses on assumptions about the static nature of products and markets. If this view holds, then design, according to Heskett, is ". . . *reduced to a trivial activity concerned with minor, superficial differentiation of unchanging commodities—a role, indeed, that it does frequently perform.*"

Neo-Classic theory, with its undue attention to cost, may appear to be meaningful in a cost-driven economy but there can be troublesome consequences for design. For example, short-term financial profitability at the expense of on-going product and service developments is one such consequence. We saw this in GM's plea to the American Congress on December 5, 2008. GM's biggest failing, reflected in a clear pattern over recent decades, has been its inability to strike a balance between those inside the company who pushed for innovation ahead of the curve and the finance executives who worried more about returns on investment.

In contrast, industrial design practice is about envisioning change, that is, designers' ideas becoming the products, communications, environments and systems of the future. The importance of creativity and quality in design and manufacturing was recognized by the liberal German politician Friedrich Naumann, who elaborated on the ideas of Friedrich List (1841) in his books *Neudeutsche Wirtschaftspolitik* (New German Economic Policy), published in 1907. Naumann's asked a relevant question: how could Germany compete and survive the intense levels of international competition? In reviewing Naumann's book, Anton Jaumann, the German politician, answered, "*We must bring goods to the market that only we can manufacture. We cannot in the long run compete in cheap mass-production. Only quality is our deliverance. If we are able to deliver such excellent goods that can be imitated by no other people in*

the world, and if these goods are so excellent that everyone wishes to buy them, then we've a winning hand." Nothing, concluded Jaumann, injured the reputation of a nation as much as "cheap and nasty." Many countries have faced this problem—the latest being China, which doesn't want to create an image that its manufactured products are lacking in design and innovation.

The example of Germany played a definite role in the modernization of Japan. In Japan, government policy established design competencies and subsequently encouraged their application in Japanese industry and commerce. The end result is now obvious: Japanese products are known worldwide for their design and quality, a quality that also existed in traditional products. In the mid-1950s, there existed very few professionally trained designers in Japan. As a result of policies introduced by the Ministry of International Trade and Industry (MITI), Japan had 21,000 industrial designers by 1992. Policies based on the Japanese model were also introduced in Korea and Taiwan where they have also played an important role in their economic development.

CONNECTING DESIGN TO BUSINESS

There are several features of modern business where we find a direct connection to design. Branding, corporate identity and design thinking are the more obvious ones. Branding and corporate identity are part and parcel of any contemporary business. No modern corporation would operate without being cognizant of the strategic value of branding and corporate identity. Much the same can be said for design thinking, which is a more recent tool of business. Leading businesses—especially those involved in the so-called creative industries—have come to rely more and more on design thinking as a strategic tool.

Branding

Most people know branding, or at least they think they know branding. It's perhaps the swoosh logo on a pair of Nike sneakers or the apple with the missing bite on their Mac laptop. Probe the issue a bit more and not much understanding is forthcoming about branding—its origin, the reasons for its use, and its effectiveness. This section of the chapter will explore these areas.

Branding isn't a recent corporate strategy devised by some entrepreneurial guru or an ivy-league business school. Branding dates back at least 2,000 years. Brands and branding have their origins with the act of marking livestock, which goes as far back as the ancient Egyptians. The Romans also branded livestock often with symbols that supposedly had magical properties. The practice continued in many countries, especially those where the raising of cattle was done on a large scale such as Spain. Eventually branding was exported to the United States where the vast open land of the west was being used more and more for grazing cattle.

Brands associated with products also have a long history going back 2,000 years in India. Brands, as we know them today, are more recent. They originated in the 19th century at the time of the Industrial Revolution. In a way, this should come as no surprise. The profusion of new products—soap, beer, dishes and furniture—created a need to differentiate one maker from another. This was even the case with lowly wooden shipping barrels. Factories would literally burn their brand or logo onto the barrels.

But it was even more so the case when products went from being made locally to being made at a large plant elsewhere in the country from where the product was sold. Before the Industrial Revolution, most products used by people were made locally by local people. The connection between people, product and place was very close. This connection created a type of product loyalty. That scenario changed with the Industrial Revolution and mass production. People, product and place were no longer so closely connected. Products were being made in one place and sold in another. As a result, product loyalty wasn't necessarily as strong. Branding became a way to increase product loyalty based upon the human need to belong despite the fact that the product came from somewhere else. That sentiment still exists today with "Buy American," in part because of the pressures created by globalization.

Two British companies claim to be the first to develop and use the concept of brand and branding.

One is Bass & Company, the British brewery, with its distinctive red triangle. The other is Tate & Lyle and its Golden Syrup brand, which has remained unchanged since 1855. A few decades later, Peter Behrens, while working as a consultant for AEG, recognized the importance of brand and branding, which is why he created a coordinated corporate identity for the company.

Today, brand and branding are common practices in business. Company executives are very much aware of and sensitive to the brand of the company and its perception by its clients, customers, and general public. The list of American companies who pay close attention to brand identity is very long. It includes such major players as UPS, Coca-Cola, Nike and Starbucks. Howard Schultz, President, CEO, and Chairman of Starbucks, was unequivocal about the role of brands when he said, "*A great brand raises the bar—it adds a greater sense of purpose to the experience, whether it's the challenge to do your best in sports and fitness, or the affirmation that the cup of coffee you're drinking really matters.*"

Corporate Identity

Corporate identity is an extension of brand and branding. That is, it's the coordination of the overall visual identity of a corporation to the general public. This is the second area that shows connections between design and business. As the name implies, corporate identity deals with the visual identity of corporations. But visual identity can extend beyond the corporate world. For example, visual identity is used for events such as the Olympic Games in order to create a cohesive and consistent visual image.

National governments, such as Northern Ireland, have also been known to create a comprehensive identity with the visual material at their disposal such as stationery, web sites, vehicles, and promotional information. The companies mentioned earlier who understand brand and branding also understand corporate or visual identity. We certainly see this with Nike, Starbucks and McDonalds. But we also see it with companies such as FedEx, American Airlines and the Shell Oil Corporation. There are many more.

Design Thinking

The last area where there's an explicit connection between design and business is design thinking. This area is somewhat recent. Generally speaking, contemporary architects and designers have always approached a problem from a more holistic point of view compared to engineers, for example. For an architect, something as complex as a building is perceived as a totality and includes location, users, purpose, services and esthetics. For the engineer, again generally speaking, something as complex as a passenger jet is often perceived as a set of discrete parts such as air frame, engines, undercarriage and avionics.

Design thinking advocates for a holistic approach. As revolutionary as this direction may sound, it's not as new as we may first think it is. Some of the earliest explorations were undertaken by Robert McKim in 1973 and published in 1980 as *Experiences in Visual Thinking*. In the 1980s and 1990s, it was Rolf Faste at Stanford University who took the idea further by teaching "design thinking" as a method of creative action. More recently, design thinking owes a great deal of its reputation to IDEO and its CEO, Tim Brown. The company has turned design thinking into a strategic tool. That said, different people define design thinking differently. Nevertheless, some elements are common to most definitions. These elements are:

- Learn from people;
- Find patterns;
- Design principles;
- Make tangible; and
- Iterate relentlessly.

In the context of business, design thinking is used much like it is in design. It provides a holistic perspective on a situation. But it does so with the goals of business in mind. Roger Martin, the Dean of the Rotman School of Management at the University of Toronto, is a champion of design thinking. He explores design thinking in his book, *The Design of Business: Why Design Thinking Is the Next Competitive Advantage*. Martin also talks about how organizations can link design principles to business strategies to produce systematic and consistent innovation. In the end, Martin

makes a case for design thinking by using terms and arguments understood by the business community. He doesn't confuse the issue by using the designer's language and values.

Clearly, design and economics, especially business, are connected. They're connected at the macro level much like they are at the micro level. If economics is about the world of the artificial and if design is about the creating of the artificial, then the two—economics and design—are working in tandem even if it's not always obvious.

NOTE: Readings for chapter 5 are found in the back of the book.

CHAPTER 6

DESIGN AND TECHNOLOGY

The theme on technology deals with three topics that are central to design and industrial design. These are (1) sources of power, (2) processes of making, and (3) materials. All are intertwined in the world of industrial design and with everyday things. After all, everyday things exist because of the power, processes, and materials used to create them.

What's meant by sources of power? Sources of power include the means by which people have gone from making things by hand using muscles to making these same things by using artificial sources of power. For example, we take electrical power for granted but people lived without electricity for thousands of years. A typical task such as washing clothes was done by hand or with basic hand-powered washing machines. With electricity, however, the situation changed dramatically. Electricity displaced human muscle and electric motors displaced the hand-powered washing machines with electric washing machines, which are now very common.

What are processes of making? Processes of making include a broad range of methods that are used in the making of everyday things. Making processes can range from simple ones such as the chipping of stone and the carving of wood to injection molding, which is complex and sophisticated. Chipping and carving were the basis for the design of the earliest tools. With industrialization, the making processes changed significantly and with it the design and production of the everyday things.

What are materials? Materials evolved in ways similar to processes. The first materials used by humans for the design of everyday things were whatever was found. Stone, wood and bone were three of the earliest materials used. Later came the first use of more refined materials such as bronze and iron. Today, we are surrounded by all types of materials, from stainless steel to all manner of plastics and carbon fiber.

SOURCES OF POWER
Mechanical

Prior to the Industrial Revolution, the main source of power in the making of everyday things was human muscle. That is, people carved tools with their hands, built shelters by using their arms, and travelled from one place to another by using their legs. There were some other forms of power as well. Animals of burden such as horses and oxen were used because these provided even more power than what was possible from human muscle. Compared to walking, riding a horse was faster in getting somewhere much like an ox was more powerful than a person and could therefore pull much more than a person could. Later, there was also the use of other forms of natural power such as water and wind. All of these modes of power allowed people to be more effective and productive.

There were also a few simple artificial devices or methods to amplify human power. The wheel was one

such device. It made it possible for people to carry larger loads more easily and over greater distances. There were also early forms of mechanical power such as levers, pulleys and wheels with cogs or gears. Each one played a role in increasing output, especially when compared to human muscle. Think of the sailings ships of the day. The raising of the heavy canvas sails relied on the mechanical advantages of pulleys, or blocks as they are called. It would have taken too many sailors to raise such heavy, cotton sails without the use of pulleys.

Over time, levers, pulleys and gear wheels became more refined. There's probably no better example of this refinement than the evolution of clocks and watches. Time keeping devices relied initially on the sun, such as we find with the sundial. There were no mechanical components to speak of. By the 8th century, however, the situation had changed. It's in this period and in China that we find the first evidence of a mechanical clock. In Europe, the first references to clocks occur in the latter part of the 13th century.

Generally speaking, clocks served two purposes: they either signaled a religious service or modeled the solar system. An excellent example of the latter type is the public clock in the Piazza San Marco in Venice. It's large, highly visible and includes celestial imagery. Power for the clock came from various sources such as water and pendulums. Because clocks were large in size, they were normally found in the steeple of the local church or town hall. Clocks were public artifacts and meant for everyone to see. Some clocks even became iconic and a symbol of place. Most people know Big Ben; they also know that it's in London.

As clock mechanisms became more refined, clocks became smaller. Because they were smaller, they found their way into the interior of buildings. Clocks remained expensive but it wasn't unusual for them to be in the homes of wealthy families. The larger ones were often called grandfather clocks; the smaller versions were called mantle clocks. More refinements in clock mechanism would eventually lead to the pocket watch and to the wristwatch. Both of these had highly refined parts of very high tolerance and used springs for power. Nevertheless, all of these clocks and watches relied on artificial mechanical power of one kind or another. With the economies of scale as the result of mass production, watches became everyday things in

the true sense of the words. With the introduction of electronic parts in the mid-20th century, watches loss their mechanical heritage but became even less expensive and more widespread in use. What began as a large public fixture with all manner of basic mechanical parts had evolved into a common, mass-produced everyday thing, small in size, and available to almost everyone.

SOURCES OF POWER

Steam

With the Industrial Revolution came a source of power greater than had ever been experienced in human history. This was the power of steam. The historian William Rosen provides a wonderful history of steam power in his book, *The Most Powerful Idea in the World*, and goes on to show that steam power was perhaps the one technological development that had the greatest impact on modern society.

Steam power spawned an extensive range of devices. And each device was more or less a mechanical extension of human muscular capacity. Most steam-powered machines were designed as a replacement for one manual skill or other. For example, mechanized looms became a replacement for the weaver and the hand loom. However, this source of artificial power did more than replace the production capacity of the weaver. While the weaver could be expected to put in one day's work—admittedly a long day—a machine could work much longer, thereby increasing output.

Steam power also had another dimension. The scale or size of machines' impact could be greater. For instance, a pail could be used to remove water from a mine. But no matter how large the pail or how quick the person was at using the pail, neither was as efficient as a mechanical pump. In part, this is what made James Watt's refined mine pump so essential to the Industrial Revolution. By removing water effectively from the mines, more coal could be produced. It should be remembered that British industry was totally dependent on coal in the 18th and 19th centuries. Coal was necessary for steam power and was the most prominent source of energy during the Industrial Revolution. The first steam engines also came about as the result of scientific knowledge gained about

pressure, gas and volume, especially because of the work of Robert Boyle, the Irish physicist, who proposed Boyle's law.

As effective as steam engines were at replacing manual labor, the early models were large and unwieldy, and therefore stationary. They were generally used as a source of power for textile mills and mines. Over time, however, the engineering of these steam engines became more refined and, as a result, smaller in size. Consequently, they became ideal for other purposes such as the power source for canal boats, ships and locomotives. With his legs, a man could walk a certain distance in one day; on a horse, that distance had increased significantly; but with an iron horse—as early steam locomotives were called—travel distance became less of an issue for people.

What do these developments in steam power and locomotion mean to industrial design? Perhaps not a great deal in the early years, but a great deal more in 1930s with designers such as Raymond Loewy and Henry Dreyfuss in what was called the golden age of the American steam locomotives. Without steam power, locomotives such as the 20th Century Limited and the S1 of the Pennsylvania Railroad wouldn't exist.

Steam power derived from coal remained the preferred choice of artificial power until the advantages of petroleum became apparent. Over a relatively short period of time, steam-powered machinery was displaced by similar machinery but powered by the internal combustion engine. Today's automobile industry, for example, is almost totally dependent on the internal combustion engine. And no one needs to be reminded to what degree the latter impacted industrial design, which we will see in the theme on Design and Transportation (chapter 7).

SOURCES OF POWER

Electricity

Although electricity is a natural phenomenon, it was only around 1600 that it began to be explored by individuals such as English scientist William Gilbert, who was one of the early pioneers. It's important to note that the words electric and electricity made their first appearance in the English language not long thereafter,

in 1646 to be precise. Later, in the 18th century, Benjamin Franklin did extensive experimentation with electricity. So, for that matter, did Alessandro Volta, with an early battery in 1800, and Michael Faraday, who, in 1821, invented the electric motor. The list of scientists and inventors quickly grew and eventually led to the two most important leaders in the innovative use of electrical power: Thomas Alva Edison and Nikola Tesla. The concept of a wired city we owe to Edison; the use of AC instead of DC power in electrical network we owe to Tesla.

What do these early developments in electrical power mean to industrial design? Think of the home appliance industry, which is huge. Before electricity, homes had wood-burning stoves and ice boxes. Today, these appliances have been replaced by stoves, ovens and fridges, all powered by electricity. Industrial designers have had a hand in the design of these and other similar devices with companies such as General Electric and LG.

Before electricity, homemakers washed clothes by hand and hung them out to dry. Today, washers and dryers, both powered by electricity, have replaced hand washing and air drying. Industrial designers also have a hand in the design of these devices with companies like Whirlpool and Electrolux.

Before electricity, homemakers used tools such as hand beaters and manual grinders. Today, these have been replaced by blenders and food processors, both powered by electricity. Industrial designers definitely have a hand in the design of these devices. Think of the designs by Braun, the German manufacturer of small appliances, as well as Black & Decker.

Before electricity, homemakers used brooms and dustpans. Today, these have been replaced by vacuum cleaners, powered by electricity. Industrial designers have a hand in the design of these devices as well. Think of James Dyson, the British designer, and his line of Dyson vacuum cleaners.

The use of electricity has expanded into other product sectors. We now have automobiles such as the Nissan Leaf, which is electric. In this case as well as all the other everyday things already mentioned, industrial design played an important role in defining the visual presence as well as the functional attributes of these new electrical devices.

SOURCES OF POWER

Electronic

The change from electric to electronic was significant in the world of everyday things. Although each method used an electrical current, the electronic phenomenon was a kind of micro version of electrical power; that is, it was based on the moving of electrons as opposed to the power potential imbedded in electricity. With the change from electric to electronic came a scale-down effect, which was to forever alter the presence of everyday things in ways never imagined.

The radio of the 1930s perhaps best exemplified this change. In those early days, the working components of radios relied on electricity within a circuitry of vacuum tubes. Vacuum tubes were like small light bulbs. The pieces needed for the electrical circuit were inserted into a glass tube and sealed in a vacuum. Radios could easily have up to a dozen or more of these vacuum tubes. Not only did these occupy a certain volume of space and generate heat but they also required electrical power from a wall outlet, making radios large and cumbersome. Nevertheless, these radios were the leading-edge technology of the day.

Everything changed with the invention of the transistor. Beginning as an experimental model in 1925, a more refined transistor was announced by AT&T's Bell Labs in 1947. All of the impediments of vacuum-tube technology—large size, heat dissipation and need of power—were more or less reduced or eliminated. No one could have imagined—even vaguely—the impact that the transistor would have on design, especially industrial design. It would eventually become the platform for today's electronic devices, from computers and cell phones to tablets and watches. As for radios, they went from being pieces of furniture to pocketsize devices; just imagine today's smartphone and how big it would be if we still used vacuum-tube technology.

The invention of the transistor is one of several important moments in the history of technology. For industrial designers working in the high-tech industry, the challenges in the design of products today are significantly different from what they were in the days before the transistor. For example, smartphones pack more punch per ounce because of developments in electronics. Much the same exists for cameras, laptops and medical devices. Yet most of the functional parts of these devices are no longer visible. As a result, the old design principle form follows function, presents a completely different challenge for designers. The barbell telephone designed by Henry Dreyfuss communicated its function by way of its form. In principle, you could read its function. That same reading of function doesn't occur as readily with one electronic black box or another such as a smartphone.

BIOTECHNOLOGY

Biotechnology may not be a typical source of power like we saw with steam and electricity but it is one of the newest technologies, one that can change the Natural World to an artificial one.

The United Nations Convention on Biological Diversity defines biotechnology as, "*Any technological application that uses biological systems, living organisms or derivatives thereof, to make or modify products or processes for specific use.*"[1]

At first reading, the definition of biotechnology doesn't sound too promising for industrial design. Thinking about it a bit more, however, we soon discover that biotechnology has applications as diverse as healthcare, agriculture, industry, and the environment. In healthcare, for example, bioengineers are creating human body parts to replace ears, bones, and even certain organs. Using three-dimensional printing technology, these same bioengineers can create a human ear using human cells taken from the patient and print these cells layer by layer much like an industrial designer would three-dimensional print a part for a new product. Biotechnology should be of great interest to industrial designers because of its connections to environmental issues such as design for sustainability, design for the environment, biodegradable materials, recycling, and design for disassembly.

[1] Definition of "Biotechnology." Courtesy of the Secretariat of the Convention on Biological Diversity.

From Analog to Digital

A great deal of the history of everyday things in our technological world was based on an analog approach. For example, early electric devices such as vacuum-tube radios relied on an analog signal. In this and other similar contexts, analog signals are based on what's called variability or an analogy such as time. Think of the hands of a mechanical clock. We tell the time by comparing the moving hand to a stationary number or scale. In other words, we are comparing a moving point to a nonmoving scale. This is the analogy or analog signal.

As adequate as analog transmission is, it has a downside: there's what engineers call noise. Returning to the clock example, the accuracy of the time is based on such elements as the angle of view, the thickness of the hands, the graphic size of the stationary scale, or other similar factors. Therefore, signal-to-noise ratio becomes critical. Digital signals are different; they use discrete values of one or zero. Returning to the clock example, we know that the analog version provides time as a spatial relationship between moving hands and stationary numbers. With digital clocks, however, there's no analogy; the exact time is always provided.

The world of computers is totally dependent on digital technology. This is why we can create the many documents or computer files that we do with ease. Or how we can transmit cell phone signals as efficiently as we do. As effective as digital technology is, especially when compared to analog technology, it has created an ethical question. In the analog world, an original document existed; it was unique. Copies of the original were always a degraded version of the original because there was a greater and greater signal-to-noise ratio with each copy. This situation doesn't exist in the digital world. In the digital world, copies are identical to the original. Therefore, what constitutes an original copy in the digital world?

Here is yet another question, which in this case impacts industrial design: Does form follow function in a digital world? A great deal of contemporary industrial design continues to apply the rule of thumb known as "form follows function." Not to be forgotten is the fact that form follows function is rooted in an ideology taken from the age of mechanization in a world that was analog. In that era, function was often equated with mechanical function of one kind or another. As electronic technology entered the marketplace, the visual identity of everyday things via mechanical components began to be lost. This loss was accentuated even more so with digital technology. In the video *Objectified*, Karim Rashid, the Postmodernist designer, made an excellent point when he asked, "*Why should a modern digital camera look like the old 35mm camera?*" He was correct. After all, it was the physical size of the 35 mm film as well as the need for it to be directly behind the lens and to be wound after every shot that gave the 35 mm camera its distinctive look. These features are no longer necessary, yet many digital cameras resemble their distant analog cousins. Does form really follow function? It does so but only if function is redefined.

Hardware to Software

From the earliest large-scale mechanical devices such as powered looms to today's miniaturized devices such as iPods, we've seen one obvious pattern: a reduction in physical size irrespective of the increased number of features. Recently, this direction in size reduction has been particularly obvious with recorded music. In the early 1950s, the 78 rpm vinyl record was the preferred recording medium. Its size was anywhere between 10 and 12 inches in diameter with one or two tracks. Later, the 33 rpm record began to displace the 78 rpm model. It was 16 inches in diameter and could have as many as 12 tracks, sometimes more. Audiocassette tapes eventually replaced the vinyl record. They were smaller than the vinyl records and more transportable. With the compact disk or CD, the physical size became even smaller yet the capacity increased.

In all of these media—vinyl records, audiocassettes, and CDs—one feature remained constant: each was a material thing. With digital music via iTunes or some other online music provider, something dramatic happened. The music remained but not the material medium that carried it. Music had become dematerialized. Where will dematerialization take us next? The so-called Cloud is leading us in one direction. Are there others? Your guess is as good as mine.

PROCESSES: THE MAKING OF EVERYDAY THINGS

Power—human, mechanical, electrical and electronic—provided the energy required to make everyday things. Integral to sources of power were making processes of one kind or another. Once again it was the Industrial Revolution that created the early developments in the making of everyday things in ways other than by hand. This section of the chapter begins by understanding a fundamental principle in the making process: it's either additive or subtractive. It will be followed with a focus on the four principal categories of processes: one-off, batch production, mass production and mass customization.

Take Away or Add On

When products are designed and made, one of two things generally happens to the material: either it's added or it's removed. Look at the wooden chairs designed by Hans Wegner, the Danish furniture designer. Wood was always used in the most appropriate way. Wegner was a master when it came to the use of wood; he knew the material exceptionally well. This is one reason why his designs were so successful; that is, he wasn't trying to make wood do what wood couldn't do. If anything, he explored the full range of possibilities that wood provided.

If we look at the various elements of the chair—the arms and back, for example—we see combination of wooden forms, where material is removed in some places and added in others. The form of the arms appears as it does because a well-defined amount of material was removed from larger pieces of wood. This was at first done using power tools followed by shapers and finally by hand sanding. With each operation, some wood was removed. These making processes we call subtractive.

The back of the chair was shaped in a similar fashion. Material was also removed. However, there are a few additional pieces. These had to be added. The extensions, for example, weren't part of the same piece of wood that gave us the combination of arms and back. Wegner went one step further with these additions. He actually made a point by creating a joint using a piece of

Image 5: Hans Wegner, the Danish designer, was a master when it came to designing chairs in wood.

wood that was visibly different from the rest. It's almost as if he was celebrating the addition. This process of adding pieces is called additive.

More complex products such as bicycles are also a combination of parts that are either additive or subtractive. Gears are most often the result of the subtractive process. A blank of metal is cut and then machined to the required tolerances. Each step removes material. Much the same occurs for the nuts and bolts. The frame, however, is generally more the result of an additive process. That is, individual tubes are welded together to create a frame. No material is actually removed to create what comes to be recognized as the bicycle frame.

From One to Many

Not all products are made in the same quantity. Some products, such as special purpose planes, are made in small quantities only. This was the case with a few special transport planes designed for Boeing in its production of the 787 Dreamliner. Other everyday things such as smartphones are manufactured in millions. Consequently, designing for the former isn't the same as designing for the latter. Quantity does indeed impact the designing process.

Generally speaking, there are four modes of production in industrial design. These are one-off production, batch production, mass production and mass customization. One-off production is the design of an everyday thing for which only one, perhaps, two copies are made. The design process involved in this approach isn't unlike architecture. Buildings such

as the Disney Concert Hall in Los Angeles or the Guggenheim Museum in New York are unique. There aren't multiple copies throughout the country. Buildings aren't the only examples of one-off production. So are cruise ships; each is an individual design. But so are unique pieces of jewelry. Most often only one of these artifacts is ever designed and made. One-off production doesn't occur that often in traditional industrial design. However, it does happen in cases like very specialized vehicles or prosthetic devices designed for a specific person. In most such cases, the economic benefits of mass production, which are synonymous with industrial design, aren't available. While material costs are low, labor costs can be very high with one-off production. Consequently, one-off artifacts are most often very expensive.

The very nature of industrial design makes it more likely that batch production, mass production or mass customization will be involved. Batch production occurs with a small run of products. What's a small run? It depends. It could be as few as 5 or as many as 50. Batch production is found in the yachting industry with the building of large sailboats or motor yachts. Batch production occurs in aerospace as well, as we see with the space shuttle. Batch production is also found in specialized sports such as bobsledding. The economics of scale aren't as obvious as they are with mass production or mass customization but there are some savings to be had with batch production because multiple copies are being made.

The economics of scale have an exceptionally significant impact with mass production. To do so effectively, two features of mass production have to be present: interchangeable parts and assembly-line production. Both features go back to the early days of American fabrication and two significant individuals. The first was Samuel Colt; the second was Henry Ford. Samuel Colt is known for the guns that bear his name. He was born in 1814; by the time that he died in 1862, he was one of the wealthiest men in America. It should also be remembered that the Industrial Revolution was in full swing in Colt's time. Colt's claim to fame was the concept of interchangeable parts. What do we mean by interchangeable parts? Imagine if you went to a local store to purchase some double-A batteries but found that in a package of four batteries no two were exactly

alike. One battery was a bit shorter than another; a second one had a slightly larger diameter. Clearly, these batteries wouldn't be interchangeable. The same parts without the same identical dimensions are indicative of one-off or craft production. Mass production can't exist in this kind of environment. Standardization is imperative. And this is exactly what Colt did. He standardized all the parts for a gun. This meant that the same gun model could be assembled in large numbers because the triggers were all identical as were the magazines, hammers, handles, and barrels. Worker could pick a part from a bin and know that it would fit. No longer was it necessary to tailor the parts individually. The savings in time and costs were enormous as was the ability to produce the guns in large numbers and to do so quickly.

Henry Ford brought another dimension to mass production. Ford was born in 1863, one year after Colt's death. Despite the popular belief, he neither invented the car nor the assembly line. Rather, his contribution to mass production was what became known as Fordism. The latter was a term used to describe the mass production of an everyday thing for the population at large. For Ford, the point of reference is the automobile. The concept of Fordism also included high wages for the workers. Ford had the reputation of paying his workers exceptionally well, the idea being that workers should earn enough to buy a car. This approach to mass production would eventually change industry on a world scale. For example, most auto manufactures can now build a typical small sedan at a rate of 50–100 per hour. Overall, it can take as few as 24 hours to build a complete car irrespective of the complexity of the technology involved. In comparison, a typical house can take several months to build principally because most houses are crafted and not manufactured. Today, there's no way that the typical laptop computer or four-door sedan could cost as little as they do if it wasn't for refined methods of mass production. Try this experiment. Go to your local car dealership and ask to see the parts catalog for their least sedan. Now add the price of each individual part. Even without the cost of labor to assemble the car, you will have easily exceeded the selling price of that same sedan.

Mass customization is the fourth process on our list. Curiously, the name mass customization reads

somewhat like an oxymoron. How can something be produced in mass numbers yet be customized? Such an approach to the mass production of everyday things is possible because of computer-aided manufacturing. Without computers, mass customization wouldn't exist. What computers allow is for the mass production process to be modified or customized for the specific needs of one individual or other. This customization normally occurs near the end of the making process. Nike is involved with mass customization with a product called NikeiD. This is a shoe that a person designs online by selecting different soles, tops, patterns, and colors. No two shoes are alike. In the end, mass customization combines the efficiency and cost saving of mass production with the uniqueness of one-off designs.

MATERIALS

It's only obvious that discussions about design, everyday things, and material culture should include information about materials. After all, it's the material that gives the everyday thing its physical presence. This section of the chapter begins with wood, a material that's used more or less in its natural state, continues with those materials that undergo some processing from their natural state such as metals, and ends with plastics and composite materials, which are materials that have undergone major processing from their natural state. The focus of each material will be on its place and importance in the history of industrial design rather than on a scientific analysis of the material. As a side note, it's not possible to touch upon all materials used in industrial design. There are too many. Therefore, only the ones most often used will be explored.

Wood: A Material Used in Its Natural State

What do the chairs and furniture of Michael Thonet, Charles Rennie Mackintosh and Charles and Ray Eames have in common? It's wood. The 21st century is already giving us a sense that we are in an age of composite materials and exotic metals. These appear to be the only ones used in many of our latest products. But

look around. Wood has been and continues to be the material of choice for many everyday objects, especially in furniture.

Many classic designs used wood as the preferred design material. Why was that? In the case of Michael Thonet, the Austrian designer and furniture maker, it was his knowledge of wood and his skills as a master craftsman. Thonet understood intimately the special properties of wood. He was like a master chef who knew his ingredients well. Thonet created design masterpieces much like a chef creates a culinary feast. Charles Rennie Mackintosh, the Scottish designer and architect, was another master chef. At first glance, his furniture doesn't appear to use wood in any exceptional way. After all, the visual lines of his chairs are generally geometric and most of his pieces are painted. In most cases, the wood isn't even visible. Yet wood was the most appropriate material given what Mackintosh was striving to achieve with his design. Similarly, Charles and Ray Eames, the American designers, were also masters of wood. They used wood as a material to express their ideas about design where they fused the new technology of bending and forming with the traditional material of wood in designs such as the famous Eames lounge chair.

Why was wood so important to Thonet, Mackintosh and the Eames and, for that matter, so many other designers? Wood has been a material of choice and the basis for design of everyday things for centuries. Historically, handles for tools such as axes and hammers were always made of wood. Some still are today. Wood was readily available. Wood is also easy to machine and absorbs shock extremely well. Furthermore, it's a sustainable material.

Wood is just not wood, however. There are many varieties, and each variety has distinctive properties, some structural and others decorative. A furniture designer soon learns this fact. Generally speaking, there are two categories of woods. One category comes from coniferous trees and is considered to be soft wood, generally speaking. Softwoods include pine, fir, spruce, redwood and cedar. Of course, soft is only a relative term. Softwoods are often used in construction for timber-frame houses, shingles for roofs and sidings, and interior wood paneling and trim. Most often, such woods are inexpensive and readily available.

Hardwood is the other category. Hardwoods come from deciduous trees such as teak, walnut, maple, beech, birch, rosewood and mahogany. Technically, aspen and poplar are also hardwoods, but both are soft compared to maple and rosewood. Because of their density hardwoods are used in quality furniture of all kinds. These woods are strong, can be cut to exact and precise dimensions, and can accept a variety of finishes. Normally, they have a longer product life.

Some woods—either soft or hard—have special properties that allow for specific uses. For example, teak resists rotting and is often used in the boatbuilding industry much like red or white cedar, which weathers extremely well and is often used for roof shingles or sidings. Of late, bamboo has found its place as a material for design. Although not classified as wood—bamboo is technically a grass—it has some special properties, chief among them being the fact that it's sustainable. Bamboo also has a long history as a material for design. The Chinese have made generous use of bamboo for steaming baskets, and European as well as American fishing-rod makers have had a preference for Tonkin bamboo for upscale fly-fishing rods.

Wood can also be used for decorative purposes. This is especially the case with woods that have a distinctive grain such as rosewood or where the color of the wood is important, as it is with the pale color of beech or the deep brown of black walnut. The Eames used Brazilian rosewood in the original version of the now famous Eames lounge chair mentioned previously.

Historically, wood has been closely associated with traditional furniture and cabinet making. However, there are exceptions where wood was at the heart of innovation. Such was the case with Thonet's bentwood chairs. Because of new production methods, Thonet was able to develop bentwood technology as a way to increase production and reduce cost. We see this technology aptly demonstrated in his Café chair. Bentwood reduced costs in two ways: the design eliminated complex wood joinery and the production used semi-skilled laborers as opposed to highly skilled cabinetmakers.

Alvar Aalto, the Finnish architect and designer, also developed innovative ways to use wood. This he did with his laminated stools. For Aalto, wood provided a direct connection to nature without impeding creativity as long as the designer understood the potential of the material well. In general, Finnish designers often

Courtesy of Jacques Giard

Image 6: Alvar Aalto, the Finnish architect and designer, explored the bending properties of wood by using laminations, a process found in the design of his small stools.

designed with a close connection to nature. In a way, it was part of their heritage. Aalto's astute use of wood in the Paimio chair for the sanatorium of the same name shows the minimalist approach of Modernism typical of so many Scandinavian designers of the day.

Frank Gehry, the American architect, designed an amusing series of chairs for Knoll based on his love of hockey—Gehry was born in Canada—and the bending of wood. Hockey sticks aren't made of just any wood but are made from ash. Ash provides great flexibility without breaking. Gehry was able to exploit this property with a series of chairs all made with bent strips of ash. By the way, he named each chair after a penalty in hockey such as Cross Check.

Wood was used in the early aircraft industry as well. Planes of the early 20th century were often nothing more than cloth stretched over a wooden frame. But even as late as the 1940s, wood was used in two special military planes. The first of these was the Mosquito fighter-bomber designed by De Havilland, the British aircraft company. It first flew in 1941 and was used extensively in World War II. Although designed with the latest technology such as the Merlin engine, the fuselage and wings were constructed totally of wood, balsa wood, birch or spruce. Nearly 8,000 Mosquitos were built. The second plane was the Spruce Goose, a military transport plane designed in 1947 by Howard Hughes and Henry J. Kaiser and manufactured by the Hughes Aircraft Company. It was a behemoth—the largest flying boat ever built—and could carry 750 fully equipped troops. Although called the Spruce Goose, it was in fact made of birch principally because aluminum

was still being rationed as the result of World War II. Only one Spruce Goose was ever built, which is now is on exhibit at the Evergreen Aviation and Space Museum in McMinnville, Oregon.

METALS

To some degree, the evolution of design and industrial design parallels the evolution of metals, especially iron. The importance of iron is evidenced by an era in human evolution: the Iron Age. Early iron tools gave people an advantage in war as well as in work. The very nature of iron made such tools more effective than those made of stone, which preceded them. In the context of industrial design, iron played a central role in the Industrial Revolution. For example, the overall structure for the Paxton's Crystal Palace was essentially a cast-iron skeleton, and the first steam-powered trains were referred to as Iron Horses. Iron also made possible the blast furnaces of the era as well as pumps in the mines and the new cast iron bridges. All of these are all identified with the Industrial Revolution. Later, steel, which is different from iron, would make it possible to design and build ocean-going vessels. As large as these were 150 years ago, they in no way compare to the massive aircraft carriers, cruise ships and container vessels of today. Iron and steel aren't the only metals important to design and industrial design; there are others such as aluminum, zinc, brass and bronze. But the section of this chapter begins with iron and steel.

Iron and Steel

There's but one metal associated with the Industrial Revolution, especially in Britain. It's iron. It was the metal that allowed for the structures of new types of buildings—a direction that would ultimately lead to the high rise. Iron was also the metal that would provide the essential material for the railways, which was the newest mode of transportation. Iron would be used not only for the railway tracks but for the locomotives and carriages as well. The use of iron would also find its place in Europe. Few people go to Paris without visiting the Eiffel Tower. Even fewer people realize that the same tower is, in a way, a celebration of steel technology. Up until the 1850s, the tallest structures in Europe were mostly the steeples on cathedrals. These steeples were

the masterpieces of stonemasons but had reached their limits at around 600 feet. With steel, however, the limit would easily be surpassed. The Eiffel Tower is over 1,000 feet tall.

Later, the masters at the Bauhaus, the German design school, would develop a fascination for steel, especially how steel was used in factories for the manufacturing of everyday things like bicycles. We see this fascination for steel in the chairs of Ludwig Mies van der Rohe and Marcel Breuer. We also see the same fascination with many other designers of the era such as Le Corbusier with his lounge chair and Eileen Gray and a side table she designed. Both designs took advantage of the special properties of steel. In the American high Modernist era of the 1970s, designers such as Harry Bertoia experimented with steel mesh with the design of the Diamond chair.

Steel clearly dominates the modern automobile industry. Almost all cars and trucks are made of steel with the exception of cars like the Corvette and some other super cars that use some form of glass-reinforced plastic or carbon fiber. That said, perhaps the most intriguing use of steel—in this case, stainless steel—was the De Lorean DMC-12 sports car. Unlike almost every other car that had painted steel bodies, the body of the DMC-12 was all stainless steel. This feature alone made the car unique among all other sports cars. Stainless steel was selected because of its durability, especially against rust, and its permanent finish; that is, there was no need to paint the metal as you do with steel used in all other cars.

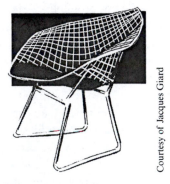

Courtesy of Jacques Giard

Image 7: Harry Bertoia, the American designer, was a sculptor by training and explored the use of metal in the design of the Diamond Chair.

As a material, steel is pervasive in the world of everyday things—from the metal blades in a disposable razor to the sheet and cast metals used in the rail and shipping industry.

Iron or Steel: Is There a Difference?

Iron and steel aren't the same thing. Iron comes from iron ore and is different from steel. Although somewhat similar, the two metals should not be confused. Iron exists usually as cast iron as we find in fire hydrants, manhole covers, engine blocks, and certain cookware. It's an ideal material for these types of everyday things because it's resilient and can be subjected to great pressure—think of the engine block; it's durable and can withstand abuse—think of the man-hole cover; it transfers heat evenly—think of cast-iron cookware; and cast iron is suitable for small- to medium-volume and even large-volume production. However, it has certain limitations. It rusts easily if not coated with paint or glazing and, if cracked, can't be repaired easily.

Steel is a refined version of iron and occurs when a very small amount of carbon—up to around 2%—is added to iron. Steel has many of the same properties of iron but without some of the shortcomings. That is, steel is more malleable and can be rolled into thin sheets; cast iron can't. Steel can be welded; cast iron can't. Steel can be forged; most iron can't. As already mentioned, few industries use steel as much as the automobile industry. The bodies of most cars are made of sheet steel, and forged steel is used for parts such as suspension arms.

By adding up to around 10% chromium, steel is further refined and becomes stainless steel. Unlike iron and steel, stainless steel doesn't rust. This makes it especially well suited for everyday things such as flatware, sailing hardware and medical equipment.

Nonferrous Metals

Industrial designers—past and present—have made generous use of nonferrous metals. What are some of these? There are several. Gold and silver are nonferrous metals as are aluminum, zinc, brass and bronze. Some of these metals are more important than others.

This section begins with two precious metals: gold and silver.

Gold and Silver

Typically, precious metals such as gold and silver aren't used that often in traditional industrial design practice. That, of course, wasn't always the case going back in history with two groups—the church and royalty. Both were identified with gold and silver objects and ornaments, and used gold extensively because of its scarcity and value as well as its symbolic value of prestige, wealth and power. For example, religious artifacts such as chalices and ceremonial crosses were often made of gold. The overt decoration found in churches such as the St. Mark's Basilica in Venice was executed in gold or gold leaf. For the royalty, gold artifacts communicated wealth, prestige and status. Gold was used in artifacts for ceremonial events—gold crowns are good examples—as well as for decoration of palaces and ceremonial coaches and carriages. Today, upscale watches such as Rolex are available in gold. Gold continues to be associated with status.

Silver is neither as rare nor as valuable as gold. However, silver still had its place as a material that expressed and symbolized status and wealth. Cutlery for the upper middle-class was often made of silver. Even today, we often use the term silverware when referring to stainless steel flatware. And the Danish designer Georg Jensen developed a reputation based on the design of silver pieces of one kind or another.

Aluminum

Gold and silver aside, the most common nonferrous metal used in industrial design is aluminum. Zinc, brass and bronze are also quite common but not to the same degree as aluminum. At first glance, your typical Boeing or Airbus passenger jet may appear to be a large metal tube. It is, but it's not just any metal. For a variety of reasons—weight being the most important—that large metal tube is a greatly enlarged aluminum can. In a way, it's like your soda can but that much larger.

It's in aviation where aluminum has had the biggest design impact. Jules Verne, the French author, makes reference to an aluminum rocket as early as 1865 in his novel *Journey to the Moon*. But it's in the early 20th

century that we find the use of aluminum in aviation. This occurred in Germany with the experimental work of Hugo Junkers. Today, modern aviation—both commercial and military—continues to rely on aluminum as the metal of choice, although more development is now occurring in composite materials such as carbon fiber.

There are product areas less obvious than aviation where aluminum is also used. Charles and Ray Eames, for example, explored the potential of aluminum with office chairs in a product line named the Alu Group. The main structural part of the chairs including the seating frame was made of cast aluminum. As a result, aluminum became a strong visual component of the chairs and provided the chairs with a distinct visual identity. Clearly, there was no desire by the Eames to hide the fact that aluminum was being used. In the Modernist fashion, theirs was what's referred to as an honest use of material.

Buckminster Fuller, the American engineer and designer, was also an advocate of aluminum. This he demonstrated well with his design of the American pavilion at the 1967 world's fair in Montreal.

His design was a geodesic dome with a structure made entirely from aluminum. Aluminum was also Fuller's material of choice with the Dymaxion House. With this design, Fuller was attempting to apply rational thinking on two levels. First, there was an abundance of expertise and production capacity for aluminum after World War II. America was going from a mode of wartime production, in which many factories had been making aluminum planes, to one of postwar production. What could these factories make instead of aluminum planes? For Fuller, the answer

was obvious: aluminum houses. Second, aluminum had two properties ideal for houses: durability and weight. Durability would reduce the maintenance cost of the house; weight would make it easier to manufacture the house in a factory and then ship it to the building site.

Aluminum: A Very Short History

The ancient Greeks and Romans knew about aluminum but it wasn't until 1825 that it became a viable material in design. Because of the very high cost of production, early use of aluminum was limited. The demand for aluminum rose dramatically in World War I because of the need for light air frames for airplanes. This same need became even greater in World War II. Aluminum had become the metal of choice for aviation principally because of its lightweight, which was necessary in aviation, as well as its resistance to corrosion. These two properties—lightweight and resistance to corrosion—also made aluminum an ideal material for masts and fittings on sail boats as well as the common beverage can in the food industry.

Zinc, Brass, and Bronze

Zinc is used in the automotive industry for all types of metal parts requiring a high-level of detail such as ornaments and carburetors. Plastic has displaced many of these parts in today's automobiles. Brass and bronze continue to be used in industrial design but sparingly when compared to the other nonferrous metals. The fine-watch industry continues to use brass for small gears and parts, and the boat- and ship-building industries uses bronze because of its resistance to salt-water corrosion.

Plastics

The design of everyday things took a dramatic turn—at least in visual terms—when plastic became available to industrial designers. Form giving was no longer restricted by the constraints of either wood or metal—or at least not as much. This new design direction became apparent with objects such as small radios in the 1920s and 1930s. Not only was the radio itself a new technology but some radios were also enrobed with a new plastic material called Bakelite. Suddenly, industrial designers could explore forms that were

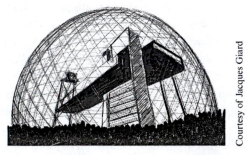

Courtesy of Jacques Giard

Image 8: The geodesic dome, designed by American Buckminster Fuller, was the US pavilion and one of the highlights at the world's fair in Montreal in 1967.

more sculptural than ever before. This is where the story of plastics and industrial design begins.

It All Began with Bakelite

When the first plastic radios came onto the marketplace, their unique forms—as well as color—created a totally different creative potential for industrial designers. Suddenly, artifacts could be more sculptural and less rectilinear. At least that was the case with the first small radios produced during the Art Deco era. Suddenly, there appeared to be a more adventuresome approach to form giving. In part, this design direction was because of the possibilities offered by Bakelite and other thermoset plastics. Plastic could be molded into almost any imaginable form. But this wasn't the only reason for these novel directions in design. The visual style of Modernism of the era, such as the teapot designed by Marianne Brandt, was considered severe by many people. It appeared to be too harsh in its design. Art Deco offered a design direction that softened this harshness.

With the development of polyester and epoxy resins thermoset plastics became more common. Unlike Bakelite, these resins allowed designers to create even larger fabricated pieces. In most cases, this was achieved by an early composite material called glass-reinforced plastic or GRP. Today, the process is commonly referred to as fiberglass. Aero Saarinen, the American architect and designer, used GRP for the seat of his Tulip chair.

So, for that matter, did Charles and Ray Eames in a simple side chair designed for Herman Miller. GRP

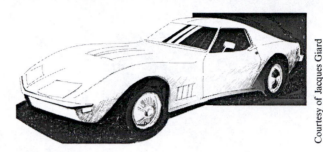

Image 10: From the very beginning of its production in 1953, the Corvette sports car's body has been made from glass-reinforced plastic.

pieces could be larger than chairs. Such is the case for the body of the Corvette sports car, the cab of semi-trailer trucks and even the hull of sailboats. All use some form or other of GRP technology.

Thermoset plastics—Bakelite in particular—have limitations however. The early versions of these plastics weren't available in a wide range of colors. Neither did they lend themselves well to true mass production because a great deal of handwork was necessary. Furthermore, small pieces with well-defined details weren't possible. Thermoplastics were different. These were available an almost infinite range of colors including clear and translucent. Furthermore, thermoplastics could be molded in ways that could produce extremely fine details by using injection molding. Larger pieces, such as storage containers, kayaks, and canoes, were also possible by way of roto-molding.

In this context, thermoplastics become the ideal material for everyday things like the basic Lego building block. The latter is small, precise, and highly detailed; furthermore, it requires a range of colors and must be manufactured in extremely large quantities at the lowest cost possible. Injection-molded thermoplastic clearly meets the bill. Italian Modernist industrial designers also found thermoplastic to be an ideal material for the products designed for Olivetti, the Italian office equipment manufacturer. A good example of this material choice is the Valentine typewriter designed by Ettore Sottsass, Jr. and Perry King for Olivetti. Its red housing as well as the red carrying case couldn't have been possible without the use of thermoplastics. And what about the typewriter designed by Rodolfo Bonetto, also for Olivetti? Once

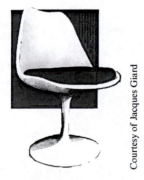

Image 9: The Tulip Chair designed by Eero Saarinen, used glass-reinforced plastic and aluminum in a novel way.

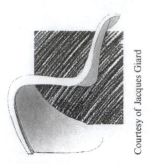

Courtesy of Jacques Giard

Image 11: Verner Panton's chair, which has become a classic, used injection-molded plastic as the basis of its design.

again, only thermoplastic could make those unique forms possible.

Joe Colombo, the Italian designer, designed one of the first injection-molded side chairs. Injection-molding technology was still in its infancy yet this piece was large, so large that the legs are actually four individual pieces added to the seat and back portion of the chair, which was molded as one piece. Vernon Panton, the Danish designer, was also made extensive use of plastic in his furniture design. This direction was unlike most of his Danish colleagues, who preferred more traditional materials such as wood. His plastic side chair has become a classic.

Panton's chair raises a fascinating point about materials and their connection to design. In the de Stijl period (1934), Gerrit Rietveld designed a very simple wooden side chair called the Zig-Zag chair. The chair was an exercise in minimalism. It only had four parts—a back, a seat, a leg and a base—in a kind of cantilever configuration. As elegant as the design was, it created two serious structural problems. Because the Zig-Zag chair was made of wood, Rietveld had no choice but to create three joints, one between the base and the leg, one between the leg and the seat, and another between the seat and the back. It doesn't take an engineer to realize that the stresses on all of these joints will be excessive once someone sits down. And no matter how well the joints are made, they will always remain the weak points of the chair. Because Panton's design uses plastic, not wood, he was able to use the cantilever concept without any concern for the joints. After all, the chair is made of one piece. There are no joints.

Plastics: A Very Short History

In principle, wood requires little processing from its natural state in order to become a useful material in design. Metals take a great deal more processing before the ore extracted from the ground becomes a useful material. Plastic, however, takes even more processing. Most plastics are derived from petroleum; it's therefore a long refining journey to go from crude oil to plastic.

For most people, one plastic is much like another plastic. The body of a Corvette sports car is made of plastic much like the body of a Swatch watch is made of plastic. However, the plastics in these two everyday things are very different. The former is a thermoset plastic; the latter is a thermoplastic. These are the two families of plastics and where the next section begins.

Thermoset Plastics

Thermoset plastics are based on a liquid polymer resin that hardens into a solid plastic only after a catalyst is added. This chemical process is called curing. Until curing occurs, the polymer resin remains a liquid. Only a very small amount of catalyst—a fraction of a percent by weight—is required to cure the polymer resin. Once cured, however, the plastic can't be returned to its original liquid state.

When and where are thermoset plastics used? Generally speaking, large structural components that are produced in small and medium quantities are well suited for thermoset plastics. As mentioned earlier, the cab of a semi-trailer truck is a good example.

What do thermoset allow industrial designers to do? Because thermoset plastics begin as liquids, they provide the industrial designers with almost infinite possibilities in form giving. Round forms with contours of one kind or another are especially appropriate. Furthermore, thermoset plastics are particularly well suited for one-off and batch production. This is why thermoset plastics are often used for small production runs of specialty cars and sail boats.

Thermoplastics

Thermoplastics are different from thermosets. They're solid and are molded by way of heat and pressure. Once cooled, they remain rigid but will deform if exposed to

heat. Several types of thermoplastics are generally used in everyday things, many of which are quite common. These are acrylic, polystyrene, ABS and polypropylene. There are many other plastics such as Nylon and Teflon but the list is too long for the purpose of this course. Only the more common and important plastics will be discussed in this section.

Acrylic

Acrylic is a plastic commonly known by the trade name Plexiglas. It's used because of its transparency and is well suited to thermo-vacuum forming. One of the early uses of acrylic was for the clear domes on military aircrafts as well as for windshields. Today, acrylic is often used for colored taillights in cars, skylights in homes, as well as small house-ware products such as clear containers.

Polystyrene

You got up this morning, went to the fridge, and pulled out a container of yogurt. Did you give any thought to the material of the container? Most likely not. There's a very good chance that the container was made of polystyrene. Polystyrene is a very common plastic and is found in all manner of mass-produced everyday things. The average home is filled with many polystyrene objects, although most people wouldn't know it. You can find polystyrene in the plastic cover of your stapler or the plastic housing of your pencil sharpener or the plastic case for your CD. You will most likely find polystyrene wherever and whenever an inexpensive plastic is needed in an everyday product that's manufactured in large quantities.

How about the foam coffee cup that you just threw away? It too is made from polystyrene but polystyrene as plastic foam. You also find polystyrene foam in packing inserts, especially for electronic products.

ABS

As a child, you might have played with Lego bricks. You most likely realized that they were made of plastic. You also liked them possibly because they were brightly colored and tough. This is because Lego bricks are made of ABS, which is the acronym for acrylonitrile butadiene styrene. As its name suggests,

ABS is similar to polystyrene but has higher strength properties and can withstand shock better. Not surprisingly, it's used in various types of helmets and in any other situation where a strong, durable material is needed.

Polypropylene

The next time you use a Tic-Tac dispenser, look closely at the flip lid. It acts like a hinge but there's no hinge to speak of. This is because the lid is made of polypropylene. If there's one feature that propylene is known, it's the so-called integral hinge. That is, polypropylene can be bent over and over without fracturing. But polypropylene can also be used for large plastic objects such as chairs as well as carpet fibers.

Composite Materials

Here is a typical challenge for an industrial designer. On the one hand, you need a material that can allow for the design of a large part yet you want it as light as possible; a polymer resin seems like a good choice. On the other hand, you need structural strength and you know that polymer resins have very little structural strength. What do you do?

One possibility is to combine polyester resin, which can be molded into almost any form, with glass fiber, which has superior tensile strength. Together, they become glass-reinforced plastic or GRP. GRP is a very common composite material as is carbon-reinforced plastic. In fact, the Boeing 787 Dreamliner has a great many large plastic-composite parts, including parts of the wings and fuselage. Think about it: a subsonic plane that can carry as many as 330 passengers made from plastic. Quite remarkable, isn't it?

Composite materials exist when two or more materials, each possessing a particular quality, are combined to create a superior material. People have known about the benefits of composite materials for a long time. In the American southwest, for example, adobe was a common material for the construction of buildings. What's adobe? Essentially, it's a combination of mud and straw; that is, a composite material.

Reinforced concrete takes the adobe concept one step further. Steel reinforcement bars replace the straw and concrete replaces the mud. Together, these two

materials make it possible to design massive structures such as buildings and bridges. Despite its superior compressive strength, concrete alone isn't sufficient because it has inferior tensile strength. For its part, steel alone would be too heavy and too costly given that relatively little steel is needed for the required tensile strength. The solution is a combination of both concrete and steel.

SUMMARY

By way of countless examples, we've discovered how the design of everyday things has evolved with developments in technology. While one-off production with basic materials permitted only very basic designs in limited numbers, the development and refinement of materials and processes has made it possible for some countries to produce sophisticated objects for most everyone. In the last four months of 2014, for example, Apple sold over 74 million iPhones. That number is absolutely staggering and is the direct result of design combined with technological progress.

NOTE: Viewings for chapter 6 are found in the back of the book.

CHAPTER 7

DESIGN AND TRANSPORTATION

INTRODUCTION

Industrial design and transportation appear to be meant for each other. The contemporary automobile is a good case in point. No serious automobile manufacturer would ever consider launching a new car without automotive designers being involved. Similarly, we find industrial designers heavily involved in the design of high-speed trains and the interiors of airplanes. This chapter will look at industrial design and its place in the transportation sector.

Land transportation devices exist principally because of the wheel. Without the wheel, there's no bicycle or cart or wagon. Neither is there an automobile or a train. The wheel made all of these modes of transportation possible. The credit for the invention of the wheel isn't easy to determine, however. The earliest wheel dates back to around 3,000 to 4,000 BCE, most likely in Sumeria and Central Europe. This isn't to say that the wheel as a basic concept didn't exist elsewhere. For example, there's evidence of the wheel in China around 1,500 BCE and on toys in South America around 1,200 BCE. But these weren't used for carts or wagons. This was most likely the result of two factors. First, people lived in mountainous areas where wheels were unsuitable for transportation. And second, animals of burden such as horses or cattle, which were used to pull wagons, weren't common. By the time of the Industrial Revolution, the wheel was almost everywhere. What will forever alter it, however, would be the combination of the wheel and artificial power. This combination will be the topic of the next two sections, first with the automobile and then with the train.

THE AUTOMOBILE

Looking back through history, the connection between the horse-drawn carriage and the automobile is somewhat self-evident. Europe and America had all manner of horse-drawn vehicles prior to the automobile. Early taxis in London were horse-drawn much like chuck wagons in the American west. The introduction of the internal combustion engine would displace the horse and would alter these vehicles dramatically. But the change wasn't without some challenges. As is often the case, people—their habits, behavior and values—don't change as quickly as technology does. People were accustomed to horses and buggies irrespective of the inconveniences of keeping horses and hitching them to wagons. And then there was the manure created in the towns and cities. Early cars didn't have these inconveniences, although running a car was more complicated then than it is today. Nevertheless, the car was new and strange. It would take some time for it to become a common everyday thing.

The First Car

The first motorized vehicle was designed and built in 1769 by the Frenchman Nicolas-Joseph Cugnot. It used a steam engine and was a cumbersome vehicle. Nevertheless, it was powered by something other than an animal of burden. Other inventors followed, mostly French and Swiss, with basic vehicles either driven by steam or by electrical power. It was Karl Benz, however, who is recognized as the inventor of the first powered motor vehicle, which he achieved in 1879. The design was based on a tricycle configuration with large wheels. The power came from a simple internal combustion engine. Over the next decades, the Benz automobile would evolve into a more sophisticated machine, such as we find with the Velo model, dated 1894.

The First Assembly-line Car

Henry Ford is credited with using an improved assembly line to mass produce automobiles. This he did with the Model T in 1914. However, credit needs to be given to three other people who helped carve the way for Ford.

The first person was Thomas Blanchard, who, in 1821, used the concept of interchangeable parts in the manufacturing of guns at the Springfield Armory. That said, credit for the concept of interchangeable parts must also be given to Samuel Colt, who was known to have used the concept of interchangeable parts for the guns that bear his name. The third person who needs to be acknowledged was Ransom Olds, who, in 1902, used a basic assembly-line process to manufacture his Oldsmobile.

As for Ford, his contribution was the integration of both mass-production techniques with the concept of interchangeable parts. This he did to a degree greater than anyone else had done previously by using the assembly line. The result would change automobile production dramatically. Ford's first success was the Model T. It was considered the first affordable American automobile and would forever reshape the country by providing ready access to private transportation. It doesn't take twenty/twenty hindsight to see Ford's genius for the production of automobiles. Not only could automobiles be made more quickly—they now came off the assembly line every 15 minutes—the

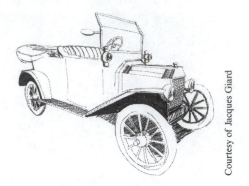

Courtesy of Jacques Giard

Image 12: Henry Ford's Model T automobile made it possible for the average person to own a car and started the American car culture.

production cost was reduced significantly. Each automobile now required fewer man-hours to produce, which created an unintended bottleneck on the assembly line. The paint couldn't dry fast enough, except for the color black. This is why early Fords were only available in black. When production for the Model T finally ceased, more than 15 million had been made.

There was a direct cost saving for the customer of the Model T with the assembly line. Consequently, more Model Ts were sold. But this cost saving equally impacted the workers at Ford because of the decent wage they earned. In 1914, for example, an assembly line worker could buy a Model T with four months' pay. This was highly unusual for the typical factory worker of the day. Other manufacturers of the day considered Ford to be a fool to pay such high wages. But that wasn't the case at all. Ford knew that production would only increase if his workers could afford to buy a Model T.

The Streamline Era: The Car Meets the Plane for the First Time

By the 1920s, the design of automobiles no longer resembled the design of their horse-and-wagon ancestors. Automobiles ceased to look like powered buggies; they now had bodies that enveloped the passengers. What had been an actual trunk on the back of the automobile was now an integrated feature of the overall design of the automobile body. The wheels and tires were also very different. Wagon wheels with rubber on the rims were replaced with pneumatic tires

much like we have today. The automobile was beginning to have a distinct visual language.

A few years after the infamous economic crash of 1929, the Streamlining Era in design began in America. Design in the Streamline Era owed most of its visual language to what was happening with aerodynamics in the aircraft industry, especially with planes like the DC-3. Automobiles were not immune to this direction in design and styling. Chrysler was one company that exploited the Streamline direction. And this it did with its Chrysler Airflow, which was produced from 1934 to 1937.

Unlike most automobiles of the day that were styled for looks, Chrysler developed the Airflow as if it was developing a plane. It used a wind tunnel and it's said the Orville Wright was involved in the project. The aerodynamic basis for the external design wasn't the only original feature for the Airflow. Engineers also relocated the engine forward. They did the same for the passenger seats. This was done in order to bring the balance between the front and rear axles more equal. With a full load, cars of the day often had up to 75% of the weight on the rear axle, making for an unstable ride.

Alas, all of this logical thinking didn't help the Airflow when it came to sales. Despite the modifications to the external design, the automobile never found favor with the public. It was deemed a commercial failure. In the years that followed, design at Chrysler remained conservative. Once again, consumer values weren't changing as fast as technology.

Form Follows Function Military Style

If there's one sector where form follows function in an uncompromising way, it's the military. In almost every respect, visual design plays no role whatsoever in the design and development of products for the military. The Willys Jeep is a perfect example of that design mindset.

The story of the Jeep begins as most stories do when designing for the military: a request to manufacturers for a concept based on a set of performance criteria. This was certainly the case for the Jeep. In the early 1940s, it was becoming apparent that the United States was going to become engaged in World War II. That being the case,

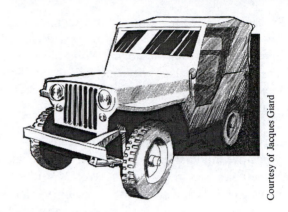

Courtesy of Jacques Giard

Image 13: The Willys Jeep was an excellent example of form follows function in design, albeit military design.

the U.S. Army asked manufacturers for the design of a four-wheel-drive reconnaissance vehicle.

Only two companies came forward: American Bantam and Willys-Overland. However, there was an almost immediate problem: Willys-Overland needed more time to meet the deadline, which they didn't get, and American Bantam was on the verge of bankruptcy. However, American Bantam had the better design but couldn't meet the production quantity needed by the Army; for its part, Willys-Overland didn't have the design but was in a better position to manufacture the vehicle. The Army suggested a compromise. American Bantam's design would be used but the Jeep would be made by Willys-Overland. Ford was also involved in the manufacturing of the Jeep as the war progressed and production numbers rose.

The Jeep owes a great deal of its success to its versatility. It was used for tasks as varied as cable laying, saw milling, firefighting pumpers, field ambulances, tractors, and, with suitable wheels, would even run on railway tracks. After the war, the Jeep helped launch the market for off-road vehicles of all type including the Jeep CJ-5, CJ-7 and Wrangler.

The Car Meets the Plane
for a Second Time

World War II had another impact on the passenger automobile. This impact came principally because of one American fighter plane. That plane was the

P-38 Lightning. Many experts considered the latter as the best plane of its kind, in part because its design departed from the norm. While most fighter planes had one fuselage with one tail, the P-38 was different. It had twin engines and two fuselages with two tails.

This look lent itself well to automobiles. There were two reasons for this. First, Americans were in a very positive mood after the war. After all, they along with the allies were the victors of World War II. Soldiers were coming home and the economy was returning to peacetime production. Second, the airplane had clearly carved a place in the minds of people as the technology of the future. It became almost natural for some manufacturers to borrow from aviation—visually if not functionally—in the design of everyday things such as automobiles.

This is exactly what happened with the Big Three—General Motors, Ford and Chrysler. In the years that followed the war, automobiles became plane-like with fins in the rear, intakes in the front, and all manner of details connected to aviation, especially the jet plane. This direction in visual design was clearly evident in many of the models from the Studebaker Car Company. Raymond Loewy, the designer who made a name for himself immediately after the 1929 depression, was responsible for many of Studebaker's designs. One of these was the Starlight model, launched onto the market in 1947. Perhaps it didn't have the fins of other automobiles, but it had all the visual trappings of jet aviation. It was streamlined like a jet airplane and even had what appears to be an intake for a jet engine in its nose. The connection to aviation and speed was also obvious in the Speedster models, the first from 1953 and the second from 1955. These designs are already 60 years old, yet they make some of today's automobiles look nothing less than stodgy.

AUTOMOBILES FOR THE PEOPLE

Automobiles are designed and meant for people. There's nothing revealing in that statement. However, several automobiles appear to have been designed with a very direct purpose of meeting the needs of the people as a group. Four of these automobiles are an important part of industrial design history.

Volkswagen Beetle

The name Volkswagen says it all: a vehicle or wagen for the people or folks.

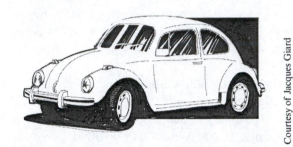

Courtesy of Jacques Giard

Image 14: The original Volkswagen Beetle was designed deliberately with the German people in mind.

This is exactly what Adolf Hitler had in mind when he commissioned Ferdinand Porsche to design a simple automobile meant for the average German family. The design of this automobile didn't begin like so many others. It wasn't, for example, the brainchild of an inventor or didn't result from a directive of the CEO of a company. The decision was autocratic and political. The chancellor of Germany, Adolf Hitler, intervened in the marketplace and ordered that a people's automobile be designed and built.

And this is exactly what Porsche did. Hitler provided Porsche with a list of performance criteria for the automobile such as load, size and speed. Porsche's role was specific: transform these performance criteria into an automobile for the German people, which he did and which became the most successful automobile ever designed and built.

Porsche's engineering mindset guaranteed that its design would be logical and rational. The power plant was a simple, air-cooled, four-cylinder engine. The simplicity would make it reliable and, if it needed repair, it would be simple to do. The engine would be mounted in the rear over the drive wheels. This would provide optimum traction. And the body would be aerodynamic, which would make the car more stable and more fuel efficient. This was form follows function at its best. Ultimately, the Volkswagen Beetle became

a global success. Production ceased in 2003. By that time, over 21.5 million Beetles had been made, more than any other automobile in history.

Citroen 2CV

France also had its automobile for the people. This was the Citroen Deux Chevaux or 2CV.

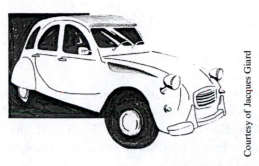

Courtesy of Jacques Giard

Image 15: The Citroen 2 CV was a form of basic transportation for the French people after World War II.

Its design was imagined as a simple vehicle meant to transition farm people from their horse and buggies to the automobile, which was considered a more modern form of transportation.

The first impression of the 2CV is somewhat deceiving. It appears to be a design exercise in simplicity—a corrugated sheet metal body with a fabric roll-top roof and basic seats. It has all the visual qualities that we associate with some do-it-yourself devices. In reality, it was an engineering marvel. One automotive journalist wrote that the 2CV was "*. . . the most intelligent application of minimalism ever to succeed as a car.*" Another wrote of "*. . . the extraordinary ingenuity of this design, which is undoubtedly the most original since the Model T Ford.*" The 2CV was an example of the difficult art of simplicity.

The design of the 2CV had its start in the late 1930s. A first prototype was ready by 1939. Much like the other automobile in this group of people's cars, several aspects of its design were innovative. It was a front-wheel drive concept with a flat twin, water-cooled engine mounted over the front wheels. This configuration provided improved traction. The two cylinders also became the basis for the name 2CV, which translates to two horses or chevaux in French. The automobile also made use of aluminum and magnesium

parts, which was somewhat unusual for such a basic vehicle. The seats were equally basic—nothing much more than hammocks slung from the roof by wires. The 2CV was ready for the market when the World War II erupted in 1939, which caused its production to be stopped.

Once the war was over, the 2CV went back into production but with some redesigning in order to reach a broader market. The air of simplicity remained but there were improvements such as the inclusion of a starter motor. As austere as the design was the 2CV became an almost immediate success on the market. It had been designed with the low-income market in mind and that's where its success resided. Today, the 2CV is considered an icon of automotive design. It even has a cult following both in Europe and abroad. When production ceased in 1990, nearly four million 2CVs had been made.

Morris Mini

The original Morris Mini came onto the market in Britain in 1959.

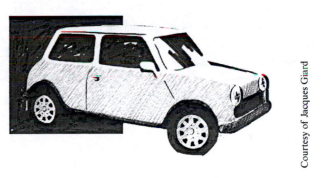

Courtesy of Jacques Giard

Image 16: The Morris Mini was designed to address the need for personal transportation in Great Britain in the late 1950s.

Nearly 15 years had passed since the end of World War II. Britain had recovered from the destruction of the war and had rebuilt a great deal of its transportation infrastructure. The country was very much looking to the future. More and more, people were now in a position to purchase the so-called big-ticket items such as automobiles. But English cities were generally dense. Space was at a premium. If people were to have personal

transportation, it needed to be compact. To meet this criterion, the design of a new automobile would have to be innovative. Moreover, there had been a recent fuel crisis. Therefore, fuel efficiency was imperative.

Sir Alec Issigonis, the English engineer, was up to the task. He began by rethinking the traditional automobile. Much like Ferdinand Porsche and his design for the Beetle, Issigonis questioned many conventional aspects of the automobile. This led him to consider design directions that were quite revolutionary. For example, he designed the Mini with a laterally mounted engine. Such a configuration would make the Mini shorter and more compact, which would be ideal for the typically congested British towns and cities. It also provided greater space in the passenger compartment. Like the Beetle, the engine was placed over the drive wheels in order to provide better traction but, unlike the Beetle, the engine was in the front. Issigonis also positioned the four wheels at the extreme four corners of the vehicle in order to allow as much space as possible for the passengers and their gear. There were also other minor design features that helped reduce the cost of the Mini such as horizontally mounted sliding windows and simple interior latches for the doors.

Over its product life, the Mini evolved into a variety of versions. Perhaps most interesting was its participation in international car rallies such as Monte Carlo, where it was the winner every year from 1962 to 1968. Production ceased in 2000. At that point, its worldwide sales stood at around two million vehicles.

FIAT 500

The FIAT 500 was a small automobile designed and produced by the Italian manufacturer FIAT.

Production began in 1957 and continued until 1975. In several ways, the FIAT 500 was similar to some of the small automobiles described above. For example, it was meant for the city like the Mini-Minor; it also had an air-cooled engine mounted in the rear like the Beetle, and it had two cylinders like the 2CV.

The introduction of the FIAT 500 was meant to satisfy the post-World War II Italian market for a small affordable automobile. It was designed to put Italians on the road, a goal it achieved despite its small size and basic engineering. If anything, Italians found the car to

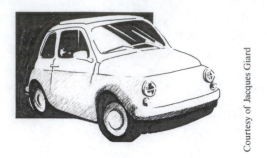

Courtesy of Jacques Giard

Image 17: The original FIAT 500 was Italy's answer to personal transportation for the Italian people in the late 1950s.

be practical. Consequently, it became extremely popular. Over its product life, various models were produced including the cheaper base model FIAT 500F, the 500K station wagon, the 500L with a redesigned interior, and the quirky Jolly.

Retro Versions

Three of these people cars—the Beetle, the Mini and the FIAT 500—all became design icons. That is, they embodied values that resonated with people over time. On one hand, their designs, especially from a technical perspective, were logical and rational; on the other, they connected at the personal and social level of the individual owner. Moreover, each one mirrored to a certain degree one cultural value or another of its country of origin. For example, the design logic of the Mini was typically British much like the engineering innovation of the 2CV was typically French.

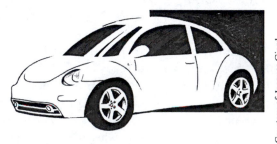

Courtesy of Jacques Giard

Image 18: In part, the design of the Volkswagen New Beetle was based on the visual memory of the original Beetle.

Not surprisingly, their iconic design qualities provided a platform for updated versions for the Beetle, the Mini, and the FIAT 500 several decades after each had gone out of production. In each case, however, there have been significant changes. For the New Beetle, the design took a page out of the original Beetle, at least visually. It borrowed a great deal from the classic look of the old Beetle. Almost everything else was different however. The New Beetle is larger and definitely more comfortable with better interior appointments. The biggest difference, however, is on the mechanical side: the New Beetle is designed as a front-wheel drive vehicle with a water-cooled engine in the front.

The new Mini was also designed to imitate the original Mini-Minor, at least visually. The overall visual design borrowed quite faithfully from the original Mini. There was definitely a family resemblance. But like the new Beetle, the new Mini is larger in size as well as being mechanically and technically more advanced. It's also available in several different models. As an aside, the new Mini is no longer made by a British company but by BMW, a German manufacturer.

Image 19: The design of the New Mini followed in the footsteps of the New Beetle by building on past visual memories of the original Mini.

The design of the new FIAT 500 followed a pattern similar to the New Beetle and new Mini. It too is based on the overall visual appearance of the original FIAT 500, but with some significant updates. The new FIAT 500 has a definite family resemblance to its distant cousin, but there are improvements everywhere—everything from the engine, which is larger and more powerful, to the interior appointments, which are more luxurious.

Image 20: Much like the New Beetle and New Mini, the design of the New FIAT 500 borrowed from the visual look of the original FIAT 500.

Is there a lesson for industrial designers in this type of design revival? In a glib sort of way there is. It appears that what goes around comes around. The past can often times become the catalyst for the future.

TRAINS: AN EARLY HISTORY

The train is a true product of the Industrial Revolution. It came to be because of the necessity to transport goods more efficiently and effectively. However, the combination of carriages, rail and steam wasn't immediately apparent. There was no obvious connection at first among these three components. For example, steam power and steam engines had been developed originally for the mines because of the need to drain water. As a result, steam engines were large, heavy and stationary. There did not appear to be any reason to make steam engines smaller and mobile. This isn't to say that there hadn't been some attempts to apply steam power to carts or carriages. As we know, the Frenchman Nicolas-Joseph Cugnot had done such a thing in 1769 when he designed and built a steam-powered wagon.

However, the challenge that faced the first steam-powered vehicles went beyond merely adding an artificial power source to a wagon. To be efficient as well as effective, the device needed a surface on which to run in much the same way that wagons needed roads. Moreover, the smaller steam engines that did exist weren't that powerful. Consequently, the running surfaces wouldn't only have to be smooth but they would have to be level as well. George Stevenson, the British engineer, was keenly aware of this design challenge when he built

The Rocket in 1829. It should be noted that his wasn't the first steam locomotive; there had been a few previous attempts, all unsuccessful. Stevenson's locomotive was different, however; it met the aforementioned criteria of small yet powerful steam engine driving a locomotive over steel rails on a more or less flat running surface. The Rocket would pave the way for what would become a preferred mode of mass transportation the world over, both for goods and for people. Stephenson's idea would spread west to North America as well as the Far East to countries such as India and China.

Early passenger trains in Britain were innovative and progressive. They were innovative because of the new technology being used; they were progressive because of their impact on English society. For example, trains permitted people to travel, even those from the lower classes. But early passenger trains also had their critics. The Duke of Wellington was an especially vocal one. He wasn't at all in favor of the lower classes traveling. Class distinction in the Victorian era was an important and a distinguishing feature of British society. Bluntly put, members of the lower class were to stay in their place, literally. Traveling was surely not in their best interest, or at least so thought the Duke of Wellington.

In the decades that followed, steam rail transportation in Britain evolved rapidly. In a way, it came to brand British industrial prowess. Steam locomotives became bigger and faster, and their network connected the country. More than that, trains took on a personality of their own. A case in point was the Flying Scotsman. This train became the flagship of British railways, doing the trip from London to Edinburgh in record time. Sir Nigel Gresley was the engineer responsible for the design of the Flying Scotsman and became a towering figure in British rail technology. The Flying Scotsman began service in 1923 and held two important records during its history. It was the first train to go faster that 100 mph, which it did in 1934, and it achieved the longest nonstop journey by a steam locomotive when it traveled 422 miles in 1989. The second noteworthy locomotive designed by Gresley was the A4 Mallard, which became the fastest steam locomotive on record. This achievement was made possible, in part, by the streamlined body of the Mallard.

The Orient Express

One European train that's noteworthy in the age of rail transportation was the Orient Express. The Orient Express was a long-distance service between Paris and Istanbul initiated in 1883. It began as part of normal international railway service within Europe. Nevertheless, the name became synonymous with intrigue and luxury travel. The latter was significant because most railway travel was still quite basic. It could even be rough and dangerous at times. The Orient Express revised that picture. It provided a first experiment in rail travel that went beyond a means of getting from A to B. Travel could be a pleasurable experience and not some utilitarian requirement. This direction in train travel would find its counterpart in America with services such as the 20th Century Limited in the 1930s.

Steam Locomotives in America

Steam locomotives were used in the United States beginning in the early part of the 19th century. To no one's surprise, a great deal of the technology in these years came from Britain. After all, Great Britain was the center of steam and rail technology. However, the design of British locomotives differed from their American counterpart because of the different contexts of operation. Two design features were particularly indicative of the contextual differences between Great Britain and America. The first was the smoke stack on the early American locomotive; it was taller and wider than its British counterpart. Why was that? It was because early American locomotives were burning wood, not coal, to generate steam. Coal burns without sparks, but wood doesn't. The larger stacks captured the hot sparks and cinders from the burning wood, which, in turn, helped prevent grass or bush fires on the prairies. The second modification was the cowcatcher, which didn't exist on most British locomotives. In Britain, trains ran in developed areas where domesticated animals such as sheep and cattle were kept in enclosed pastures. On the American prairies, however, all manner of animals such as free-range cattle and wild bison could easily find their way onto the tracks. It was easier to dislodge an animal or

other obstruction from the track than put a derailed train back on the track.

The intervention of industrial designers in American railways didn't really occur until the 1930s. This was the era immediately after the Great Depression of 1929. Railways were competing for business. This was especially the case on the busy New York–Chicago corridor. As a competitive edge in the early age of aviation, which was perceived as the transportation mode of the future, railways borrowed the streamline language that had developed with airplanes like the DC-3. What had previously been nothing more than an engineered combination of boiler, furnace, and wheels entwined with pipes of all kinds quickly became an elegant machine with the clear promise of high-speed travel.

Two locomotives by two different industrial designers stood out in this era of streamlining. The first was the 20th Century Limited, a train service operated by the New York Central Railroad between New York City and Chicago. Service began in 1902 and came to an end in 1967. During that period, it became known as the greatest train in the world. It should be remembered that rail travel was considered a serious undertaking in this era. People who traveled by train acted accordingly, being very mindful of dress, status and decorum. The American designer Henry Dreyfuss was directly involved in the design of the 1938 version of the 20th Century Limited for which he created the streamlined exterior as well as the Art Deco interior. Raymond Loewy did much the same in 1939 for the Pennsylvania Railroad with the S1 locomotive, which was the largest steam locomotive ever built. The locomotive had the streamlined profile of a bullet and was immensely impressive, especially with its Art Deco treatment. Unfortunately, the locomotive proved too much of a challenge in day-to-day operations. Only one was ever built, which was taken out of service in 1945.

The involvement of Mary Jane Colter needs to be noted at this point. Colter was an architect whose work can be found in the American southwest as the result of her connection to the Fred Harvey Company, which owned and managed hotels along the Chicago–Los Angeles route of the Santa Fe Railroad. An excellent example of her work is La Posada Hotel in Winslow, Arizona. In Spanish, la posada means the pause. The hotel was built originally because cross-country rail

journeys in the 1930s took days. It wasn't unusual for people to stop here and there and spend a few days. The American southwest, with its vistas and Native population, provided valid reasons for one of these stops. And La Posada was a hotel of choice. When cross-country rail travel ceased to be popular in the 1950s, La Posada was nearly demolished. Fortunately, the hotel has been totally renovated. A visit there today reminds us of the heyday of transcontinental railways in the American west in the 1930s. Amtrak still makes a daily stop at the station next to the hotel.

Courtesy of Jacques Giard

Image 21: La Posada, designed in 1930 by Mary Jane Colter, served as a hotel for transcontinental rail passengers. It is located in Winslow, Arizona, and has been recently renovated.

By the 1950s, air transportation began to slowly replace passenger rail in many parts of the world. Industrial design didn't begin to impact rail transportation again until the 1960s. It's in Japan where industrial design and trains connect once more, followed by innovative train designs in France, Britain and Germany.

Japanese Shinkansen

Geographically speaking, Japan is a small country but it has a relatively large population. Its land area is about the same size as California with one major difference: about 70 % of its land mass is mountainous and inhabitable. In the 1960s, when Japan began thinking about high-speed rail, the country's population was around 120 million. Consequently, the country provided an ideal scenario for high-speed rail: a densely populated country with relatively short distances between major cities. This scenario would make it much easier for

Japan to rationalize such a project because a significant investment would be required to finance it.

The Japanese high-speed train was a totally new concept; there was no precedent to speak of. Everything—infrastructure, locomotives, coaches, rail, and related technology—was to begin at square one, so to speak. Moreover, the train would be competing with the airlines and would succeed or fail because of its fast and on-time service. In addition, the cost of a totally new high-speed train was prohibitively high. If such initiatives were to succeed, the Japanese government needed to be involved. In the case of Japan, the World Bank would also need to play a role. After all, the Japanese proposal was unique. No other country was considering high-speed rail. But in such a densely populated country with short distances between city centers, the project made sense. So began the idea for the Shinkansen or Bullet Train.

From the start, the Shinkansen had some very specific design criteria. The service was to be between major city centers such as Tokyo and Kyoto. It wasn't meant to be a commuter-type train. Neither was it to be a long distance, overnight train. The Shinkansen was to be an intercity day train for short to moderate distances. It was also to be what's called a push/pull train; that is, the train would be equipped with a locomotive at each end. The train was to offer both first- and second-class services. Lastly, high speed meant at least 200 kph or 120 mph, and on-time performance was critical. In combination and if the Shinkansen was to meet its goal of efficient, on-time service, one design feature became clear: the train required a network of dedicated rails. The existing rail network in Japan was narrow gauge

Image 22: The Japanese Shinkansen or Bullet Train was the first modern high-speed passenger train.

Courtesy of Jacques Giard

and inadequate for the demands of this new high-speed rail.

The first version of the Shinkansen provided all of these features, and did so in innovative ways. For example, there was no traditional locomotive at each end that pulled the train. Instead, all axles—even the ones on the coaches—were powered. Because it was a high-speed train, the locomotives were streamlined but with a form more reminiscent of early passenger planes such as the Douglas DC-4. Passengers were offered both first- and second-class service. Unlike their European counterpart, however, first class had four seats abreast and second-class had five. Passenger windows were also smaller than the typical panoramic windows, principally because of the lower replacement cost of the glass.

There was an additional aspect of the first Shinkansen that was especially Japanese in nature. The first Shinkansen service was from Tokyo to Osaka. On this route, the train travels south of Mount Fuji, which is considered a sacred mountain by the Japanese. The first Shinkansen had a dining car but with windows on only one side. This situation could have been problematic because it would be inconceivable to pass by Mount Fuji and have the passengers' view blocked. Therefore, the dining car was always situated in such a way that Mount Fuji was visible.

Not long after the first Shinkansen was launched a second line was created going northeast from Tokyo. At first glance, the two train sets appeared to be the same but a closer look revealed two important differences. The first was strictly cosmetic. It was the green stripe along the length of the train. The original Shinkansen going from Tokyo to Osaka had a blue stripe. The stripe was more than a decoration, however. The colors—blue and green—designated and differentiated one service from the other. The second difference was more significant. The Shinkansen for the northern line was made of aluminum, not steel. Aluminum was used to save weight because the territory of operation is mountainous; therefore, weight reduction becomes important. So important, in fact, that at certain points along the way de-icing agent is sprayed on the train in the winter in order to remove snow and ice that has accumulated. Ice and snow add unnecessary weight and reduce the train's efficiency.

Since its inauguration, the design of the Shinkansen has evolved on a regular basis. The speeds have increased and there have been regular changes to the train's design, yet it remains as punctual as ever.

The French TGV

France was the next country to develop a high-speed train. And like Japan, the railways in France during the 1970s were facing competition from the airlines. Airfares from Paris to various parts of France had dropped and had placed the French railways in a difficult position. The new technology of aviation was beating the old technology of rail. A fresh approach was needed, clearly.

The French approach would take a page from both the Japanese Shinkansen and the airlines. The new train concept was called the Train à Grande Vitesse or TGV. Like the Japanese Shinkansen, it would run on a dedicated-rail network. This infrastructure was costly but would allow for greater speed and uninterrupted service caused by slower local passenger trains or even slower freight trains if the TGV used the existing rail network. Dedicated rails would also guarantee on-time service. Like the jet plane of the day, the TGV would not only have to be fast but also give the impression of high speed.

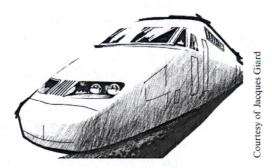

Courtesy of Jacques Giard

Image 23: The French TGV is considered the second modern high-speed passenger train; it has often held the world speed record for passenger trains.

The design process to achieve this end had two steps. First, the engineers at Alstom, the French manufacturer of the train, developed the train and rail technology for what would eventually become the fastest passenger train in the world. Second, the French state railways hired Jacques Cooper, an automotive designer who had worked previously with Peugeot, the carmaker. Cooper was asked to design a train that would make passengers feel that they were on a plane flying at ground level. As a result, the visual look of the TGV was determined well before the aerodynamic or wind-tunnel testing by the engineers. For the TGV, the visual appearance of the train took priority over functional parameters.

The TGV had several other notable design features. Like the Shinkansen, the TGV is a push/pull train; that is, there is a locomotive at each end. And like the Shinkansen, the TGV is a short to medium distance, day train, and not a long distance, overnight train. The initial service was between Paris and cities south such as Lyon. First- and second-class services were offered, and high speed meant at least 250 kph or 150 mph.

The first TGV quickly became the gold standard of high-speed rail travel. With its pointed nose and bright orange color scheme, it clearly expressed speed and flashiness much like some of the passenger jets of the day. The airplane experience continued in the interior as well where the traditional passenger compartments were removed and replaced with aircraft-like seating with overhead luggage racks. The original goal of the French railways was achieved: TGV passengers were now flying at high speed but at ground level. By 2007, it had become the fastest passenger train in the world when it reached a speed of 350 mph.

Over the decades that followed, the service was extended to the west of France with the TGV-Atlantique. More recently, new TGVs with even more streamlined train sets have entered service not only within France but also to nearby countries such as Switzerland, Italy, Germany, and Belgium.

The British HST

There was a clear need for a British high-speed train in the 1970s. The existing rail technology had become worn and dated. So had the rail infrastructure. Some of it was from before World War II. Like Japan, Britain was densely populated and major cities were often no more than an hour apart. Furthermore, the British people were regular users of public transport. In part, this was because automobile ownership was relatively expensive as was its day-to-day cost of operation.

British Rail, the state-owned rail corporation of Great Britain, began the development of a high-speed train with the Advanced Passenger Train or APT. This occurred in the late 1970s. Its design DNA was not found within traditional rail technology but within the aerospace industry partially because the latter had fallen on hard times in Great Britain. In other words, there was an opportunity to use expertise from the leading edge technology of aviation and apply it to a sector that was technologically very traditional. To no one's surprise, the APT was an exemplar of sophisticated aviation engineering. Like an airplane, it was made of aluminum. And like an airplane, it used a turbine engine similar to ones used in jet planes. In addition, the locomotive and its coaches were designed using a pendulum-like system. This system would allow the train to tilt in the curves in order to attain higher speeds. This kind of technology was necessary because British Rail didn't have the financial means to provide a dedicated track network like Japan and France. A nontilting train couldn't attain the desired high speeds in the curves of the existing rail network.

Unfortunately, many of the design features of the APT that could go wrong did go wrong. Two of these were especially significant. The first problem was with the pendulum system; it failed regularly, meaning that the APT couldn't go as fast as planned. The second problem was the oil crisis of the mid-1970s. This unintended event put the use of the turbine engine in jeopardy. With the much higher price of oil, the APT was no longer going to be an economical means of travel. These issues placed British Rail in a difficult position because time was passing by and the country was no closer to having a high-speed train service in place. A Plan B was necessary; that is, a new design direction was needed in order to have a high-speed train up and running in a timely manner. The new design direction quickly focused on making use of the best existing train and rail technology in the context of a high-speed train that could achieve a speed of 200 kph or 125 mph.

So began the development of the High Speed Train or HST. British Rail engineers began to put together a train set using state-of-the-art diesel-electric drive technology and lightweight coaches with redesigned interiors. Everything was moving forward as expected until the new design of the locomotive reached the Design Board of British Rail. The latter group was the gatekeeper, so to speak, of the brand identity of British Rail. From the Board's perspective, the HST locomotive proposed by the engineers was perhaps technically appropriate but it didn't project the visual image of a high-speed train. The form or look of the locomotive didn't visually express the high-speed nature of the HST. It was at this point that industrial designer Kenneth Grange, a partner in the British design firm Pentagram, was commissioned to give the HST a redesign.

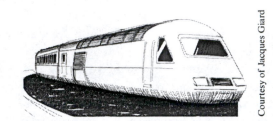

Image 24: The High Speed Train or HST was Britain's answer for the need of more efficient passenger rail service.

Grange began by asking what are sometimes called silly questions, something that industrial designers are prone to do in order to understand the challenge. Grange asked questions such as "Why does the locomotive have bumpers for shunting when it's not expected to shunt? Is the HST not a push/pull train set?" Or "Why are so many bits sticking out here and there? Isn't this train supposed to be aerodynamic?" His questions and his ideas eventually led to the design of the HST that we know today. It went into general service in 1976.

There are several different high-speed trains other than the HST in service in Britain today. British Rail, the rail company that originally launched the HST, no longer exists. Private rail companies such as Virgin Express and Great Northern Railway have replaced it. Nevertheless, many of the original HSTs are still in service. Good designs are often timeless.

The German IC-E

The German state railways took yet another approach for the design of a high-speed train. Contextually and much like France and Britain, Germany had a

relatively large population with many cities in close proximity to one another. Such a combination made high-speed rail transportation feasible. Furthermore, the use of private automobiles in Germany was expensive. Public transportation made logical sense. And like British Rail, the German rail corporation didn't have any desire to invest in a totally dedicated rail network like the Japanese or French did. Instead, the existing rail network was going to be improved to allow for the operation of a state-of-the-art train set. These goals were achieved with the Inter City Experimental, later called the Inter City Express or IC-E. The first-generation IC-E went into service in 1989.

Like the British HST, the IC-E began as an engineering project. And like the HST, the engineered solution didn't quite meet with the approval of the Design Board of the German railways. The latter was responsible for the control of the overall visual image of the railways, from the uniforms of the train crews to the graphics on printed materials and the rolling stock. The external design or look of new trains was included in this design mandate. In the case of the IC-E locomotive prototype, the external design was the result of an extensive study using computer-aided design and included variables critical in the operations of the locomotive such as speed of the train, curves in the track, tunnels and trains passing by one another. Despite this logical approach, the final form of the locomotive was found to be visually unappealing by the Design Board and therefore unacceptable. The visual design didn't convey in any convincing way the high-speed look desired by the Design Board. It was at this point that the German industrial designer Alexander Neumeister was invited to intervene in the project and work with

engineers in order to resolve the form-giving challenge of the IC-E. His design contribution met the board's approval, leading to what would become the first generation of the IC-E train.

Much like the challenge faced by the TGV, the German railways knew that they were competing with the airlines for customers. This is why the train service was designed to replicate the best feature of air travel—speed and on-time arrivals—all the while offering service from city center to city center, which airlines cannot do because airports are most always on the outskirts of cities. In addition, the IC-E created a particularly effective business-class service. Since its launch, the train has gone through regular design improvements and modifications. The latest generation, the third, isn't only extensively streamlined but it has adopted the technology of powered wheels all around much like what's found in the Japanese Shinkansen.

The Eurostar Train

The Eurostar is a high-speed rail network operating between London and Paris with service also to Brussels. On its service to and from London, the train uses the Channel Tunnel under the English Channel. The train service is quite similar to what's available on the TGV and IC-E. That is, passengers are made to feel as if they're traveling business class—inviting interiors, comfortable seats, and full onboard services. Once again, the railways were competing directly with the airlines and doing so by providing safe, on-time service but from city center to city center.

Today's high-speed trains are distant cousins to the trains of the Streamline Decade and even more so with the early trains of the Industrial Revolution. In Europe and in Japan, they provide comfort and services easily comparable to the best airlines and do it often faster and cheaper.

PEOPLE AND EARLY FLIGHT

Ever since the Wright Brothers made the first powered flight, people have been closely connected to airplanes. Industrial design may not have been involved directly in the earliest experiments of flight but it has permeated a great deal of modern aviation.

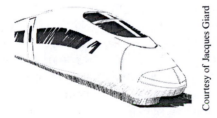

Courtesy of Jacques Giard

Image 25: The German Inter City Express or IC-E is one of the latest high-speed passenger trains in Europe.

Courtesy of Jacques Giard

Image 26: Leonardo da Vinci had an interest in flight and designed some of the earliest flying devices such as this glider. The detailing and execution were perhaps crude compared to today's standards; nevertheless, they were credible concepts. Clearly, da Vinci was ahead of his time.

There's a long history of human interest and involvement in flight. A good example is Leonardo da Vinci, who observed birds in flight and then went about imitating what he saw with designs such as gliders and other flying devices.

Winged flight didn't always immediately capture people's imagination but lighter-than-air crafts certainly did. This is what happened with the Montgolfier Brothers, the French inventors of the first hot-air balloon. The craft they built may have been simple in design but its fabrication was somewhat questionable given that hot air was going to be used. The globe-shaped balloon was made of sackcloth with layers of paper on the inside and held together with around 1,800 buttons and a fishnet on the outside. Nevertheless, the device functioned and first flew in June 1783, reaching an altitude of 5,000–6,000 feet and covering a distance of a little over one mile. The flight lasted around 10 minutes.

The Wright Brothers

Connections between early adventures in flight by da Vinci and the Montgolfier Brothers, on one hand, and modern jet planes, on the other, aren't that obvious. Such isn't the case with the first powered flight by the Wright Brothers, although the connection may still seem a bit remote. After all, there doesn't appear to be a great similarity between a wood-and-cloth airframe and a multiton aluminum jumbo jet. But there is.

The story of powered flight begins with the Wright Brothers. Their story is a classic case of American innovation. It's a magical combination of boundless curiosity about flight and human inventiveness about technology. Orville and Wilbur Wright were born in 1871 and 1867, respectively. They're credited with designing and developing the first controlled, powered flight of a heavier-than-air craft on December 17, 1903. More important, perhaps, was the three-axis control that the Wright Brothers designed to fly the airplane. The principles that underpin this control system remain the basis for all flight control to this day.

The first flight—because there was more than one on that day—was a short one. The plane went a distance of 120 feet, which isn't even the length of a football field, and flew at around seven miles an hour for 12 seconds. The next two flights were slightly longer, one at 175 feet and the other at 200 feet. The plane never went higher than about 10 feet. Who could have imagined that a flight of such small-scale would eventually lead to wide-bodied jets that can go over 600 mph, at over 35,000 feet and for distances of 5,000 miles or more? You would have to be a dreamer or even insane to imagine such a feat at the turn of the 20th century.

For designers, the context and process that led to the invention of the plane is worthy of note. First, the Wright Brothers learned a great deal about how things are made by working in their shop with devices such as printing presses and with everyday things such as bicycles, internal combustion engines and other machinery. In other words, there was no direct connection between their immediate day-to-day experiences and the concept of flight. The Wright Brothers had to imagine that connection.

Second, they did a great deal of design work with gliders. In fact, they even built a small wind tunnel. In the end, it was by way of designing, testing and redesigning that the Wright Brothers arrived at a solution for powered flight. In many ways, their process is similar to how today's everyday things are designed, manufactured and placed on the market. The difference is that the Wright Brothers did it by intuition and experience; today's designers do it more often than not by using design research and design methods.

Development in aviation grew quickly in the years following the flight of the Wright Brothers. Aircraft

designs became more sophisticated and power plants more refined. World War I would see the use of airplanes for the first time in warfare with a commensurate leap in innovation, designs and concepts.

Lindbergh and the Spirit of St. Louis

World War I saw the introduction of biplanes as weapons of war. Once the war was over, there was little doubt that aviation was a promising mode of transportation. As basic as these early airplanes were, they were faster than automobiles and trains. Not to be discounted was the fact that airplanes didn't require an extensive infrastructure such as roads or rails. Clearly, airplanes provided the potential for a new form of transportation, leading to a surge of developments for better and better concepts. Part of the encouragement for this development was the Orteig Prize offered by the French-born, New York hotel owner Raymond Orteig. The prize of $25,000, which was a large sum of money in those days, was to be awarded to the pilot who would successfully fly nonstop between New York City and Paris. It should be noted that two British pilots, John Alcock and Arthur Whitten Brown, did the first nonstop crossing of the Atlantic in 1919. They flew their modified Vickers Vimy IV from Canada to Ireland for a total distance of nearly 2,000 miles.

Many pilots entered the competition for the Orteig Prize. Charles Lindbergh was among them. His attempt, however, was fraught with one challenge after another right from the start. One of these challenges was the difficulty in getting the necessary funding to

Courtesy of Jacques Giard

Image 27: Compared to modern jet planes that cross the Atlantic effortlessly, Lindbergh's Spirit of St. Louis was a simple and basic airplane.

buy, service and fly an airplane. Worse still, Lindbergh couldn't even acquire a suitable aircraft for the flight. In the end, it was the Ryan Aircraft Company of San Diego that rescued him and provided the aircraft that would become known as the Spirit of St. Louis. Lindbergh took off early May 20, 1927. Over the next 33.5 hours, he would face all manner of flight hazards, from icing on the wings to storms and fog. He landed after 10 pm on May 21 to a jubilant crowd at Le Bourget Airport northeast of Paris.

If nothing else, Lindbergh proved once and for all that aviation wasn't a passing fancy. This mode of transportation gave a glimpse to what the future would be for travel whether transcontinental or transoceanic. Automobiles and trains, as important as they were, were now part of the past. Airplanes were about to supersede both of them as a preferred mode of transportation.

Douglas DC-3

The period between World War I and World War II—that is, from the 1920s to the early 1940s—was a time of great progress in American aviation. If there wasn't already an interest in flight before Lindbergh's exploit of 1927, there certainly was after. The period was one marked by one innovation after another in aviation. The Douglas DC-3 was an exemplar of this innovation fever. People were beginning to travel by air more and more, and airlines were sprouting everywhere. That was certainly the case with American Airlines. It had been using the Curtis Condor II biplane and was looking to replace it. C. R. Smith, the CEO of American Airlines, called Donald Douglas, the founder of the Douglas Aircraft Corporation, for assistance. Smith wanted Douglas to build a 20-passenger plane with sleeping accommodation. Smith's request would eventually culminate in the design of the DC-3.

As a design, the DC-3 wasn't totally new. The DC-1 had been designed for Transcontinental and Western Airlines or TWA because the plane of the day, the Boeing 247, was being made and sold to United Airlines and no other airline. In those days, there appeared to be a distinct corporate allegiance between airlines and aircraft makers. The first DC-1 flew in 1933. This design led to the DC-2, an improved version of the DC-1. Like

the DC-1, it was an all-metal aircraft and carried 14 passengers. The first DC-2 flew in 1934. Douglas used the DC-2 as the basis for the DC-3. The plane became larger, could carry 20 passengers, and first flew on December 17, 1935, exactly 32 years to the day after the first powered flight by the Wright Brothers. The DC-3 proved to be one of the most commercially successful planes in aviation history. By the time that production ceased in 1950, over 16,000 had been built. Many are still flying today in places like Alaska as well as many developing countries.

The design of the DC-3 played an important but indirect role with industrial design of the same era. Not only did the plane make passenger travel possible but it also became the visual icon of its day. That is to say, the visual look of the DC-3, with its streamline features, was novel and significantly different from many earlier planes such as the Ford Tri-motor. As a result, a new visual language in design was created, one that was soon found in the automobile such as the Chrysler Airflow and in locomotives such as the 20th Century Limited. Even stationary everyday things that had nothing to do with flight and speed, such as pencil sharpeners, were victims of the streamline frenzy. The streamlined look began to appear almost everywhere irrespective of whether it was functionally appropriate or not.

WAR AS A SOURCE OF INNOVATION

By the late 1930s, the Western world was once again on the brink of war. By 1939, it had officially broken out in Europe; by 1941, the United States joined the fray. As terrible as wars are, they can produce benefits especially in the areas of innovation and technology. Four airplanes designed specifically for the war effort are remarkable because of their unique qualities. Each one contributed to design innovation in aviation as well as to civilian life afterward.

Supermarine Spitfire

World War II had not yet begun, yet Britain, France and Germany were busy with the development of a new generation of all-metal, low-wing fighter planes. There had been great advances in aircraft technology since

1918 when World War I ended. Biplanes, which were used extensively in World War I, were now things of the past. Metal had replaced wood and cloth. Engines were more powerful and more sophisticated. Planes had become faster.

The British entry into this generation of fighter planes was the Supermarine Spitfire, which first flew in 1936. It had an all-metal, semi-monocoque body with complex, compound curves as would be expected from such a streamlined machine. It was also designed with the thinnest wings possible, which allowed the Spitfire to outmaneuver other fighter planes. But it was the elliptical shape of the wings that clearly distinguished the Spitfire from the rest. The aircraft remained in production until 1948. By then, over 20,000 had been built.

To this day, many experts consider the Spitfire as one of the finest examples of form follows function for any kind of product despite the fact that it was the result of an engineering exercise and not of a typical exercise in industrial design. Its streamlined form reinforced the concept that the design of some everyday things couldn't be divorced from the functional parameters.

P-51 Mustang

World War II had just begun when, in 1940, Britain made a request to North American Aviation, an American designer and builder of airplanes, for a high-altitude fighter. This request gave birth to the P-51 Mustang. As was sometimes the case when designing under wartime conditions, the P-51 had a short gestation period. The contract for the new design was signed in early 1940, the first prototype rolled out in September of that same year, and the Mustang took its maiden flight at the end of October. In other words, one of the premier fighter planes of World War II went from drawing board to a plane in the sky in about 12 months.

The Mustang didn't, however, have the same visual elegance of the Spitfire. Its visual appearance was more rugged and muscular. For example, its tail and wing tips were blunt, whereas the Spitfire's were elliptical and elongated. In most instances, the P-51 was left unpainted, showing the bare aluminum of its construction, whereas Spitfires were always painted as if wearing a costume. If anything, it was this exposed

aluminum skin that became the trademark of the Mustang and which created the look of the modern aircraft after World War II. As we learned in Design and Technology (chapter 6), aluminum would become the material of choice for all types of airplanes.

P-38 Lightning

The P-38 Lightning was designed in 1939 by the Lockheed Corporation for the United States Army Air Corps. It was like no other aircraft of its time. Its design was unique, to say the least. No other fighter aircraft had the twin tail booms of the P-38. It was also one of the few twin-engine heavy fighters of World War II and remained in production until 1945. By then, over 10,000 had been built.

It was the visual uniqueness of the P-38's twin booms that influenced industrial design after World War II. One need only look at the Fords, Chevrolets and Chryslers of the early 1950s to see the similarity in a twin-tail design. For Americans, the euphoria of being on the winning side of World War II was transferred—at least in part—to some of their everyday objects. This was certainly the case with the American automotive industry, which saw an obvious design direction for new cars by making a connection between innovative designs in war and the personal automobile. By owning a car with fins, you claimed to be part of what was new, innovative and futuristic.

Messerschmitt Me 262

The propeller-driven airplane was developed to its maximum potential during World War II. This was evident with fighter planes such as the Spitfire, the Mustang and the Lightning. It was also the case with bombers such as the B-17, B-24 and B-29. To reach the next level of performance in airplane design, however, another source of power would be needed. The internal combustion engine had reached its limit. That other source of power would be the jet engine.

The German Messerschmitt Me 262 was the first operational jet-powered fighter. It first flew in 1942 and saw service in the war in 1944. Some historians speculate that the war could have been quite different had the Germans had the jet fighter earlier. The Me 262

continued to fly with the Czechoslovakian Air Force until 1951. In total, a little over 14,000 were built.

The Messerschmitt Me 262's contribution to design is self-evident. The world's air transportation sector is now totally dependent on the jet engine. Propeller-driven airplanes are still being manufactured but serve a distinct but smaller market. Many are small private airplanes; others are meant for special purposes such as bush planes or short-takeoff-and-landing aircrafts. Everywhere else, from corporate jets to large military transports, it's the jet engine that rules the skies.

DEVELOPMENTS POST WORLD WAR II

There was a pattern shared among the Spitfire, the Mustang, the Lightning and the Me 262. The pattern was the need for the ultimate development possible achieved in the most timely manner because there was a well-identified purpose. In these cases, the purpose was World War II. The best plane had to be designed because nothing less would suffice.

Once that purpose no longer existed, technological developments from the war effort began to spread to the civilian sector. For example, Buckminster designed the Dymaxion House out of aluminum, which was used extensively in the war; Harley Earl, the chief designer at General Motors, was responsible for the first fins on cars, which resembled the P-38; and the Boeing 707, with jet-powered engines similar to the Me 262, changed passenger air travel forever. In the space of fewer than 50 years, society went from a very short powered flight by the Wright Brothers in 1903 to transcontinental jet travel at speeds of 600 mph with the De Havilland Comet in 1949. Clearly, this was technological progress as it should be.

The development of the jet engine was part of this technological progress. It occurred during the last years of World War II, and its principal purpose was for military supremacy. Once the war was over, however, it didn't take much time for the jet engine to quickly find its place in the civilian world. The first commercial passenger jet was the Comet, designed and built by the British company De Havilland. It first flew in July 1949 and went into service three years after in 1952.

A design flaw—squared passenger windows—created stress concentrations in the corners and proved to be disastrous in the first version of the Comet. It caused several planes to break up in flight. The Comet was redesigned and relaunched as the Comet 4 in 1958. It stayed in service for a total of 30 years.

The Americans weren't far behind the British with the design and development of the passenger jet plane. The Boeing Corporation led the way with the 707. It was first flown in 1957, although an earlier prototypical version flew in 1954. Regular service began with Pan American Airways in 1958. The Boeing 707 proved to be the first successful passenger jet plane. Over 1,000 were made for civilian use with nearly as many made for military purposes. The 707 is still in limited service well after 50 years of its launch.

There's no meaningful connection between industrial design and the Comet and Boeing 707. Both were essentially the product of engineering design. However, there's an unintended consequence between the Boeing 707 and industrial design that does create a kind of connection. This connection comes from Joe Schwartz, the retired senior vice president of design and research at Herman Miller, the American company known for its leading-edge design in office and contract furniture. He worked with many of the exceptional American designers of early American Modernism, including George Nelson, Charles and Ray Eames, and Alexander Girard. It was during that same period—the 1950s and 1960s—that Schwartz witnessed the rise in the popularity of Scandinavian Modern furniture in America. Art and design historians have provided various rationales for the presence of this phenomenon in America, but Schwartz has his own take on the story, which is different from the experts yet equally credible. Unlike the historians, he credits the Boeing 707 for the introduction of Scandinavian Modern in popular American taste. His reasoning is quite simple: The improved access to air travel permitted Americans to visit Europe more easily than in the past. Once in Europe, Americans discovered what they had never seen before: the clean and functional lines that characterized Danish, Swedish, and Finnish furniture, the so-called Scandinavian Modern design. Once back home, these same American travelers wanted Scandinavian furniture in their homes.

This story isn't unusual. It parallels other examples of one society discovering another society and then adopting some of its art and design. In 1853, U.S. Admiral Matthew Perry "opened" Japan, which had been a closed society. For the first time in two centuries, the world got a glimpse of Japanese society and its everyday things. It was no coincidence whatsoever that soon thereafter designers in Europe began to not only visit Japan but also to be influenced by Japanese design. That was certainly the case with some of the designs of Charles Rennie Macintosh and his use of black lacquer or Christopher Dresser and his visually simple designs. This connection also occurred in European woodblock printing, which was greatly influenced by Japanese woodblock printing of the same era.

Passenger jet planes continued to develop one incremental step at a time with stretch versions of existing planes as well as long distance versions. After the Boeing 707, the Boeing 747 was to be the next leap forward. For the first time, a passenger jet could carry over 400 passengers and would change commercial aviation greatly. Not only was it a wide-bodied jet but it also had two levels. This allowed it to carry twice the passengers of a Boeing 707. First flown in 1970, the 747 would be the passenger jet with the greatest capacity for the next 37 years. In a coach-class configuration only, for example, the latest version of the airplane can hold over 600 passengers.

From the first days of the passenger jets, their design and development were based on optimum passenger load at subsonic speed. The next development in passenger aviation technology would take an opposite direction. It reduced passenger capacity but vastly increased speed. That passenger jet plane was the Concorde. Developed in a partnership between Britain and France, the plane was designed to reduce the flying time between cities to at least half of what it was with regular passenger jet planes.

To achieve this level of performance, Concorde was smaller in size. It carried around 100 passengers in a two-plus-two seating arrangement. Headroom was somewhat limited. Concorde made up for this reduced passenger capacity with a speed of over 1,300 mph flown at an altitude of 60,000 feet. This was around 20,000 feet higher than most passenger jets. In all, 20 Concordes were built.

The high-technology aspects of the Concorde came with two serious liabilities. Breaking the sound barrier was one. It created issues for landing rights at certain airports. Citizens and government authorities didn't want the thunder crack that came with the breaking of the sound barrier near their cities. And then there was the cost of flying Concorde. It was very expensive. In commercial terms, it was what's called a loss leader; that is, it never really made a profit for the two airlines but became part of the brand identity for both British Airways and Air France. Passenger service ceased in 2003 for a variety of reasons including the only crash of Concorde in Paris in 2000.

What's next in the design of passenger jets? The focus is clearly on the environmental impact that passenger travel is having. People are traveling more now than ever. Consequently, the greater number of passenger jet planes is having environmental consequences. Boeing's new 787, called the Dreamliner, is showing the way with reduced weight, use of plastic composites, better passenger comfort, and greatly reduced fuel consumption. Where does industrial design fit into the picture? It's with the need for passenger comfort. Industrial designers are involved in the design of more spacious interiors, more comfortable seats, and a better user experience.

SUMMARY

The section on transportation has clearly shown that getting from one place to another has forever been a human activity. It began first as a need for survival. This is why our ancestors were at one time nomadic. Today, transportation exists for reasons of business, trade, commerce, and pleasure. It even exists for war. In every case, design has been an active part of the evolution of transportation.

NOTE: Readings for chapter 7 are found in the back of the book.

CHAPTER 8

DESIGN AND COMMUNICATION

DEFINING COMMUNICATION

Communication is a kind of buzzword in this early part of the 21st century. For example, we often hear that we are living in the communication age. And that graphic design has now become visual communication design. Therefore, what role does communication play in the history of industrial design? To understand its role, we need to go back to the roots of communication; that is, its place and meaning in society. We also need to understand communication from two different perspectives. The first deals with the theory of communication as visual signals; the second deals with communication technology.

Much like several keywords already mentioned, words such as design, context and culture, communication can be defined in several ways. For example, there are the many facets of human communication much like the many facets of communication technology. Fortunately, they're all interconnected despite the fact that this may not appear to be the case at first glance. It therefore makes sense to begin the chapter with human communication because all communication begins with people. Our latest smartphone may be an awesome example of high-tech design but it only exists because people need to communicate. It's nothing but a tool.

HUMAN COMMUNICATION

Human communication can be divided into several sub-sections, each one dealing with people and their needs. There is, for example, intrapersonal communication or communication with ourselves. Designing in your head is a form of intrapersonal communication. We do it all the time. As interesting as the topic is, intrapersonal communication won't be part of the material in the course.

More important for us is interpersonal communication, which is communication between and among people. Language is probably the most important form of interpersonal communication but certainly not the only form. For example, we identify one everyday thing from another because we read something into their color, shapes and forms that we identify with a cup, table, kayak or any number of everyday thing. This form of communication is commonly referred to as visual language.

Language has another important attribute. It clearly distinguishes us from animals. Apes and dolphins may be able to vocalize but they have yet to develop an alphabet, rules of grammar and syntax, and reference sources such as dictionaries. That being the case, no one is quite certain when human language began. It could be as far back as 100,000 years or even more. The difficulty in establishing a date is because

there's no hard evidence or clue available to scholars. Nevertheless, human language developed in different places over time. And the spoken language was the first of many human extensions that would impact the evolution of society.

Body language is yet another language, which is sometimes referred to as a paralanguage. It was one of the earliest forms of communication. From a smile to a scowl—that is, the way we show our teeth—people communicated their feelings without ever using words. And we do it much the same every day with our hand gestures and body movements. Just watch two people speaking in public and you can quickly detect whether the conversation is friendly or not, and do so without ever hearing a word. The clothes that we wear can also be considered a kind of paralanguage. Clothes communicate a great deal about who we are. For example, different generations dress differently. Clothes can also communicate a particular human activity—a wedding dress needs no explanation much like a neoprene wet suit used for SCUBA diving. And we make our loyalty known to others by donning our team's jerseys at a football game. What we wear always communicates something about our values and belief systems.

With the spoken language came the written language; that is, the transfer of vocalized sounds into permanent visual signs of one kind or another. The first evidence of such a written language dates back to around 3,000 BCE with the cuneiform inscriptions found in the Sumerian regions of the Middle East. Cuneiform inscriptions were wedge-shaped indentations or signs in clay tablets. Not long thereafter came the development of Egyptian hieroglyphs. These glyphs look like small pictographs. It wasn't unusual for such writing systems to have 800 or more different signs. The real breakthrough with written languages, however, came with the Phoenicians who introduced the basis for the modern day alphabet. Their writing system was based on the sound of a letter, which produced fewer visual signs.

It should be noted that written languages in many Southeast Asian countries such as Japan and China were also based on visual signs. Learning to write in either one of these languages requires that a person learn hundreds of different signs. As a matter of fact, the concept of the moveable type, which is attributed to Gutenberg,

Image 28: Cuneiform tablets are among the earliest examples of a written language.

was first developed in Korea and China. What made the invention successful in Europe and not in China was the fact that Gutenberg only needed around two dozen different signs or letters to compose a text; a Chinese printer, on the other hand, would have needed several hundred signs.

Today, the study of communication occurs in many disciplines and can cover everything from visual communication in design to telecommunication systems in engineering. In most cases, however, communication deals with some form of signal transmission. And as such, a modified version of the Shannon/Weaver communication model helps us understand what occurs in the communicative powers of artifacts.

THE SHANNON/WEAVER COMMUNICATION MODEL

The Shannon/Weaver Communication Model is based on four separate elements that operate in a sequential fashion: a message, an output, an input and a response. Successful communication occurs when the response matches the message. The typical red octagonal stop sign is a good example of communication and helps explain the Shannon/Weaver Communication Model. The intended message of the stop sign is that car drivers come to a stop at a designated place; the output is a large sign in the shape of an octagon, painted red, and with the word STOP positioned in the center; the input occurs when drivers see the stop sign; and the response is the act of stopping by the drivers. As desirable as this may be, it doesn't always occur as planned. There

are always possibilities for miscommunication. For example, the stop sign could be missing, which leads to no input and the possibly an undesirable response. Or the driver hasn't yet learned the meaning of the stop sign and doesn't stop. In the end, the stop sign is indicative of all everyday things: we read all kinds of messages by way of the visual language. Most of the time, we read the visual language correctly; there are those occasions, however, when we don't.

THE VISUAL LANGUAGE

When designers speak of communication, they almost always mean visual communication. Before we begin exploring visual communication, we should never forget that human senses other than sight play a role in communication. Humans communicate with sound such as music, for example. Imagine if you can that scene in the film Jaws when the three men are getting drunk in the cabin of the boat at the same time as the giant great white shark is approaching. The men don't know that to be the case but we in the audience do because of the thumping music in the background. Or think of how smell and scent communicate. Chanel, the makers of perfume, knows that to be true because they wouldn't be in the scent business otherwise. And then there's texture, which plays a direct role in how we perceive the quality of many everyday objects, especially those that we come into contact such as clothes. The human senses of hearing, smell and touch are important in our understanding of everyday things. However, it's our sense of sight that tends to dominate all other senses. It's at the heart of the visual language and therefore essential to industrial design and everyday things.

The visual language is much like a written language. It too communicates. But it's not the same as a written language. It's different. The written language uses well-defined signs such as letters and words with well-defined meanings. It also has equally well-defined rules of use such as grammar and syntax. The visual language is no way as explicit. Nevertheless, it communicates. For example, people will recognize an airplane when they see one yet the name "airplane" doesn't appear anywhere. Similarly, we recognize churches, scooters, knives and forks without ever seeing a label on each one. This is the power of the visual language.

What constitutes the visual language? And how is it that designers can communicate churches, scooters, knives and forks without ever using words? The visual language begins with design elements and design principles. These are the designers' visual alphabet and visual grammar, respectively. The design elements and design principles are described in more detail in *Designing: A Journey Through Time*, the textbook for DSC 101 Design Awareness.

A SHORT HISTORY OF COMMUNICATION TECHNOLOGY

Human communication has evolved greatly over time, from the era when people were merely vocalizing to the development of spoken, written and visual languages. The concept of communication is also imbedded in the world of technology. A comment by Bill Mitchell of MIT perhaps states it best. To paraphrase Mitchell, *"With landlines, you knew where the phone rang but not who would answer; with cell phones, you now know who answers but not where they are."* In a nutshell, Mitchell's statement focuses on two important variables of communication technology: people and place. His comment also illustrates how communication technology affects the very nature of people and place. More recently, at least relatively speaking, the developments in communication technology have been nothing less than astounding. A quick look at some of the important milestones going back 600 years or so makes the point.

1439 Movable Type

The design of movable type, as obvious as it may appear to be as a design solution in this day and age, was revolutionary in Middle Age Europe. In the period prior to Johannes Gutenberg's invention of the printing press, the only books available were hand scribed. Understandably, there were few books because each one took a great deal of time to produce, sometimes up to three years. As a result, these books were only available to the rich and powerful. By making books available to a larger portion of the population, Gutenberg's invention

ultimately altered this balance of wealth and power. More people became literate, and with literacy, civilization and societies changed.

1792 Long-Distance Semaphore Telegraph Line

Claude Chappe, a French inventor, established the first long-distance semaphore telegraph line. This invention continued a process that brought people closer together. Roads certainly did this as well but people had to physically move or travel to get closer. Telegraph lines changed that proposition; people could now stay in one place and send a message to someone in another place. The latter was a very different proposition compared to roads.

1822 Photoetching

The early developments of chemical photography would become an early version of photography. Nicéphore Niépce, the French inventor, produced the first permanent photoetching in 1822, and went on to create the first permanent photograph of a scene from nature in 1825. It should be noted that exposure times for these early photographs were exceptionally long.

1836 Daguerreotype

Working with fellow Frenchman Louis Daguerre, Niépce developed an imaging process known as daguerreotype in 1836. Over the next century, daguerreotypes would lead to what is photography. And as we know, photography today is child's play. Everyone does it. Yet we should never forget that photographs served two important functions: They recorded a moment in time and also froze or stopped time. This is why old photographs are so important in recording history because they provide a kind of social memory.

1835–1843 Telegraphy

Along with a few scientific colleagues, Samuel Morse, an American painter who turned inventor, developed single-line telegraphy as well as the Morse code. In part, the incentive for Morse to do this was personal. He was in Washington, D.C. when his wife died. By the time he learned of her death via a letter and returned

home to Boston, she had been buried. The Morse code didn't only decrease the distance between people but also increased the speed of communication delivery.

1876 Telephone

Morse code and telegraphy could send a kind of text signal. They couldn't, however, send vocal signals. This happened in 1876 when Alexander Graham Bell and Thomas A. Watson demonstrated the first telephone in Boston. Bell's personal story is an intriguing one principally because he was neither trained nor educated as an engineer or technologist. Bell's fascination with human speech and deafness was more because of personal interest and family history. His mother was deaf. Because of this Bell was forever experimenting with artificial ways of creating and transmitting vocal sounds and language. This personal interest culminated in the device that we now know as the telephone. With Bell's telephone communication technology took a giant leap forward because for the first time a vocal message could be transmitted over a long distance.

1877 Phonograph

Around the same time as Bell was inventing the telephone, Thomas Edison, the American scientist and inventor, patented the phonograph. If books via Gutenberg's printing press recorded text, Edison took the process of recording one step further by capturing sound or vocal messages. Moreover, and unlike similar inventions at the same time that only recorded a message, Edison's invention could reproduce the sound.

Like the telephone in its infancy, no one could have ever imagined the full impact of recorded sound and the phonograph. The phonograph became the first step in what would lead to different recording systems such as vinyl records, audiocassettes and compact disks as well as the music recording industry. Edison could have never imagined the impact nor the unintended consequence his invention was to eventually have.

1901 Wireless Transmission

Long-distance transmission such as the ones developed by Morse and Bell remained limited to the physical constraint posed by the wires that needed to be installed across the country. Guglielmo Marconi

changed that scenario totally when he transmitted the first wireless signal from England to Canada. This transmission of a wireless signal led ultimately to the development of the radio. Suddenly, wires were no longer necessary for the transmission of communication signals. In fact, the early radio was sometimes referred to as a wireless. As revolutionary as this development was in 1901, we at times take it for granted today. After all, most communication devices can function wirelessly; however, we need to remember that that wasn't always the case.

1925 Television

The transmission of text and voice, even wirelessly, became more and more common with time. Not so the transmission of images. The situation changed when, in 1925, John Logie Baird, the Scottish engineer and scientist, transmitted the first television signal. The leap in technological development was significant: not only could text, voice and images be transmitted but so could movement. This development was the beginning of artificial reality; in other words, a communication signal that had most of the components of reality, that is, images, motion and sound, yet was totally artificial.

1947 Mobile Phone

Given the ubiquity of cell phones and smartphones today, it may be a bit difficult to believe that the technological underpinning of cell phones was developed well over 60 years ago. After all, most people who use smartphones today weren't even born when the cell phone was invented. This invention occurred in 1947 when Douglas H. Ring and W. Rae Young of Bell Labs proposed a cell-based approach to signal transmission, which eventually led to cellular or mobile phones. The concept of the cell phone—a truly personal, long-distance communication device for text, voice and images—wouldn't only revolutionize communication technology but would also alter the concept of person-to-person communication. Moreover, the use of cell and smartphones has had an immeasurable impact on world events of late. The Arab Spring, which began in late 2010, was mostly fueled by the use of social networking via mobile phone technology. Today, most news agencies such as CNN and the BBC make use of people on site with smartphones to report world events as they happen. These news agencies no longer need official reporters in all four corners of the planet.

1989 World Wide Web

The most significant development in communication technology in the modern era occurred when two computer scientists, Tim Berners-Lee from Britain and Robert Cailliau from Belgium, built the prototype for what became the World Wide Web. Along with its access to the Internet, the World Wide Web or www became a force of interconnectivity of people and information. In what is a relatively short period of time, people, place and data became accessible as if all three were in the same place. The world suddenly shrunk. Marshall Macluhan's concept of The Global Village, which he had predicted decades before, was now a reality.

THE PLACE OF INDUSTRIAL DESIGN IN COMMUNICATION TECHNOLOGY

In 1946, the creator of Dick Tracy, a popular comic strip, gave his detective a wrist radio/telephone. No one in his right mind would have ever thought that such a technological feat of fictitious design would ever become a reality. But it did. By 1996, 50 years after the Dick Tracy radio/telephone, millions of people were using cell phones every day all over the world and communicating much like Dick Tracy did in the comics of 1946.

The place of industrial design in communication technology is best understood by going back in history. Once human language developed, people often shared communication at the village well, especially when the communication came from other places. This was so because the village well was the communal center of village life. After all, it was the center for physical sustenance because that's where people went to get their water. But it was also the center for interpersonal communication, a place where people shared their views and ideas. In fact, the presence and importance of the village well in Roman times gave us the word trivia—tri for three and via for road. It was at the village well that three or more different roads intersected and where people using these

roads shared their stories. Over the next centuries and because of advances in communication technology, the local village with the village well would become the global village, connected as it now is by voice, text and images on a 24/7 basis.

Communication technology was much more than one invention or another developed in a laboratory using bits of wire. It reshaped how people interacted, and did so in several important ways. Some of these were discussed previously. However, a few important ones need to be highlighted.

Communication technology compressed distances. As a result, human communication went from being local to regional and eventually global. When communication was local, there was no external influence to speak of; with connections to a broader community via telegraph lines, wireless radio transmission and the Internet, nothing was local anymore, including industrial design.

Communication technology didn't only compress distances, it also compressed time. Generally speaking, things now happened more quickly. Think for a moment about the story of Samuel Morse. He learned about his wife's death well after it had occurred. Today, we learn of such events almost instantaneously. Our personal expectations have also changed with the compression of time. We now expect immediate results, which is human desire often referred to as immediate gratification. And our attention span has diminished. Watch an old movie and measure how long, in seconds, the camera's position remains on the same scene. Then watch a recent film. You will see that the camera's position changes every few seconds. It seems that our minds need to be stimulated constantly. Even Monopoly, the board game introduced by Parker Brothers in 1933, has undergone recent changes in order to speed it up.

CHALLENGES FOR INDUSTRIAL DESIGN

It's accurate to say that industrial design, as a profession, was absent during the early periods of technological evolution in communication. Industrial design didn't really exist, for example, at the time of Bell, Edison or Marconi, or not at least in the way that it exists today. Industrial design's presence only became apparent once the inventions in technology became commercially viable as an everyday thing in the marketplace. Such was the case with the examples that follow.

The Telephone

Most often, industrial design begins to play an active role in the design of everyday things once the original invention becomes a commodity in the marketplace. That is, the invention is no longer a novelty but has become a useful object in everyday life. This was certainly the case with the telephone. Early telephones tended to have the so-called engineered look; that is, technological bits and pieces cobbled together in the most appropriate way for the device to the work technically. Questions about industrial design, manufacturing, ergonomics and distribution had yet to be asked.

The first telephone in the marketplace to benefit from the application of industrial design was the one designed by Henry Dreyfus in 1930 for Bell Laboratories. Dreyfuss faced a challenge not uncommon with a radically new invention: there was no predecessor. In other words, Dreyfuss couldn't rely on a precedent or past model for the form of a telephone. He therefore needed to examine how a person actually used the telephone in order to design its shape. As history would show, his design became the iconic form for the telephone. Not only would the basic, overall design be mimicked by many other manufacturers but its form would also become the basis for pictographs for telephones as we see on public signs at airports and even on an iPhone. As late as the 1960s, telephones in many countries had borrowed from Dreyfuss' overall telephone design. The combination of two separate pieces—a handset and a base with its dial function—followed in the design footsteps originally established by Dreyfuss.

Once again it would be Dreyfuss who would change the look of telephones with the Princess model launched in 1959. It clearly departed from the bulky, severe look of previous phones, principally because electrical components had become smaller and color had become more important as a sales generator. Perhaps unnoticed was the human factors research that had gone into the design of the telephone itself.

This transformation—from an engineered solution to the design of a true everyday thing—became even more apparent in the next phase: the Trimline phone launched in 1965. Because of even smaller electrical components, the dial pad could now be incorporated into the handset. The overall size of the phone was also greatly reduced. More important yet, the form of the handset lost its distinctive barbell look; it now had the form that we most closely associate with handsets. This generic form became even more common as the telephone became wireless and eventually mobile.

Wireless Connections

Wires—those to the wall and those connecting the handset to the base—continued to be a defining element of telephones well into the 1970s. The first breakthrough from this constraint came with cordless connections; that is, the possibility of liberating the handset from the base. However, this development didn't alter the overall design of the telephone; it would, however, set the stage for totally wireless mobile or cell phones.

Complete wireless transmission came with mobile or cell phone technology developed in 1947. The first working model of a cell phone came on the market in 1973. It was both large—it was nicknamed the brick—and expensive, about $4,000. Over the next 10 years, mobile telephone networks were established in various countries, beginning with Japan in 1979 and followed with systems in Denmark, Finland, Norway and Sweden in 1981. At about the same time, mobile telephone systems were put in place in the United Kingdom, Mexico and Canada. Surprisingly, the first system in the United States wasn't launched until 1983 despite the fact that cell phone technology had been invented in America 10 years before.

Consumer demand was strong regardless of constraints such as the large size, weight, short battery life and long recharge time. Of course, all of these constraints would become challenges for designers over the next decades. As expected, each generation of cell phone became lighter, smaller and faster. That said, design innovation was a double-edged sword; that is, you needed to innovate to be in the game but a momentary lapse could prove to be disastrous. This was the case for Motorola, which was the company that launched the aforementioned brick. It was the first

company in the marketplace with a cell phone. No one had yet heard of Samsung or Nokia or Apple. Now, few people own Motorola smartphones. The story would repeat itself with Blackberry a few decades later.

Cell phones take on a new persona when they transformed into smartphones. However, there's a need to explore other design developments before we look at smartphones.

The Radio

Like the telephone, the radio was initially conceived as an invention and perceived as a novel idea. And like the telephone, it too had to find its own visual image. The first ones were large in size and tended to look like modified pieces of furniture. Adopting that design direction made sense for something as new as the radio. A new technology often needs to look like something that people already know and are familiar with in order to be accepted by the general population. A novel technology that's offered in an equally novel shape or form may be disconcerting to a user. The early electrical technology in radios was also physically large. Transistors and microchips had yet to be invented. A large piece of furniture was therefore a logical choice for housing this new technology.

With time, however, the technology became more refined and smaller. Moreover, the radio became more common in everyday life. A case in point is the design of radios in the Art Deco period in the United States. Not only was the radio now physically smaller in size, but it also borrowed heavily from the visual language of Art Deco. It became a reflection of both the technology as well as the design style of the day. A similar transfer of technology and style occurred with the radios and turntables designed by Dieter Rams for Braun in the 1960s. In this case, Rams applied the rules of Modernism in a most adroit way.

Over time, the radio became a common everyday thing and found its place in most homes. It was with the radio that people received their news or heard an announcement from the President or were entertained by early radio shows. The situation changed totally with television. Now the news became visual, as did the President's address to the nation and the game shows. The radio was relegated to the car, and music became something you heard in elevators and grocery stores.

At least that was the case for many people but not for audiophiles. For these people, music via the radio remained relevant. One group in society that fell into this latter category was the young, urban youth of the inner cities. Two concurrent developments—one technological and the other societal—came together to create a unique phenomenon. The technological development had two distinct parts: the invention of the transistor and the innovation of the cassette recording tape. The invention of the transistor made it possible to reduce drastically the size of electrical components; the innovation of the audiocassette made it possible to carry and listen to your personal music, not someone else's, which was the case with the radio. The societal development was the mobility afforded by the aforementioned technological developments. People could now carry and play their music wherever they went. They were no longer at the mercy of radio waves to hear their music. And so was invented the boombox.

Despite the fact that transistor technology had reduced the size of the radio, the boombox remained large in size. The principal reason for the large size was the speakers. The larger the speakers, the better the sound. But large speakers created another issue. Anyone near a boombox heard someone else's music. This combination—large speakers and audible sound—created the spawning ground for a breakthrough design. That breakthrough was the Sony Walkman. What was the Sony Walkman? It was a portable cassette player—the fusion of the audiocassette, transistor technology and small earphones as a replacement to large speakers and audible sound. The Walkman allowed a person to create his or her own personal audio sphere. The music was now yours to listen to; you no longer shared it with the world. The Sony Walkman went on the market first in Japan in 1979, and one year later in the United States.

The portable cassette player would remain the device of choice until Apple launched its first iPod in late 2001. The iPod took size reduction to a whole different level, with both internal and external components. Digital technology is what made the reduction in size possible; that is, the recording medium went from analog or audiocassette tapes to digital or computer memory chips. The latter weren't only significantly smaller in size than audiocassettes but could also hold a great deal more music. As innovative as the iPod system of portable playback devices

may appear to be, it should never be considered as a radically new invention. Like so many other everyday things, it was yet another example of how advances in technology can impact design incrementally. In the case of the iPod, the technological advances were in the physical reduction of size and the increased capacity of recorded music. The concept for the iPod, however, isn't that much different to the Sony Walkman; that is, both were physically small devices that played your own music selection.

Radios as self-standing objects are somewhat rare today. There are exceptions, of course. Brionvega, the Italian company of consumer electronics, did produce

Courtesy of Jacques Giard

Image 29: Early radios were large, bulky, and often existed as pieces of furniture. With technological developments, they became smaller such as this radio designed by Richard Sapper and Marco Zanusso for the Italian company Brionvega.

a small radio designed by Marco Zanuso and Richard Sapper in 1963. It became a kind of design icon in the age of Modernism. More recently, the American company Bose has become one of the leaders in the design and production of up-market radios. Leading edge technology—combined with astute industrial design—has played an important role with this company. Radios continue to be found in automobiles, although people often connect their iPhone or MP3 players in order to play their own music. In the end, the audio message—whether a voice or music—still exists but the radio has faded as a stand-alone, everyday thing.

The Phonograph

The recording and playing of vocal messages occurred in ways other than by radio waves. There was Edison's gramophone, for example. His idea became the source

of continued design iterations for recording vocal messages as well as their reproduction. Its design style, however, wasn't dissimilar to Bell's early telephone; that is, these devices had an engineered look with little sense of what industrial design could contribute. For example, there was no obvious application of a known design style such as Arts and Crafts or even the consideration for ergonomics or anthropometrics. If anything, these devices followed the sense of pragmatism that reigned in America: It works doesn't it? What more do you need? If there was a design direction, it most often borrowed from other popular domains. It was therefore not unusual to see record players disguised as period furniture.

Over the next decades, the technology for recording devices changed, especially the medium used for recording. Wax cylinders gave way to flat disks such as vinyl records. The earliest of these were developed in the early 1900s and were played at various speeds, from 60 to 130 rpm. By 1925, however, 78 rpm became more or less the standard speed. As for size, these varied as well, beginning with discs of around five inches in the 1890s. A few years later, the disk size had grown to around seven inches. These were replaced by 10-inch disks, which became increasingly popular by 1910. The 12-inch disk existed but was used almost exclusively for classical music. It's interesting to note that the 12-inch disk, which eventually became the recording standard, could hold from three to four minutes of music on each side. By extension, this length of recording became the broadcasting standard when music was played on the radio. In other words, musician had to perform their songs to fit a three- to four-minute time slot. And this standard, although unofficial, still exists today.

Where does industrial design fit into this picture? The physical dimension of the 12-inch disk was a central factor or criteria for industrial designers when tasked with designing a record player. After all, a 12-inch disk wasn't a small component. More than that, the user had to be able to handle it, placing it on the turntable and taking it off. Consequently, the turntable took on a certain physical presence and became an identifying visual feature of stereo equipment in the 1960s and 1970s as we find with record players from Clairtone, Brionvega, Bang & Olufsen and Braun.

The Clairtone record player, much like the ones from Bang & Olufsen and Braun, left the traditional furniture cabinet aside, at least the cabinet used as a disguise for the technological character of the record player. There was honesty in its design; in other words, the record player was a new technology and its design was perceived as an appropriate visual reflection for this new technology. This design direction was Modernism, a case of form follows function. That said, there were elements of traditional cabinet making that remained such as the wood compartments for the electrical components and the storage of the 12-inch disks. But the speakers didn't hide the fact that they were speakers.

Brionvega, the Italian company, took a design approach that was not unlike Clairtone. Its record player was also a relatively large artifact with visible components, each with a separate function. Like Clairtone, Brionvega didn't borrow from previous furniture styles but created its own unique look.

From a design point of view, the Danish company Bang & Olufsen followed in a vein similar to Clairtone; that is, their first record players incorporated wood, which is a traditional material. Nevertheless, there was never any doubt what the device was. It didn't hide its function or its identity. Its smaller size, compared to Clairtone, was the result of the first forays into micro-circuitry, resulting in smaller electrical components.

Braun's version of the turntable couldn't be mistaken for anything other than the state-of-the art technology presented as the epitome of German Modernism. There was no traditional cabinet and no connection to an old design stereotype. It was form follows function in the way that only Braun could do it. Every design element and feature was considered logically. There was no arbitrariness whatsoever in its design.

The Televisvion

As significant as television has been in our lives, it never became an object of fascination for designers with perhaps a few exceptions. Television's evolution in terms of industrial design followed in the same general footsteps as the radio. That is, the first televisions were encased in pieces of period furniture such as wooden cabinets. Like the radio, this design direction allowed new technology to be integrated into a known home environment of traditional style.

The few exceptions were Modernist designs such as those from Brionvega and Braun. These examples were to show how new technology could find a place in our built environment without a need for one historical costume or another. Television models from both companies were devoid of decorative elements; there was no harkening back to the past with wood and sculpted moldings.

Television, however, had a secondary impact. The television was a novel idea; an important part of the novelty was the shape of the television screen itself. It wasn't only new but also very different. It's what gave the television its visual identity. The first television sets used the early cathode-ray tube, which had a unique shape—a rectangle with generously rounded edges. Because this shape was the dominant visual feature of the television set and because the television set had a prominent place in the home, the shape became an important and new visual element for many everyday things. The distinctive shape of the television screen began to appear in many products such as serving trays and side tables. Even the infamous TV dinner had a tray shaped somewhat like the television screen itself. This pattern of using shapes and forms from one product context and applying them to another yet very different context was nothing new. It occurred earlier with streamlining and would occur once again with computers in the 1990s.

Overall, Modernism and its particular design direction didn't to have any significant impact on the form or function of televisions. This is especially the case with flat-screen televisions, which are more recognizable by their screen size rather than any specific design style.

The Smartphone

As mentioned previously, human communication occurs using all of the senses, not just sight. We saw that with the recording of sound and moving images of early television. However, most early communication technologies dealt with one human sense or other; there was little combination or integration of technologies. Voice technology in the telephone, image capture in the camera, and text transmission in the telegraph were all considered as different and separate medium. Except for television, a combination of the three

technologies into one package was never an option. The smartphone would alter the situation. It would fuse these three technologies and more in a remarkably very small package. As ubiquitous as smartphones have now become, this wasn't always the case. It took more than one hundred years to go from what appears to be very basic communication technology to the integration of voice, text and images into one device, to do it all wirelessly, and to make it available in a very small package.

Generally speaking, smartphones had their beginning with the basic cell phone. The latter provided wireless voice communication. As technology in other areas such as the Internet and digital imaging become more advanced, sophisticated and smaller, these would become incorporated into a single device. That said, the old form-follows-function principle of Modernism was put to the test. What visual form do you give to a device with so many different functions? Not surprisingly, the end product became very generic. It had few distinguishing physical features to identify the many functions in the old form-follows-function model of design. Moreover, one brand looked very much like another. This dilemma posed a challenge to mainstream industrial design: form could no longer be an indicator of technical or technological function as these had become all but invisible. The challenge forced the design community to define function differently, which eventually led to what's now known as interaction design.

With interaction design, it now appeared that industrial design as a profession was moving from a focus on hardware design to one more directed at software design. As a result and in the case of Apple, for instance, a great deal of attention began to be paid to the intangible features of the iPhone, which had come to have all the trappings of an intimate object. As a user, you not only identified with the brand but, more specifically, with the content of your phone. After all, these were your personal choice of apps and your personal selection of music and images. This was you! In the end, smartphones looked more similar than different as material objects; their design differences had more to do with the intangible features, that is, those things that were invisible rather than visible.

With twenty/twenty hindsight, we can now see that today's smartphone is a fusion of many of the same

but different communication technologies of the past. It's a telegraph, a telephone, a television and a recorder of voice and images. Dick Tracy would have been very proud of us, clearly.

DESIGN AND THE FUSION OF FUNCTION

Designers can learn several lessons from communication technology and its evolution over the past three centuries. Two stand out and need to be noted.

Peter Trussler was vice president of design with a leading telephony company some years ago. He once quipped, *"Technology changes but values endure."* This is how he saw the challenge for industrial designers in a time of constant technological change. Innovation in technology is expected but the newest doesn't necessarily mean the best in the market place. Generally speaking, human values don't change as quickly as technology does. Yet, it's people who buy—or not—the latest technological devices. In part, this explains why the first radios and televisions looked like period furniture. Using a known form for a new technology made its acceptance into mainstream society more palatable.

It was like giving a sweet flavor to foul tasting medicine. People felt comfortable with something that they recognized and already knew. There's a lesson here for industrial designers, especially those dealing with new and innovative technologies.

The second lesson for industrial designers is the one of unintended consequences. Henry Ford had no idea—or intention, for that matter—to create the concept of the suburb when he developed his Model T. Yet, that's exactly what happened. In that vein, neither did designers of cell phones and smartphones ever imagine that the uprisings in the Middle East in 2010, which came to be known as the Arab spring, would be fueled by smartphones. But it was. This small, portable device allowed for instant communication not only among members of the different factions within the country but to the outside world as well. This kind of communication wouldn't have been possible a decade earlier. Unintended consequences are just that: unintended. Designers could easily shrug them off, but they shouldn't. We must always recognize the possibility of such occurrences despite the fact that they're generally beyond our immediate control.

NOTE: There are no readings or viewings for chapter 8.

CHAPTER 9

DESIGN AND EDUCATION

INTRODUCTION

Designing occurs in one of three ways. It either occurs intuitively, intellectually or as a combination of both. For example, the Shakers designed their built environments—from clothing and tableware to furniture and buildings—without ever attending design school. Their approach was in part based on intuition and on past experience that was passed down from one person to the next. This design approach is totally different from scientists and engineers at NASA who design satellites and space shuttles and do so intellectually by way of knowledge. The chapter that follows will deal with industrial design education and how it has evolved from the time of the Industrial Revolution to today, in Europe as well as the United States. The chapter begins in England around 1850.

THE DISPLACEMENT OF THE ARTISAN

The Industrial Revolution brought two opposing forces together in the worlds of designing and making. On the one hand, there were the traditional ways of designing and making artifacts as existed with the craftsmanship of the artisan. In the high Renaissance, for instance, artisans were highly skilled. On the other hand, there was the encroachment of machines, especially into the making process. Clearly, a conflict existed between

these different approaches. Both were to have an impact on design education.

Artifacts designed and made by artisans were a reflection of the high level of craftsmanship and skills possessed by these same people. Such skills took a great deal of time to learn. Moreover, and because handmade artifacts didn't lend themselves to mass production, these artifacts were costly. As a result, they were meant for the elite in society, that is, for royalty, the nobility and the wealthy upper class.

Going back as far as Egypt, the training to become an artisan occurred by way of the apprenticeship model. In this era, it wasn't unusual to consider disciplines such as art, architecture and engineering as a form of craft. Later, craftsmen in the Middle Ages organized themselves and became members of guilds. There were different guilds with different specializations. And membership into a guild occurred by way of the apprenticeship model. Young boys usually entered at the age of 10–13 and worked with a master craftsman for five to seven years until a journeyman certificate was awarded. Even today, some American states allow a person to become a licensed architect by way of the apprenticeship model with no requirement to graduate from an accredited school of architecture. An important change in this scenario of the artisan and the apprenticeship model occurred in the High Renaissance. Art became part of human intellect. It was no longer considered merely a hand or manual skill. With this change came recognition

that art had something to contribute to everyday things other than an external visual image. Art also had an internal content, something that was more cerebral.

EARLY DESIGN SCHOOLS

Early design—at least design as we know it today such as industrial design—was a form of applied art. In other words, design had a high decorative quality about it. For example, it wasn't unusual for machinery in factories to be embellished with scrolls and other decorative elements. Much the same occurred with ceramic pottery and porcelain dishes. Artisans were therefore needed to decorate these same everyday things. Their training in applied decoration created a design education underpinned by a strong art foundation. Such was the case with the School of Design, which opened in London in 1769. Its curriculum was based on art; the instruction was offered principally by painters and sculptors. This art-based model would continue for decades. The word design had a different meaning then.

Schools of design didn't develop in a cultural vacuum, however. There were other developments that influenced early design education. This was the case in England with the Society for the Encouragement of Arts, Manufactures, and Commerce, now the Royal Society of Arts, which was established in 1754. It provided a kind of rationale for the presence of design in industry and therefore a reason for a design school. There were also early design competitions as early as 1758 such as the one in industrial art based on the premise of "*. . . any other Mechanic Trade that requires Taste. . . .*"

In France, where the Industrial Revolution did not have the same strong footing that it had in England, the picture was somewhat different. There, the education and training of architects occurred via the Beaux-Arts school. The Beaux-Arts style was modeled on classical "antiquities," preserving the idealized forms of the past and passing the style on to future generations. The Beaux-Arts school was older than its English counterpart, going back to 1648 when the Académie des Beaux-Arts was founded by Cardinal Mazarin. It was known for demanding classwork and setting the highest standards for education. Consequently, it attracted students from around the

Image 30: The exuberant Beaux-Arts style is evident in this statue in front of the Garnier Opera in Paris.

world including many Americans, who would go on to spread the Beaux-Arts style in the United States. If nothing else, the Beaux-Arts style placed the skills of the artisan at the forefront of the design process. The Pont Alexandre III in Paris exemplifies this particular style extremely well.

A CONFRONTATION: HAND-MADE VERSUS MACHINE-MADE

By 1835, it appeared that the tables had turned. In Britain, certain individuals in both commerce and government were expressing concern for the quality and state of design in the country. The government intervened by way of the Select Committee on Arts and Manufactures. It was generally agreed that French manufacturers were far superior to their British counterparts when it came to design. It's important to note that the French had intellectual property protection for design but that Britain didn't. In part, intellectual property protection was perceived as one reason for the superiority of French design because British manufacturers had no incentive to pay designers because their work couldn't be protected. Consequently, British manufacturers often copied designs that they saw.

This British perception of superior design quality in other countries was partially responsible for one of the more significant next steps in design education, not only in Britain but outside of Britain as well. This step was the Government School of Design, which was established

in 1837. The School had three categories or disciplines: artists, manufacturers and amateurs. Furthermore, the design direction was essentially ornamental.

The training of artists for British industry faced another challenge, one of identity. To be an artist was to be in a noble profession; to be an applied artist was perceived to be less so by the artist community. Design education, for its part, seemed to cater to the full spectrum. At one extreme were some of the Scottish schools. They trained applied artists and favored more pragmatic courses and fewer courses in the fine arts. The French schools were at the other extreme. Students were taught life drawing in their first year before doing anything ornamental. As for some of the German schools, they seemed to be somewhere in the middle, which is where the authorities in Great Britain wanted to be.

Over time, the Government School of Design expanded and evolved to include all major disciplines in art and design. It became the National Art Training School in 1853 and received its royal charter in 1896, becoming the Royal College of Art, which still exists today. The Royal College of Art has become one of the world's leading schools of art and design offering graduate degrees at both the master's and doctoral levels in design areas such as architecture, automotive design, and industrial design. It doesn't offer undergraduate education. As a side note James Dyson, who designed the vacuum cleaner that bears his name, is a graduate of the Royal College or the RCA as it's commonly known.

BEAUX-ARTS EDUCATION

There was one and only one significant educational model for European architecture and design in the 19th century: the Beaux-Arts school. Some of the same tenets that applied to architecture applied equally to the design of everyday things because these also tended to be embellished with motifs and decoration from the past. The Beaux-Arts style was based on neoclassical elements; that is, a revival of known architectural styles and their associated design elements. In architecture, for example, these classical elements included a symmetrical plan, an imposing facade, figurines, and columns applied in such a way that there was a sense of controlled exuberance. A Beaux-Arts education also

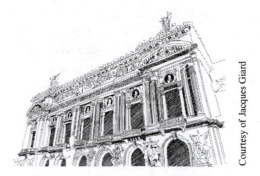

Courtesy of Jacques Giard

Image 31: The Garnier Opera in Paris is one of the finest examples of Beaux-arts architecture.

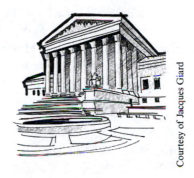

Courtesy of Jacques Giard

Image 32: The architectural design of the U.S. Supreme Court building shows a direct connection to classical Greek architecture.

placed an emphasis of the classical design traditions from Imperial Rome, the Italian Renaissance, as well as French and Italian Baroque. The Garnier Opera House in Paris is an excellent example of this style. American architects also trained under the Beaux-Arts curriculum. They tended to favor Greek models as we see with the U.S. Supreme Court Building built in 1935. Externally, the building had all the visual trappings of a traditional Greek temple.

The training—education may not be quite the appropriate term—was focused on quick conceptual sketches, highly finished perspective presentation drawings, and close attention to details. This teaching approach continues in many contemporary schools of architecture and design today even if these approaches don't adhere exactly to the Beaux-Arts tradition. Even terms like charette, which is still in use, come from the

Beaux-Arts era. A charette was a small cart. In the days of Beaux-Arts education, the charette or small cart was used to collect the students' projects and take them to the exhibition. Today, the word refers to a gathering of stakeholders on a design project.

NATIONAL ACADEMY OF DESIGN

In the 19th century, the United States wasn't facing the same art-and-design challenges in design education as those faced by England, France or Germany. Nevertheless, there was a growing friction among members in the fine arts community such as those who belonged to the American Academy of Fine Arts. The latter group was founded in 1802 and was composed of progressive artists of the era. However, certain members began to show displeasure with the lack of appreciation for the study of art in design.

In 1825, a group of these disenchanted members separated from the American Academy and formed their own association, which would eventually become known as the National Academy of Design. The National Academy of Design is situated in New York City and is a professional honorary organization. It has a school that offers studio instruction as well as workshops and lectures. There's also a museum with a collection of over 7,000 pieces of American art from the 19th to the 21st century. Although an academy of design, its areas of interest are principally art and architecture. That said, the academy planted one of the first seeds of design in America.

FROM BEAUX-ARTS TO BAUHAUS

The design ethos exemplified by the applied-art model in England and the Beaux-Arts approach in France remained in force into the early part of the 20th century despite the fact that industrialization was now impacting society at every level. Nevertheless, the potential for a new type of architecture as well as a new direction for mass-produced everyday things could neither be ignored nor denied. The situation in design education was much the same. But changes were in the wind.

The foundation that underpinned the education and pedagogy of Beaux-Arts architecture and design was the adherence to the goodness of style imbedded in classical forms, especially the many connections to sculpture and the arts. This was clearly the age of more is more, not of less is more. The flamboyance of Beaux-Arts architecture would, however, become one of the catalysts for design revolutionaries like Adolf Loos, the Austrian architect of the early 20th century. In a world that was becoming more informed by scientific discoveries and more industrialized—including the visible presence of the machine—the visual exuberance of Beaux-Art architecture and design was out of place for people like Loos. For Loos, this visual exuberance was a near criminal act, so to speak. As voiced in his now famous 1910 treatise, *Ornament and Crime*, Loos was quite blunt when he wrote that, "*Ornament is wasted manpower and therefore wasted health. It has always been like this. But today it also means wasted material, and both mean a waste of capital.*" Loos' diatribe was predicated by a personal moral objection to ornamentation because of the explicit waste, which in part laid the foundation for both the premise and promise of industrialization.

Industrialization was also creating a dramatic upheaval in European society, which wasn't only evident in areas such as the mass production of goods but also changes at the level of the individual such as the greater ability to travel and the greater access to and acquisition of everyday things. Loos wasn't alone with the belief that industrialization had to be considered on its own terms and not those of the past. There were others like him such as the founders of the Deutscher Werkbund, the German association of architects, designers, politicians and manufacturers, who placed their finger on the schism that was developing between the manufacturers of everyday things, on the one hand, and the designers of everyday things, on the other. Prior to industrialization, makers—there were no manufacturers as such—and designers were more often than not the same person. Because of industrialization and the advent of machines, the designer was being displaced from the designing/making process. All that appeared to matter was making without designing. This was the schism identified by the Werkbund. For its members, the consequence of such a schism was a

loss of quality in everyday things. Knowing full well that industrialization wasn't about to go away, the Werkbund took a proactive approach for the bridging of this schism by campaigning for the inclusion of designers in the manufacturing process.

In this changing societal context, architects and designers who continued to employ the ethos of the Beaux-Arts school were doing all that they could to fit a round peg of classical architecture into the square hole of industrialization. And it wouldn't fit! How could the ornamentation of Beaux-Arts coexist with the changes imposed by industrialization? Ornamentation was nothing more than icing on a cake. The Gare St. Lazare in Paris, although not strictly Beaux-Arts in style, typified this dilemma: its traditional architectural exterior was the ornamental icing to the metal railway "shed," which was the cake. The latter structure was a clear reflection of industrialization—a steel structure meant for the latest in technology: the steam locomotive.

There were other architects and designers who acknowledged the round-peg-in-a-square-hole dilemma. Chief among these were the ones who would eventually form the leadership of the Bauhaus: Walter Gropius, Ludwig Mies van der Rohe, Marcel Breuer, Johannes Itten and Josef Albers. With their interventions, the curriculum for the teaching of art, architecture and design would never be the same. It would be overhauled and rewritten. In the face of industrialization, tinkering with or modification to the existing Beaux-Arts curriculum wouldn't suffice. What was the reason for such a drastic action on their part? Principally, it was because industrialization was creating an equally drastic change in society. Consequently, the Beaux-Arts formulation for architecture and design—both practice and education—was out of context. It was becoming obvious: the round peg indeed did no longer fit the square hole.

THE BAUHAUS

In principle, the Bauhaus model of design education was the recognition that industrialization was a reality and that design education had to acknowledge the shift, going from an approach that was based on applied arts—that is, an application of art in a decorative way—to one that was integrated in the function of the artifact. The latter premise became part of the design phenomenon that would become known as rational design, a precursor to Modernism.

The Bauhaus became the leading and most influential school of architecture and design of the first half of the 20th century. As such and compared to other art and design movement in the modern era, it had the greatest impact on design education and design practice. Its framework of activities and interventions was broad. Consequently, the Bauhaus dealt with a range of subject matter, from architecture, furniture, and everyday objects to graphics and textiles. Walter Gropius described the vision of the Bauhaus this way: *"The Bauhaus strives to bring together all creative effort into one whole, to reunify all the disciplines of practical art—sculpture, painting, handicrafts, and the crafts—as inseparable components of a new architecture. The ultimate, if distant, aim of the Bauhaus is the unified work of art—the great structure—in which there's no distinction between monumental and decorative art."*

What made the Bauhaus pedagogically unique was the subject matter of design and its approach to teaching it. For example, there was less distinction made between the teachers—or masters—and the students. A learning environment was created purposely to encourage interaction between the two groups. It's worthwhile to note that the studio environment of today's schools of architecture and design is partially a result of this Bauhaus experiment.

Furthermore, Gropius insisted that students explore the nature and the potential of various materials by learning the crafts associated with each one of them. He felt that it was only after students had a true understanding of a material that they could contemplate the design for machine production.

Lastly, the incorporation of theory into the program's curriculum was novel and, at the same time, actively encouraged. At the Bauhaus, design was perceived as being more than the application of a known style in a kind of monkey-see, monkey-do fashion. The theme proposed by the Bauhaus was an intellectual one in which designers were expected to explore and articulate their ideas, not simply to mimic existing styles in an unthinking fashion.

The Bauhaus was situated in three different cities over its relatively short history. Its first location was Weimar, in 1919. However, the radical zeal exhibited by the leaders and students of the school proved to be

too much for the city fathers of Weimar. Walter Gropius, the founder and first director of the Bauhaus, was pressured to move. This he did and the Bauhaus was resettled in Dessau in 1925. New facilities—designed by Gropius—were built. Later, Gropius stepped down as director. Hannes Meyer succeeded him, only to be replaced by Ludwig Mies van der Rohe. Once again, political pressures were brought to bear and, in 1933, the Bauhaus was forced to relocate to Berlin. This political pressure came from the National Socialist Party, the right-wing government of the day. Its ideas about the nature of national architecture and design didn't conform to what was happening at the Bauhaus. By then the spirit of the Bauhaus had been broken and, six months after the move, the school closed. Certain members of the Bauhaus left Germany before World War II and established themselves in the United States. Some of these people went on to establish the New Bauhaus in Chicago in 1937, now known as the Institute of Design at the Illinois Institute of Technology. Its leader was Laszlo Moholy-Nagy, a former master at the Bauhaus. Initially, the program of study offered was similar to the original Bauhaus program. Today, it's a graduate school with a strong focus on research and design as a strategic tool of business. Other Bauhaus leaders who went to America included Gropius, who found a home at Harvard University and Albers who went first to Black Mountain College and then to Yale University.

Various explanations abound as to why the Bauhaus was so momentous. Some historians have claimed that it was the powerful influence exerted by the Bauhaus leaders—especially Gropius and Mies van der Rohe. Other design historians are of the opinion that it was the reputation of the teaching masters—especially the painters—that contributed to the importance of the Bauhaus. Still other experts believed that the strength of the school lay with its innovative pedagogy: students and masters were learners and teachers together. Individually, the importance of these particular qualities should not be discounted: they all played a role in creating a distinct identity for the Bauhaus. But perhaps it was the synergy that resulted from these qualities that created the "idea" behind the institution that's so remembered. This was probably best stated in the Manifesto of 1919, where there was a call for, ". . . *the unity of all creative arts under the primacy of architecture and*

for a reconsideration of all artists." This unity became the goal of the revised Manifesto of 1923, under the thesis, *Art and Technology—a New Unity*. This action was a deliberate attempt on the part of the Bauhaus to reconcile the split that had occurred earlier between the artisans and industry.

DESIGN EDUCATION POST 1945

The important strides in industrial design education occurred mostly in Europe after 1945, the period immediately after World War II. In part, this was because a great deal of the development in industrial design education had occurred in Europe prior to the war, and Europe was now in a postwar era, a time of rebuilding and looking at peacetime development. At about the same time, two different directions in industrial design education came onto the scene—one in Germany and the other in England. Both would have an impact on industrial design education over the next half century.

The Ulm School of Design

The Bauhaus no longer existed in Germany after World War II. It had closed its doors in 1933. However, there was still a need for industrial design education in a country whose economic force was manufacturing. Design had been important before the war; it would surely be important after the war.

The Ulm School of Design, in Ulm, Germany, was the first new initiative in design education after the war. It was launched in order to place German design education back on track. The school was founded in 1953 and had two people as its philosophical leaders: Otl Aicher and Max Bill. Aicher was a German graphic designer and typographer who, coincidentally, was born in Ulm. Max Bill was a Swiss architect and designer who, earlier, had been a student at the Bauhaus. Together, they wanted to bring approaches to design and design education that were more in step with a postwar world in an era of industrialization. Like the Bauhaus, the school's duration was short, from 1953 to 1968. Like the Bauhaus as well, it would be one of the most influential schools of design of its time.

It was never the intention of the founders for the Ulm school to become the revival of the Bauhaus. That said, several of the Bauhaus leaders played a role in its foundation. This included Walter Gropius, Josef Albers and Johannes Itten. The Ulm school also made a point of inviting leading designers to lecture or to spend time in Ulm, people such as Mies van der Rohe, Charles and Ray Eames, and Buckminster Fuller. The design curriculum was based on the one-plus-three model; that is, one year of general design studies followed by three years in areas of specialization such as product design, visual communication, industrialized building, information and filmmaking. Integral to the Ulm-school approach was the studio model of design education, that is, learning by doing. This approach existed with the Beaux-Arts school and the Bauhaus; it would also continue with the art-and-design model both in England and the United States.

The Ulm school was anything but a training establishment for designers. If anything, it was a living laboratory for experimentation in designing. Not surprisingly, this constant ebb and flow of ideas and changes were at times unnerving and created conflicts among the faculty and personnel. In part, it was these conflicts that precipitated the school's closure. At the heart were the differences in design approaches between Max Bill and Otl Aicher. Bill believed that the principal role of the designer was to be the creator of things by way of formgiving, which had been the case in the Bauhaus. He was opposed by a group of faculty, including Aicher, who believed differently. They held the view that design needed to focus more on a systematic approach with connections to theoretical issues as found in the social sciences and economics. If the old model was "designer as artist," the new model was "designer as integrator." The shift toward a more systematic approach to design became apparent with visits of design experts like Horst Rittel and Bruce Archer.

Eventually, the conflict left the corridors of the school and entered the public arena. This public venting greatly disturbed local government officials because the Ulm school was a state establishment and received funding from the local government. In a scenario vaguely reminiscent of the Bauhaus, the school was closed. Given the internal strife, the local government felt that it had no choice but to cut the school's funding.

The English Art-and-Design Model

The one-plus-three model at the Ulm school was also the basis for postwar design education in Great Britain. Essentially, the one-plus-three model assumed that there were visual fundamentals shared by all design disciplines, including architecture. These visual fundamentals were taught in projects designed to develop skills in color, space, two-dimensional shape, three-dimensional form and experimentation in various materials. The fundamentals were taught as the foundation course. Moreover, the foundation course was also shared by the disciplines in fine arts, such as painting, printmaking and sculpture, in what would become known as the art-and-design model.

The art-and-design model considered both art and design as being interrelated, principally because the mode of representation was visual; that is, the design of a product was similar to sculpture because both had a three-dimensional presence. As original and innovative as this approach may have appeared to be, its origins were with the Bauhaus. Nevertheless, the model eventually found favor with most art and design colleges in Great Britain and became the established curriculum at schools such as the Central School of Art in London, the Birmingham College of Art and Design, the Manchester College of Art and Design, and the Leicester College of Art and Design. Most of these programs are no longer stand-alone colleges but are now part of universities.

The implicit sense of logic in this academic direction spread beyond Great Britain and became the basis of many design schools in the United States, Australia, and Canada. In the United States, for example, the National Association of Schools of Art and Design or NASAD, which is the accreditation authority of design schools, still uses criteria that are essentially based on the art-and-design model.

AMERICAN DESIGN EDUCATION
From the 19th Century to Today

To a great extent, design education in the United States borrowed heavily from Europe, at least in the early years. The section that follows traces the path of several important American schools, from their early days as art or vocational schools to what they're today.

Formal education in design in the United States first began in 1868 when the Massachusetts Institute of Technology or MIT offered architecture as a major. Its program was greatly influenced by the Beaux-Arts direction in Europe. In fact, it wasn't unusual for American architects and designers to borrow extensively from European styles as these were perceived as being refined. This was certainly the case with certain American students who returned from Paris to design buildings that would influence the history of architecture in America, including the Boston Public Library (1888–1895) by McKim, Mead & White and the New York Public Library (1897–1911) by Carrière and Hastings. Harvard University followed MIT when it began offering a program in landscape architecture in 1900.

With the Bauhaus model, American design education was thrown into conflict in and around 1930. The Bauhaus direction, which was providing a fresh perspective on Modernity, was a radical departure from the preferred Beaux-Arts approach. Not to be forgotten was the fact that the Bauhaus in Germany had closed in 1933 and that several of its leaders were now living in the United States. As a result, the Bauhaus influence on American design education was happening, in part, with the appointment of Josef Albers to Black Mountain College in North Carolina in 1933, with Walter Gropius joining Harvard's Department of Architecture in 1937, and with Ludwig Mies van der Rohe going to the Illinois Institute of Technology, also in 1937. All three persons had been influential leaders at the Bauhaus. But the framework of the Bauhaus was at odds with many of the existing design programs in the United States such as the University of Pennsylvania, which had a much more prescriptive form of architectural education based on the Beaux-Arts tradition.

As for programs of industrial design, most developed as extensions of art programs, and followed the model that had been developed in Great Britain. One of the earliest schools was at the Maryland Institute in Baltimore in the 1850s, which was based closely on its European counterparts of applied arts and skills training. Most other American design schools at the time were essentially meant for the training of women to do art in areas such as textiles and wallpaper. One of the first schools of art to have an industrial design program was the Pennsylvania Museum and School of Industrial Art founded in Philadelphia in 1876. It changed its name to the Philadelphia Museum and School of Industrial Art in 1938. In 1964, the school became independent of the museum and became known as the Philadelphia College of Art. In 1985, it became the University of the Arts when it fused with the Philadelphia College of the Performing Arts.

Rhode Island School of Design began in 1877, one year after the Pennsylvania Museum and School of Industrial Art. It too was essentially an establishment focused on art and design education, although it developed a close association with Brown University. RISD, as it's commonly known, offers programs in most areas of design including industrial design.

Pratt Institute was founded in 1887 by Charles Pratt, who was a businessman and oil baron. Initially, the educational focus was vocational and technological. Not surprisingly and by the turn of the century, the School of Science and Technology had become the most prestigious unit at Pratt. The various curricula developed over the next decades and by 1938 most programs offered a bachelor's degree. As a result, Pratt went from being a vocational school to a degree-granting college. There were other changes in the wind, however. One of these was architecture; its enrollment began to surpass that of engineering. By 1993, this increase in enrollment had reached a point where the engineering program was abandoned. Today, Pratt is one of the country's leading schools of design.

Parsons The New School for Design was established, first, as the Chase School in 1896 and changed its name to the New York School of Art in 1898. By 1904 and with the advent of the Industrial Revolution, the school began to offer programs in fashion design, interior design, advertising and graphic design. The name was changed once again in 1909 to the New York School of Fine and Applied Art, and in 1936, it became the Parsons School of Design. Changes even more significant occurred in 1970 when Parsons merged with the New School for Social Research, allowing it to be part of a university. When the latter was renamed The New School, Parsons became Parsons The New School for Design.

Cranbrook Academy of Art was founded in 1915 as a center for education in the arts and architecture. Its focus is on graduate education and one of its areas

of interest in three-dimensional or industrial design. A good deal of the campus was designed by the Finnish architect Eliel Saarinen. Cranbrook was also where Charles Eames began exploring and teaching industrial design and where he met Eero Saarinen, the son of Eliel. As a team, Eames and Saarinen became a formidable force in early American Modernism.

Art Center College of Design began as the Art Center School in Los Angeles in 1930. Somewhat like Pratt, it was at first a vocational school, especially in the area of illustration. Its programs expanded after World War II, coinciding with the return of veterans. Bachelor's and master's degrees were first offered in 1949. The name was changed to Art Center College of Design in 1965. The school has strong programs in most design areas but is particularly well known for its major in automotive design and its close connection to the automobile industry.

The D School at the Hasso Platner Institute of Design at Stanford University is the latest design school to be established. Its manifesto says everything about what the school stands for.

- Create the best design school. Period.
- Prepare future innovators to be breakthrough thinkers and doers.
- Use design thinking to inspire multidisciplinary teams.
- Foster radical collaboration between students, faculty, and industry.
- Tackle big projects and use prototyping to discover new solution.[1]

Given that we are now in a postindustrial era, Stanford is perhaps showing the way to a new direction in design education much like the Bauhaus did 100 years ago.

Several of the large public American universities have thriving programs of industrial design. These include the Ohio State University, Georgia Institute of Technology, Auburn University, the University of Cincinnati, California State University at Long Beach, and, of course, Arizona State University. All offer undergraduate as well as graduate degrees. A few, such as Arizona State University, even have PhD programs.

The establishment of industrial design programs at the university level was a major step in the evolution of industrial design education and had a positive impact on industrial design. If nothing else, it situated industrial design education at the university instead of vocational schools and alongside other professions such as architecture and engineering. However, there continues to be a general tendency to favor the art-and-design model and to not fully embrace the rigors of the university in the areas of research and doctoral education.

NASAD and the IDSA: Their Roles in Industrial Design Education

One of the challenges of an open market in university education as it exists in the United States is the validation of programs of professional design education. In other words, if anyone can offer a degree in industrial design, how do you know which ones are credible and, more importantly, which ones aren't? This is where NASAD and IDSA play a role.

The National Association of Schools of Art and Design or NASAD is the national accreditation body for industrial design programs in the United States. NASAD's role is to verify that programs of industrial design meet a set of minimum standards. Who sets those standards? NASAD does with the direct cooperation of the Industrial Designers Society of America or IDSA, which is the professional organization of industrial designers. Consequently, industrial design programs that meet NASAD standards are perceived as having met IDSA professional standards for an industrial design education.

What are these standards? As would be expected from an association of schools of art and design, the standards lean heavily toward the typical topics in art and the humanities such as design studios, design-related topics and history, especially art history. Topics that are more scientific in nature aren't dismissed altogether but aren't always given the same prominence. This academic direction is supported by IDSA because the majority of industrial design programs are situated in art-school environments. Most of the good and very good programs of industrial design are

[1]Manifesto reprinted with the permission of Diego Rodriguez and George Kembel from the Hasso Plattner Institute of Design at Stanford University.

accredited by NASAD, but not all. Obviously, there are some programs that can't meet the NASAD standards. However, there are also certain schools that can easily meet the NASAD standards but that neither wish nor need NASAD accreditation. Which programs are these? Programs such as Stanford, which by its own reputation as a world standard university, don't need NASAD's stamp of approval. In case you are curious, the industrial design program at Arizona State University is accredited by NASAD.

CONTEMPORARY DESIGN EDUCATION ELSEWHERE

Contemporary industrial design education in Europe, especially Great Britain, France, Italy and Germany, and in Canada hasn't changed in any significant way since the two aforementioned shifts in design education, first with the Bauhaus and second with the foundation core in the art-and-design model. If there has been a change in direction, slight as it is, it's with industrial design programs that have moved toward a more engineering and business approach.

Great Britain

Industrial design education in Great Britain continues to reflect the art-and-design model, although most programs are now found within a university system and not in a stand-alone college model as before. In the past, a college-level program was often more skills oriented; as part of a university, there's now an additional focus on theoretical subjects as well as topics from the liberal arts and the sciences. Most schools have graduate programs and a few even offer PhDs. A recent development away from the art-and-design model is the product design program in the School of Mechanical Engineering at the University of Leeds. This program leans more toward the engineering side of industrial design; nevertheless, there's a strong visual component.

France

France has always had several strong programs of industrial design, most of which have been associated with the decorative art model of design education.

Don't let the name fool you, however. The curriculum is as rigorous as its British counterpart; as well, a few of these schools are associated with universities. In that respect, there's still a great deal of separation between the disciplines such as business, engineering, design, and the humanities. In France, these disciplines are rarely found under one roof within a university setting as you would find in an American university.

Italy

Given that Italian design has often been at the forefront of contemporary industrial design, at least since the 1960s, it may come as somewhat a surprise that industrial design education, at least at the undergraduate level, isn't as well structured as it is in Great Britain, France and Germany. Graduate education is another story, however. Two schools stand out: the Milan Polytechnic and the Domus Academy, also in Milan.

Germany

German programs of industrial design follow, at least generally speaking, variations from both the Bauhaus and the Ulm school. Most programs are now found within a university environment and therefore provide a greater breadth in general education. Most major cities in Germany have schools of industrial design with some of the better known ones found in Stuttgart, Berlin and Pforzheim. The Bauhaus in Dessau has been revived and offers a few design courses. However, the school is more of a foundation dedicated to the history of the original Bauhaus.

Finland

Aalto University offers one of the latest programs of industrial design in Scandinavia. It's a new university but with over a century of history. Aalto University was created with the merger of three existing universities in Finland: the Helsinki School of Economics, the Helsinki University of Technology, and the University of Art and Design Helsinki. Consequently, Aalto University opens up new possibilities for strong multidisciplinary education and research. The Department of Design is the largest department in the School of Arts,

Design and Architecture and one of the largest departments in Aalto University. The department conducts research and artistic activities, and provides education in bachelor, master, and doctoral programs across a broad range of subjects and themes.

Canada

Canada has several programs of industrial design. Two, OCAD University in Toronto and the Emily Carr University of Art and Design in Vancouver, follow the art-and-design model quite closely. Despite being universities, their breadth of expertise is more or less limited to art and design because both focus primarily on the disciplines found in art and design. Neither are comprehensive universities. The industrial design program at the University of Alberta isn't that dissimilar to OCAD and Emily Carr except for the fact that it's located within a comprehensive university, which allows for a greater breadth of general education. Two other industrial design programs are worthy of note. One is the program at the Université de Montreal, which is located alongside programs in interior design, architecture and landscape architecture. The other is at Carleton University. This industrial design program is located within a college of engineering. In several ways, it resembles the product design program at the University of Leeds in England; that is, there's an art-and-design component but many of the associated courses are from engineering and the applied sciences.

INDUSTRIAL DESIGN EDUCATION ELSEWHERE

Not surprisingly, industrial design programs have been established in many countries, especially those that have a strong manufacturing or technology sector. This is especially the case with countries such as Japan, Taiwan, South Korea and now China. Most of these programs are based on the one-plus-three, art-and-design models found in Europe or the United States. Consequently, graduates of these programs are well trained in the typical skills of industrial design. However, there are changes occurring. For example, research is encouraged in schools such as the Hong Kong Polytechnic, and doctorate degrees are becoming more common.

SUMMARY

Industrial design education has evolved greatly in the past century. As people become more demanding about their environment and as contextual conditions become more challenging, industrial design education will have to continue to evolve if it's to remain relevant.

NOTE: Readings for chapter 9 are found in the back of the book.

CHAPTER 10

DESIGN AND MATERIAL CULTURE

WHAT DO WE MEAN BY MATERIAL CULTURE?

In the context of industrial design, we need to think of material culture as something like archeology but within a unique scenario: The designers of today's artifacts are still alive or, if they aren't, have often left an extensive record of their designs. Collectively, these artifacts and their records become what are often called material culture. With such evidence, we're able to gather insight on the designing process because the designers can inform us or have left archival material that can inform us. The architect Paolo Soleri is a good example. He may have died in 2013 but he has left an extensive archive of his designs for Arcosanti and other projects. Consequently, there's no need to speculate on his intentions because there are ample records to describe what underpinned his thoughts and ideas.

This isn't often the case with designs and artifacts that go back hundreds or thousands of years. For most of these, we can only speculate on what the designer was thinking. For example, what was da Vinci really thinking when he designed his many devices? Why did he do what he did? And why did he do it the way that he did it? It would be interesting to know but he is no longer here. His drawings and notes provide some insights but not nearly enough. This scenario is typical for a great deal of archeology, where there's a need to piece things together with the best possible evidence

and where a bit of speculation is at times necessary. This is certainly the case with southwest petroglyphs. They may be beautiful examples of visual designs but we still don't know what they mean. There are no archival records that explain their meanings. At best all that we can do is speculate on what these signs were meant to communicate.

Material culture is a well-known area of study in anthropology. Generally speaking, it's the study of the relations between artifacts or everyday things, on one hand, and social relations or people, on the other. This is because there's a direct connection between everyday things and people. As stated by Arjun Appadurai, associate professor at the University of Pennsylvania, "*People's relationship to and perception of objects are social and culturally dependent.*" That being the case, the study and understanding of some aspects of material culture becomes important to industrial designers.

As we already know, design is very much concerned with the Artifact/User interface. Therefore, it's in this sphere of activity where material culture resides for industrial design. We know, for example, that tools are often extensions of human senses. We have tools that extend our muscular capacities such as farm tractors; tools that extend our sense of sight such as radar or our sense of hearing such as the telephone; or tools that extend our ability to compute and think such as calculators, computers and artificial intelligence. Clearly, the understanding of the interrelationship between people

Courtesy of Jacques Giard

Image 33: Petroglyphs contain all manner of visual signs but these don't constitute a written language as such.

and artifacts can't be ignored. If anything, it needs to be undertaken, encouraged and supported. The focus of this chapter will be on three types of artifacts: tools, structures and signs, and their human interconnections. Before we begin, however, we need to have a common meaning for tools, structures and signs.

It's easy to imagine that tools are small, hand-held devices. We've often used the word tool when referring to a hammer or a saw. Both are commonly known as tools. In our case, however, a tool goes well beyond this popular definition. In principle and in practice, most tools are human extensions. More than that, tools have purpose. In our case, they serve to satisfy human needs and wants. But tools have one more defining characteristic: they're mobile. What's meant by mobile? This question calls for a short story.

In the French language, the word for buildings or real estate is *immeuble*. It's the base word for the English word immobile. Similarly, the French word for furniture is *meuble*, which is the base word for the English word mobile. The connection to the French language comes from an unusual phenomenon that occurred in and around the 18th century in France. In that era, the French royalty and nobility had residences in Paris as well as in the countryside, especially in the Loire Valley. Despite their wealth and two residences, they only had one set of furniture. Therefore, they transported the furniture from their Paris residences to their homes in the Loire Valley at the beginning of the summer and transported it back to Paris in early autumn. It was in this context that the concept of *meuble/immeuble* or mobile/immobile developed. Their homes were immobile and their furniture was mobile. For the purpose of this course, tools will be defined as everyday things that

are mobile, that are human extensions, and that exist to meet human needs and wants.

Now for the word structures and its definition. In a way, structures are like tools. They're also artifacts that serve human needs and wants such as our need for shelter and protection. That's why we put a roof over heads or build walls around a community. Unlike tools, however, structures are immobile. That is, they normally exist and remain in one place. Consequently, they're also conditioned by the specific nature of that place. This scenario is very different from tools. For example, the location of a house in relationship to the rising and setting sun is important. That isn't the case whatsoever for a laptop. For the purpose of this course, structures will be defined as everyday things that are immobile, that are extensions of human capabilities, and that exist to satisfy human needs and wants.

Signs are slightly different from tools and structures. Nevertheless, they're important in understanding design. For our purpose, signs are defined as that combination of design elements that constitute the visual language—either explicit or implicit—in everyday things. It's why we recognize a table for what it is without ever seeing the word "table" written on it anywhere.

A great deal has been written and published about well-known tools and structures. Think, for example, of the annual design awards for products such as the IDEA awards given by the Industrial Designers Society of America or the many coffee-table books on architect-designed houses or museum collections of outstanding posters. Traditionally, this is how many people have come to know about design. This book takes a slightly different tact. The tools and structures selected won't always be examples of design that are celebrated by and known to most of us; instead, they will be the more common kind of everyday objects. However, connections to industrial design will always be made in each case. So will connections to users.

Much the same direction will be taken for signs. The book won't deal with explicit visual signs such as logos or the implicit visual language found in most everyday things. Instead, theoretical aspects of signs and the visual language will be offered, a great deal of it by way of a topic called *productology*, or the classification of products.

TOOLS

As stated above, tools are everyday things that are mobile, are extensions of human capabilities, and serve to satisfy human needs and wants. There's an almost infinite number of artifacts that fit that description. Therefore, where do we begin our exploration? We could begin almost anywhere. There are, of course, those many celebrated design objects that would be appropriate for the exploration such as an Eames chair or some Braun appliances. However, these objects are well known, are mainstream artifacts of industrial design, and have been discussed at length elsewhere. There's most likely very little new to be learned from them. Perhaps a better direction is one that examines non-traditional design objects, those that aren't normally considered mainstream when discussing industrial design. By taking this direction, we not only have a subject matter for our exploration but we can also show the pervasiveness of design in our artificial world. This being the case, this section of the chapter will look at a select few everyday things that illustrate well the nature of design as everyday tools and that aptly show that design is pervasive in ways not always imagined.

The tools or everyday things that will be discussed are the paper clip, the Post-it Note, the Airstream trailer, the Laser sailboat and the SizeChina project. The tools range both in physical size and complexity, from the small paper clip to the much larger Airstream trailer, and from a watercraft to helmets in China. A few of these artifacts, such as the Post-it Note, also demonstrate that trained designers weren't always involved despite the success of the design. Several others, such as the Laser sailboat and SizeChina, show how industrial designers made a difference. Each example provides lessons for industrial design and industrial designers.

The Paper Clip

Industrial design is often billed as a problem-solving process. That is, a problem is identified, multiple solutions are proposed, a few prototypes are built and tested, and the preferred solution is selected, which becomes the final product. The paper clip exhibits all of these steps in the design process. But it also exhibits other important design properties as well. For example, it exhibits the special quality of invisibility as a design; that is, the paper clip is rarely noticed in our Artificial World despite the fact that it's one of the most refined everything thing ever designed. Moreover, it's an excellent example of less is more. Look at the typical paper clip: is there anything in its design that's superfluous and should be eliminated? Not really. And if that weren't enough, the paper clip serves many unintended purposes or uses. Its metal end can be used to pierce open a tube of glue. This use is perhaps a bit obvious, but there are less obvious uses such as a device used to determine the level of creativity in people. How is that goal achieved? People are asked how many uses they can find for a paper clip. The more uses, the more creative you are deemed to be.

The history of the paper clip is fascinating. It surfaces as an artifact around 1867 but not as a device meant to hold pieces of paper together. In fact, its original purpose was to hold a paper ticket to a piece of fabric. A U.S. patent was awarded to Samuel B. Fay in 1867 for the device that has come to be known as the paper clip. That said, Fay's design wasn't the one that we associate with today's paper clip. Curiously, the design of the paper clip that we know today was never patented. It owes its origin to the Gem paper clip in use in Great Britain in the 1870s and made by the Gem Manufacturing Company. In 1899, a patent was granted to William Middlebrook of Connecticut for a machine to make paper clips. The paper clip in question was similar if not identical to the Gem paper clip. Over the next 100 years, the paper clip became a staple of the office where sheets of paper needed to be temporarily fastened together. With time and given the pervasiveness of the paper clip, it became an object of interest for some designers. The trombone shape was set aside for circular or triangular shapes and some paper clips also became available in a range of different colors.

The long history of the paper clip as a device for attaching paper together has made it a familiar everyday thing. Who, after all, doesn't know or hasn't used a paper clip? Does it therefore come as a surprise that it has become the preferred icon on a computer screen when the act of attaching a document was called for? Look closely at the icon for attaching a document on Outlook or on Apple's Mail app and you will see a pictograph of a paper clip.

Looking back, what can we learn from the history and evolution of the paper clip? First, a great many designs are the embodiment of a problem-solving idea made by someone, either trained as a designer or not. Be it as it may, people want to make their lives easier. Arriving at solutions like the paper clip is clear evidence of this human desire.

Second, very good ideas tend to last over time because they connect to the problem in the most appropriate way. Look at the paper clip: other than a change of shape or color, can you imagine any way that it can be improved? Most likely not.

Lastly, the traditional paper clip is an excellent example of less is more, not intentionally perhaps but certainly as the result of the application of good common sense. Looking at the paper clip, it would be difficult to imagine adding or removing anything to it in order to make it better.

The Post-it Note

By definition, the design process is purposeful. That is, a design exists because there's a purpose or goal to be met. A design is therefore deemed successful if it meets that purpose or goal. At least that's what the design process is in theory. What happens when the practice of designing doesn't quite match the theory of designing? In other words, the initial goal was not met. This is the story of the Post-it Note.

The Post-it Note could easily be classified as design by mistake. It was a solution without a problem. Thomas Edison was familiar with this approach. He was known to have said, *"Just because something doesn't do what you planned it to do doesn't mean it's useless."* Clearly, what's useful and what's useless is relative.

The story of the Post-it note was a series of happenstances, and began in 1968. Dr. Spencer Silver was a scientist working with 3M. His quest was to develop a new super adhesive. But he failed in his quest, so to speak. He ended up developing a reusable glue that was anything but a super adhesive. Not deterred and certainly not dissuaded by his failed experiment, Silver began what became a five-year test trial in which he promoted his low-tack glue wherever and whenever someone would listen. It wasn't until 1974 that one

of his colleagues, Art Fry, suggested that perhaps the adhesive could be used to create removable bookmarks. This was to be the second happenstance in the evolution of the Post-it Note. At this point, it was Fry who ran with the idea. With the backing of 3M, Silver and Fry launched in 1977 the product known then as "Press 'n Peel." The reception by the market, albeit limited, was disappointing. Nevertheless, 3M wasn't deterred. They continued refining and promoting the product. It launched once again in 1980 but this time as Post-it Notes, the name that's familiar with people today.

Since its launch, a diverse range of Port-it Notes products with an equally diverse range of applications has hit the marketplace. For example, brainstorming sessions often make use of Post-it Notes. Who would have ever imagined that connection between the low-tack adhesive and brainstorming sessions when it was first created? Moreover, and somewhat like the computer icon for a paper clip, there now exists computer versions of the Post-it note such as Stickies on a Mac.

There was one last bit of happenstance in the story of the Post-it Note: the color. It first appeared in yellow but the color wasn't selected deliberately. It was the color of the only paper available when the first samples were made in the laboratory.

What lessons can we derive from the Post-it note story? There are perhaps three. The obvious one, of course, is that there's always the potential for success from failure. In the end, failure is like beauty: it's only in the eye of the beholder. Silver and Fry could see usefulness for the low-tack glue, whereas others saw very little. Silver and Fry also provided another lesson: perseverance. Neither gave up when others were more or less convinced that their quest could lead to nothing else but a dead-end. Lastly, history often shows that some artifacts with narrow uses can often develop a greater breadth of use as they become known and as people interpret the use of these artifacts differently. This was certainly the case with the Post-it Note as well as with the paper clip.

The Airstream Trailer

More and more baby boomers—the generation born after 1946—are retiring every year. And with each year, we're seeing a proliferation of trailers, recreational

vehicles and motorhomes. It's as if the baby boomers are returning to the nomadic lifestyle of their ancestors. They want to be on the road and moving from place to place.

In the context of everyday things, trailers, recreational vehicles and motorhomes are quite fascinating artifacts. They're not always easy to situate in one category of objects or other. In one way, they're like houses but architects don't usually design them; they're also like cars because they're mobile but few appear to have been designed by an industrial or automotive designer. Most trailers, recreational vehicles and motorhomes exist as a kind of design hybrid between the physical comfort of a home and the technical requirements of a car. Not surprisingly, most trailers, recreational vehicles and motorhomes aren't perceived as exemplar of good design. Most but not all. There's an exception, and that exception is the Airstream trailer.

The story of the Airstream trailer began in California in the 1920s with Wally Byam, a Los Angeles lawyer. His first foray in the trailer market was with how-to kits. However, he connected with the Bowlus Company, acquired the company, and in 1936 launched a slightly redesigned 1935 Bowlus. Byam's redesign improved fuel efficiency by cutting down on wind resistance by way of the overall form of the trailer. That form—a kind of elongated sausage—became the corporate design style for the Airstream trailer.

The 1930s weren't the best years to be in the business of designing and making trailers because trailers were essentially leisure products. The 1930s were defined by the Great Depression. A large number of Americans were unemployed and people weren't buying leisure products. That said, Airstream not only made trailers during this same era but was also the only trailer manufacturer to survive the Great Depression.

Manufacturing challenges such as the economic downturn weren't the only ones faced by Airstream. With the advent of World War II in 1941 came the need to ration aluminum, and aluminum was the principal material used in Byam's trailers. Once the war was over, the social and economic picture changed. Americans felt the joy from the victory of the war. The post-war economy began to boom. Leisure travel was again a possibility. Production continued in California but a

new factory was opened in Ohio. The California plant closed in 1979.

Intentionally or not, Airstream trailers reflect the pragmatism and innovative thinking that we've come to expect from American design. For example, there's the pragmatism connected to fuel efficiency, which is achieved both by the trailer's form—which is more aerodynamic than most boxy trailers—and the use of aluminum, which is lighter than steel. There's also the honesty of design. The aluminum is left bare and unpainted.

In addition, the Airstream provides an indirect connection to what would have been the leading-edge industry of the day: aviation. Both the streamlined form and the aluminum body were pages taken out of the aviation industry. This connection would situate the Airstream trailer as something of the future, and not of the past.

And lastly, there's no denying that the Airstream was created with the spirit of form follows function. Perhaps most telling about the philosophy of the company is this statement on its web site, *"Let's not make changes; let's make only improvements."*

The Laser Sailboat

In the fall of 2013, the America's Cup races took place in San Francisco Bay. This event is the ultimate race in the world of yachting and is meant only for those people or corporations with extremely deep, financial pockets. The sailboats can cost up to $10 million each; and it can cost several million dollars more just to compete in the race. In this most recent round of the America's Cup, 15 teams were expected to compete. In the end, only four teams showed up. Clearly, this level of sailing is meant only for the wealthy elite and no one else.

Clearly, competing for the America's Cup is extremely expensive. Sailing—as undertaken by millions of Americans—isn't that costly but neither is it an inexpensive pastime, at least generally speaking. A basic sailboat—even a small one—can cost a few thousand dollars. Then there's the challenge of sailing; some sailboats are simple to rig and sail but most aren't. If that wasn't enough, there's also the need for access to water such as a lake or the ocean. Neither should we forget the costs connected with marina facilities, which are

often provided via a yacht club. This too costs money. Move up from a small sailboat to a larger one and the costs can go up exponentially. No wonder that sailing isn't a common everyday pastime. Who can afford it?

What if sailing were perceived differently? What if a designer decided to make sailing an everyday activity for everyday people? This is exactly what Ian Bruce, Bruce Kirby and Hans Fogh did in the 1970s. Together they designed a one-person sailboat that was both inexpensive to buy and simple in design; that is, it was easy to rig, easy to sail and easy to transport. More than that, its design would also allow an experienced sailor to enjoy sailing at a higher level. In other words, the design potential for the sailboat would go well beyond the novice market.

How did the design story begin? It began with three experienced sailors, two of whom were Olympic-class sailors. The story continued with the vision that there was a design opportunity in the waiting if sailing was perceived differently. During the 1970s, there were only a few entry-level sailboats. Most of these sailboats, however, weren't taken seriously by the sailing community. This is where the idea of a small, portable sailboat was first conceived, a sailboat that was easy to rig, easy to transport, relatively inexpensive, and yet designed for new as well as serious sailors, those desiring high-level performance in a boat. So was born, in 1971, the Laser sailboat.

In almost every way, the Laser is a simple design. It's composed of two glass-reinforced plastic pieces— the hull and the deck. This makes it both durable and inexpensive to manufacture. There's an additional ingenious design feature. The deck mates to the hull in such a way that it creates a handle, making it easy to carry the boat all the while adding structural strength. The simplicity goes further. The Laser doesn't have the traditional sailboat rigging. Instead, it has what's called a sock sail, which slips over the mast. As for the mast, it drops into a hole in the deck called a mast step. Consequently, set-up time is quick. The elimination of rigging saves a good bit of money because hardware for rigging can be costly. That said, the sailing hardware that's used on the Laser is the best quality, which pleases the serious sailor.

There's another facet to the design that makes the Laser very different from its competitors. The story

begins with this fact: not everyone knows that races in sailing—called regattas—are normally based on classes of sailboats. That is, boats of the same design race against each other. In other words, when you're buying a sailboat you are also buying into a specific sailing community or class. The people who designed and developed the Laser were well aware of that fact because they were sailors themselves. Consequently, they developed what's called a class association for all Laser owners shortly after launching the boat onto the market. This action reinforced the sense of community among Laser owners and encouraged new buyers to purchase a Laser instead of another boat with no class association. This particular approach would eventually lead to the Laser becoming an Olympic-class sailboat; it made its debut at the summer games in Atlanta in 1996. The Laser was a great design because it made sailing possible for most people yet didn't "dumb" down sailing itself.

The story of the Laser offers several lessons for industrial designers. First, your passion can create the platform for new ideas and concepts. At times these coincide with industrial design. In the case of Ian Bruce, who happens to be an industrial designer, his passion for sailing melded extremely well with his professional skills as an industrial designer.

Second, designers can be employers as well as employees. With the Laser, Bruce created a thriving business that, at one point, had factories in Canada, where the boat was designed, the United States, England, Ireland, Australia, New Zealand and Brazil.

Lastly, designing can often go well beyond the everyday thing being designed. Bruce's knowledge of the cultural behavior of sailors and the sailing community placed his boat in a unique position in the market. He knew that most sailors wanted to belong to a specific sailing community.

The SizeChina Project

Roger Ball is an industrial designer. Over his many years of professional experience, he has developed an expertise in the design of helmets, especially those meant for sports such as hockey and snowboarding. One of his clients manufactured helmets for snowboarders, including elite snowboarders. That being the

case, the manufacturer was puzzled by the fact that elite snowboarders from countries such as Korea weren't using the company's products. What was it about the company's helmets that Korean snowboarders didn't like or didn't find acceptable? After all, elite snowboarders from other countries used the helmets. Why not Koreans? Clearly, the answer couldn't be about the performance aspect of the helmet. It had to be about something else, perhaps the color or the visual style. As we know, both can have negative connotations with certain cultures.

The manufacturer and Ball decided to investigate the situation by way of a focus group. They invited some elite Korean snowboarders to a meeting with the intention of discovering their reasons for not selecting the company's helmet. Did the colors available go against some cultural belief? Or was it perhaps the look of the helmet that didn't meet with their approval? Meeting with the Korean snowboarders would most likely provide answers. And it did. But the answer came as a total surprise. It wasn't the colors that caused the problem. Neither was it the style of the helmets. Simply put, the helmets didn't fit well.

Stepping back, Ball began to see the problem from a different perspective. Helmets are like shoes. To work well, the fit of a shoe has to be exact. Go for a five-mile hike in a pair of ill-fitting boots and you will quickly know why fit is so important. Boots must conform to the shape of your feet to work well. It appears that much the same was happening to the Korean snowboarders and the helmets. But why? In this case, it was principally because of anthropometrics. That is, the human factors data used in some areas of the helmet industry didn't reflect the typical physical dimensions of the Asian population.

Ball happened to be employed as a faculty member at the School of Design at the Hong Kong Polytechnic University at the time when the above story occurred. It became obvious to him that there was an opportunity in the making. Perhaps the absence of Asian head measurements provided the necessary platform to launch a research project focused on the anthropometry of Chinese people. After all, there are millions of Chinese who ride bicycles every day. If nothing else, there was a huge potential market for a better bicycle helmet in China.

The research project became known as SizeChina. The purpose of the research was to "create the first-ever digital database of Chinese head and face shapes." Why would such a research project be necessary? Two reasons quickly became apparent. First, there was an absence of relevant data on the human measurements for Chinese people. This situation can create a problem because so many products are designed using anthropometric data from people of Western countries. Second, these new data could allow for improved design in areas where head shape and size are important such as helmets of various types and glasses of one kind or another but especially safety glasses and face masks. Since the launch of SizeChina, the data have been used in the design and commercialization of a pair of military-police goggles.

What do we know now that we didn't know before with the SizeChina project? First, human factors data are important but only if they're relevant. It's too easy to make assumptions, such as the fact that measurements for heads for any segment of the population are generally the same all over the world. Such isn't the case. Second, everyday objects that are used in direct contact with people need to fit well. This is even more the case when these same everyday objects are meant to provide protection. A helmet, by its design, implies protection; therefore, a user should expect the best protection possible. Lastly, designers can find opportunities to explore new product opportunities in the least expected places but only if they're receptive to the opportunity to begin with.

STRUCTURES

The section on structures is similar to the section on tools; that is, it examines structures in order to understand their presence as an everyday thing and to reveal some lessons learned. Once again, none of these structures are prize-winning designs. Nevertheless, each one has made an important contribution to design. Connections to industrial design will also be made despite the reality that structures aren't generally considered as part of industrial design. As a reminder, structures are defined as everyday things that are immobile and that address human needs and wants. Obviously, houses and shopping malls are structures, but so are bridges and towers.

The structures selected for this section aren't always included when discussing the history of architecture, although a few fit that category. In part, this is because they don't appear to contribute to mainstream architecture theory and practice. These same structures do, however, provide connections to one or more principles relevant to and found in industrial design theory and practice.

The structures included in this section are the Crystal Palace, the Eiffel Tower, Taliesin West, Arcosanti, the Dymaxion House, Habitat 67, Fuller's geodesic dome, and the San Francisco-Oakland Bay Bridge.

The Crystal Palace

The Industrial Revolution was a dramatic turning point in how everyday things were produced and how machines were replacing people in the making process. No longer were everyday things made by hand as they had been for centuries. Machines of one kind or another were now doing the work faster and cheaper.

Curiously, the revolution in the designing and making of structures wasn't occurring at the same pace or with the same intensity as it was with everyday things. The traditional ways of architecture remained very much in place. Masons were still being used, much like carpenters and framers. A building was essentially a large hand-made project or prototype. A good example was the design of the Houses of Parliament in London, better known as the Palace of Westminster. The original structure, or the Old Palace, was destroyed by fire in 1834. The competition for the design of a new building was won by Charles Barry, a London architect, who designed the building in a Neo-Gothic style. August Pugin, a leading authority of the day on anything Gothic, assisted Barry with decorative aspects of the building as well as the furnishings. Construction started in 1840 but wouldn't be completed until around 1870. This Neo-Gothic direction needs to be placed in context because the original Gothic style goes back several hundred years. Think of Chartres Cathedral in France, which was begun in 1194 and finished in 1250. That was 600 years before Barry's concept for the Palace of Westminster. Clearly, the latter wasn't in any way a reflection of the industrial age.

The Crystal Palace was designed and built in the same era as the Palace of Westminster. Yet when looking at the two buildings, the era is perhaps the only thing that the two buildings have in common. Everything else—especially the architecture and the construction—was vastly different. The background story of the Crystal Palace explains this difference.

The Crystal Palace was the center stage for The Great Exhibition of 1851. The latter was an event that brought countries of the world to London with one goal: for each country to show its manufacturing prowess. The Crystal Palace was the exhibition center. As expected, certain design criteria were established right from the beginning for the design of the building. It had to be conceived as a temporary structure, had to be simple to build, and had to be inexpensive. Remarkably, the commission that was established to oversee the construction of the building didn't begin to invite submissions for its construction until March 1850, about one year before the opening of the Great Exhibition. Coincidentally, Charles Barry, the architect of the Palace of Westminster, was a member of the commission.

Well over 200 entries were submitted to the competition over a relatively short period of time. Of these, 38 originated from countries other than Britain. Two entries stood out. Both used steel and glass construction, but both were considered too expensive to build. They were soon eliminated. As a last-minute alternative, a brick and iron design was suggested. However, public opinion considered the concept unacceptable and it too was rejected. Time was running out. Henry Cole, the English civil servant and champion of design, happened to be a member of the commission and a friend of Joseph Paxton. Paxton was a celebrated gardener and a designer of green houses. They met and soon Paxton became fascinated with the challenge of designing a building for the Great Exhibition. However, it was already June 1850; there was less than a year before the official opening. Two days after his meeting with Cole, Paxton had already completed a sketch of the building, which was based on a greenhouse but massive in scale. His design not only met the commission's criteria but also surpassed them. Although large at 770,000 square feet, it was cheaper to build than any of the other entries and could be erected in less time. Two features of the design were particularly telling. First,

Paxton's design embodied the virtues of the Industrial Revolution; that is, it made use of the advantages of machine-made rather than hand-made parts. Second, the architectural style of the building was looking to the future, which was unlike the Neo-Gothic Palace of Westminster, which was looking to the past.

As a greenhouse, the Crystal Palace was large. It stood 100 feet at the top of the central arch. Basic geometry—especially the principle of the module—played an important role in the design of the building. In this case, the module was the largest standard size of a pane of glass, which was 10 inches by 49 inches. Using these dimensions as the module and repeating it over and over, Paxton was able to make the construction more efficient and reduce the cost. His approach was something connected more to industrial design and not as much to architecture, where one-off construction was the rule. Another design feature that connected the Crystal Palace to industrial design was the fact that parts for the building were made in various places in England and then shipped to London. The glass panes make the point. These were produced in Birmingham, a city in central England, and shipped to Hyde Park in London. This practice—that is, parts coming from factories throughout England and shipped to a central location—was to become a pattern for the construction of the Crystal Palace. The pattern has become a common practice in contemporary industrial design.

The Crystal Palace also had many innovative design features. One of these was the basic roofing unit, a kind of long triangular prism. The concept for the roofing unit came from another one of Paxton's designs. The prisms were light yet strong and used a minimum amount of material. Combined into rectangles and supported by cast iron beams and pillars, these formed a cube of 24 foot square, which became a module for the overall building. Like any module, it could be extended as desired. In the case of the Crystal Palace, the building became 77 modules long and 19 modules wide. Once again, Paxton was borrowing from a principle and practice well known to industrial design—the module. Paxton dealt with certain technical problems in an equally elegant way. For example, the accumulation of water on the roof could prove to be a problem. This was resolved with an ingenious design of cast iron channels that shed water efficiently into the cast iron columns. However, they also served another purpose. They functioned as rails for the trolleys that were used by workers to install the glass during the construction: the same design detail, but with two very separate functions.

Economies of scale played an important role in the design of the Crystal Palace. This is perhaps where Paxton's idea is closer to industrial design than it is to traditional architecture. Whereas the Palace of Westminster was an example of a one-off design, Paxton's idea came a great deal closer to batch production or even mass production. Admittedly, there was only one Crystal Palace but the basic concept could have been easily replicated elsewhere. The design of the Crystal Palace took clear advantage of the potential that resides with the concept of mass production. The building was designed based on a series of a few similar parts; these parts were made in the most efficient way possible; they were then shipped using the latest mode of transportation; and finally assembled on site. Many of today's complex designs follow a similar pattern. Think of the Boeing 787, the new Dreamliner. Parts for the plane are made in multiple places throughout the world. These are then shipped to a central location in the state of Washington where they're assembled and prepared for delivery wherever the buyer is found.

The Eiffel Tower

Generally speaking, Paxton's Crystal Palace found favor with the English public. This was perhaps because the greenhouse was used as the basis for its design. The English public recognized that form and was comfortable with it despite the fact that the Crystal Palace was much larger than the typical greenhouse. The presence of an industrial language in the cast-iron columns and the acres of industrially produced glass didn't seem to upset people, although it did have its critics. This wasn't the case with Gustave Eiffel and the structure that bears his name in Paris. The public wasn't kind towards the tower, at least not initially.

The Eiffel Tower came to be at an important time in French history: the centennial of the French Revolution, which had occurred in 1789. Paris had been designated as the site of the World's Fair, which was to take

place in the Champs de Mars, one of the more prestigious parks in Paris. The Eiffel Tower was to serve as the entrance to the latter. The design for the tower was undertaken as a competition, which is often the case for this type of structure. For all intents and purposes, however, Eiffel's design was the only entry because the commission that oversaw the competition favored his design. As much as the tower was to be the focal point of the 1889 celebration, Eiffel provided an additional perspective when he said that the tower was, ". . . *not only the art of the modern engineer, but also the century of Industry and Science in which we are living, and for which the way was prepared by the great scientific movement of the eighteenth century and by the Revolution of 1789, to which this monument will be built as an expression of France's gratitude.*"

Quite obviously, Eiffel wanted to celebrate the scientific and industrial progress of the Industrial Revolution, which wasn't at all dissimilar to Paxton and the Crystal Palace. It's with this perception in mind that he, along with Maurice Koechlin and Emile Nouguier, two of his senior engineers, designed the mechanistic structure that we know as the Eiffel Tower. He even asked Stephen Sauvestre, the head of the architectural department at his firm, to contribute to the design by adding decorative arches and a glass pavilion on the first level.

In a city populated with historical buildings and Beaux-Arts architecture, there was no doubt whatsoever: Eiffel's tower was different. It was a bare-bone approach to design, as if design was a science and not an art. And the objections soon began. One group, the Committee of 300, was particularly vocal. It was composed of artists, writers, and architects who were totally against the structure. In a petition to the government minister responsible for the exposition, the group wrote, "*We, writers, painters, sculptors, architects and passionate devotees of the hitherto untouched beauty of Paris, protest with all our strength, with all our indignation in the name of slighted French taste, against the erection . . . of this useless and monstrous Eiffel Tower.*" One of the members of the Committee was the French author, Guy de Maupassant, who signed the petition yet ate at the Eiffel Tower regularly because, as he said, it was the only place in Paris where you couldn't see it.

Perhaps more than many structures, the Eiffel Tower was a catalyst for a very natural human behavior: change and the resistance to change. The Industrial Revolution was an agent of change, and changes were coming quickly. The comfort zones of people were being disturbed. This reaction had occurred in the past, and it would continue to occur in the future. The design of the Eiffel Tower also created a swing in the pendulum of styles. The Beaux-Arts style—with its overt and exuberant decoration—was the preferred visual language in architecture. This was certainly so with the Garnier Opera in Paris built in 1875. No structure could be more different from the Eiffel Tower, devoid as the latter was of decoration. This sudden shift in architectural style was unnerving to many Parisians, to say the least.

As we of course know, the tower wouldn't only become a permanent fixture in the Paris skyline but would also be the icon of the city. It's the most visited monument in the world and received its 250 millionth visitor in 2010. Moreover, the concept of an iconic building for a city would be repeated on a regular basis. As a case in point, Frank Gehry was hired to design the Guggenheim Museum in Bilbao, Spain. This he did in his distinctive style in part to create an icon for the city. Without Gehry's intervention, Bilbao would remain unknown to most people.

Taliesin West

In some ways, Taliesin West in Scottsdale, Arizona, is an excellent example of traditional architecture. It's a multipurpose structure designed to be both a residence and a school. Its appearance may be unique but no one would mistake for anything other than a building. In other ways, however, Taliesin West isn't traditional architecture. It defies the canons of style typical for America in the 1930s.

The design story for Taliesin West began in the United States in the 1930s with Frank Lloyd Wright. Design in America in that era, whether architecture or furniture, was greatly inspired by European traditions. For example, it wasn't unusual for some American architects to study in Europe, especially in Paris and to do so in the Beaux-Arts tradition. For those that didn't, the European influence was taught in American schools of architecture and applied in practice. A quick look at

the buildings of the day proved the point. European influence was the dominant style. The design of the San Francisco Opera House is an excellent example. It has all the trappings of classicism with its wall of columns dating to the time of the Parthenon. Yet it was built in 1932. In Wright's opinion, something was wrong with this picture of European-influenced architecture. After all, the United States wasn't Europe. The country was making its own history and developing its own culture. Consequently, American architecture should reflect the essence of America—the people, the place and the values. Taliesin West would do just that, as did most of his buildings. It's telling to note that Taliesin West was started in 1937, roughly at the same time as the opera house in San Francisco.

The Sonoran Desert is a special place. This is where Taliesin West is located. It's an environment where extremes reside. It's arid but not without vegetation. The geology is apparent, as is the azure blue of the sky. The light can be strong. And then there's the heat. This is where the design concept began. There's always a responsibility that comes with situating a building in a specific location. In some instances, that responsibility is ignored and the building appears alien to place, out of context so to speak. In other cases, the responsibility is accepted and the building appears connected to the place. It's an extension of it, as if a seed had been planted and allowed to grow. This is Taliesin West. Wright referred to this design approach as organic architecture. For example, the stone used in the construction of the main buildings at Taliesin West is the same stone found in the Sonoran Desert. The buildings therefore appear to be as one with the surroundings. The fenestration of the buildings was designed to take into consideration the intensity of the natural light of the Sonoran Desert. There are even areas where Wright incorporated features based on the Venturi effect, which would allow for natural ventilation. It should be noted that the especially high daytime temperatures of Arizona weren't an issue because Taliesin West was designed for winter use only. It was never designed for the extremes of summer. Today, air conditioning has been installed because the buildings are used year around.

What have we learned from the design experience at Taliesin West? Obviously, we learned that context in design is important, perhaps more so for architects

because buildings are immobile. But context is equally important for industrial designers as we saw with the SizeChina project. Moreover, context isn't only about a physical location or place but also about climate and people. Such contextual factors—there are others—should never be ignored. If you do, you do so at your own peril. We also learned that the sacred cows of design need to be burned now and then. Although the architectural community in the United States was firmly on the side of the Beaux-Arts style or some other revivalist genre in the 1930s, Wright perceived this attitude as something that was out of place, literally. Designers need to ask questions about the status quo constantly. A good dose of skepticism isn't a bad thing. Lastly, the appropriateness of material selection is important in design. In the case of Taliesin West, the local stone was ideal. After all, it had been an integral part of the geology of the place for millions of year. Surely it would last in a building with a much shorter lifespan. Industrial designers need to approach material selection with a similar attitude of appropriateness.

Arcosanti

Arcosanti is the life work of Paolo Soleri. Like Taliesin West, it too was a design experiment in a desert environment. But Arcosanti was different from Taliesin West, and the difference begins with Soleri himself. Soleri graduated as an architect in his native Italy in 1946. In that same year, he visited the United States for the first time, in part to study under Frank Lloyd Wright. After all, many people in the architectural community perceived Wright as a design pioneer. Soleri returned to Arizona in 1956 and settled in Scottsdale. His first experiments in a new direction in architecture occurred there in a place that he called Cosanti. Later, he transferred his architectural experiments to Arcosanti in Cordes Junction, a small community some 80 miles north of Phoenix.

Arcosanti wasn't just another architecture project; it was a living laboratory. It was Soleri's personal vision of how people should occupy a place, live as a community, and build accordingly. Unlike the traditional concept of community planning and building, which is based on subdividing a large piece of land into equal sized properties each with its own house, Arcosanti

was based on a very different approach. Soleri believed that land was more than a place on which to build and where no connection is made between the building and the adjoining land. For him, human activity should be concentrated in a small area, thereby leaving more land for other productive uses such as cultivation, grazing or left as is. In other words, a 200-acre plot should not be divided into one-acre lots, each with a house with four people. From Soleri's point of view, there should be a greater concentration or higher density of human occupation. The same 800 people on the 200-acre lot would be better served if they resided in a dense core taking up perhaps 20 acres, thereby leaving 180 acres for other purposes. Soleri's design approach considered the use of the land in a way that was more holistic in scope with a greater sense of the bigger picture. The latter included natural resources as well as services such as water, sewage and roads.

Soleri called this approach arcology, which was the fusion of two words important to Soleri: architecture and ecology. Architecture was important for Soleri but not if it excluded ecology. Like Wright, the place or location for a structure mattered, but it appeared to matter in a way different from Wright. At Taliesin, Wright respected the concept of place by using local materials and incorporating natural conditions. For Soleri, the built environment was much more about people and the structure, on one hand, and the biological presence of place, on the other.

Visiting Arcosanti today is like visiting a work in progress. The buildings, as densely packed as they are, sit on several hundred acres of land but occupy a small footprint only. There's a small community of permanent residents, and construction continues. More important perhaps is the ongoing production of Soleri bells. These are made of cast bronze and are available in a variety of shapes and sizes. They've been an integral part of Arcosanti since the earliest days because they produced the income that Arcosanti needs for its continued growth.

It's on this latter point where Soleri is different from most other architects. As a rule, architects work on a commission offered by another party. In the time of the Renaissance, that party else would have been a prince or even the Pope; today, it's a government, a builder, a developer or an individual. In most of the

cases, the architect is in a position of service and without total control of the project. This wasn't the case for Soleri and Arcosanti. The Soleri bells provided funds, and with these funds, Soleri could do exactly what he wanted.

What lessons have been learned from Soleri and Arcosanti? A few come to mind. Once again, context and design are interconnected. However, the interconnection can sometimes be broad, comprehensive and often much more than what's first perceived. This was the case with Arcosanti, where architecture was fused to ecology with all of its biological connections, and not just the physical nature of place that we observe. In a way, arcology became a precursor of the sustainability movement that we are experiencing today. We also learn that doing what we want as designers comes with certain conditions. Soleri most likely knew that no one would fund his dream. Therefore, he found another way to fund it himself. His previous knowledge of metal casting led to the designing and making of bells as a means to an end. In other words, if the existing model of designing doesn't allow you to do what you want to do, then the answer is a simple one: change the model.

The Dymaxion House

Buckminster Fuller wasn't your average designer, architect or engineer. He didn't come to these professions via the traditional route. For example, he never graduated from a school of architecture. That being the case, his knowledge base and his approach to design wasn't conditioned by long-standing practices in these disciplines. One could go as far as to say that his professional education hadn't been tainted by a belief system passed on from one generation to the next such as we saw with the Beaux-Arts style. The latter originated in France yet found its place in the United States because many American architects were trained in Paris and brought the style back with them.

Fuller's story is much more than one style over another. For example, Fuller never based his designs on the right angle, which permeates so much of design and the built environment. Think about it: the right angle is everywhere. It occurs in vertical walls on buildings, as well as square rooms in museums and rectangular wayfinding signs at airports. For Fuller, the simplest

and most stable geometric shape was the triangle, not the square. After all, we know that a square has to be triangulated if it's to be structurally sound. Look at a trestle bridge; it's full of triangles. Consequently, Fuller would always revert to the triangle when considering structures. And with the triangle, came the concept of the dome. In this case, it wasn't only the fact that a triangle could be the basis for a dome but that the dome itself was an ideal form for certain uses. For example, a dome exposes less surface area for its given volume than those a cube of the same volume. Needless to say, Fuller didn't follow the conventional stylistic path when designing.

It's this unconventional approach to designing that led Fuller to rethink the common house. This he did in 1929. Not only was the unconventional portion of his thinking based on the dome shape for the house but it was also based on the use of factory production. These two features—domes and factory production—were totally out of place in residential architecture. Perhaps because he wasn't trained in the ways of the architect, Fuller wasn't constrained by conventions. His approach was much more based on applying scientific logic to a house, including early considerations for water usage and air circulation. Moreover, he saw no reason why the typical services needed in a house should not be centralized into a kind of service core.

What did the Dymaxion house look like? It had a circular floor plan with a dome roof. Both were perceived by Fuller as the only logical formal approaches for a house. It was made of aluminum. Although aluminum was a more expensive material, it had a longer life than other materials and needed little maintenance. He placed the services such as water and sewage into a central core, which made a great deal of sense. Lastly, the house was made in a factory, shipped and assembled on site. His design was perhaps unconventional but it made logical sense, at least it did to a person such as Fuller.

The design of the Dymaxion house remained dormant until the end of World War II. With the conflict over, young men began returning home. They were about to start families and would want to buy houses. This contextual change and potential market for new homes would surely favor the Dymaxion house. There was also a second change that favored the Dymaxion

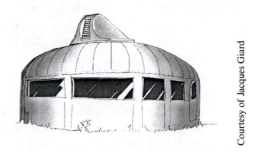

Courtesy of Jacques Giard

Image 34: The Dymaxion House, designed by Buckminster Fuller, was a complete departure from the architectural style of the traditional American house.

house: the overcapacity of production in some aircraft factories. These factories had a great deal of experience with aluminum fabrication but would most likely close with the end of wartime production. The combination of the two—a demand for houses and available production facilities—seemed to be an opportunity in the making. But it wasn't to be because only two Dymaxion houses were ever made.

What are the lessons learned? There are several but perhaps there's a notable one, which is that technology may be logical at times but not so human emotions. Buying a house isn't only a financial decision; it's also an emotional one. When a family invests its entire savings into something as significant as a house, it's not about to invest into something that's dramatically different and new from what's known and traditional. The risk is too great. Logic can only take you so far when emotions are involved. The example of the Dymaxion house shows the difference between a house and a home. This sentiment was stated by Lao Tse a long time ago when he said, "*The reality of the building doesn't consist in the roof and walls but the space within to be lived in.*"

Habitat 67

Paxton's Crystal Palace focused on the form of an artifact and its appropriateness to an era steeped in new technology. As we discovered, industrialization was creating—if not imposing—changes on society. Design and designers weren't immune to these changes; in some respects, they were creating opportunities to design in ways appropriate to the changes. That said, traditions endure. They aren't easily altered or even displaced.

One hundred years later, we would witness another change in thinking when it comes to the design and construction of structures and buildings. The time was the 1960s; the place was Montreal, Canada; the person was Moshe Safdie, who was in his last year of architecture at university; the event was a world's fair scheduled to open in the spring of 1967. Safdie, as well as an army of other designers and architects, had descended on the city because of the opportunity of being involved in leading-edge design typical of a world's fair. On that note, Buckminster Fuller, the American architect and engineer of the Dymaxion House discussed previously, was among these designers. His story of the geodesic dome will follow next in this section. Returning to Safdie, he had an idea for a housing complex, one that was based on mass production as opposed to the traditional one-off direction of most building construction. Looking at his design today, you can almost see what was going through his mind: if factories can produce identical components in large quantities, why can't the same general manufacturing principle be used to make housing units? Admittedly, these building units would be larger than most everyday things but they could nevertheless be based on the principles of mass production. Think of the Lego brick. Injection-molding machines spit out identical pieces in a million copies. Why can't the same manufacturing principle be used to create large quantities of housing units?

The concept of using an industrialized approach instead of the traditional hands-on approach became the basis for Safdie's concept for a housing complex

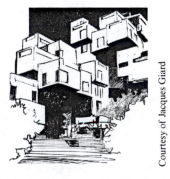

Courtesy of Jacques Giard

Image 35: Habitat 67, designed by Moshe Safdie, was based on the industrial process of cast concrete modules, which were later assembled on site.

that came to be known as Habitat 67. Large housing units, the size of small houses, were made out of concrete in a local factory. Each unit was fitted with the needed electrical and plumbing services. Once having left the factory, the units were transported to the site, where they were lifted and stacked one on top of the other. When you first see the housing complex, the analogy to Lego becomes even more apparent.

What are some of the lessons learned from Safdie's Habitat 67? Two stand out. The first is that the Habitat concept exemplifies how artifacts are connected intimately to making. If innovation is to take place, then there may be a need to do a complete rethinking of the design process. Paxton did much the same with the Crystal Palace. His design direction was predicated on a factory-made approach accompanied with on-site assembly. In combination, it was this design direction that made the Crystal Palace innovative. It would have the same results for Safdie and Habitat 67 a century later. Second, there's the lesson of scale; that is, a dramatic change in the scale of an everyday thing—from small to big or vice versa—can provide us with a totally different perception of that same everyday thing. In many ways, the principle that underpins the Lego block and the Habitat module is the same. The only difference is scale.

The Geodesic Dome

For Buckminster Fuller, the triangle was the ultimate building block. We saw the application of the triangle, at least on a lesser scale, with the Dymaxion house. The triangle would become much more obvious with the concept of the geodesic dome. As a point of clarification, a geodesic dome is a lattice structure in which circular elements, or geodesics as they're called, constitute a shell in the form of a dome. The geodesics are created using triangular components.

The dome isn't a conventional type of structure. Few buildings are shaped like a dome. When the dome does exist, it can be for functional reason such as the storage of pressurized gas. In such situations, the use of a dome makes sense, certainly more sense than a rectangular structure. The latter would suffer from what's called centers of stress concentrations, which would occur at every corner of a rectangular structure.

As logical as the dome may be, there are some impracticalities. You can't, for example, nest or stack domes efficiently. On a typical city block, several rectangular buildings can be nested without a great deal of lost space. This isn't the case with a dome. Nevertheless, the dome has its merits, especially for buildings intended for a specific use. Such was the case with the American pavilion at the 1967 world's fair in Montreal. This was the same event as the one where Safdie designed and built Habitat 67. In events such as world's fairs—think of the Great Exhibition of 1851—each country wants to put its best foot forward. These are moments when only your best will do. For the United States, the best foot forward when it came to a structure was the ingenious design of the geodesic dome. After all, the design was innovative and like the Eiffel Tower it made a statement about the state of technology in America. Its visual simplicity combined with its size also made it a memorable structure. There was no other structure quite like it on the exhibition site. The exhibits on the inside were equally memorable. They clearly spoke of the progress that the United States was experiencing. But it was the building that made the overall statement about American ingenuity and progress.

Like the other designs that we've seen, there are lessons to be learned from the geodesic dome. Much like the innovative features found in the Crystal Palace and Habitat 67, the geodesic dome was constructed of components that were mass produced in a factory and shipped to the site for assembly. There's nothing radically new in this design direction except for the fact that it's still not the practice of choice for most buildings, even today. More significant perhaps was the underlying logic of the structure. The style of most buildings is classified either by a period or era such as Baroque or Modernism or with a person such as Mies or Gehry. Classifying the geodesic dome as a style wasn't possible. On the one hand, it was engineered and without the imposition of a visual style; on the other hand, Fuller's geodesic dome can't easily be forgotten once seen because of its pure simplicity and logic.

The San Francisco–Oakland Bay Bridge

One feature that differentiates structures from tools is mobility. Tools are mobile, but structures aren't. They're immobile. Consequently, tools are more prone to the economic forces of globalization. That is, a tool can be designed in one place, made in a second, and used in a third. The smartphone is a good case in point. The Apple iPhone is designed in Cupertino, California. However, it's not made in the United States; it's made in China. Perhaps this is because it's used only in China; but we know that this isn't the case at all. It's used in the United States, China as well as many other countries. The physical nature of the smartphone makes this possible. They're small, light and compact.

Obviously, structures aren't like smartphones. They're mostly large, heavy and anything and anything but compact. Moreover, they're immobile. Designing them in one country, building them in a second, and shipping them to a third is out of the question. At least that was the case until recently. The San Francisco–Oakland Bay Bridge is a good example of a design that has been subjected to the forces of globalization.

The San Francisco–Oakland Bay Bridge is the latest addition to the many bridges in the Bay Area. It was designed as a replacement for a part of the original bridge that had been seriously damaged as the result of an earthquake in 1989. The project began in 2002 and was completed in 2013 at an estimated cost of $6.4 billion. The interesting part of the story is the making. Large projects such as we find in civil engineering or in architecture, such as bridges or skyscrapers, are most often built in the place where they will be used. In certain situations, some components could originate from other parts of the country such as spans made in a steel factory in Ohio, for example. Generally speaking, however, the further the distance, the greater the cost because of the transportation incurred. This is why contractors want to keep the making local.

The San Francisco–Oakland Bay Bridge posed a different challenge. It appears that the requirements for the proposed design of the steel components couldn't be made in America. This situation created a logistical problem because, in principle, the cost of the bridge should increase in direct proportion to the distance where the parts would be made. This scenario should therefore rule out places such as China. But that wasn't to be the case. As far away as China is from Oakland, it was the place to go to have the bridge made and shipped back to the Bay Area for assembly. The reduced costs

of making the components as far away as China compensated for the shipping costs.

In part, the story of the San Francisco–Oakland Bay Bridge parallels the story of the smartphone: designed in one place, made in a second, and used in a third. Yet, we are talking about something that's immobile. Is there a lesson to be learned here? Yes, there is. It would appear that the certainty of immobile everyday things being designed, made and used in the same place is no longer the case. Even the long distance between California and China is no longer an impediment for design.

SIGNS AND THE VISUAL PRESENCE OF EVERYDAY THINGS

Here's a puzzling reality of life. Despite the thousands of different everyday things that surround us, we've no difficulties in recognizing each one and we do so without using labels or tags to identify these many everyday things. This is quite an amazing feat when you think of it. That is, we've all these different everyday things with very different shapes and colors—tennis racquets, coffee makers, bicycle helmets and spoons—yet we recognize each one, give it a specific name, and rarely confuse one with the other. Clearly, there's a sign-like quality in each that we can read.

What are signs? In the context of design, a sign is usually a visual element used to signify something. Think of the letter A. It's a visual composition of three lines. When used in the Roman alphabet, it signifies a certain human sound. But it can just as well signify a top grade in a course or the first in a series or a personality type. Whatever it stands for, there remains a general agreement to its meaning or code. Such signs are considered to be explicit. However, there are many signs in our Artificial World that don't carry such explicit meanings—at least a meaning that is so well codified. The everyday things mentioned previously—the tennis racquets, coffee makers, bicycle helmets, and spoons—fit into this category. General categories or families of forms do exist but they aren't always explicitly codified. Such signs are examples of implicit signs.

Some Background on Signs

Human beings have been using signs of one kind or another for millennia. Some of the earliest signs, many of which go back to the days of the Fertile Crescent, were meant for record keeping and as a means for organized societies to govern themselves. Cuneiform writing was one of the earliest decipherable sets of signs. Simple signs were also used to communicate at a time when there was no known alphabet. Such is the case with pictographs and petroglyphs, which we believe represent known elements in the daily lives of the people who created them, such as images of deer and snakes. Nevertheless, we can never be certain. Today, the same concepts of simple visual images exist for pictograms on highway signs and icons on computer applications.

Explicit and Implicit Codes

Some signs have very specific meanings and are used accordingly. Alphabets are such sets of signs. With our very simple 26 graphic signs or letters—after all, a letter is nothing more than a few simple lines—we can create a written language with words and meaning that can be transmitted, read by others and kept as a record. This is rather impressive for such a simple system. Signs such as letters as well as numbers, pictograms and icons constitute an explicit form of visual communication. This is because, generally speaking, we've agreed to a common meaning or code for each sign. But explicit signs are not the only signs; there are also implicit signs for which we don't have an explicit code. For instance, most people who see a Rolls Royce limousine for the first time read the explicit sign: this everyday thing is an automobile; after all, it has all the requisite signs of an automobile—wheels, windshield, hood and trunk. But this person also reads the implicit signs or code: this car is expensive or the owner is an important person or is wealthy. There's no sign or code that provides this information explicitly. The manufacturer's retail selling price isn't pasted on the automobile; neither is there a curriculum vitae of its owner. Nevertheless, the form of the automobile—its color, the details and context—says it all. And it does so without ever using letters or numbers or icons. We quickly decode the implicit message of the Rolls Royce limousine.

Explicit and implicit visual communication are common in industrial design. After all, we interact with all manner of everyday things every day. We see a chair and we sit. We see a door, look for a door handle, and open it. We see a pink cell phone and assume that it belongs to a young girl. Yet, there's no visual code for everyday things that's as specific as there is for letters and icons. Everyday things don't have labels or tags on them with which we can identify them and their purpose. Yet we read and recognize everyday things repeatedly and do so with few errors. We identify them all, generally know what they are, and use them as they're meant to be used. When was the last time you saw an automobile with a label that said "Automobile"? Or an airplane with the word "Airplane" painted on the side? Nevertheless, we recognize both as well as most other everyday things despite the diversity in the forms and shapes of everyday things.

The Look of Everyday Things

The chief engineer of the Challenger corporate jet made a revealing comment years ago while briefing his design team about the new project. He stated that whatever its performance criteria, the Challenger had to look like a corporate jet. From his perspective, one thing was clear: Irrespective of the engineering requirements for the new Challenger, there was a form that was more appropriate than any another when it came to the look of corporate jets. What's particularly revealing about the statement is that it came from a person involved in aeronautical engineering where measurable factors of one kind or another are objective and critical to product success. Yet here he was talking about something as subjective as the look of an everyday thing.

The forms of everyday things help determine what we identify as an everyday thing. This is why we never mistake a chair for a church or for dishes. They look different because their forms are different. Like the letters of the alphabet, signs—alone or in combination—communicate via a visual language. The form of the everyday thing is part of the visual language as is its color and texture. Moreover, we learn to read the visual language of everyday things from our earliest childhood. We certainly don't learn to read it theoretically by way of lectures and assignments like we do with

arithmetic. Furthermore, we become very proficient with the visual language. Even when placed in an alien environment, it doesn't normally take a person that much time to read the everyday thing and discover what they are. Yet, these same everyday things have no nametags or labels.

People have developed different means and principles by which they identify and group everyday things. This is generally done in order to make some sense or order and provide some structure to the panoply of everyday things that surrounds us. For example, it's not unusual to use names that pertain to the human body as the basis for the name of an everyday thing. Therefore, an axe or hammer has a head and a handle. Both words are connected either directly or indirectly to the human body. Much the same can be said about chairs. It has legs, arms, feet, a seat and a back. All of these terms connect to the human body.

Names of everyday things can also derive from their technological and scientific sources. This basis for names uses a kind of logical code for naming. The concept of distance or *tele* is one such scientific source and has given us names such as telegram, telephone, television and telescope. Similarly, we use terms that define size to define some everyday things. This is the case with kilo, mega and giga with the size of memory in computers. Or with terms such as micro, macro, supra and mega when referring to other types of sizes or physical dimensions.

Wim Gilles, a Dutch designer and professor, used the phenomenon of parts—alone or in combination—in his study of everyday things. He called this approach *productology*, or the study of products much like biology is the study of life. He also used the term micro, macro, supra and mega. Gilles' approach begins by assuming a kind of atomic structure in everyday things. That is, no matter how complex an everyday thing is, it can be broken down into its simplest, composite parts. A machine may be a complex everyday thing but, in the end, it can be broken down to nuts and bolts, so to speak.

Based on this supposition, all everyday things are first located into one of two general groups: prime products or composite products. By their very nature, these groups constitute the basic elements of a visual language. Prime products are everyday things that are

complete in and of themselves. They don't require the addition of other everyday things to become an entity. A nail is a prime product, much like a bolt or a screw. As visual elements, these are easy to learn and remember principally because of their simplicity. Composite products are different. They're everyday things that exist as a combination of prime products. A simple hinge like we find on a door is a composite product. It's a combination of several prime products.

Prime and composite products can be viewed from yet another perspective. In this perspective, there are four classes of product signs or elements: micro-products, macro-products, supra-products and mega-products. Micro-products are essentially the same as prime products. That is, they're monolithic things. Furthermore, they're components that, when combined, go on to become macro-, supra- or mega-products.

The second group of everyday things is called macro-product. Everyday things in this group are composite products; that is, they're a combination of micro-products that become a stand-alone everyday thing such as a pair of scissors. In other words, micro-products with one visual meaning go on to take on a second but altogether different meaning when combined as macro-products. Returning to the scissor example, each part has its individual name or identity as a sign but, once combined, becomes the name that we associate commonly with products known as scissors.

When macro-products combine with other macro-products, they become a supra-product. This is the third group of everyday things. Such everyday things are normally assemblies of various macro-products as well as micro-products. Examples of supra-products are power tools, automobiles and airplanes. Any one of these supra-products could be deconstructed into a variety of micro- and macro-products.

The last category includes the mega-products. These products are a combination of micro-, macro- and supra-products. Mega-products can be as large as the largest of the supra-products, such as an airplane. The difference, however, is that they're immobile. Mega-products stay in one place and include such everyday things as houses, buildings, structures and cities.

As complex as the relationship of these various categories and groups may first appear to be, a real-life example, such as a mobile phone, clarifies the picture. At first glance, the modern mobile phone may seem to be just one more everyday thing. Based on Gilles' *productology*, however, it's an example of a composite product and, more specifically, a supra-product. Why? First, the modern mobile phone is constructed of many different individual parts. There are some very simple components such as the electronic switches on the inside that activate the functions of the buttons. In Gilles' system, such switches are prime or micro-products because they can't be decomposed into fewer or smaller bits. Second, there are several composite products in the modern mobile phone such as the microphone or the keypad or even the electronic plugs. In such cases, various micro-products have been assembled to create two subassemblies that, alone, would be virtually useless. Lastly, we have the mobile phone as a supra-product, which is nothing more than an astute assembly of well-selected but different micro- and macro-products.

Any supra-product or mega-product can be analyzed in the same fashion, leading to a similar analytical result. And most people would make no mistake in identifying this combination of micro- and macro-products as a mobile phone. The visual language occurs first in the individual parts yet changes when the parts are combined. Almost magically, switches, keypad and screen—all names of individual parts—become recognized and known as a mobile phone.

There's one other fascinating aspect of the transformation of many micro-products to supra-product. It's an aspect not unlike the written language. Everyone has experienced the reading of a complex topic. We read the paragraphs several times but still don't understand the content. Not long thereafter we come across the same topic but written by a different author. We read the material and immediately understand the topic. In this case, we experienced the benefits of effective communication by way of translating complexity into simplicity using words. Much the same happens when reading the signs imbedded in products. Our example of the mobile phone makes the point. Taken separately, all of the micro-products create a rather visually complex supra-product. In such a situation, industrial designers must become like the author who simplified the complex text mentioned above. Industrial designers are often tasked with taking the complexity of the

micro-products to the simplicity of the supra-product in order for users to read it correctly. Modernism via form follows function attempted to do just that.

In summary, the quantity and variety of everyday things can be overwhelming. That certainly is the case for industrial designers, and even more so for the average person. Nevertheless, there's one certainty about this quantity and variety despite the complexity: everyday things are like mirrors. They reflect who we are, our desires and our values. As material culture, they can tell us a great deal about ourselves, if we can only learn to read them.

NOTE: Readings for chapter 10 are found in the back of the book.

CHAPTER 11

DESIGN AND POLITICS

INTRODUCTION

Nothing situates better the place of design in context than does politics. Why is that so? Because politics is the system by which societies govern themselves. That being the case, how does design fit into something as broad yet as important as governance? After all, politics determines what we do as a society and how we do it. What does that have to do with design?

As a first step in arriving at an answer, we need to return briefly to the time in history when humans began to come together as groups. At the most basic level, it began with bands of people, then tribes and eventually chiefdoms. Later, larger jurisdictions were created such as states, then empires and ultimately leagues. As societal groups became larger, a need arose for well-defined political systems. Three became more common than others: authoritarianism, monarchies and democracies. Egypt is a good example. Egyptian society was large in numbers yet well organized with a well-defined societal order or hierarchy. In part, this is why Egypt was successful for as long as it was.

The hierarchies in these early empires most often vested supreme authority to a dictator or emperor. The reigning emperor remained in power until he was deposed. Such was the case with Napoleon who saw himself as Emperor of the French. Monarchies were similar to the authoritarian emperor except that authority was passed down to the heirs in waiting.

Monarchies came to an end generally in one of two ways: the monarchs were either overthrown by the people such as occurred with the French Revolution in 1789 or the monarchs remained in power but only as figureheads as is the case in the United Kingdom.

Democracies exist when the people control the political system. In such cases, there are general elections where each person has a vote, or at least does so in principle. There are, however, nuances among democratic systems. For example, a country can be democratic and still live under socialism as do most countries in Europe. In fact, many European countries even have communist parties. In such cases, and if the people so decided by vote, the communist party could come to power. Generally speaking, however, communist governance as found in Cuba, China, and North Korea is based on the one-party system. There are elections now and then but everyone running is a member of the same party, in this case the communist party.

GOVERNANCE

Governance implies that there's a governing structure or model within a specific jurisdiction or country. Most often, this becomes one form or other of government. But governments aren't all the same; they span the spectrum of influence in society, from top-down control and regulations at one end to bottom-up,

grass-root governance at the other. The governance of most developed countries sits in the middle of this spectrum, from a more regulated governance in many countries of Southeast Asia to a somewhat less-regulated governance in most European countries and an even more deregulated model in the United States.

What about design? How does it fit into this political and government landscape? It fits in as long as design is perceived as part of the broader economy of creating the artificial as understood by Herbert Simon, the American economist and social scientist. If the production of anything artificial—such as iron, oil and lumber—is perceived as a design activity, then clearly design is integrally linked to politics and governments. After all, iron, oil and lumber do not only provide a form of economic strength but have also served as political weapons in the past and will continue to do so in the future. Think of the recent oil crises and their connections to the Middle East or the dumping of cheap steel by China or ongoing trade disputes between Canada and the United States over lumber. All of these had political overtones of major proportions and each one is connected to an artificial commodity.

At the scale of everyday things or products, the same pattern has occurred with political maneuvering using tariffs on certain imported goods or with trade pacts such as the North American Free Trade Agreement, known as NAFTA, with the United States, Canada and Mexico. These actions may have been precipitated by politics but they have had a direct impact on products of one kind or another. The example of the Sea-Doo personal watercraft or jet-ski makes the point well, in this case between Canada and Brazil. The company that designs and makes the Sea-Doo is based in Canada. The product is made and assembled in a factory in Canada and is ready for use once delivered from the factory. That's the case for most countries but not for Brazil, which has a high tariff of some fully assembled products. Personal watercrafts are one of these products. Therefore, the Sea-Doo is shipped in two separate parts: the body shells are in one container and the engines are in another. Both of these parts are then assembled in a small plant in Brazil. This political decision on the part of Brazilian politicians forces the designers of Sea-Doos to design the jet-skis in such a way that they can be assembled somewhere else other than the main Canadian factory. Clearly, the politics of Brazil are impacting the decisions of a designer in Canada.

POLITICAL AND SOCIAL VALUES

Certain social values are associated with certain societies. For example, values such as equal rights, multiparty democracy, the rule of law, open economies and freedom of speech are at times perceived as Western values. But are they? Or are they universal? How are they connected to design?

Let's begin with values that are often said to be Western values. Some of these were just mentioned—equal rights, multiparty democracy, the rule of law, open economies and freedom of speech. We in the West take most of these for granted because we've lived with them all of our lives. We've known nothing else. Moreover, they have become an integral part of so-called Western culture with their roots originating mostly from European history and traditions. These values are so imbedded in our culture that they have at times become the topic of popular art. Normal Rockwell, the American artist, made freedom of speech a theme for a series of paintings that he did in 1943. It's difficult for most of us to see a world that would be anything but one defined by equal rights for all people or one with elections of one political party or another or one with a justice system that treats everyone equally. These values appear nothing less than common sense. However, such isn't always the case. Turning back to the Industrial Revolution or the colonial era of the United States, we would quickly realize that what we take for granted today wasn't common practice. For example, child labor was a fact of life in England in the 1800s. And women in England weren't allowed to vote until 1918. Even then, they had to be 30 years of age and meet certain property qualifications. In the United States, women obtained the right to vote in 1920. As a bit of trivia, Switzerland is clearly considered as a developed country yet it only allowed women to vote in 1971.

Politics create a context, and, as we know, design always exists within a context. The next section of

this chapter becomes more specific about design and politics. It explores several examples where design and politics are intertwined and almost inseparable. These examples will be offered as short case studies.

DESIGN IN THE BOTTOM-UP POLITICAL MODEL

Today's smartphone owes its design origin to the original telephone invented over 100 years ago. What possible connections could there therefore be between early technology and politics? After all, isn't a telephone an issue of technology? How do politics enter the picture? The story is a fascinating one and begins with Alexander Graham Bell. By understanding the context of Bell's life beyond the invention of the telephone, we come to realize that the impact of politics or context on design is limitless.

Bell was born in Scotland in 1847. History tells us that he had a natural curiosity even as a child and was known to have built homemade devices as early as the age of 12. He was also inclined to engage in art and music. His connection to music, or at least sound, provides us with a clue of how his life would evolve. His mother was also gradually becoming deaf, which deeply affected Bell to the point that he would voice his speech directly onto his mother's forehead. This affinity to sound, voice and music also came from members of Bell's family and their involvement with the teaching of elocution and the concerns of people who were deaf or mute. Clearly, the subject and study of human sound was becoming an integral part of Bell's psyche and expertise. However, there's quite a leap between the study of human sound, the invention of a telephone, and politics.

Despite Bell's prolific record as an inventor, he wasn't the most successful high school student. Except for the sciences, most other school subjects didn't interest him. His grandfather, however, had some very positive influence on Bell's education, especially with speaking clearly and with personal conviction. Both qualities were perceived to be important to a person's education and upbringing. However, the benefits gained from the contact with his grandfather were somewhat unintended. So, to a certain extent, was a visit in 1863

undertaken by Bell and his father to a demonstration of a machine that simulated the human voice and that had been developed by Sir Charles Wheatstone. This demonstration reinforced Bell's desire to understand the human voice and its artificial creation even more.

A few years after, at the age of 19, Bell wrote a paper based on some experiments that he had done only to find that Hermann von Helmholtz, a German scientist, had already published similar findings. Fortunately, this revelation didn't deter Bell. If anything, it encouraged him to pursue the experiments even further. He stated as much when he commented, "*I thought that Helmholtz had done it . . . and that my failure was due only to my ignorance of electricity. It was a valuable blunder . . . If I had been able to read German in those days, I might never have commenced my experiments!*"

It doesn't take a clairvoyant to realize that the combination of the artificial voice and electricity was the early beginning of the telephone. Family illness, especially the death of Bell's brother in 1870, changed his future plans, however. Now living in London, the Bell family—his brother's widow and Bell's parents—moved to Canada in the same year, more specifically, to Brantford, Ontario. This was the first political connection in Bell's story. Canada had gained its independence from Britain three years earlier in 1867 but was still considered a kind of colony for the British. Canada was perceived as a safe haven for them—it had the same language, same religion, same social values and a parliamentary government, which was based directly on the British parliament.

Once established in his new home, Bell continued his work on the human voice. He built a small workshop for himself and developed experiments with electricity and sound. For example, he worked on the electrical transmission of music over distance. With his father, Bell continued to be involved in speech training. This expertise provided an opportunity to become involved with the Boston School for Deaf Mutes when he visited the school in 1871, and then to the American Asylum for Deaf Mutes in Hartford as well as the Clarke School for the Deaf in Northampton. His obsession about the challenges for people who were deaf or mute never ceased. In fact, Bell believed that with the necessary resources deafness could be brought to an end.

The connection between Canada and the United States is yet another political element that impacts design. Not all countries have borders that afford easy passage of people back and forth. Many countries have strict border controls. This was not the case with the border between the United States and Canada. The border policies between these two countries have most always been instrumental in encouraging the exchange of goods and services. It's said to be the longest undefended border in the world. This cross-border connection was formalized in 1994 with the North American Free Trade Agreement or NAFTA in which the border between the two countries almost disappeared for the purpose of the trading and exchange of goods and services.

Bell continued to work in the Boston area while regularly returning to Canada. He obtained the post of professor in the School of Oratory at Boston University, where he became engrossed in the scientific environment at the university and the many experiments that were being undertaken there. Perhaps not the ideal situation for Bell, he nevertheless continued with his teaching all the while spending time with experiments in sound and its transmission. Balancing these two demanding agendas began to take their toll on him. In 1873, Bell decided to concentrate strictly on his experiments with sound. In the years that followed, he focused his energy of the harmonic telegraph and a device he called a *phonautograph*, which was a device that drew the shapes of sound waves. These devices he developed both in Boston and in Canada. A breakthrough, of sorts, occurred in 1874 when Bell received the financial support to develop the technology to send multiple tones on a single telegraph wire. The latter was becoming more common. It was in the same year that Bell met Thomas A. Watson, an electrical engineer. Their meeting would propel Bell even closer to what would eventually become the telephone. The first step in that direction was taken in 1875 when Bell filed a patent for the acoustic telegraph. Experimentations continued, this time in Canada, where Bell began transmitting voice messages, albeit simple ones, over a five-mile distance. This achievement is now considered the first ever long-distance telephone call.

With the idea in hand, Bell sought to commercialize his telephone idea. He offered the patent to Western Union for $100,000, which would have been considered a large amount given the unknown commercial viability of this new technology. The president of Western Union considered the offer unacceptable and rejected it, which is a decision that he would regret stating two years later that he now would gladly pay $25 million for the patent.

The story of the Bell company is now history. It would go on to become one of the early industrial giants and became a leader in research and development in telephony. As for Bell himself, he continued to be the inveterate inventor and played a role in the design and development in the first powered flight in the British Empire and the first hydrofoil. His range of interest seemed to be as broad and diverse as those of Leonardo da Vinci and Thomas Edison.

How were politics a part of this design story? They occurred in several ways. First, there was the free market economy based of a democratic political system. Both in the United Stated and in Canada, inventors had few impediments to slow down their research and development. Governments imposed few restrictions. Then there was the freedom to change country of residence in a relatively unencumbered way because of shared political beliefs. For Bell, this was the case both from his move from England to Canada and once again from Canada to the United States. This was a second political consideration. There was also the freedom to move ideas from one country to another in a political environment that allowed for such transactions. This happened regularly as Bell went back and forth between Canada and the United States.

Bell and the telephone is an exemplar of an invention resulting from personal ingenuity that was allowed to evolve in a context with few encumbrances. It's the story of a man whose ideas and perseverance made the world a better place, but who was able to do as much because of a political setting that provided the necessary catalyst for this invention to happen in the first place. These are the operational qualities often found in the bottom-up political model.

DESIGN IN THE TOP-DOWN POLITICAL MODEL

The story of Bell and the telephone is an example of a bottom-up story. That is, Bell's invention came as the result of the curiosity of one person investigating an area of personal interest and developing it in an

unfettered economic and political environment. This setting appears to be ideal for an inventive mind but great ideas can also occur in a direction quite opposite to this. This was certainly the case with the Volkswagen Beetle.

It's important to situate time and place when discussing the Volkswagen Beetle. Both factors are significant in the understanding of any artifact and perhaps even more so with the Beetle. Germany and the German people were in a state of political flux in the 1930s. The country had suffered severe losses—both human and material—in World War I. Moreover, there were conditions in the Treaty of Versailles—the treaty signed by Germany that ended World War I—that had become a sore point for many Germans. One of these conditions was the fact that Germany was required to accept full responsibility for all losses and damages caused by the war. Consequently, Germany was forced to disarm, make territorial concessions and pay certain countries for the cost of rebuilding. For some Germans, these conditions were unacceptable. Adolf Hitler was one of these Germans. Hitler had fought in World War I and had experienced Germany's defeat personally. In 1919, one year after the end of the war, he joined the German Worker's Party, which would become the National Socialist German Workers Party. He became its leader in 1921. His attack on the Treaty of Versailles combined with his exceptional skill as an orator placed him in the forefront of the changing political scene in Germany in the 1920s. By 1933, Hitler had become the chancellor of Germany and with this appointment turned the politics of the country into a one-party, autocratic system.

Not long after coming to power Hitler set his sights on the highway system or autobahns of Germany. He perceived this infrastructure as a strategic element in his plans to dominate Europe. Highways connected important cities and centers; they allowed the quick deployment of troops and weapons. The autobahns also provided the average German with an opportunity to travel however, that could only happen if there was an automobile available for the German people. In his autocratic way, Hitler gave the order to Ferdinand Porsche, a well-known engineer, to design an automobile for the German people, one that could carry Hitler's intention in its name: *Volks* or people and *wagen* or carriage.

Hitler didn't, however, give Porsche a blank check for the design. His order had specific design criteria or expected outcomes. For example, the design had to be simple, air cooled, capable of carrying two adults and three children, meet certain performance specifications such as a speed of 100 kph, and have a fuel economy of 7 liters of fuel per 100 kilometers. Hitler even went as far as creating the personal savings scheme that would allow Germans to purchase the automobile. Nothing in the design was to be left to chance.

Porsche already had some experience with automotive design when he helped develop the Porsche Type 12 for Zundapp in 1931. With his new engineering team in place, Porsche began the design and development of the Volkswagen, initially known as the Type 60. Two prototypes were built by 1935, followed in 1937 by 30 preproduction models made at the Daimler-Benz factory. These models showed what was to become the iconic look of the Volkswagen: an air-cooled engine mounted in the rear within a rounded, somewhat streamlined body.

Next came the need for a factory to build the Volkswagen. Hitler himself laid the cornerstone in the spring of 1938, but talk of war was once again in the air. The factory built only a few cars before production was begun on two vehicles for the military. One was the Kubelwagen or bucket car; the second was the Schwimmwagen or amphibious car. Porsche had a hand in both of these. Production after the war was understandably slow given the need to rebuild Germany from the ground up. The Volkswagen plant was initially under British control and the Beetle, as it was now known, began to come off the production line.

In the years that followed, design changes were most often minor and meant to add improvements. Styling, for the sake of styling, wasn't undertaken. Perhaps more significant was the fact that the simplicity of the design combined with its versatility made the Beetle an excellent car for many developed countries such the United Kingdom, Ireland and Japan as well as developing countries such as Mexico and Brazil. By 1972, the production of the Beetle surpassed that of the Ford Model T at 15,007,034. Ten years after, over 21 million Beetles had been produced. However, this level of production couldn't be sustained. With sales diminishing, Volkswagen closed its last plant, which was in Mexico, in July 2003 after making 21,529,464 Beetles over its 65-year history.

How were politics involved in the design of the Volkswagen? The story of the Beetle was one that evolved in an autocratic political setting, which is clearly the opposite of the democratic political system that we saw with Bell and the telephone. Nevertheless, the design of the Volkswagen was just as successful as the telephone and just as significant in its impact on society. One important difference between the two political systems, however, is the dependency of the autocratic political system to the autocrat in power. This dependency can be either good or bad. In the case of Hitler, the autocratic model had both advantages and disadvantages. The disadvantages we know all too well; one person is allowed to dictate to all others, which is undemocratic. That said, the disadvantages of autocracy didn't diminish the advantages that derived from the introduction of the Beetle and Hitler's vision for this relatively new technology. Of course, another autocrat may not have had a similar vision.

THE SOCIAL-AGENDA POLITICAL MODEL

Some political models are bottom-up; others are top-down. In the case studies of Bell and the telephone and Hitler and the Volkswagen, we saw how these two political models affected the design process. In both cases, however, we were dealing with the mind-set of two individuals—Bell in one case and Hitler in another. It was their values as individuals that drove the design process. What if the mindset is that of a group or of a culture? This will be the theme of the third case study.

The case study is set in Sweden. Politically speaking, Sweden is a democratic country with a constitutional monarchy. By land area, it's the third largest country in Europe but has a relatively small population of nearly 10 million people. By most figures and rankings used by the United Nations and other such agencies—whether measuring life expectancy, health, education, competitiveness or human development—Sweden is always ranked very high. Based on a 2013 report from *The Economist*, Sweden, as well as other Nordic countries, was declared as "...*probably the best-governed country in the world.*" It appears that the Swedes have found a way to use politics, which, as we know, is the means of governing, to their advantage.

There's one additional feature to the Swedish picture that needs to be included in the context. Sweden is an inclusive culture. There's a strong sense of community or of the group. For example, nearly 70% of Swedes belong to the same church, the Church of Sweden. This sense of group as the result of one shared religion creates a strong bond or identity for the Swedes compared to, for example, the United States where there are many different religions. This sense of group also makes the idea of socialized services easier to accept. A social service such as healthcare is perceived more as something to help members of your own group than the right of the individual. The same principle applies to state education and state social services. Therefore, it's not at all surprising that one form or another of socialism governs the country. This doesn't mean, however, that design and innovation can't thrive. They do and do so very well. IKEA is a multinational corporation with very deep Swedish roots and remains one of the most innovative corporations anywhere.

Another example is the inclusion of people who aren't physically or mentally capable as the average person. As early as 1969, Swedish designers were working on projects meant for the so-called handicapped market. *Ergonomi Design Gruppen* was one of these groups of designers. It was involved in the design of everyday things that needed to be handled such as kitchen tools and much like what we see with OXO Good Grips but 30 years earlier. Such design exploration was justified, in part, because of the attitude that design should not only be inclusive but that people should not be excluded because of design.

The same inclusionary attitude existed with the story of the seat belt—sometimes called a safety belt—in passenger cars. In this case, the story begins in the 19th century, well before the automobile was a common everyday thing. There are records of early seat or safety belts going back to England with George Cayley, an English engineer, as well as a U.S. patent issued in 1885 to Edward J. Claghorn. Certain early aviators also cobbled seat belts together in order to be more secure in the seats of their airplanes. This type of safety belt would eventually become standard issue in military planes by World War II.

The design and development of seat belts like we find in automobiles today began in the early 1950s with Dr. C. Hunter Shelden, a physician in California. Because he often dealt with injuries as the result of car accidents, he proposed a series of safety modifications to the passenger car, including a retractable seat belt. Because of his initiatives, Congress passed a set of safety standards in 1959 but didn't go as far as mandating the seat belt. Some auto manufacturers—Nash and Ford, for example—offered seat belts as options as early as 1949, but it was SAAB, the Swedish car manufacturer, that first offered seat belts as standard equipment in 1958.

The design of the three-point seat belt—the type that we find in most automobiles today—was the brainchild of Roger W. Griswold and Hugh DeHaven, both Americans, in 1955. Unfortunately, it never went much further than a good idea seeking industry support, which it didn't find. There were several reasons for this lack of support. First, few car buyers ordered seat belts when these were offered as optional equipment. Second, the general feeling and logic among most American automobile manufacturers about the use of seat belts was quite simple: They would be a clear indication that automobiles were unsafe; therefore, don't make them available.

The Swedish inventor Nils Bohlin was of another opinion. He was convinced that seat belts could save lives. In a study undertaken by Bohlin, he showed that unbelted car passengers would suffer much greater injuries than passengers using a seat belt. By 1959, Volvo made the seat belt standard equipment in their cars. Moreover, Volvo made the patent available to other automobile manufacturers at no cost. In 1963, Congress made history by requiring that seat belts be standard equipment. Today, most of us don't give a second thought of buckling up. We do so in our vehicles and on planes. But one can't help but think that the sense of group—that is, taking care of our own—that so identifies the Swedes was an important catalyst for the general adoption of seat belts. After all, it wasn't the Swedish government that mandated seat belts but a car manufacturer that showed concern for its users and did so to the point of offering the patent to others at no cost.

How do politics fit into this story? As a country, Sweden is governed in such a way that people—its citizens—matter. This attitude isn't only made manifest in the political governance of the country with health-care and education for everyone but also in the attitude of the Swedes themselves. This was certainly the case with Nils Bohlin as well as the upper management at Volvo.

For most designers, political systems may be the last thing on their minds. That said, political systems are always part of the context and can impact design in a substantial way. Political systems have also impacted design in another way. They have influenced the development of national design policies of one kind or another. This will be the topic of the next section of the chapter.

THE CONCEPT OF NATIONAL POLICIES OF DESIGN

In the so-called Modern era, that is, since the early 20th century, certain national governments have found it to be in their best interest to support and promote design as part of a national strategy for growth. These government actions have manifested themselves most often as national design councils of one kind or another. That said, not all government policies followed the same model of operation. The political system in which these policies exist helped define the particular model. John Heskett, the British design historian, evaluated many of these models and concluded that design initiatives by national governments tended to exist in one of four categories. What follows is a description of each one of these categories.

The Statist Model

The statist model is one where industry is owned by the national government. Consequently, the design policy is created and implemented by a central government authority. Generally speaking, the government dictates the initiatives and quotas for manufacturing. Customers or consumers in that country have no real voice in the market place.

The design policies of the former Soviet Union and Eastern Bloc countries exemplified the statist model. So do the economies of North Korea and Cuba, although the latter is beginning to experience some changes. The

control of the political model came from the top and operated in a context based on conditions and priorities other than those derived from a free marketplace. Furthermore, factories and retail outlets were owned by the government, as was the land on which farmers grew crops or raised animals. In such a situation, farmers would be allocated a tractor by the state; shopping around for a tractor wasn't an option.

Competition—as it exists in an open and free market economy—doesn't exist in a statist model. A Polish industrial designer friend of mine once described the statist model under which he worked when he lived in Krakow, Poland. He wouldn't seek design work such as we do in the United States. Instead, he would wait until a government official directed him to go to this or that factory, where the manager of the factory would provide him with a design brief.

The Centrist Model

The centrist model is one where the national government plays a direct and an important role in determining and implementing economic policy. This is normally done in cooperation with industry. In other words, government and industry become partners in the economy of the country. The design policies in countries such as Japan, Taiwan and Korea are excellent examples of the centrist model. In each case, the partnership between government and industry is meant to assure commercial success, especially in areas of trade and export markets. Consequently, good design is perceived to be part of the strategy for commercial success.

Japan was an early leader in Southeast Asia in incorporating a policy of good design. The initiative began with the Design Council, which was situated in the Japanese Ministry of International Trade and Industry, and culminated with the Japan Industrial Design Promotion Organization launched in 1969. It's important to note that the initiative had its roots from the government sector involved with trade and industry and not from culture. In other words, industrial design was perceived to be an economic engine, not just a visual style.

Korea has taken a page out of the Japanese book on design and industry–government cooperation. In 1970, it created a design promotional agency called the Korean Institute of Design Promotion. Its mandate is to expand the design industry in Korea by promoting Korean design at home and abroad. We should therefore not be surprised by the variety of Korean brands now available to us—Hyundai, Kia, LG and Samsung. Their products all qualify as good design.

The Devolved Model

The devolved model is one where there's no explicit national policy on design, but where a government or para-governmental agency plays a role in promoting design. Most European design councils or design centers fall into this category, including those of Germany, Denmark, France and Great Britain. As a result, most of these countries have national design awards and design centers where design exhibits are held regularly. Unlike the centrist model, there's no direct connection or link to industrial or economic government policy. If connections or links do exist, they're indirect. The German Design Council or Rat fur Formgebung is such a devolved model. It was established in 1951 with the specific mission of promoting "... *the best possible form of German products*."

The Design Council in Great Britain is probably the granddaddy of European design councils. It began as the Council of Industrial Design in 1944, just as World War II was ending. Its mission then was "... *to promote by all practicable means the improvement of design in the products of British industry*." In 1947, Sir Gordon Russell took charge of the Council; he remained its leader for the next 40 years. Over that period, he established the essential operational framework of the Council. Russell's interest wasn't limited to the role of design in manufacturing and retailing; he also looked at design education and the role that it played in promoting good design. He was instrumental in opening the Design Centre in London in 1956. The Council expanded its area of influence by including technology and engineering, and with that move, changed the name from the Council of Industrial Design to the Design Council in 1971. The Design Council remains very much active today and is seen as playing an important role in the success of British industry. Many countries have looked to the Design Council as a model to imitate when thinking of their own design council.

The Indirect Model

The indirect model is one where a government implements laws, rules, and regulations for all sectors—the general population as well as industry—and in which design, like any other sector, is responsible for its own development. No one area or sector is favored over another, at least not in principle. If there's favoritism, it often comes as the result of lobbying or other similar pressures.

The United States is an example of the indirect model. Except in the areas of standards, safety and regulations, the government is never perceived as a partner of industry; neither does the government act as if it was a partner of industry. Therefore, there's no more reason for the government to promote industrial design than there's for it to partner with and promote marketing or the opera or NASCAR races. That said, there does exist the U.S. National Design Policy Initiative.

Its activities are nowhere near as focused or as broad as the Design Council of Britain, for example. Moreover, the initiative's last major activity was a conference in 2009. There's also the American Design Council, which, by its name, appears to include the many design professions. Unfortunately, this isn't the case because it only includes graphic design.

Given the noninvolvement of government implied by the indirect model, it would be fair to assume that industrial design would be relegated to the background in American industry. Of course, that isn't the case at all. Companies such as Apple, Ford, P&G and Herman Miller continue to produce world-class design by using all kinds of design services.

NOTE: Readings for chapter 11 are found in the back of the book.

CHAPTER 12

DESIGN AND SOCIETY

INTRODUCTION

There have been regular references made to context from the very first chapters in the book. The reference has almost always centered on the fact that design can't occur out of context. Whether we are conscious of contextual factors or not, they're always present. In The Designing Triad, reference was made to two types of contexts. One was micro-context or those tangible visual elements that we see and touch. These elements create the visual language and go on to define the artifact in visual terms. These micro-contextual elements include color, shape, form and texture. This is why we can recognize a chair despite the fact that the chair doesn't have a label or a tag with the word *chair* inscribed.

Macro-contextual factors in design are different. They're neither tangible nor often recognized in an overt way. But they're present nevertheless. Returning to the chair example above, it only exists because of social contexts in which chairs are used, where rank is created, or where some other social construct provides a rationale for a chair. In other words, the chair represents or reflects some form of social value. Much the same could be said about the chairs material. A chair that's made of plastic by way of injection molding says a great deal about the society that created it much like a handcrafted chair does. Both artifacts are chairs but each one reveals very different societal values about

the making process. In order to understand the place of the artifact in society, it's necessary to gain some general understanding of human groups of one kind or another and do it over time. This will be the focus of this chapter.

THE INDIVIDUAL AND THE GROUP

Humans have lived as members of groups for as long as we've been on this planet. For several reasons, people are essentially group oriented. Groups allow humans to better protect themselves. People can also better fend for themselves in groups. And they can also better care for the young and elderly. Early tribal societies were essentially small groups, at first nomadic as hunters and gatherers, and later as sedentary groups living in villages, towns and cities. People belonged to groups and identified with their group. They did so even overtly. Think of the tartan—or plaid as it's sometimes called—of the Scottish clans. The combination of lines and colors served to identify different groups in Scottish society.

Notwithstanding the group phenomenon, the place of the individual often existed within a group. For example, it wasn't unusual for a tribe to have a chief, someone who stood above all others and did so as an individual or in the form of rank. As groups

became larger, the presence of an individual in a ranking position grew. And with rank came more and more the identity of self. Think of the military. It's a group but certain individuals rise in rank and with that rise the individual comes forward more and more.

If we fast-forward to today, societies can be situated on a continuum where, at one end, we've societies of groups, and at the other we've societies of individuals. This chapter begins with societies of groups and how people tended to function in these societies. Short case studies of the design of high-speed trains in both Europe and Japan in the 1980s will be used to make the point. These same high-speed trains were presented in the chapter on Design and Transportation (chapter 7) but with a very different focus.

A great deal of information exists about various design aspects of the high-speed trains of Japan, France, Great Britain and Germany. For example, the names of the industrial designers for the French TGV, the British HST and the German IC-E are known. Respectively, they were Jacques Cooper, Kenneth Grange and Alexander Neumeister. But who was the industrial designer for the Japanese Shinkansen? Either no one knows or no one took credit. The European scenario shows that even in cultures of group—after all, France, Great Britain and Germany are more group oriented than the United States—certain individuals are recognized as the persons responsible for the industrial design despite there being hundreds of engineers and technicians involved in the design and development of the trains. This phenomenon isn't unlike Mies van der Rohe being recognized as the architect of the Seagram's Building in New York City. Did he personally design everything, inside and out? Of course not. Yet he remains the architect of record as if he was responsible for the design of the entire building.

The essence of group as found in certain European countries such as Sweden shows another tendency not always found in countries where individual rights trump the rights of the group. The seat belt in the typical passenger car is such an example. As we learned in the chapter 11 on Design and Politics, it has a long history. The three-point seat belt that we use today, however, was the work of two Americans, Roger W. Griswold and Hugh DeHaven, who patented it in 1955. Its development was the result of increasing concerns

over injuries because of auto accidents. Given these circumstances, it would be quite logical to assume that the American automobile industry would install these devices in their cars. But they didn't, on the pretext that installing seat belts would send a signal that their cars were unsafe. It was a Swedish engineer with Volvo who refined the design of the seat belt. Volvo then went one step further and included the seatbelt as standard equipment in their cars in 1959. From one perspective, it appears that the social concerns for the group by Volvo were greater than their corporate concerns.

Staying with the auto industry for a moment, the phenomenon of designing for the group occurred in a different vein in Japan in the 1980s. This was a period when Japanese cars were becoming more common in the United States. They were challenging the dominant position of the Big Three—General Motors, Ford and Chrysler. In many ways, these American companies were quite similar to their Japanese counterparts. However, there was one significant difference, which is sometimes referred to as time to market. That is, how long does it take to go from an idea in the executive suite to a product in the market place? Generally speaking, it wasn't unusual for any one of the Big Three to take five years from the time of the executive decision was taken to develop a new car to its appearance in a showroom. For their part, the Japanese could do it in three and a half years, which meant that for any market segment the Japanese could be selling a car for 18 months before their American competition. Losing 18 months of sales isn't good business. From all appearances, the culture of group that permeates Japan made it easier for the Japanese companies to design and produce a car because collaboration and cooperation among the different corporate units was easier. It was part of the Japanese cultural fabric to cooperate. Not so in the United States, in part because of the individuality of the different and separate corporate units such as marketing, finance, engineering, design, production and sales. Each was a silo, so to speak; collaboration and cooperation wasn't always forthcoming between and among these units because of barriers. Fortunately, the corporate mentality at the Big Three changed. They had no choice. What evolved is what's now commonly called concurrent engineering or concurrent design. That is, all the different units—marketing, finance, engineering,

design, production and sales—are together on the project from the very beginning.

The place of the individual isn't to be dismissed altogether however. It often allows for superlative developments in technology as we've seen with **Bill Gates** with Microsoft as well as Steve Jobs with Apple. Or for the breakthroughs from people like Alexander Graham Bell or Thomas Alva Edison or the Wright Brothers. Or from designers like Charles and Ray Eames. Where individualism begins to go astray, however, is when it occurs at the expense of the group. What's good for the individual may not be necessarily good for the group. People who are physically challenged are one such group. They can't easily conform to the wishes of individuals who aren't physically challenged. In such cases, it often becomes the role of governments or other agencies to advocate for the group. This is exactly how the Americans with Disabilities Act or ADA came about, and with that, the concept of Universal Design. The latter is a belief that the built environment and products should be designed keeping in mind people who aren't as able as the general population. This is why public buildings need to provide access to people who are wheelchair bound or why buses kneel in order to make it easier for people to board. The days of designing for only young, healthy, and fit individuals are well behind us.

From a more moralistic position, rights can't be isolated from responsibilities. As the often-stated story goes, it may be your right to yell "Fire" in a theater but you have a responsibility to the group when you do so if there isn't a fire. Otherwise, yelling "Fire" can have serious consequences.

GUILT OR SHAME

Looking at cultures of individuals and of groups is one way to observe and understand societal groups. There's yet another way: cultures of guilt and cultures of shame. Perhaps we in the West don't realize it but we tend to exist in a culture of guilt. This culture of guilt comes from our sense of truth, which is deeply embedded in our culture. This is why we create courts of law, which in part is a place where the determination of right or wrong is made, and where people are found to be guilty or not guilty. It's also why we have

lawyers and judges, whose duties are to help determine who is guilty and who isn't. This societal aspect of guilt has also created legal means of protection for the individual such as contracts, patents, trademarks and copyrights. That is, your intellectual property can be legally protected. If someone takes it, he or she can be prosecuted and found to be guilty. Therefore, binding legal documents are an important part of our culture. As a case in point, Apple and Samsung appear to be forever in court, fighting over this or that patent. Why? Because the ownership of a patent is an invaluable asset.

This cultural approach based on guilt isn't universal however. Many cultures operate on a societal system of shame. This is why the concept of losing face, which is very strong in Chinese culture, is almost unheard of in the West. What's losing face? Losing face is bringing shame to you and your family by way of your action. What you have done to lose face may not be illegal but the law is irrelevant in such situations. More important is the fact that you have acted in a shameful way. The rules of shame can at times override the laws of a society. This is why a Japanese businessman may want to know you as a person by way of several meetings and lunches well before signing a contract with you. Knowing who you are overrides the legal words in a contract. For the Japanese, a handshake is as good as a contract. For us in the West, the words are often more important. How often have you heard someone say, "May I have that in writing, please?" Clearly, a handshake isn't good enough for these people.

Soon after World War II, the American anthropologist Ruth Benedict was asked to study Japanese society because the American occupiers of Japan couldn't quite understand the persistent pattern of copying or pirating that was occurring with many Japanese companies. That is, it appeared that Japanese companies were stealing the ideas of American companies. What she discovered was something totally different: it wasn't copying as such. While many Americans saw the Japanese as blatant copiers of ideas, Benedict discovered that the Japanese were engaged in acts of flattery. In the minds of the Japanese, they had been conquered and defeated by a superior nation. For the Japanese, there was no better way to become better than the Americans than by mimicking them.

For a myriad reasons, people create and associate with one type of group or another. For industrial design, many art and design movements of the past have been identified and associated with certain societal groups. These movements will become the subject of the following modules, beginning with the period before Modernism.

BEFORE MODERNISM: BEAUX-ARTS AND THE INDUSTRIAL REVOLUTION

Cultural groups and their value sets are often identified under a common name or banner. The hippies of the late 1960s and early 1970s in America, especially in San Francisco, were such a cultural group. Their value set included peace, free love, use of recreational drugs, and flower power. Hippies also wore sandals and beads, and often drove Volkswagen Minivans. In the sections that follow, several important movements in design will be explored based on cultural groups and their value sets. To various degrees, these cultural groups have had a measurable impact on everyday things and industrial design.

Before we begin, however, we need to set the stage. To do so, Modernism needs to be placed at center stage because it tends to be a kind of fulcrum for contemporary industrial design. That is, important events and developments in industrial design occurred either before or after Modernism. This section will deal with the period before Modernism, beginning with Beaux-Arts, the movement that preceded Modernism, and the change that would be imposed because of the Industrial Revolution.

Beaux-Arts (ca. 1795–1968)

The Industrial Revolution, especially in the mid-19th century, wasn't occurring in a design or cultural vacuum. There was an existing design ethos for everyday artifacts, especially buildings but objects as well. That ethos was the Beaux-Arts style. It was the direction of choice in architecture and design in most European centers. The comfort zone implicit from this design tradition would soon be challenged by industrialization,

which was nothing less than a monumental cultural change affecting people, society, economies and the environment. It would put into question common social standards and, by extension, the practice of architecture and design.

Perhaps no building evokes the design grandeur of Beaux-Art architecture better than the Paris opera house designed by Charles Garnier known as Garnier's Opera. Built between 1860 and 1875, it's an exemplar of the tour de force that typified the Beaux-Arts style. Its visual exuberance is overwhelming, with its never-ending use of architectonic devices such as columns, friezes and sculptures. It's as if Garnier had to embellish the building with every conceivable detail known to architecture, which he did. And he did so outside as well as inside the building. But Garnier's Opera wasn't alone. Somewhat less exuberant, the Union Station in Washington, DC, is also an excellent example of Beaux-Arts architecture. It too is a massive collection of known architectural elements albeit elegantly arranged in a balanced and cohesive arrangement.

Beaux-Arts architecture was defined by a school of thought. The Ecole des Beaux-Arts was founded in 1819 following the dissolution in 1793 of the Académie Royale d'Architecture. The school was intended primarily for French students but was visited by students from around the world who spread the style and pedagogical system elsewhere. Characteristics of the Beaux-Arts style usually began with symmetrical plans and then proceeded with the addition of different features, which could include a combination of heavily arched masonry and stone bases with rusticated stonework. As we see in Garnier's Opera, the style included sculptured figures embedded in a massive and symmetric façade. Greek designs, ornamental keystones, medallions, elaborately decorated panels, and the like typified Beaux-Arts architecture. The interior of these buildings was no different. It wasn't unusual to have monumental flights of stairs and classical columns often set in close pairs. If nothing else, the Beaux-Arts style served as a showcase for both the architect and artisan in an age when exceptional craftsmanship reigned supreme. The conflict with the pragmatism of the Industrial Revolution, which was on the horizon, was predictable indeed. One set of social values, the highly decorative and orderly Beaux-Arts school, was

about to be confronted by another set of social values, that of industrialization, with the esthetic of the machine age.

The Industrial Revolution (ca. 1760–1900)

Revolutions aren't anything new in the history of societies. They have occurred for a variety of reasons and at various times. Most have been social revolutions such as the American Revolution and the French Revolution. The Industrial Revolution was different. It wasn't a social revolution per se, but it was a revolution nevertheless, and its social impact would resonate throughout Europe and the developing world.

The Industrial Revolution was underpinned by two essential societal factors. First, there was the increased application of scientific thought to day-to-day life such as the discoveries of the scientists Isaac Newton and Robert Boyle. Second, there was the development of machines, which would ultimately displace the artisan/maker in the making process of everyday things. As an aside, some scholars consider the Industrial Revolution as the catalyst for industrial design because it was the beginning of true mass production of everyday things by way of machines and technology.

The Industrial Revolution was also a significant shift in society, one in which technology—as crude as it was compared to today's technology—put into question societal values of one kind or another. For example, many everyday things that were only accessible to the nobility were now available to the growing middle class. Perhaps more significant, this new source of artificial power was to change both manufacturing and agriculture, which resulted in the displacement of people both from the farms and the factories. The designing process associated with everyday things didn't go untouched either. The Industrial Revolution changed totally the role of the person in the designing and making processes. Up to now, the Designer/Maker or artisan was at the center of artifact creation. With the Industrial Revolution, however, machines—not human skills and muscles—would become the center of artifact creation or at least the making part.

The Industrial Revolution must be contextually situated if we are to understand it well. It begins in Great Britain in and around 1760. Why Great Britain? Great Britain was a world power in the 18th century. The British Empire spanned the globe with colonies in Canada, Australia, India and South Africa. As was often stated, the sun never set on the British Empire. Furthermore, Great Britain was a military super power. Its navy was feared by everyone. Equally important was the fact that Great Britain was a commercial powerhouse, trading all over the world. In many ways, Great Britain then was what the United States is today.

If the Industrial Revolution were a brand, its three most significant and relevant features would be textile, steam and iron. The textile industry exemplified the commercial and trading power that was Great Britain in the 18th and 19th centuries. As a country with a global presence, Britain could acquire the raw materials it needed almost anywhere. No matter where the material came from, one thing was certain: It usually found its way back to Great Britain and to the manufacturing and textile centers in the Midlands in cities such as Liverpool, Manchester and Leeds. The textile industry was a commercial force for two reasons: machines and steam power. In combination, they totally changed how everyday woven products were made, going from handmade artifacts to mass-produced goods. For example, the output of a typical cotton-spinning machine was up to 1,000 greater than someone doing the same work by hand. This increase in output occurred with other machines as well such as the power loom and the cotton gin. In other words, the return on investment in a machine for a factory owner had clear and substantial benefits.

Steam power was the second important feature of the Industrial Revolution. As previously mentioned, it existed in the textile industry. But it was also present in those industries where power was necessary. After all, the use of steam power was nothing new; it had been around for some time, especially in the mines. This was the case because as coalmines went deeper into the ground a problem arose: flooding. In order to remove the water, a better, more efficient pump was necessary. This is where James Watt's improved steam engine made the difference because flooded mines could be drained more effectively. Over the next decades, the design of steam engines evolved, and each new version brought improvements of one kind or another. For

instance, steam engines became more efficient by using less fuel. They also achieved a greater power-to-weight ratio and became lighter, which made them suitable for other uses such as rail transportation. The latter made possible the development of Robert Stevenson's Rocket steam locomotive built in 1829, which was the beginning of steam rail transportation in England.

Iron was the third important feature of the Industrial Revolution. As bridges, blast furnaces and machines were becoming larger in size, there came a need for more iron and iron products. As a result, the production of iron became critical. It also became more efficient with the use of coke. Coke is made from coal but has fewer impurities and a higher carbon content. Its use had two direct impacts on the production of iron: it reduced the cost and increased production with the use of larger blast furnaces. Consequently, iron became more common as a building material and allowed for the construction of more innovative structures such as the first cast iron bridge in Shropshire, England, and, of course, the Crystal Palace in 1851.

Without doubt, there were many positive outcomes from the Industrial Revolution. Overall, the average person benefitted from its impact. Robert E. Lucas, Jr., the American economist, was unequivocal about the benefits when he stated, *"For the first time in history, the living standards of the masses of ordinary people have begun to undergo sustained growth . . . Nothing remotely like this economic behavior is mentioned by the classical economists, even as a theoretical possibility."* There were other benefits as well, many of which remain with us today. For example, mass production became possible because of machines. No longer was the making of an artifact a one-off process as it had been with the artisan or Designer/Maker of the past. As a result, everyday things became readily available to more people. There was also a reduction in prices because of the economics of scale implicit in mass production; that is, machine production of everyday things was less expensive than the one-off making of artifacts. In combination, the increase in volume of production with a decrease in cost was the seed for the beginning of the consumer society and of a middle class, a reality that we take for granted today.

Another benefit—although not one that impacted everyone in the same way—was the increased mobility of the general population. Prior to the railways, it wasn't unusual for someone to be born, raised and die in the same village without ever leaving its boundaries. Because factories tended to be centralized throughout various parts of the country such as the Midlands and not dispersed throughout the land as craft industries often were railways as well as inland waterways were built to provide connections between these centralized commercial centers. Suddenly, canals and rails brought the country's commercial centers closer together. There was, however, an unintended consequence. This new infrastructure also connected people. They were no longer relegated to a life spent strictly in the village where they were born.

Revolutions can also have a negative side. Such was certainly the case with the Industrial Revolution. Craftsmen and artisans—the former Designer/Makers—lost their place in society. To a great extent, machines had replaced them. And in situations where machines couldn't do the job, child labor became common practice. In addition, working conditions were often poor. This was especially the case in the coalmines, where people spent a substantial part of their lives underground. It's said that some people, even families, actually lived in the mines. Their working hours were so long that it made little sense to go above ground. Over times, these conditions would change. For example, the workforce in factories needed to be more educated than it previously was. The need for educated workers created the first public school system. Unions would also pressure the factory owners for better working conditions leading to safer and cleaner factories. There were a few exceptions to these inhumane conditions. One such exception was Sir Titus Salt, an enlightened textile factory owner who had a great respect for his workers and treated them accordingly. With Saltaire, a factory complex that included housing for the workers as well as ancillary services such as shops and schools, he provided a working and living built environment that wasn't only more humane than what existed in other textile mills but that was also more productive and therefore financially rewarding for him. Sir Titus was of the opinion that treating factory workers well was an investment, not merely a cost of doing business.

Conditions in textile mills and factories would change over time. Trade unions certainly played a role,

as did improved conditions imposed by the British government. Eventually, however, one major force was to alter the industrial picture of Great Britain: more and more industry was going off shore. One by one, mills and factories were shuttered. Textile mills began opening elsewhere, first in the United States and then to low-wage countries such as China, India and Pakistan. By the 1980s, the coalmines also closed because they were no longer financially viable. Perhaps the one legacy of the Industrial Revolution that not only remains but also haunts us today is the use of carbon as a source of energy. Coal fueled the Industrial Revolution, literally. It provided the energy for the steam engines and iron furnaces. Industry became dependent on coal for power, much like we've become dependent on oil for power today. The combination of machines, new production methods, availability of goods, and reduced prices were too great not to have an impact on industrial design, as we shall see in the next section.

The Arts and Crafts Movement (ca. 1860–1910)

Something as remarkable as the Industrial Revolution doesn't occur without some form of societal reaction or protest. People's worlds were either being changed radically or eliminated altogether because of the Industrial Revolution. Despite a better standard of living for many people in society, the Machine Age was displacing the human content in everyday artifacts, both in the designing and the making. Two reactions to this radical change were important and are discussed next.

The first reaction, an early one, came from a group of 19th-century textile artisans known as the Luddites. The unrest in the group grew from the direct displacement of textile workers because of the introduction of machines in the workplace or, if not because of machines, by low-wage workers with lower levels of skills. The favored reaction of the Luddites to this invasion by machines was their destruction. They considered the machine as the source of their miseries. Therefore, destroy the machine and you end the misery, or so they thought. Where does the name Luddite originate? Its origin isn't at all certain but many people believe that it comes from the name of a young man, Ned Ludd, who destroyed some machinery in 1779. To

this day, there exists a common British saying, *"Don't throw a spanner in the works."* Spanner isn't a common word in America; however, it is in Britain and is the word for a wrench. The saying is stating that someone who throws a wrench into the works or into the machinery stops it from working. This saying has become a derogatory term for anyone who creates a hurdle or an impediment for moving forward. People who act in this way are often called Luddites. This is especially the case for a person who doesn't accept new technology such as the microwave oven or computer.

The second reaction came a bit later and was different from the Luddites. It was the Arts and Crafts Movement. Like the Luddites, this movement developed as a reaction to the Industrial Revolution but wasn't based on creating an impediment to industry. Instead, it advocated for a return to the hand-making of everyday things. The movement was led by individuals with a deep conviction about the place and role of people in the design of everyday things

William Morris (1834–1896) was the principal leader of the movement but the writings of two individuals—John Ruskin (1819–1900) and Augustus Pugin (1812–1852)—underpinned its ideological direction. Morris went further than merely protesting about the impacts of the Machine Age. He not only designed everyday things but also launched a retail outlet in 1861, first known as Morris, Marshall, Faulkner & Co. and then Morris & Co. It goes without saying that Morris' initiatives were influenced by his belief in socialism. For Morris, society and its evolution was about people, not about machines. For many others, especially British industrialists, the Arts and Crafts Movement appeared to be nothing less than a form of anti-industrialism.

Much of what we admire about the Arts and Crafts Movement today is found in certain artifacts such as patterns for wallpaper, chairs and cabinets. Many of these everyday things made visual connections to elements taken from nature. After all, what better antidote exists to counter the mechanistic world of machinery than nature? When thinking about it, nature is as possibly far removed from the iron and steam of the Industrial Revolution as anything can be. Wallpaper patterns were therefore often based on patterns seen in leaves and flowers. The other concern for the members of the Arts and Crafts Movement was the making of

artifacts by machine. Once again, the machine needed to be replaced by something more natural. In this case, it was the making of everyday things by human hands. Chairs and cabinets therefore became exemplars of fine craftsmanship in woodworking, which aptly demonstrated the Designer/Maker of everyday things made by hand and not by machine. Moreover, the patterns of the fabric for upholstered chairs were often derived from shapes found in nature much like the wallpaper previously mentioned.

The Arts and Crafts Movement was also present in architecture of the day. Perhaps the finest example is Red House in Bexleyheath, near London. Philip Webb designed the house for William Morris in 1859. Webb based his design on what would best be identified as English vernacular architecture using wide porches, a steep roof and brick fireplaces. Webb placed an accent on elements associated with the crafts and hand making such as stone, tiles and timber. Overall, these elements constitute the perceived quaintness about the house.

Morris was advocating for a return to the way things were. His design direction attracted a certain following, most likely because the past can bring a certain level of psychological comfort. Change—as was occurring with the Machine Age—was having an unnerving effect on people. Consequently, over one hundred associations and craft communities were created in reaction to the invasion of machine production. Three are particularly notable. The first was the Birmingham School of Art, which became a leading center for the Arts and Crafts in the Midlands; the second was the Arts and Crafts Exhibition Society founded in 1887; and the third was the Guild and School of Handicraft founded in 1888 by C. R. Ashbee. Its mission was to train craftsmen in the guild tradition of the past. Several well-known designers and architects of the day were also party to these associations and craft communities. Two are particularly noteworthy. They are A. H. Mackmurdo, the English architect and designer, who created the Century Guild, and William Lethaby, who was one of five architects to start the Art Workers Guild.

In his later years, Morris became more and more involved with politics and socialism. And although his heart was in the right place—elevating the hand-making in everyday things—the cost of such artifacts was often beyond the purchasing power of the average English person. In other words, the lower cost of machine-made everyday things would override the higher cost of hand-made everyday things.

There was a more modest manifestation of Arts and Crafts Movement in America. It was generally known as the Craftsman style and occurred later than it did in England, between 1910 and 1925. Unlike its counterpart in Great Britain, which was reactionary in nature, the movement in America—located in cities like Boston and Chicago—was much more predicated on the importation of European design, that is, a kind of interpretation of European ideals for Americans. Generally speaking, it was perceived as yet another style and not as much a quasi-political or social movement. Gustav Stickley (1858–1942) was a leading designer of the American Arts and Crafts style as was, to a certain degree, Frank Lloyd Wright (1867–1959).

Art Nouveau (ca. 1890–1910)

Unlike the Arts and Crafts Movement, the Art Nouveau movement permeated many of the fine arts as well as design and architecture. There are excellent examples of Art Nouveau in painting and sculpture. This section, however, will focus on Art Nouveau as it occurred in design.

Art Nouveau shared some similarities with the Arts and Crafts Movement. It too was a reaction against industrialization and the Machine Age. Art Nouveau also looked to nature for inspiration. However, there was at least one significant difference between the two. Unlike the Arts and Crafts Movement, Art Nouveau architects and designers weren't against machines and machine production as such. Many Art Nouveau designers would come to embrace new materials such as glass and iron as well as new techniques such as casting. In architecture, for example, new technological innovations were integrated into projects leading to features such as exposed iron elements and the expressive use of glass. In the end, the wish of Art Nouveau designers and architects was to move forward in step with industrialization but to do so on their own terms. Consequently, lines, shapes, and forms become organic, not mechanistic. After all, mechanistic forms didn't exist in nature.

Once again, the visual lines, shapes, and forms found in nature became an antidote.

The person perceived as the father of Art Nouveau was the Belgian architect Victor Horta (1861–1947). Generally speaking, historians credit him for borrowing the Art Nouveau direction already present in the decorative arts and applying it to architecture. In this vein, his design for the Hotel Tassel in Brussels, built between 1892 and 1893, was an exemplar of Art Nouveau in design. This is certainly the case with architectural details such as the stairways in the hotel. Curvilinear lines abound everywhere. The ironwork is curvilinear as is the handrail and the painted decoration on the wall. The absence of geometric lines is quite evident.

Horta's work was highly influential; perhaps the one person most influenced by it was Hector Guimard (1867–1942), the French architect and designer. For Guimard, Art Nouveau and its connection to nature played an important role in the development of the designs that he did for the Paris Metro. In a city that was the epitome of an artificial setting—stone and glass buildings based very much on the right angle with Beaux Arts architecture here and there—Guimard's light fixtures for and entrances to the Metro were a definitive contrast to the surrounding environment. With their tall, green stems and floral-like features, the light fixtures looked like plants growing out of the concrete and stone environment of the Parisian neighborhoods. As for some of the Metro entrances, these were also organic in design but included petal-like elements borrowed from flowers, or so it appears. What needs to be noted as well is the typography used on the Metro signs. With its curvilinear bias, it too deviated from the more rigorous font styles of the day. Clearly, Guimard was using a visual language that was in opposition to the mechanistic visual language of the Eiffel Tower. Remember that both the Metro fixtures and the Eiffel Tower were built in generally the same general era.

Art Nouveau was also present in Germany, where it was known as Jugendstil. A fine example of this style in architecture was the house designed by Peter Behrens (1868–1940), who was the principal designer at AEG as well as a member of the Deutscher Werkbund. The house is in Darmstadt and is still in use today.

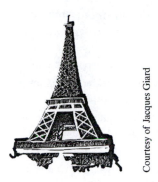

Image 36: If nothing else, the Eiffel Tower celebrated the new and innovative possibilities that iron and steel provided in building and architecture.

One can't discuss Art Nouveau without mentioning Antoni Gaudi (1852–1926), the Spanish architect. With his early buildings such as Casa Batllo and Casa Mila, Gaudi expressed his ideals by repeatedly using organic forms. The Casa Batllo in Barcelona is a case in point. Inside or outside, it's difficult to find a straight line anywhere. It's as if Gaudi did everything in his power to avoid it. However, it's Gaudi's Sagrada Familia, also in Barcelona, that stands as his supreme expression of Art Nouveau visual ideals. Begun in 1882, it's still under construction and was consecrated only in 2010. Its form—outside and inside—remains impressive as the exploration of a new visual language.

One other influence of Art Nouveau must be noted. This influence came from Japan, which had recently been "opened" as the result of the visit by Matthew Perry (1794–1858), the American admiral. Japanese wood-block prints, which had never been seen before

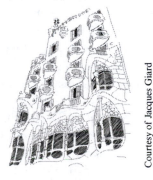

Image 37: Few straight lines are found in Casa Batllo, designed by the Spanish architect Antoni Gaudi in 1904.

in Europe, became more common in the design language of European artifacts as were certain other artifacts such as furniture lacquered in black. One designer who would draw greatly upon this Japanese influence was the Scottish architect Charles Rennie Mackintosh (1868–1928). Mackintosh was born and raised in Glasgow at a time when the city was prospering. It was a center of shipbuilding, which also led to the construction of buildings throughout the city. Personal income was high and there was a demand for everyday things of all types. Mackintosh was inspired by what he saw in the Japanese style, especially the sparseness of decoration. The style seemed to express a logical use of material, which was just the opposite of the overt decoration that was present in the Beaux-Arts movement. Instead of everyday things being objects of status, these Japanese artifacts were objects of use. This appreciation was coming at a time when the proto-Modernist designers were just beginning to focus their attention on functionalism in design, not just form for the sake of decoration but form derived from purpose. Mackintosh wasn't at all insensitive to this new direction. Certain designs from Mackintosh, especially some of his chairs, show the Japanese influence quite clearly. Such is the case with a small, black side chair as well as his high-back chair, also done in black. As a color, black was unusual and wouldn't have been a preferred color for chairs in the Victorian period. Cassina, the Italian furniture maker, continues to produce the Mackintosh high-back chair under license.

Mackintosh's Scottish or Celtic heritage was another source of imagery and inspiration for many of his designs. The formal language for this source was quite different from the Japanese influence and relied more on shapes and forms from the past Celtic traditions such as we find with the fluted legs of tables and elliptical tops as well as with medallion inserts in the furniture. These shapes and forms were a clear departure from the rectilinear shapes and forms of his Japanese influenced designs.

Like many of his contemporaries, Mackintosh also designed buildings such as Hill House. However, he's most remembered for his interiors. The interior of Hill House shows an astute mixture of both Japanese and Celtic influences, both in the furniture and the many architectural details in the rooms. The Room De Luxe at The Willow Tearooms, which he designed with his

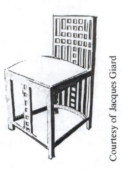

Courtesy of Jacques Giard

Image 38: Several of the chairs designed by Charles Rennie Mackintosh, the Scottish architect and designer, showed a distinct Japanese influence.

wife Margaret Macdonald (1864–1933), shows the same attention to detail.

The Vienna Secession

Disenchantment with the status quo in art and design similar to what was occurring in England, France and Belgium was also occurring in Austria. In Austria, the movement was called the Vienna Secession, and its most noteworthy proponents were the artists and designers Gustav Klimt (1862–1918), Josef Hoffman (1870–1956), Joseph Maria Olbrich (1867–1908), and Otto Wagner (1841–1918). Their disenchantment was principally with the prevailing historical traditions in art and design. With industrialization, society was changing but the traditions in art and design were stuck in the past and weren't changing.

The movement found various niches for their interventions. One of these was the Wiener Werkstatte, which was an association of architects and designers with a concern for the crafts. In many ways, it was similar to the Arts and Crafts Movement in England and had as its goal the reformation of the crafts in Austria. From a design point of view, architects and designers associated with the Wiener Werkstatte were moving in the direction of simpler and more geometric forms. Applied decoration, a design direction associated with the past, was rejected. This new design direction became apparent in the chairs of Josef Hoffman. These exemplified a clear departure from applied decoration by placing a greater focus on function and rational thinking on the design of artifacts. As a side note, it's important to remember that Adolf Loos (1870–1933),

who wrote the seminal paper "*Ornament and Crime*," was from Vienna and was active in this same era.

Art Nouveau in America

Art Nouveau in America didn't have the social, grass-root quality that it did in Europe. Nevertheless, its presence was made evident by designers such as Louis Comfort Tiffany (1848–1933). Tiffany worked principally with glass, and some of his stained glass windows are considered masterpieces of this kind of design, such as the stained-glass window done in 1904 and found at the Indianapolis Museum of Art. Like most other Art Nouveau designers, he was inspired by the imagery found in nature. This is certainly the case with the lamps that bear his name. These often include all shapes and forms of leaves, fruits, and tree branches interpreted as only Tiffany could do. Tiffany's legacy continues to this day with the retail outlets that bear the family name.

Art Nouveau, albeit over a relatively short period of time, was a bridge between the 19th-century revivalist styles, such as Neo-Gothic as we saw with the Houses of Parliament in London, and Modernism, which was to come next. It was a perfectly normal human reaction to changes as the result of industrialization. These were occurring quickly and having a great impact on people. Unlike the Arts and Crafts Movement, however, the proponents of Art Nouveau weren't against industrialization as such. What they were seeking was a role in how the changes were to be interpreted in everyday life.

MODERNISM: BEFORE AND AFTER

Changes or redirections in societal movements usually occur because of some disruption in the previous mode of operation. For example, computers came along and with it came the end of typewriters and, to a great extent, typists and secretaries. Similarly, two disruptions in the late 19th and early 20th centuries are worthy of note. Both would impact industrial design. The first was the invention of photography in 1837; the second was the writings of Adolf Loos.

The invention of photography created an upheaval in the art world. This upheaval was important because of industrial design's close association to the arts, both in education and practice. If anything and as we discovered in Design and Education (chapter 9), industrial design originated as an applied art. Loos' writings were equally important; they established a framework for architecture and design based on rational thinking, which would eventually create the basis for functionalism in design. The section will begin with photography and its impact on industrial design.

The Challenge Posed by Photography

The invention of photography goes back to 1790 in Britain with Thomas Wedgwood the son of Josiah Wedgwood; it develops further with the French inventor Nicéphore Niépce in 1826, and finally, in 1837, with Louis J. Daguerre, a French stage designer and painter. More details about these inventors and their inventions appear in Design and Communication (chapter 8). Because the underlying premise of the fine arts of the 19th and early 20th centuries was image making by hand, the invention of photography posed a serious threat. Until then, one of the fundamental roles of the artist was to represent the everyday world by way of realistic landscapes and portraits painted by hand. Photography totally changed the need to paint such realistic images because photos were realistic images. Artists were suddenly out of a job, or so it seemed. What happened next to artists, of course, was quite different. Photography became a catalyst for change and artists began to explore dimensions beyond the world of visual reality. They delved into more fundamental issues such as light, composition and emotions. Cubism, de Stijl, Impressionism and Expressionism all became different modes of a kind of visual exploration that was different from the photography of the period. Among these, De Stijl is particularly relevant to design.

De Stijl, or the Style, was a Dutch art movement. It explored color—the primary colors of red, blue, and yellow as well as black and white—in combination with simple abstract, rectilinear geometry. In some respects, de Stijl went beyond Cubism and removed any visual connections to form and volume such as shade, shadow, depth, and perspective. It was the Dutch painter Piet Mondrian (1872–1944) who was the driving force behind de Stijl; his paintings were minimalist exercises in geometry and primary colors. Gerrit Rietveld (1888–1964) explored a somewhat different direction and gave de Stijl a third dimension by designing buildings like

the Schroder House and furniture like the Red-and-Blue chair. The latter, designed in 1917, should not be perceived as a strict exercise in the design of a seating device with due consideration for appropriate material, effective manufacturing methods and good ergonomics. On those criteria, the chair isn't a design exemplar because it was essentially an exercise in minimalism and rationalism; that is, Rietveld seemed to be posing the question: What's minimally needed in an artifact to have those properties that we associate with the chair?

Much the same can be said about the Zig-Zag chair, designed in 1934. Once again, Rietveld was reducing the chair to its fewest components—a back, a seat and one leg attached to a base. Four pieces, no more. This kind of approach was a dramatic departure from the Beaux-Arts style, which had become the common style, or even Art Nouveau, which could be visually flamboyant as we saw with Guimard and Gaudi. The unintended consequences of a new technology of photography on society were clear: artists, architects and designers began to explore new visual directions in their respective disciplines.

Loos, Rational Thinking and Design

By the late 19th century, hints of a radical departure in the visual language of architecture and design of the Beaux-Arts were beginning to surface with movements such as Art Nouveau in parts of Europe and the Vienna Secession in Austria. But the clearest indication of a break with the overly decorated buildings and objects of the era was with the writings of Adolf Loos. Working in Vienna in the early 20th century, Loos wrote what was to become a seminal treatise on modern design and architecture entitled, *Ornament and Crime*. In it, he stated, "*Ornament is wasted effort and therefore a waste of health. It has always been so. But today it means a waste of material as well, and the two things together mean a waste of capital.*"

For Loos, however, words weren't enough. He put his beliefs into practice. The Steiner House in Vienna, built in 1910, demonstrated his passion for useful form over useless decoration, at a time when the latter was the rule and not the exception. Loos' direction was the precursor of what came to be known as functionalism and its roots in logical and rational thinking in design. It was to become the movement that most influenced

design in the first half of the 20th century. As defined by British design historian Guy Julier, functionalism is, "*. . . aspects of Modernism that makes the most economical use of materials, space and visual codification.*" And it was in Germany that functionalism gained its first footing, especially with the Deutscher Werkbund and the Bauhaus.

The Deutscher Werkbund

The concept of bringing design, government, and industry together wasn't new. Henry Cole (1808–1882) had encouraged such a concept in England in the mid-19th century. Unfortunately, his concept didn't find a favorable audience with government officials However, a German civil servant working in London at that same time was fascinated with Cole's concept. This person was Hermann Muthesius (1861–1927). Upon his return to Germany, he began to promote what was essentially Cole's idea. In 1907 and with the encouragement of Muthesius, a group of German industrialists, businessmen, artists and architects joined to form the Deutscher Werkbund. Its task was focused on reconciling what had become a division or schism between the manufacturing of everyday things, on the one hand, and the designing of everyday things, on the other. For the members of the Werkbund, the absence of designers in the manufacturing process was leading to an inferior quality in German manufactured products.

The thrust of the Werkbund's manifesto was to protest against the ugliness of the built environment, and to revive artistic, moral and social ethics, with an overall bias towards standardization. The founders of the Werkbund also acknowledged the division that was occurring between manufacturers and designers because of industrialization. Nevertheless, it's important to note that the members of the Werkbund weren't against industry. If anything they were keenly aware that industrialization was a reality and was here to stay. In their minds, it wouldn't suddenly disappear. Moreover, industrialization provided new opportunities for designers. This sentiment became a central part of the Werkbund's ideology, which was founded on the concept of quality production of everyday things derived from the explicit cooperation between the so-called accomplishing spirit or manufacturers, on the one hand, and the inventing spirit or designers, on

the other. The ultimate goal was bridging the gap that existed between these two components in the design process. The Werkbund's audience included design leaders Ludwig Mies van der Rohe (1886–1969), Walter Gropius (1883–1969), and Le Corbusier (1887–1965)—people who would eventually shape the design and architecture of post–war Germany and Europe.

THE BAUHAUS: A MARRIAGE OF THEORY AND PRACTICE

While movements such as de Stijl were largely experimental and visionary, the essence of the Bauhaus ideology was based on a more rational application of design theory and practice, having as its goal the education of a new and very different generation of artists, architects, and designers. These features were discussed in a previous section under Design and Education (chapter 9). For the leaders of the Bauhaus, design and design imagery were to be the result of functional parameters as well as artistic imperatives. In that vein, the Bauhaus began as the integration of a school of arts and crafts and an academy, a kind of marriage between the hands and the mind, or practice and theory. At a time when there was a very clear division between manual training and academia, this hybrid direction in higher education was revolutionary. As logical as the combination of these two basic yet different educational components might appear to be, they didn't enjoy equal status in the early years at the Bauhaus. In reality, there was a kind of anti-academic feeling at the institution; its program leaned heavily toward training in the practical portion of the curriculum. In the years that followed, this initial tendency toward practicality gave way to the acceptance of theory, an approach that was more in tune with educating than with training. In retrospect, the Bauhaus would totally changed design and design education. This is quite exceptional given that the Bauhaus was only open for about 13 years.

Art Deco (ca. 1920–1940)

For some people, even some in the design community, Functionalism—or Modernism as it would become known—appeared to be too rational and logical. There was a harshness and paucity in its visual language,

which gave a quality that was almost sterile. The clean lines of Bauhaus furniture such as the Wassily chair were lacking in any visual pleasure. With Functionalism, there was a feeling that absence of decoration was like throwing the baby out with the bath water. Art Deco architects and designers wanted to address this visual sterility by adding the missing element of decoration in everyday things.

Art Deco got its start and its name from the Exposition Internationale des Arts Decoratifs et Industriels Modernes held in Paris in 1925. It should be noted that Art Deco wasn't a movement per se because it had neither known leaders nor an underpinning philosophy nor manifesto, as did previous movements. It was more of a groundswell for a middle-class consumer style, what Russell Lynes' would eventually call a middle-brow market. As a visual style, it was also a departure from Art Nouveau, which had gone out of favor partly because the production of everyday things in the Art Nouveau style was often expensive.

Art Deco borrowed from Modernism. It had a tendency to be more symmetrical than asymmetrical, more rectilinear than curvilinear. Groups of horizontal lines were often identifying trademarks. These appeared in everyday things as small as radios and as large as steam locomotives and buildings. Moreover, Art Deco designers didn't shy away from using new materials such as Bakelite and new processes such as metal castings.

Despite its European origins, Art Deco found greater favor in the United States, especially as an expression of the roaring 20s. In that respect, one of the finest examples of Art Deco is the Chrysler Building in New York City. The style permeates much of the external architectural details of the building such as the tower at the top as well as the entrances to the foyer including its interior design. The Art Deco district of Miami Beach, yet another example, is a living museum of the Art Deco style in America.

The Streamline Era (1930s)

The Great Depression of 1929 had a disastrous economic impact on the United States and other parts of the developed world. The New York stock market crashed, industries ground to a halt, and unemployment skyrocketed. The economic picture was bleak. By the mid-1930s, however, the market conditions

had improved. So had certain industries, among them aviation. This was especially the case with the Douglas Corporation and the DC-3, probably the most significant plane designed and built by the company. The DC-3 revolutionized the nascent air passenger industry. But it did more than that. Because of its aerodynamic design, which was something new in aviation, it created a totally new visual style or look.

That new look—a look derived from the streams of line created around an object in a wind tunnel—became the visual language of many mass-produced products of the day, including some not at all associated with aviation such as locomotives. The 20th Century Limited passenger train, designed by Henry Dreyfuss, was an excellent example of this streamlined style in design. The car industry also adopted the streamline look with cars such as the Chrysler Airflow, which, by the way, wasn't a commercial success. Even products that had nothing to do with faster speed and aerodynamics became the subject of streamline design, such as a pencil sharpener designed by Raymond Loewy. The Streamline Era continued for some years. In 1939, however, World War II erupted in Europe. Two years later and with the bombing of Pearl Harbor in 1941, the United States entered the conflict. In both theaters of war—Europe and the Pacific—the focus of industry was on the factory production for the purpose of war. Nothing returned to normal until after 1945.

As we saw with photography, a new technology can prove to be disruptive but with disruption comes new ideas and directions in design. As we will see yet again with, for example, the NASA space program and the novelty of television, new technologies would not only impact society directly but would also influence

industrial design indirectly or in ways not at first imagined by the designers of the original idea.

MODERNISM AFTER 1945

World War II had devastating effects on industry in Europe and parts of Southeast Asia. A great many areas of Germany, England, France and Italy were totally destroyed, including factories and transportation infrastructure. Nevertheless, wartime production began to shift slowly to peacetime production. In that vein, Modernism, which had its beginnings several decades before in Germany, became the direction of choice. No other design movement had impacted contemporary industrial design the way that Modernism had—not the Arts and Crafts Movement, not Art Nouveau nor Art Deco. Many of today's everyday things—from our buildings and automobiles to our furniture and laptops—have been impacted one way or another by the design principles of Modernism. We see it in our high-rise buildings; we also see it in everyday objects like housewares and appliances; and we see it in graphics, such as the Helvetica font used in the corporate identity of Crate & Barrel. Each one is an example of the Modernist ethos.

Before going further, however, one important aspect of Modernism must be understood. Modernism was a design expression based on a specific set of values or social mindsets. It began with people in Austria and then spread to Germany, England and Scandinavia. Only later did it begin to have a place in France and Italy and eventually the United States. To declare that there's something truly and universally international about Modernism is somewhat presumptuous. Modernism is fundamentally an expression of a northern European ethos, nothing more. Moreover, the application and interpretation of Modernism, even within Europe, varied depending on the social context of the country, as we will explore in the following sections.

Scandinavian Modern

As well grounded in a philosophy of rational thinking and functionalism as Modernism was, it didn't manifest itself in exactly the same way everywhere, even in those countries where it originated. It's revealing to look at the differences in some of these countries given that

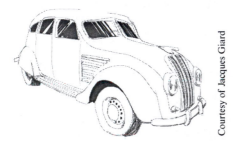

Courtesy of Jacques Giard

Image 39: The airstream frenzy of the 1930s was evident in many everyday objects, such as the Chrysler Airflow designed in 1934.

all seemed to comply with the fundamental premise of Modernism. Denmark, Sweden and Norway make the point. These countries are generally considered as Scandinavia. For our purpose, however, Finland will also be included. In all four countries, the first forays into Modernism began to appear between World War I and World War II. And in most instances, the basic tenets of Modernism were adhered to; that is, function was the prime criterion of design. Consequently, there was no added or unnecessary decoration.

One just has to look Paimio chair (1931–1932) designed by Alvar Aalto (1898–1976) to see that functionalism was paramount: two identical arms that cradled a bentwood-seating platform. Nothing more. This was minimalist design at its best. Or the Eva side chair (1939) designed by Bruno Mathsson (1907–1988) also made of bentwood but with an interwoven fabric seating area. The Danish architect and designer Arne Jacobsen (1902–1971) was certainly among the leading proponent of Scandinavian Modern as he expressed in his design of the Ant chair. With its fluid lines, it has all the qualities of form follows function but none of the harsh right angles.

Clearly, the fixation on function and logical thinking made these chairs excellent examples of Modernism. What made these same designs Scandinavian Modern were features that we often associate with Scandinavia: respect for nature and a strong sense of people and community. Consequently, we see more curvilinear forms as we find in nature and the extensive use of natural material. These shapes and form also appear to be more connected to human values and less with mechanistic and industrial imperatives.

German Modernism

Scandinavian Modern was different from German Modernism. The latter was Modernism expressed in what could be called its purest form. A comparison between the Wassily chair (1925–1926), designed by Marcel Breuer (1902–1981), and Aalto's Paimio chair makes the point. Generally speaking, both chairs are of the same type. But that may be where the similarity ends. The Wassily chair was made of chrome-plated steel tube with a leather sling seating area. Its visual language was all about factory production and form follows function at its purest. The Paimio chair is also

factory made but because wood is used and its form contains curvilinear lines, it looks less mechanistic. With no applied decoration both are excellent examples of Modernism.

The design qualities in the Wassily chair appeared in other German chairs such as the Cesca chair (1928) also designed by Breuer. As a chair, it's the same type as Mattson's Eva chair. Like the Wassiliy chair, however, it's all about mass production in a factory setting. This chair is a machine meant for sitting and executed in a pure form of Modernism. This German approach would eventually permeate a great deal of German design after World War II, from utensils and small appliances to automobiles and high-speed trains.

Italian Modernism

Italian designers also adopted Modernism as a design direction but their version was different from the Scandinavians and Germans. While the Scandinavian designers made a connection to nature and the Germans clung to an unadulterated version of Modernism, Italian designers developed what could be called an irreverent side of Modernism. That is, they saw a side of Modernism that wasn't necessarily serious but more joyful.

The plastic 4867 chair (1964) and storage cabinet (1969), both designed by Joe Colombo (1930–1971), make the case for this direction. Because he used plastic in the way that plastic should be used and not as a replacement of another material, the visual language for his chair was new and unique. The same novelty also occurred with the use of various colors, most of them primary and bright. Nevertheless, the Italian direction in design was predicated on the principles of Modernism. There's no unnecessary decoration and every aspect of the design can be rationalized. The color red or green for a chair? Why not? Is there a reason that it can't be red or green? Colombo certainly never thought that there was.

BRAUN: AN EXEMPLAR OF MODERNISM IN DESIGN

For industrial design, perhaps the best example of Modernism in practice came from Braun AG, the German manufacturer of shavers, beauty care

products, and small home appliances. A visual analysis of its many products would reveal certain patterns that were all extensions of Modernism. For example, form was the result of a direct analysis of function; therefore, there was no decoration whatsoever. In addition, color was used logically. Dieter Rams (b. 1932), the chief designer at Braun, would explain the predominance of white in the small appliances by stating that an appliance was like an English butler. It should fade into the background until required. There was no need to shout its presence. Beyond the application of Modernist principles to its products, Braun went as far as creating the so-called Ten Rules of Good Design, which became a kind of corporate policy.

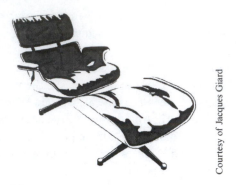

Image 41: The Eames chair, designed by Americans Charles and Ray Eames, is a classic example of Modernism in contemporary furniture and design.

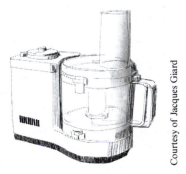

Image 40: Braun, the German maker of small appliances and other similar everyday objects, was the leader in the implementation of the principles of Modernism in industrial design.

THE EAMES: EXEMPLARS OF MODERNIST DESIGNERS

Modernism can't be discussed without mentioning the designs of Charles (1907–1978) and Ray Eames (1912–1988). The Eames lounge chair (1956) exemplifies all the tenets of Modernism. It's form follows function in its finest manifestation. The design challenge for comfortable seating was met, all without the need of unnecessary devices, decorations, or accessories. Nothing needed to be added to the design much like nothing needed to be removed. The Eames were to repeat this Modernist approach with other designs such as the Alu Group of office chairs, the bent-wood LCW chair, and several molded fiberglass arm chairs.

MODERNISM TODAY

Does Modernism still exist in today's industrial design? Is it still being practiced? It does exist and it resides at Apple with Jony Ive, the senior vice president in charge of design. Modernism exists in the MacBook Pro, clearly. There's no unnecessary decoration anywhere. Neither is there any unnecessary decoration with the various models of the iPod and iPhone. From all appearances, everything about Apple's many consumer products appears to follow Braun's Ten Rules of Good Design.

If there was something about Modernism that needs to be noted, it's that it was prescriptive. That is, there appeared to be rules to follow, most of which were based on some aspects of logical and rational thinking. Nevertheless, its prescription was interpreted differently depending on context. Modernist designers in Italy may have followed the same rules as their German counterparts but as we saw previously the end results were most often visually different.

Modernism exists in other product areas as well. Many designs at IKEA, for example, borrow strongly from Modernism. You can also find examples of Modernisn at Design Within Reach and Crate & Barrel. However, its glory days are more or less over. Standardization and the rigorous application of a set of rules have given way to a reaction by users and designers alike. For users, mass customization has opened the door to a codesign model used by industry more and more. For designer, the change has manifested itself

as design eclecticism or Postmodernism, which will be explored in the next section.

POSTMODERNISM

As often stated, every good thing must eventually come to an end, at least to some degree. Modernism was no exception. As already mentioned, Modernism was often prescriptive. In certain instances, the design prescription was applied much like a formula is applied to a mathematical problem. To a great degree, we saw that with Braun products. These often appeared to be the result of a single design algorithm. Consequently, every new Braun product looked very much like the last one. There were a strong and definite family resemblance or design DNA.

In principle, there was nothing wrong with this prescriptive direction. In practice, however, the social shift that developed next was both predictable and to be expected. This scenario had occurred previously whenever the current movement in art or design was displaced because of some reaction to it. After all, Modernism had displaced the Beaux Arts movement. And Modernism, no matter how logical or rational, wasn't immune to these forces. Sometime in the early 1970s, there came some grumbling about Modernism, just when Modernism was at its height. Robert Venturi (b. 1925), the American architect, is credited with starting the grumbling by editing Mies van der Rohe's famous quip "*Less is more*," which had become the essence of Modernism, to now read, "*Less is a bore*." In industrial design, the displeasure was based, in part, on the formulaic approach that was Modernism. The result of "less is more" created more of the same. For some designers, the predictability of Modernism became its weakness. When it was new and displacing the Beaux-Arts style, Modernism was novel and different. Fifty years after, it was the only game in town. Like a machine, it was producing the same thing with the same look over and over again. The swing of the pendulum had begun.

For industrial design, Postmodernism meant a re-evaluation of what the essence of an everyday thing was. For example, the transistor radio of the 1960s was typically a small box made of hard, opaque plastic with a few controls and a speaker area. This is exactly what Sony produced. However, Argentinean designer Daniel Weil (b. 1953) had a different idea. Why opaque? Why hard? Why the radio look? Who determined that look? Weil's radio, designed in 1981, was transparent, soft, and didn't look like what a radio should look like. Then again, where does the generic look for a radio come from? It was this design standardization associated with Modernism that Postmodernist designers like Weil were questioning.

If there was one faction of Postmodernism that had an inordinate impact on industrial design, it had to be the Memphis group (1981–1987) from Italy. Memphis was the congregation of several very active designers, most of whom resided in Milan. The name of the group comes from the Bob Dylan song, "*Stuck Inside of Mobile with the Memphis Blues Again*," which was playing at the time when these designers first met. Many of them weren't only practicing industrial designers but were also advocates of Modernism. Ettore Sottsass, Jnr. (1907–2007) was the prototype for this type of designer. He worked for the Olivetti corporation and designed several iconic products such as the Valentine typewriter (1969), which was nothing less than an exemplar of Italian Modernism. As a Postmodernist designer, however, Sottsass surprised everyone with his Carlton bookcase (1981), which was a clear departure from the design rules of Modernism. Sottsass believed that design didn't need to be constrained by a set of rules such as those of Modernism. Design could be more than a known prescription. And he wasn't alone. There were others,

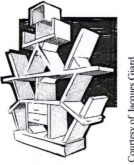

Courtesy of Jacques Giard

Image 42: Postmodernist designers defied the rules of Modernism. We see that with the Carlton bookcase, designed by the Italian Ettore Sottsass, Jnr.

such as Michele de Lucchi (b. 1951). His design for an iron and a hair dryer, although never produced, defied all the rules of Modernism. Michael Graves (1934–2015) wasn't part of Memphis but his designs were certainly Postmodernist in genre. This direction is evident in the kettle he designed for the Italian manufacturer Alessi. Andrea Branzi (b. 1938), a member of Memphis, placed the Memphis movement and Postmodernism in context. In his opinion, neither was to be taken seriously, at least not so seriously that they would eradicate Modernism. If nothing else, Postmodernism was a kind of wake-up call to what had become the predictability of Modernism.

Where's industrial heading today in an age of social concerns with digital media and the environment? It's perhaps too early to tell but one design direction appears to be taking place. That direction is a general dematerialization of the design artifact. There are two underpinning reasons for this change in direction. First, products are becoming physically smaller. Just think of how big televisions once were, or how we no longer have physical disks to record and to play music. The principal reason for this change is digital technology and the advances that have been made in miniaturizing almost everything. More changes will occur as nanotechnology becomes mainstream. Second, we are becoming more aware of our footprint on the environment and acting accordingly in order to eventually make and own fewer everyday things. Our greater knowledge about climate change is the principal reason behind this shift in direction.

SUMMARY

This chapter dealt with society and design movements, and how the two are intertwined. As we saw from the time of the Industrial Revolution to Postmodernism, changes in industrial design have occurred most often as a reaction to a critical change in society. For example, the Arts and Crafts Movement was a reaction to industrialization much like Postmodernism was a reaction to Modernism. As best as we can tell, nothing is about to change that pattern of action and reaction, not now or in the future. If anything, we can take a page out of Isaac Newton when he stated that for every action , there's an equal but opposite reaction. Human society appears to react much like the forces in physics.

NOTE: Readings for chapter 12 are found in the back of the book.

Chapter 3: A World View of Design

Readings:

Sigmund Freud, Civilization and Its Discontents

The Austrian Sigmund Freud (1856–1939), the founder of the field of psychoanalysis, wrote as provocatively about human society as he did about the human mind. In his 1930 book, Civilization and Its Discontents, he compared the cultural development of civilizations to the psychic development of individuals. Freud's comments about the roles of technology and hygiene in human societies are particularly fascinating, given the dramatic increases in the levels of both during his lifetime. (The theory of antisepsis, for example, which was developed during Freud's childhood, became universally accepted in the early twentieth century.)

During the last few generations mankind has made an extraordinary advance in the natural sciences and in their technical application and has established his control over nature in a way never before imagined.

The single steps of this advance are common knowledge and it is unnecessary to enumerate them. Men are proud of those achievements, and have a right to be. But they seem to have observed that this newly-won power over space and time, this subjugation of the forces of nature, which is the fulfilment of a longing that goes back thousands of years, hasn't increased the amount of pleasurable satisfaction which they may expect from life and hasn't made them feel happier. From the recognition of this fact we ought to be content to conclude that power over nature isn't the only precondition of human happiness, just as it isn't the only goal of cultural endeavour; we ought not to infer from it that technical progress is without value for the economics of our happiness. One would like to ask: is there, then, no positive gain in pleasure, no unequivocal increase in my feeling of happiness, if I can, as often as his destination that he has come through the long and difficult voyage unharmed? Does it mean nothing that medicine has succeeded in enormously reducing infant mortality and the danger of infection for women in childbirth, and, indeed, in considerably lengthening the average life of a civilized man? And there's a long list that might be added to benefits of this kind which we owe to the much-despised era of scientific and technical advances. But here the voice of pessimistic criticism makes itself heard and warns us that most of these satisfactions follow the model of the 'cheap enjoyment' extolled in the anecdote—the enjoyment obtained by putting a bare leg from under the bed-clothes on a cold winter night and drawing it in again. If there had been no railway to conquer distances, my child would never have left his native town and I should need no telephone to hear his voice; if travelling across the ocean by ship had not been introduced, my friend wouldn't

have embarked on his sea-voyage and I should not need a cable to relieve my anxiety about him. What's the use of reducing infantile mortality when it "we've created difficult conditions for our sexual life in marriage, and have probably worked against the beneficial effects of natural selection? And, finally, what good to us is a long life if it is difficult and barren of joys, and if it is so full of misery that we can only welcome death as a deliverer?

It seems certain that we do not feel comfortable in our present-day civilization, but it is very difficult to form an opinion whether and in what degree men of an earlier age felt happier and what part their cultural conditions played in the matter.

It is time for us to turn our attention to the nature of this civilization on whose value as a means to happiness doubts have been thrown. We shall not look for a formula in which to express that nature in a few words, until we've learned something by examining it. We shall therefore content ourselves with saying once more that the word 'civilization' describes the whole sum of the achievements and the regulations which distinguish our lives from those of our animal ancestors and which serve two purposes—namely to protect men against nature, and so on. As regards this side of civilization, there can be scarcely any doubt. If we go back far enough, we find that the first acts of civilization were the use of tools, the gaining of control over fire and the construction of dwellings. Among these, the control over fire stands out as a quite extraordinary and unexampled achievement, while the others opened up paths which man has followed ever since, and the stimulus to which is easily guessed. With every tool man is perfecting his own organs, whether motor or sensory, or is removing the limits to their functioning. Motor power places gigantic forces at his disposal, which, like his muscles, he can employ in any direction; thanks to ships and aircraft neither water nor air can hinder his movements; by means of spectacles he corrects defects in the lens of his own eye; by means of the telescope he sees into the far distance; and by means of the microscope he overcomes the limits of visibility set by the structure of his retina. In the photographic camera he has created an instrument which retains the fleeting visual impressions, just as a gramophone disc retains

the equally fleeting auditory ones; both are at bottom materializations of the power he possesses of recollection, his memory. With the help of the telephone he can hear at distances which would be respected as unattainable even in a fairy tale. Writing was in its origin the voice of an absent person; and the dwelling-house was a substitute for the mother's womb, the first lodging, for which in all likelihood man still longs, and in which he was safe and felt at ease.

Man has, as it were, become a kind of prosthetic God. When he puts on all his auxiliary organs he is truly magnificent; but those organs have not grown on to him and they still give him much trouble at times. Nevertheless, he is entitled to console himself with the thought that this development will not come to an end precisely with the year 1930 A.D. Future ages will bring with them new and probably unimaginably great advances in this field of civilization and will increase man's likeness to God still more. But in the interests of our investigations, we will not forget that present-day man doesn't feel happy in his Godlike character.

We recognize, then, that countries have attained a high level of civilization if we find that in them everything which can assist in the exploitation of the earth by man and in his protection against the forces of nature—everything, in short, which is of use to him—is attended to and effectively carried out.

We [also] require civilized man to reverence beauty wherever he sees it in nature and to create it in the objects of his handiwork so far as he is able. But this is far from exhausting our demands on civilization. We expect besides to see the signs of cleanliness and order. We do not think highly of the cultural level of an English country town in Shakespeare's time when we read that there was a big dung-heap in front of his father's house in Stratford; we are indignant and call it 'barbarous' (which is the opposite of civilized) when we find the paths in the Wiener Wald littered with paper. Dirtiness of any kind seems to us incompatible with civilization. We extend our demand for cleanliness to the human body too. We are astonished to learn of the objectionable smell which emanated from the Roi Soleil; and we shake our heads on the Isola Bella when we are shown the tiny wash-basin in

which Napoleon made his morning toilet. Indeed, we aren't surprised by the idea of setting up the use of soap as an actual yardstick of civilization. The same is true of order. It, like cleanliness, applies solely to the works of man. But whereas cleanliness isn't to be expected in nature, order, on the contrary, has been imitated from her.

Beauty, cleanliness and order obviously occupy a special position among the requirements of civilization. No one will maintain that they're as important for life as control over the forces of nature or as some other factors with which we shall become acquainted. And yet no one would care to put them in the background as trivialities. That civilization isn't exclusively taken up with what's useful is already shown by the example of beauty, which we decline to omit from among the interests of civilization. The usefulness of order is quite evident. With regard to cleanliness, we must bear in mind that it is demanded of us by hygiene as well, and we may suspect that even before the days of scientific prophylaxis the connection between the two was not altogether strange to man. Yet utility doesn't entirely explain these efforts; something else must be at work besides.

The development of civilization appears to us as a peculiar process which mankind undergoes, and in which several things strike us as familiar. We may characterize this process with reference to the changes which it brings about in the familiar instinctual dispositions of human beings, to satisfy which is, after all, the economic task of our lives. A few of these instincts are used up in such a manner that something appears in their place which, in an individual, we describe as a character-trait. The most remarkable example of such a process is found in the anal erotism of young human beings. Their original interest in the excretory function, its organs and products, is changed in the course of their growth into a group of traits which are familiar to us as parsimony, a sense of order and cleanliness—qualities which, though valuable and welcome in themselves, may be intensified till they become markedly dominant and produce what's called the anal character. How this happens we do not know, but there's no doubt about the correctness of the finding. Now we've seen that order and cleanliness are important requirements of civilization, although their vital necessity isn't very apparent, any more than their suitability as sources of enjoyment. At this point we cannot fail to be struck by the similarity between the process of civilization and the libidinal development of the individual. Other instincts [besides anal erotism] are induced to displace the conditions for their satisfaction, to lead them into other paths. In most cases this process coincides with that of the sublimation (of instinctual aims) with which we are familiar, but in some it can be differentiated from it. Sublimation of instinct is an especially conspicuous feature of cultural development; it is what makes it possible for higher psychical activities, scientific, artistic or ideological, to play such an important part in civilized life. If one were to yield to a first impression, one would say that sublimation is a vicissitude which has been forced upon the instincts entirely by civilization. But it would be wiser to reflect upon this a little longer. In the third place, finally, and this seems the most important of all, it is impossible to overlook the extent to which civilization is built up upon a renunciation of instinct, how much it presupposes precisely the non-satisfaction (by suppression, repression or some other means?) of powerful instincts. This 'cultural frustration' dominates the large field of social relationships between human beings. As we already know, it is the cause of the hostility against which all civilizations have to struggle. It will also make severe demands on our scientific work, and we shall have much to explain here. It isn't easy to understand how it can become possible to deprive an instinct of satisfaction. Nor is doing so without danger. If the loss isn't compensated for economically, one can be certain that serious disorders will ensue.

NOTES

[1] The woods around Vienna.
[2] The "Sun King," Louis XIV of France (1643–1715), who was reputed to have bathed only twice in his life, both times on doctor's orders.
[3] An island in Lake Maggiore, Italy."

Freud, Sigmund. "Civilization and its Discontents" from *The Standard Edition of the Complete Psychological Works of Sigmund Freud*, translated and edited by James Strachey, published by the

Freud, Sigmund, *Civilization and Its Discontents*, in The Industrial Design Reader

Victor Papanek, Design for the Real World

Designer and citizen of the world Victor Papanek (1927–1998) was born in Austria, grew up in England, studied design and architecture in the United States, taught at universities in the United States, Canada, Denmark, Sweden, and the United Kingdom, and practiced design around the globe for such organizations as the United Nations Educational, Scientific and Cultural Organization (UNESCO) and the World Health Organization (WHO). He published his book, Design for the Real World, in 1971; it has since been translated into over twenty languages. In it, building on the work of Buckminster Fuller (who wrote its introduction), Ralph Nader (see Unsafe at Any Speed), and environmentalists such as Rachel Carson (author of Silent Spring, 1962), Papanek castigated practitioners of industrial design for wasting both natural and human resources on the design of unnecessary, dangerous, and environmentally harmful products. In a direct challenge to the doctrine of artificial obsolescence (see Earnest Elmo Calkins, "Consumer Engineering"), Papanek claimed that designers needed to work for positive social good, and, failing that, to "stop working entirely."

Excerpted from Victor Papanek, Design for the Real World: Human Ecology and Social Change (New York: Bantam Books, 1971

There are professions more harmful than industrial design, but only a very few of them. And possibly only one profession is phonier. Advertising design, in persuading people to buy things they don't need, with money they don't have, in order to impress others who don't care, is probably the phoniest field in existence today. Industrial design, by concocting the tawdry idiocies hawked by advertisers, comes a close second. Never before in history have grown men sat down and seriously designed electric hairbrushes, rhinestone-covered file boxes, and mink carpeting for bathrooms, and then drawn up elaborate plans to make and sell these gadgets to millions of people. Before (in the "good old days"), if a person liked killing people, he had to become a general, purchase a coal mine, or else study nuclear physics. Today, industrial design has put murder on a mass production basis. By designing criminally unsafe automobiles that kill or maim nearly one million people around the world each year, by creating whole new species of permanent garbage to clutter up the landscape, and by choosing materials and processes that pollute the air we breathe, designers have become a dangerous breed. And the skills needed in these activities are taught carefully to young people.

In an age of mass production when everything must be planned and designed, design has become the most powerful tool with which man shapes his tools and environments (and, by extension, society and himself). This demands high social and moral responsibility from the designer. It also demands greater understanding of the people by those who practice design and more insight into the design process by the public. Not a single volume on the responsibility of the designer, no book on design that considers the public in this way, has ever been published anywhere.

In February of 1968, Fortune magazine published an article that foretold the end of the industrial design profession. Predictably, designers reacted with scorn and alarm. But I feel that the main arguments of the Fortune article are valid. It is about time that industrial design, as we've come to know it, should "cease to exist. As long as design concerns itself with confecting trivial "toys for adults," killing machines with gleaming tail-fins, and "sexed-up" shrouds for typewriters, toasters, telephones, and computers, it has lost all reason to exist.

Design must be an innovative, highly creative, cross-disciplinary tool responsive to the true needs of men. It must be more research-oriented, and we must stop defiling the earth itself with poorly-designed objects and structures.[. . .]

Looking at the books on design in seven languages, covering the walls of my home, I realized that the one book I wanted to read, the one book I most wanted to hand to my fellow students and designers, was missing. Because our society makes it crucial for designers to understand clearly the social, economic, and political background of what they do, my problem was not just one of personal frustration. So I decided to write the kind of book that I'd like to read.

This book is written from the viewpoint that there's something basically wrong with the whole concept of patents and copyrights. If I design a toy that provides therapeutic exercise for handicapped children, then I think it is unjust to delay the release of the design by a year and a half, going through a patent application. I feel that ideas are plentiful and cheap, and it is wrong to make money off the needs of others. I have been very lucky in persuading many of my students to accept this view. Much of what you will find as design examples throughout this book has never been patented. In fact, quite the opposite strategy prevails: in many cases students and I have made measured drawings of, say, a play environment for blind children, written a description of how to build it simply, and then mimeographed drawings and all. If any agency, anywhere, will write in, my students will send them all the instructions free of charge. I try to do the same myself. [. . .]

[. . .] In an environment that's screwed up visually, physically, and chemically, the best and simplest "thing that architects, industrial designers, planners, etc., could do for humanity would be to stop working entirely. In all pollution, designers are implicated at least partially. But in this book I take a more affirmative view: It seems to me that we can go beyond not working at all, and work positively. Design can and must become a way in which young people can participate in changing society.

Ever since the German Bauhaus first published its fourteen slender volumes around 1924, most books have merely repeated the methods evolved there or added frills to them. A philosophy more than half a century old is out of place in a field that must be as forward-looking as this.

As socially and morally involved designers, we must address ourselves to the needs of a world with its back

to the wall while the hands on the clock point perpetually to one minute before twelve.[1]

All men are designers. All that we do, almost all the time, is design, for design is basic to all human activity. The planning and patterning of any act towards a desired, foreseeable end constitutes the design process. Any attempt to separate design, to make it a thing-by-itself, works counter to the inherent value of design as the primary underlying matrix of life. Design is composing an epic poem, executing a mural, painting a masterpiece, writing a concerto. But design is also cleaning and reorganizing a desk drawer, pulling an impacted tooth, baking an apple pie, choosing sides for a back-lot baseball game, and educating a child.

Design is the conscious effort to impose meaningful order.

[. . .] The mode of action by which a design fulfills its purpose is its function. "Form follows function," Louis Sullivan's battle cry of the 1880's and 1890's, was followed by Frank Lloyd Wright's "Form and function are one." But semantically, all the statements from Horatio Greenough to the German Bauhaus are meaningless. The concept that what works well will of necessity look well, has been the lame excuse for all the sterile, operating-room-like furniture and implements of the twenties and thirties. A dining table of the period might have a top, well proportioned in glistening white marble, the legs carefully nurtured for maximum strength with minimum materials in gleaming stainless steel. And the first reaction on encountering such a table is to lie down on it and have your appendix extracted. Nothing about the table says: "Dine off me." Le style international and die neue Sachlichkeit2 have let us down rather badly in terms of human value. Le Corbusier's house as la machine à habiter3 and the packingcrate houses evolved in the Dutch De Stijl movement reflect a perversion of aesthetics and utility.

NOTES

[1] This may be a reference to the "Doomsday Clock" maintained by the Bulletin of the Atomic Scientists.

[2] The International Style and the New Objectivity (forms of early twentieth-century architectural modernism).

Papanek, Victor, **Design for the Real World**, in The Industrial Design Reader

Margolin, V., *Design, the Future and the Human Spirit*, in Design Issues: Volume 23, Number 3, Summer 2007 http://www.mitpressjournals.org/doi/pdf/10.1162/desi.2007.23.3.4

Chapter 4: Design and the Natural World

Readings:

Horatio Greenough, The Law of Adaptation

Horatio Greenough (1805–1852) was a well-educated and well-traveled Boston neoclassical sculptor who is perhaps best known today for his over-life-size, half-nude, seated marble statue of George Washington (now in the National Museum of American Art, Washington, DC). However, under the pseudonym Horace Bender, he published his ideas on race, evolution, architecture, design, and the arts as The Travels, Observations, and Experience of a Yankee Stonecutter. In this book, which was published the year of his death, Greenough argued that beauty in architecture and design was a result of fitness to function. His is one of the earliest statements of the doctrine of functionalism that was so famously adopted in the late nineteenth and early twentieth centuries by architect-theorists such as Louis Sullivan and Ludwig Mies van der Rohe. Greenough's comparison of the "evolution" of design to biological evolution was also an early formulation of a pattern of thought that was later to characterize many modernist histories of design.

Excerpted from The Travels, Observations, and Experience of a Yankee Stonecutter (New York: G. P. Putnam, 1852): 136–141, 202–203.

If, as the first step in our search after the great principles of construction, we but observe the skeletons and skins of animals, through all the varieties of beast and bird, of fish and insect, are we not as forcibly struck by their variety as by their beauty? There's no arbitrary law of proportion, no unbending model of form. There's scarce a part of the animal organization which we do not find elongated or shortened, increased, diminished or suppressed, as the wants of the genus or species dictate, as their exposure or their work may require. The neck of the swan and that of the eagle, however different in character and proportion, equally charm the eye and satisfy the reason. We approve the length of the same member in grazing animals, its shortness in beasts of prey. The horse's shanks are thin, and we admire them; the greyhound's chest is deep, and we cry, beautiful! It is neither the presence nor the absence of this or that part or shape or color that wins our eye in natural objects; it is the consistency and harmony of the parts juxtaposed, the subordination of details to masses, and of masses to the whole.

The law of adaptation is the fundamental law of nature in all structure. So unflinchingly does she modify a type in accordance with a new position, that some philosophers have declared a variety of appearance to be the object aimed at; so entirely does she limit the modification to the demands of necessity, that adherence to one original plan seems, to limited intelligence, to be carried to the very verge of caprice. The domination of arbitrary rules of taste has produced the very counterpart of the wisdom thus displayed in every object around us; we tie up the camel leopard to the rack; we shave the lion, and call him a dog; we strive to bind the unicorn with his band in the furrow, and to make him harrow the valleys after us!

When the savage of the South Sea islands shapes his war club, his first thought is of its use. His first efforts pare the long shaft, and mould the convenient handle; then the heavier end takes gradually the edge that cuts, while it retains the weight that stuns. His idler hour divides its surface by lines and curves, or embosses it with figures that have pleased his eye, or are linked with his superstition. We admire its effective shape, its Etruscan-like quaintness, its graceful form and subtle outline, yet we neglect the lesson it might teach. If we

compare the form of a newly invented machine with the perfected type of the same instrument, we observe, as we trace it through the phases of improvement, how weight is shaken off where strength is less needed, how functions are made to approach without impeding each other, how the straight becomes curved, and the curve is straightened, till the straggling and cumbersome machine becomes the compact, effective, and beautiful engine.

[. . .]

Let us now turn to a structure of our own, one which from its nature and uses commands us to reject authority, and we shall find the result of the manly use of plain good sense so like that of taste and genius too, as scarce to require a distinctive title. Observe a ship at sea! Mark the majestic form of her hull as she rushes through the water, observe the graceful bend of her body, the gentle transition from round to flat, the grasp of her keel, the leap of her bows, the symmetry and rich tracery of her spars and rigging, and those grand wind muscles, her sails! Behold an organization second only to that of an animal, obedient as the horse, swift as the stag, and bearing the burthen of a thousand camels from pole to pole! What Academy of Design, what research of connoisseurship, what imitation of the Greeks produced this marvel of construction? Here is the result of the study of man upon the great deep, where Nature spake of the laws of building, not in the feather and in the flower, but in winds and waves, and he bent all his mind to hear and to obey. Could we carry into our civil architecture the responsibilities that weigh upon our shipbuilding, we should ere long have edifices as superior to the Parthenon for the purposes that we require, as the Constitution or the Pennsylvania is to the galley of the Argonauts.1 Could our blunders on terra-firma be put to the same dread test that those of shipbuilders are, little would be now left to say on this subject.

Instead of forcing the functions of every sort of building into one general form, adopting an outward shape for the sake of the eye or of association, without reference to the inner distribution, let us begin from the heart as a nucleus and work outward. The most convenient size and arrangement of the rooms that are to constitute the building being "fixed, the access of the light that may, of the air that must, be wanted, being provided for, we've the skeleton of our building. Nay, we've all excepting the dress. The connexion and order of parts, juxtaposed for convenience, cannot fail to speak of their relation and uses. [. . .]

What a field of study would be opened by the adoption in civil architecture of those laws of apportionment, distribution and connexion, which we've thus hinted at? No longer could the mere tyro huddle together a crowd of ill arranged, ill lighted and stifled rooms, and masking the chaos with the sneaking copy of a Greek façade, usurp the name of architect. If this anatomic connexion and proportion has been attained in ships, in machines, and, in spite of false principles, in such buildings as make a departure from it fatal, as in bridges and in scaffolding, why should we fear its immediate use in all construction!

[. . .]

The normal development of beauty is through action to completeness. The invariable development of embellishment and decoration is more embellishment and more decoration. The reductio ad absurdum is palpable enough at last; but where was the first downward step?2 I maintain that the first downward step was the introduction of the first inorganic, non-functional element, whether of shape or color. If I be told that such a system as mine would produce nakedness, I accept the omen. In nakedness I behold the majesty of the essential, instead of the trappings of pretension. [. . .]

Beauty is the promise of function. [. . .]

NOTES

1 The USS Constitution ("Old Ironsides"), the oldest commissioned ship still serving in the U.S. Navy, is an American frigate that was first launched in 1797. The first USS Pennsylvania, a ship-of-the-line commissioned in 1812 (but not launched until 1837), was the largest sailing warship ever built for the U.S. Navy. See James L. Mooney, Dictionary of American Naval Fighting Ships, vol. II (Washington, D.C.: Navy Department, Naval History Division, 1963): 173–7,

and Mooney, Dictionary of American Naval Fighting Ships, vol. IV (Washington: Navy Department, Naval History Division, 1969): 596–7. "The galley of the Argonauts" refers to the small oar- (rather than sail-) powered ship Argo, which in ancient Greek myth was the vessel of the hero Jason.

[2] The Latin phrase reductio ad absurdum means "reduction to the absurd."

Excerpted from *The Travels, Observations, and Experience of a Yankee Stonecutter*, G. P. Putnam, 1852, pp. 136–141, 202–203.

Greenough, H., **The Law of Adaptation**, in The Industrial Design Reader

Fuller, R. B., *Operating Manual for Spaceship Earth*, in The Industrial Design Reader
http://designsciencelab.com/resources/
OperatingManual_BF.pdf

Chapter 5: Design and Economics

Readings:

THE ESSENCE OF JUST-IN-TIME: PRACTICE-IN-USE AT TOYOTA PRODUCTION MANAGED ORGANIZATIONS–How Toyota Turns Workers Into Problem Solvers

11/26/2001

Toyota cars and trucks have a reputation for quality—and the company works hard to keep the bar set high. But its methods aren't secret. So why can't other carmakers copy Toyota's success? HBS professor **Steven Spear** says that answer is partially in how the company teaches problem solving to every employee. Toyota's "Rules-in-Use" allow the organization to engage in self-reflective design, testing, and improvement, with everyone contributing.

by Sarah Jane Johnston, *HBS Working Knowledge*

When HBS professor Steven Spear recently released an abstract on problem solving at Toyota, HBS Working Knowledge *staffer Sarah Jane Johnston e-mailed off some questions. Spear not only answered the questions, but also asked some of his own—and answered those as well.*

Sarah Jane Johnston: Why study Toyota? With all the books and articles on Toyota, lean manufacturing, just-in-time, kanban systems, quality systems, etc. that came out in the 1980s and 90s, hasn't the topic been exhausted?

Steven Spear: Well, this has been a much-researched area. When Kent Bowen and I first did a literature search, we found nearly 3,000 articles and books had been published on some of the topics you just mentioned.

However, there was an apparent discrepancy. There had been this wide, long-standing recognition of Toyota as the premier automobile manufacturer in terms of the unmatched combination of high quality, low cost, short lead-time and flexible production. And Toyota's operating system—the Toyota Production System—had been widely credited for Toyota's sustained leadership in manufacturing performance. Furthermore, Toyota had been remarkably open in letting outsiders study its operations. The American Big Three and many other auto companies had done major benchmarking studies, and they and other companies had tried to implement their own forms of the Toyota Production System. There's the Ford Production System, the Chrysler Operating System, and General Motors went so far as to establish a joint venture with Toyota called NUMMI, approximately fifteen years ago.

"We concluded that Toyota has come up with a powerful, broadly applicable answer to a fundamental managerial problem."

— Steven J. Spear

However, despite Toyota's openness and the genuinely honest efforts by other companies over many years to emulate Toyota, no one had yet matched Toyota in terms of having simultaneously high-quality, low-cost,

short lead-time, flexible production over time and broadly based across the system.

It was from observations such as these that Kent and I started to form the impression that despite all the attention that had already been paid to Toyota, something critical was being missed. Therefore, we approached people at Toyota to ask what they did that others might have missed.

What did they say?

To paraphrase one of our contacts, he said, "It's not that we don't want to tell you what TPS is, it's that we can't. We don't have adequate words for it. But, we can show you what TPS is."

Over about a four-year period, they showed us how work was actually done in practice in dozens of plants. Kent and I went to Toyota plants and those of suppliers here in the U.S. and in Japan and directly watched literally hundreds of people in a wide variety of roles, functional specialties, and hierarchical levels. I personally was in the field for at least 180 working days during that time and even spent one week at a non-Toyota plant doing assembly work and spent another five months as part of a Toyota team that was trying to teach TPS at a first-tier supplier in Kentucky.

What did you discover?

We concluded that Toyota has come up with a powerful, broadly applicable answer to a fundamental managerial problem. The products we consume and the services we use are typically not the result of a single person's effort. Rather, they come to us through the collective effort of many people each doing a small part of the larger whole. To a certain extent, this is because of the advantages of specialization that Adam Smith identified in pin manufacturing as long ago as 1776 in *The Wealth of Nations*. However, it goes beyond the economies of scale that accrue to the specialist, such as skill and equipment focus, setup minimization, etc.

The products and services characteristic of our modern economy are far too complex for any one person to understand how they work. It is cognitively overwhelming. Therefore, organizations must have some mechanism for decomposing the whole system into sub-system and component parts, each "cognitively"

small or simple enough for individual people to do meaningful work. However, decomposing the complex whole into simpler parts is only part of the challenge. The decomposition must occur in concert with complimentary mechanisms that reintegrate the parts into a meaningful, harmonious whole.

This common yet nevertheless challenging problem is obviously evident when we talk about the design of complex technical devices. Automobiles have tens of thousands of mechanical and electronic parts. Software has millions and millions of lines of code. Each system can require scores if not hundreds of person-work-years to be designed. No one person can be responsible for the design of a whole system. No one is either smart enough or long-lived enough to do the design work single handedly.

Furthermore, we observe that technical systems are tested repeatedly in prototype forms before being released. Why? Because designers know that no matter how good their initial efforts, they will miss the mark on the first try. There will be something about the design of the overall system structure or architecture, the interfaces that connect components, or the individual components themselves that need redesign. In other words, to some extent the first try will be wrong, and the organization designing a complex system needs to design, test, and improve the system in a way that allows iterative congruence to an acceptable outcome.

The same set of conditions that affect groups of people engaged in collaborative product design affect groups of people engaged in the collaborative production and delivery of goods and services. As with complex technical systems, there would be cognitive overload for one person to design, test-in-use, and improve the work systems of factories, hotels, hospitals, or agencies as reflected in (a) the structure of who gets what good, service, or information from whom, (b) the coordinative connections among people so that they can express reliably what they need to do their work and learn what others need from them, and (c) the individual work activities that create intermediate products, services, and information. In essence then, the people who work in an organization that produces something are simultaneously engaged in collaborative production and delivery and are also engaged in a collaborative

process of self-reflective design, "prototype testing," and improvement of their own work systems amidst changes in market needs, products, technical processes, and so forth.

It is our conclusion that Toyota has developed a set of principles, Rules-in-Use we've called them, that allow organizations to engage in this (self-reflective) design, testing, and improvement so that (nearly) *everyone* can contribute at or near his or her potential, and when the parts come together the whole is much, much greater than the sum of the parts.

What are these rules?

We've seen that consistently—across functional roles, products, processes (assembly, equipment maintenance and repair, materials logistics, training, system redesign, administration, etc.), and hierarchical levels (from shop floor to plant manager and above) that in TPS managed organizations the design of nearly all work activities, connections among people, and pathways of connected activities over which products, services, and information take form are *specified-in-their-design, tested-with-their-every-use, and improved close in time, place, and person to the occurrence of every problem.*

That sounds pretty rigorous.

It is, but consider what the Toyota people are attempting to accomplish. They're saying before you (or you all) do work, make clear what you expect to happen (by specifying the design), each time you do work, see that what you expected has actually occurred (by testing with each use), and when there's a difference between what had actually happened and what was predicted, solve problems while the information is still fresh.

That reminds me of what my high school lab science teacher required.

Exactly! This is a system designed for broad based, frequent, rapid, low-cost learning. The "Rules" imply a belief that we may not get the right solution (to work system design) on the first try, but that if we design everything we do as a bona fide experiment, we can more rapidly converge, iteratively, and at lower cost, on the right answer, and, in the process, learn a heck of lot more about the system we are operating.

You say in your article that the Toyota system involves a rigorous and methodical problem-solving approach that's made part of everyone's work and is done under the guidance of a teacher. How difficult would it be for companies to develop their own program based on the Toyota model?

Your question cuts right to a critical issue. We discussed earlier the basic problem that for complex systems, responsibility for design, testing, and improvement must be distributed broadly. We've observed that Toyota, its best suppliers, and other companies that have learned well from Toyota can confidently distribute a tremendous amount of responsibility to the people who actually do the work, from the most senior, experienced member of the organization to the most junior. This is accomplished because of the tremendous emphasis on teaching *everyone* how to be a skillful problem solver.

How do they do this?

They do this by teaching people to solve problems by solving problems. For instance, in our paper we describe a team at a Toyota supplier, Aisin. The team members, when they were first hired, were inexperienced with at best an average high school education. In the first phase of their employment, the hurdle was merely learning how to do the routine work for which they were responsible. Soon thereafter though, they learned how to immediately identify problems that occurred as they did their work. Then they learned how to do sophisticated root-cause analysis to find the underlying conditions that created the symptoms that they had experienced. Then they regularly practiced developing counter-measures—changes in work, tool, product, or process design—that would remove the underlying root causes.

Sounds impressive.

Yes, but frustrating. They complained that when they started, they were "blissful in their ignorance." But after this sustained development, they could now see problems, root down to their probable cause, design solutions, but the team members couldn't actually implement these solutions. Therefore, as a final round, the team members received training in various technical

crafts—one became a licensed electrician, another a machinist, another learned some carpentry skills.

Was this unique?

Absolutely not. We saw the similar approach repeated elsewhere. At Taiheiyo, another supplier, team members made sophisticated improvements in robotic welding equipment that reduced cost, increased quality, and won recognition with an award from the Ministry of Environment. At NHK (Nippon Spring) another team conducted a series of experiments that increased quality, productivity, and efficiency in a seat production line.

What's the role of the manager in this process?

Your question about the role of the manager gets right to the heart of the difficulty of managing this way. For many people, it requires a profound shift in mind-set in terms of how the manager envisions his or her role. For the team at Aisin to become so skilled as problem solvers, they had to be led through their training by a capable team leader and group leader. The team leader and group leader were capable of teaching these skills in a directed, learn-by-doing fashion, because they too were consistently trained in a similar fashion by their immediate senior. We found that in the best TPS-managed plants, there was a pathway of learning and teaching that cascaded from the most senior levels to the most junior. In effect, the needs of people directly touching the work determined the assistance, problem solving, and training activities of those more senior. This is a sharp contrast, in fact a near inversion, in terms of who works for whom when compared with the more traditional, centralized command and control system characterized by a downward diffusion of work orders and an upward reporting of work status.

And if you are hiring a manager to help run this system, what are the attributes of the ideal candidate?

We observed that the best managers in these TPS managed organizations, and the managers in organizations that seem to adopt the Rules-in-Use approach most rapidly are humble but also self-confident enough to be great learners and terrific teachers. Furthermore, they're willing to subscribe to a consistent set of values.

How do you mean?

Again, it is what's implied in the guideline of specifying every design, testing with every use, and improving close in time, place, and person to the occurrence of every problem. If we do this consistently, we are saying through our action that when people come to work, they're entitled to expect that they will succeed in doing something of value for another person. If they don't succeed, they're entitled to know immediately that they have not. And when they have not succeeded, they have the right to expect that they will be involved in creating a solution that makes success more likely on the next try. People who cannot subscribe to these ideas—neither in their words nor in their actions—aren't likely to manage effectively in this system.

That sounds somewhat high-minded and esoteric.

I agree with you that it strikes the ear as sounding high principled but perhaps not practical. However, I'm fundamentally an empiricist, so I have to go back to what we've observed. In organizations in which managers really live by these Rules, either in the Toyota system or at sites that have successfully transformed themselves, there's a palpable, positive difference in the attitude of people that's coupled with exceptional performance along critical business measures. such as quality, cost, safety, and cycle time.

Have any other research projects evolved from your findings?

We titled the results of our initial research "Decoding the DNA of the Toyota Production System." Kent and I are reasonably confident that the Rules-in-Use about which we've written are a successful decoding. Now, we are trying to "replicate the DNA" at a variety of sites. We want to know where and when these Rules create great value, and where they do, how they can be implemented most effectively.

Since we are empiricists, we are conducting experiments through our field research. We are part of a fairly ambitious effort at Alcoa to develop and deploy the Alcoa Business System, ABS. This is a fusion of Alcoa's long standing value system, which has helped make Alcoa the safest employer in the country, with the Rules in Use. That effort has been going on for

a number of years, first with the enthusiastic support of Alcoa's former CEO, Paul O'Neill, now Secretary of the Treasury (not your typical retirement, eh?) and now with the backing of Alain Belda, the company's current head. There have been some really inspirational early results in places as disparate as Hernando, Mississippi and Poces de Caldas, Brazil and with processes as disparate as smelting, extrusion, die design, and finance.

We also started creating pilot sites in the health care industry. We started our work with a "learning unit" at Deaconess-Glover Hospital in Needham, not far from campus. We've got a series of case studies that captures some of the learnings from that effort. More recently, we've established pilot sites at Presbyterian and South Side Hospitals, both part of the University of Pittsburgh Medical Center. This work is part of a larger, comprehensive effort being made under the auspices of the Pittsburgh Regional Healthcare Initiative, with broad community support, with cooperation from the Centers for Disease Control, and with backing from the Robert Wood Johnson Foundation.

Also, we've been testing these ideas with our students: Kent in the first year Technology and Operations Management class for which he is course head, me in a second year elective called Running and Growing the Small Company, and both of us in an Executive Education course in which we participate called Building Competitive Advantage Through Operations.

Johnston, Sarah Jane. "The Essence of Just in Time: Practice-In-Use at Toyota Production System Managed. Organizations—How Toyota Turns Workers Into Problem Solvers." November 11, 2001. Reprinted by permission of HBS Working Knowledge.

Johnston, S. J., *The Essence of Just-in-Time: Practice-in-Use at Toyota Production System Managed Organizations—How Toyota Turns Workers into Problem Solvers*, HBS Working Knowledge

The Role of Design in Business
by Ravi Sawhney and Deepa Prahalad at
http://www.bloomberg.com/bw/stories/2010-02-01/
the-role-of-design-in-businessbusinessweek-
business-news-stock-market-and-financial-advice

Heskett, J., Creating Economic Value by Design, International Journal of Design Vol.3 No.1 2009; Link: http://www.ijdesign.org/ojs/index.php/ IJDesign/article/view/477/243

Chapter 6: Design and Technology

Viewings:

Levy, K., *A Chinese Company 3-D Printed 10 Houses in a Day* at http://www.businessinsider.com/ a-chinese-company-3d-printed-10-houses-in-a-day-2014-4

Noe, R., *True I.D. Stories #26: Accidental Orange and the Democratization of the Scissors* at http://www.core77.com/blog/true_id_stories/ true_id_stories_26_accidental_orange_and_the_ democratization_of_the_scissors_26986.asp

Chapter 7: Design and Transportation

Readings:

Ford, H., *Machinery, the New Messiah*, in The Industrial Design Reader http://www.unz.org/Pub/Forum-1928mar-00359

Chapter 9: Design and Education

Readings:

Lewis Day, To Ladies and Amateurs

According to historian Joellen Secondo, Lewis Foreman Day (1845–1910) was educated in France and Germany, "but his interest in design was provided by visits to the

South Kensington Museum, London (now the Victoria & Albert Museum)"—the institution that was one of the fruits of the Great Exhibition of 1851. In the 1860s and 1870s, Day worked as a glass painter and designer, and, in 1880, started his own firm, for which he designed textiles, wallpapers, stained glass, embroidery, carpets, tiles, pottery, furniture, silver, jewelry, and book covers. In his numerous books and essays, Day advocated fine craftsmanship and promoted the merits of decorative designs based on natural forms. In these excerpts from his essay, "To Ladies and Amateurs," Day comments on the relative status of the decorative arts and fine arts, and explains why women were (as was commonly believed) unsuited for serious careers as designers and artists.[1]

Excerpted from Lewis Foreman Day, "To Ladies and Amateurs," in Every-Day Art: Short Essays on the Arts Not Fine (London: B. T. Batsford, 1882): 250–2, 254, 256, 260–262, 264–266.

The greatest art has always been of a decorative character; but let it suffice for the present to assert that decorative art is, as such, second to no other; that granted, we may admit that under the head of "decorative" are included also the lesser arts applied to industry. These arts have suffered from the slight esteem in which they have been held among us. "High art," so called, has been so far prejudicial to them that it has attracted, by its pretensions, the best of those whom nature had meant for decorators; and many a one who might perhaps in the natural direction of his own genius have risen to fame, has dissipated his talent "in vain attempts to paint pictures. If high art were less high the art of every-day would be higher.

A most dangerous will-o'-the-wisp is high art to amateurs, and to lady amateurs in particular. It must be remembered that the signal success of certain lady artists is the result of a devotion to art, and a sacrifice to it, that amateurs are scarcely prepared to offer. How many even of those ladies who really love art would be willing to shut themselves out from household pleasures and from household cares, and devote some six or eight hours daily to the study of it? how many of them, even though they might be willing, would feel themselves justified in doing so? Those who clamour for women's rights aren't yet in a majority; ladies are for the most part content with their

privileges, none the less precious for the duties with which they're associated. Assuming that lady amateurs do not, as a class, think of materially altering their mode of life, but simply desire to occupy their leisure pleasurably, and at the same time not unprofitably, in the pursuit of art, it would be better and for art too, that they should realise at the outset that, though they may easily paint such pictures as give satisfaction to their friends, it is improbable that the paintings of many of them will have any great value as art. The conditions of their life are against it. On the other hand, society is so constituted that there's every encouragement for the less ambitious arts in which they have hitherto distinguished themselves, and for some in which they have not as yet made very great progress.

The most obvious opportunity for the exercise of a woman's artistic faculty seems to lie in needlework. She may not compete favorably with professional men in the picture galleries, but in such delicate work as embroidery she has the game in her own hands. The needle was her sceptre from the first, and she has achieved with it royal results. Yet her sphere doesn't end there. Wherever there's question of taste, what might not woman's influence do for art? And how little it has actually accomplished!

[. . .]

There's here no thought of depreciating in any way the feminine capacity. More often than not a man's wife is his "better half" indeed, without suggestion of irony in the title. If man be the superior animal, it is mainly as animal that he is superior. Whether superior or inferior to him, woman is certainly different from man; her highest qualities are those in which man cannot compete with her, just as she cannot cope with him in things wherein his strength lies. With all the nattiness and delicacy which she brings to bear on decorative art, we miss largeness of treatment, breadth, originality, and self-restraint. The straight line, so needful in decoration, is hateful to her. The judicial faculty, on which (unrecognised) so much of taste depends, isn't her forte.

[. . .]

The part that a lady can take in the execution of decorative work depends of course upon her artistic

qualifications. There appears to be a notion prevalent that china-painting, panel-painting, and the like, are lesser arts that can be acquired in a few lessons, without previous training in art. Certainly a flat ornament is more easy to paint than a picture; but then the flat ornament has to be designed, and the art of design isn't learnt in a day. There would be no difficulty in finding ladies well able to paint oak leaves; but most of them would find considerable difficulty in adapting them to decorative design. The truth, so obvious that one is half ashamed to have to reiterate it, is that only those who are prepared to work steadily and earnestly at the art they adopt, however small that art may be, are likely to produce anything in the least worth doing. The amateur needs to be advised that decoration is a much more serious matter than she imagines.

[. . .]

One difficulty that ladies have to contend with in decoration is that what's most available, and most wanted, is bold work, large in design and treatment, whilst ladies lean rather towards refinement and finish than breadth. It is work, too, that's best done in situ, and a lady isn't quite at home on the top of a scaffold. She has fuller opportunity for the exercise of her talent on panels, tiles, and all the smaller details of furniture, and these details can be executed conveniently and at leisure. The cabinet or sideboard is useful all the same, and isn't unsightly, whilst the panels are yet unpainted; but the decoration of the walls of a room, which must be done quickly, is a tax upon the strength and endurance of the artist that few women can stand. [. . .] Ambition isn't greatly to be encouraged in amateurs. It may safely be left to grow of itself with growing power. It is a pity that unprofessional effort is mainly directed towards the production of objects which only rare artistic excellence can make worth having. It is to be remembered that we judge more useful work with much greater leniency than that which has no other justification than beauty.

[. . .] In all respects the work of ladies would be more available in domestic decoration, if it were less lofty in its aim. The amateur burns always to do something of importance—figures probably, or at the very least flower-groups. But even if this ambition be warranted by ability, the occasion for a great deal of such prominent work seldom occurs in an ordinary living-room. There is, on the other hand, considerable scope for ornament of that more modest kind which is content to take its lowly place in the general effect.

[. . .]

The simple truth, as it seems to me, is that ladies seldom give sufficient thought and study to decoration. If they have aptitude, they're too readily persuaded that they know all about it, when in reality their knowledge is rudimentary; they're too impatient, too ambitious, too little aware of the difficulties before them, and of the limits of their ability. On the other hand, if they be modest they're wanting in self-reliance, they do not believe enough in themselves, and they allow their feeling to be overruled by those who, knowing less, talk more confidently. Needlework excepted, there's very little ladies' work done that's of real value in decoration, yet there's scarcely a young housewife but might learn to do good work, worth doing in the house, but which, failing her, remains undone.

[. . .]

NOTES

[1]This introduction is adapted from Joellen Secondo, "Day, Lewis Foreman," The Grove Dictionary of Art Online, ed. L. Macy, < http://www.groveart.com>, (accessed 18 December 2002).

Excerpted from Lewis Foreman Day, "To Ladies and Amateurs," in *Every-Day Art: Short Essays on the Arts Not Fine* , B. T. Batsford, 1882, pp. 250–2, 254, 256, 260–262, 264–266.

Day, L. F., *To Ladies and Amateurs*, in The Industrial Design Reader

Gropius, W., *Program of the Staatliche Bauhaus in Weimar*, in The Industrial Design Reader

Walter Gropius, Program of the Staatliche Bauhaus in Weimar

As did his contemporaries Adolf Meyer, Ludwig Mies van der Rohe, and Le Corbusier, the German architect and designer Walter Gropius (1883–1969) worked for a time in Peter Behrens's Berlin architecture and design firm. He left Behrens's office in 1910, joined the Deutscher Werkbund in 1911, and built the famed Fagus Factory at Alfeld in 1911–13. After returning from service in World War I, he became the head of the Kunstschule and Kunstgewerbeschule in Saxony (formerly directed by Henry van de Velde), which he merged into the institution known as the Staatliche Bauhaus, Weimar. Gropius served as director of the Bauhaus from 1919 to 1928; when the Bauhaus moved to Dessau in 1925, he designed its new facilities. (The Bauhaus moved again in 1932 to Berlin, where the Nazis closed it in 1933.) The title page of Gropius's program for the Bauhaus, which was printed as a four-page leaflet in April 1919, featured Lyonel Feininger's cubist/expressionist woodcut Cathedral of Socialism—a fitting symbol of the institution's guild-inspired educational system, emphasis on architecture, and political ideals.

Reprinted in its entirety from Walter Gropius, "Program of the Staatliche Bauhaus in Weimar," translated by Wolfgang Jabs and Basil Gilbert, in Bauhaus: Weimar Dessau Berlin Chicago, by Hans Wingler (originally published in German as Das Bauhaus [Cologne: Verlag Gebr. Rasch & Co., 1962]; English adaptation copyright ©1969 by The Massachusetts Institute of Technology): 31–33. Reprinted by permission of MIT Press.

The ultimate aim of all visual arts is the complete building! To embellish buildings was once the noblest function of the fine arts; they were the indispensable components of great architecture. Today the arts exist in isolation, from which they can be rescued only through the conscious, cooperative effort of all craftsmen. Architects, painters, and sculptors must recognize anew and learn to grasp the composite character of a building both as an entity and in its separate parts. Only then will their work be imbued with the architectonic spirit which it has lost as "salon art."

The old schools of art were unable to produce this unity; how could they, since art cannot be taught. They must be merged once more with the workshop. The mere drawing and painting world of the pattern designer and the applied artist must become a world that builds again. When young people who take a joy in artistic creation once more begin their life's work by learning a trade, then the unproductive "artist" will no longer be condemned to deficient artistry, for their skill will now be preserved for the crafts, in which they will be able to achieve excellence.

Architects, sculptors, painters, we all must return to the crafts! For art isn't a "profession." There's no essential difference between the artist and the craftsman. The artist is an exalted craftsman. In rare moments of inspiration, transcending the consciousness of his will, the grace of heaven may cause his work to blossom into art. But proficiency in a craft is essential to every artist. Therein lies the prime source of creative imagination. Let us then create a new guild of craftsmen without the class distinctions that raise an arrogant barrier between craftsman and artist! Together let us desire, conceive, and create the new structure of the future, which will embrace architecture and sculpture and painting in one unity and which will one day rise toward heaven from the hands of a million workers like the crystal symbol of a new faith.

Walter Gropius

Program of the Staatliche Bauhaus in Weimar

The Staatliche Bauhaus resulted from the merger of the former Grand-Ducal Saxon Academy of Art with the former Grand-Ducal Saxon School of Arts and Crafts in conjunction with a newly affiliated department of architecture.

AIMS OF THE BAUHAUS

The Bauhaus strives to bring together all creative effort into one whole, to reunify all the disciplines of practical art—sculpture, painting, handicrafts, and the crafts—as inseparable components of a new architecture. The ultimate, if distant, aim of the Bauhaus is the unified

work of art—the great structure—in which there's no distinction between monumental and decorative art.

The Bauhaus wants to educate architects, painters, and sculptors of all levels, according to their capabilities, to become competent craftsmen or independent creative artists and to form a working community of leading and future artist-craftsmen. These men, of kindred spirit, will know how to design buildings harmoniously in their entirety—structure, finishing, ornamentation, and furnishing.

PRINCIPLES OF THE BAUHAUS

Art rises above all methods; in itself it cannot be taught, but the crafts certainly can be. Architects, painters, and sculptors are craftsmen in the true sense of the word; hence, a thorough training in the crafts, acquired in workshops and in experimental and practical sites, is required of all students as the indispensable basis for all artistic production. Our own workshops are to be gradually built up, and apprenticeship agreements with outside workshops will be concluded.

The school is the servant of the workshop, and will one day be absorbed in it. Therefore there will be no teachers or pupils in the Bauhaus but masters, journeymen, and apprentices.

The manner of teaching arises from the character of the workshop:

Organic forms developed from manual skills.

Avoidance of all rigidity; priority of creativity; freedom of individuality, but strict study discipline.

Master and journeyman examinations, according to the Guild Statutes, held before the Council of Masters of the Bauhaus or before outside masters.

Collaboration by the students in the work of the masters.

Securing of commissions, also for students.

Mutual planning of extensive, Utopian structural designs—public buildings and buildings for worship—aimed at the future. Collaboration of all masters and students—architects, painters, sculptors—on these designs with the object of gradually achieving a harmony of all the component elements and parts that make up architecture.

Constant contact with the leaders of the crafts and industries of the country. Contact with public life, with the people, through exhibitions and other activities.

New research into the nature of the exhibitions, to solve the problem of displaying visual work and sculpture within the framework of architecture.

Encouragement of friendly relations between masters and students outside of work; therefore plays, lectures, poetry, music, costume parties. Establishment of a cheerful ceremonial at these gatherings.

RANGE OF INSTRUCTION

Instruction at the Bauhaus includes all practical and scientific areas of creative work.

A. Architecture,
B. Painting,
C. Sculpture

including all branches of the crafts.

Students are trained in a craft (1) as well as in drawing and painting (2) and science and theory (3).

1. Craft training—either in our own, gradually enlarging workshops or in outside workshops to which the student is bound by apprenticeship agreement—includes:

 a) sculptors, stonemasons, stucco workers, wood-carvers, ceramic workers, plaster casters,
 b) blacksmiths, locksmiths, founders, metal turners,
 c) cabinetmakers,
 d) painter-and-decorators, glass painters, mosaic workers, enamelers,
 e) etchers, wood engravers, lithographers, art printers, enchasers,
 f) weavers.

 Craft training forms the basis of all teaching at the Bauhaus. Every student must learn a craft.

2. Training in drawing and painting includes:

 a) free-hand sketching from memory and imagination,
 b) drawing and painting of heads, live models, and animals,

c) drawing and painting of landscapes, figures, plants, and still lives,

d) composition,

e) execution of murals, panel pictures, and religious shrines,

f) design of ornaments,

g) lettering,

h) construction and projection drawing,

i) design of exteriors, gardens, and interiors

j) design of furniture and practical articles.

3. Training in science and theory includes:

a) art history—not presented in the sense of a history of styles, but rather to further active understanding of historical working methods and techniques,

b) science of materials,

c) anatomy—from the living model,

d) physical and chemical theory of color,

e) rational painting methods,

f) basic concepts of bookkeeping, contract negotiations, personnel,

g) individual lectures on subjects of general interest in all areas of art and science.

DIVISIONS OF INSTRUCTION

The training is divided into three courses of instruction:

I. course for apprentices

II. course for journeymen,

III. course for junior masters.

The instruction of the individual is left to the discretion of each master within the framework of the general program and the work schedule, which is revised every semester.

In order to give the students as versatile and comprehensive a technical and artistic training as possible, the work schedule will be so arranged that every architect, painter, and sculptor-to-be is able to participate in part of the other courses.

ADMISSION

Any person of good repute, without regard to age or sex, whose previous education is deemed adequate by the Council of Masters, will be admitted, as far as space permits. The tuition fee is 180 marks per year (It

will gradually disappear entirely with increasing earnings of the Bauhaus). A nonrecurring admission fee of 20 marks is also to be paid. Foreign students pay double fees. Address inquiries to the Secretariat of the Staatliche Bauhaus in Weimar.

April 1919.

The administration of the Staatliche Bauhaus in Weimar:

Walter Gropius

Chapter 10: Design and Material Culture

Readings:

Donald Norman, Time for a Change: Design in the Post-Disciplinary Era

American Donald Norman is a cofounder of the Nielsen Norman Group, an executive consulting firm that promotes human-centered development processes for products and services. Formerly a vice president of advanced technology at Apple and Hewlett Packard, he is now a professor of computer science at Northwestern University. In this 1999 essay, he reiterates some of the ideas he laid out in his influential 1988 book, The Design of Everyday Things, arguing that designers' focus on aesthetics often comes at the expense of usability.

What do I look for in a product or service? Sensible things. I want prod-ucts that are attractive and that look and feel good. I want them to fit nicely in my home, office or wherever else I might use them. I want

to be able to understand how to use them without reading a manual. They should be safe, endangering neither me nor anyone else. All of these aspects matter to me as a user. They make up the user experience. I'm not happy with what I see. Products are difficult to use. They're unsafe. Or they flout style for the sake of style, without regard for the consequences upon use. Bad design, all of it.

In part, bad design results from producing design for the interest of design. This is exacerbated by design prizes that focus only on a product's appearance. Bad design results from a process that ignores the whole product.

Good design, on the other hand, results from interdisciplinary, human-centered product development. This approach addresses the whole product, fulfilling the needs of the user and the business that manufactures the product. It takes into account the total user experience.

Defining the user experience requires at least five different activities:

• field observation, which is best done by applied anthropologists;
• product design, best done by a team of industrial designers, human factors experts and engineers;
• rapid prototyping, by industrial designers, model makers, artists and programmers;
• user testing, usually done by psychologists;
• user manual writing, best done by technical writers.

All five of these activities play an essential role in creating the total user experience. All of these user experience experts must work together as a team from conception through shipping to the start of the next design cycle. In addition, these people must work harmoniously with others who are involved in the product development process, particularly manufacturing and marketing.

In the current product development process, each discipline makes its contribution to product design in isolation and then complains bitterly that other people ruined the outcome. I have heard designers grumble that their clients undo their work. They develop a great design, but by the time the product is shipped it has been completely distorted. "Can you help us stop companies from ruining the design?" designers ask.

This question points out the fundamental flaw in understanding the role of design. Design cannot be separated from the other considerations of a product. The person who 'ruined' the design probably was trying to improve some other dimension of the product. The design must have been unsatisfactory in some way. This happens when the industrial design team's work is completed without consideration of all the relevant variables and then the team is frozen out of the final decision process.

Industrial designers and human-factor engineers often are kept out of the loop because they argue for superior aesthetics or usability at the expense of everything else. This attitude may win design prizes, but it bankrupts companies. All design is a series of tradeoffs. Cost, time to market, compatibility with previous products, making a brand statement—these are important factors.

It's time for a change. It is time to break out of the segregation that keeps the various disciplines tightly locked in their own boxes. It is time for a post-disciplinary revolution.

Each of the legs of product development—industrial design, engineering, user experience, marketing and manufacturing—is essential to good design. The disciplines have to work as a team throughout the entire development process, together making the necessary tradeoffs to better satisfy the needs of the customer and the company.

This isn't always easy. People from other disciplines have different educational backgrounds, different sensibilities and work styles. The same words may have entirely different meanings when used in other disciplines. It can take weeks, months or even years before working as a team goes smoothly. But time allows each discipline to gain an appreciation of the contributions that others can make.

Real collaboration results in superior design. This means that industrial designers, as well as everyone else involved in the product development process, must learn to be team players, doing what's best for the company and the product rather than focusing on any

single aspect or feature of the pro duct. They must recognize that the best design doesn't always lead to the best product.

At the end of the day, what makes something beautiful is whether or not it works.

Norman, Donald. "Time for a Change: Design in the Post-Disciplinary Era" from *Innovation, the Quarterly of the Industrial Designers Society of America*, vol. 18, no. 2 (Summer 1999), pp.16–17. Used by permission of the publisher. www.idsa.org

Norman, D., *Time for a Change: Design in the Post-Disciplinary Era*, in The Industrial Design Reader

Chapter 11: Design and Politics

Readings:

Nixon, R., and Khrushchev, N., *The Kitchen Debate***, in The Industrial Design Reader**
http://teachingamericanhistory.org/library/
document/the-kitchen-debate/

Americans With Disabilities Act **(U.S. Public Law 101-336), in The Industrial Design Reader**

SEC. 2. FINDINGS AND PURPOSES. 42 USC 12101.

a. FINDINGS.—The Congress finds that—

1) some 43,000,000 Americans have one or more physical or mental disabilities, and this number is increasing as the population as a whole is growing older;

2) historically, society has tended to isolate and segregate individuals with disabilities, and, despite some improvements, such forms of discrimination against individuals with disabilities continue to be a serious and pervasive social problem;

3) discrimination against individuals with disabilities persists in such critical areas as employment, housing, public accommodations, education, transportation, communication, recreation, institutionalization, health services, voting, and access to public services;

4) unlike individuals who have experienced discrimination on the basis of race, color, sex, national origin, religion, or age, individuals who have experienced discrimination on the basis of disability have often had no legal recourse to redress such discrimination;

5) individuals with disabilities continually encounter various forms of discrimination, including outright intentional exclusion, the discriminatory effects of architectural, transportation, and communication barriers, overprotective rules and policies, failure to make modifications to existing facilities and practices, exclusionary qualification standards and criteria, segregation, and relegation to lesser services, programs, activities, benefits, jobs, or other opportunities;

6) census data, national polls, and other studies have documented that people with disabilities, as a group, occupy an inferior status in our society, and are severely disadvantaged socially, vocationally, economically, and educationally;

7) individuals with disabilities are a discrete and insular minority who have been faced with restrictions and limitations, subjected to a history of purposeful unequal treatment, and relegated to a position of political powerlessness in our society, based on characteristics that are beyond the control of such individuals and resulting from stereotypic assumptions not truly indicative of the individual ability of such individuals to participate in, and contribute to, society;

8) the Nation's proper goals regarding individuals with disabilities are to assure equality of opportunity, full participation, independent living, and economic self-sufficiency for such individuals; and

9) the continuing existence of unfair and unnecessary discrimination and prejudice denies people with disabilities the opportunity to compete

on an equal basis and to pursue those opportunities for which our free society is justifiably famous, and costs the United States billions of dollars in unnecessary expenses resulting from dependency and nonproductivity.

b. PURPOSE.—It is the purpose of this Act—

1) to provide a clear and comprehensive national mandate for the elimination of discrimination against individuals with disabilities;

2) to provide clear, strong, consistent, enforceable standards addressing discrimination against individuals with disabilities;

3) to ensure that the Federal Government plays a central role in enforcing the standards established in this Act on behalf of individuals with disabilities; and

4) to invoke the sweep of congressional authority, including the power to enforce the fourteenth amendment and to regulate commerce, in order to address the major areas of discrimination faced day-to-day by people with disabilities.

SEC. 3. DEFINITIONS. 42 USC 12102.

As used in this Act:

1. AUXILIARY AIDS AND SERVICES.—The term "auxiliary aids and services" includes—

A) qualified interpreters or other effective methods of making aurally delivered materials available to individuals with hearing impairments;

B) qualified readers, taped texts, or other effective methods of making visually delivered materials available to individuals with visual impairments;

C) acquisition or modification of equipment or devices; and

D) other similar services and actions.

2. DISABILITY.—The term "disability" means, with respect to an individual—

A) a physical or mental impairment that substantially limits one or more of the major life activities of such individual;

B) a record of such an impairment; or

C) being regarded as having such an impairment.

3. STATE.—The term "State" means each of the several States, the District of Columbia, the Commonwealth of Puerto Rico, Guam, American Samoa, the Virgin Islands, the Trust Territory of the Pacific Islands, and the Commonwealth of the Northern Mariana Islands.

Chapter 12: Design and Society

Readings:

Hoffman and Moser, The Work-Program of the Wiener Werkstätte

The Austrian architect-designers Josef Hoffmann (1870–1956) and Koloman Moser (1868–1918), both members of the Vienna Secession movement of the 1890s, cofounded the Wiener Werkstätte (Viennese Workshop; 1903–1932) with the industrialist and collector Fritz Wärndorfer, who provided financial backing for the endeavor.[1] Modeled on C. R. Ashbee's Guild of Handicraft (see next selection), the Wiener Werkstätte was an enterprise dedicated to realizing the ideas of John Ruskin and William Morris by producing exquisitely hand-crafted furnishings, decorative objects, textiles, jewelry, and bookbindings.[2] Despite constant financial pressures, the members of the Wiener Werkstätte remained committed to the handcraft ideal long after the heyday of the Arts and Crafts movement.

Reprinted from Josef Hoffmann and Koloman Moser, Katalog mit Arbeitsprogramm der Wiener Werkstätte (Vienna, 1905), translated by Tim and Charlotte Benton, reprinted in Form and Function: A Source Book for the History of Architecture and Design, 1890–1939, edited by Tim and Charlotte Benton and Dennis Sharp (London: Crosby Lockwood Staples in association with the Open University Press, 1975): 36–37. Reprinted by permission of Tim and Charlotte Benton.

The boundless evil, caused by shoddy mass-produced goods and by the uncritical imitation of earlier styles, is like a tidal wave sweeping across the world. We've been cut adrift from the culture of our forefathers and are cast hither and thither by a thousand desires and considerations. The machine has largely replaced the

hand and the business-man has supplanted the crafts-man. To attempt to stem this torrent would seem like madness.

Yet for all that we've founded our workshop. Our aim is to create an island of tranquillity in our own country, which, amid the joyful hum of arts and crafts, would be welcome to anyone who professes faith in Ruskin and Morris. We are calling for all those who regard culture in this sense as valuable and we hope that the errors we are bound to commit will not dissuade our friends from lending their support.

We wish to create an inner relationship linking public, designer, and worker and we want to produce good and simple articles of everyday use. Our guiding principle is function, utility our first condition, and our strength must lie in good proportions and the proper treatment of material. We shall seek to decorate when it seems required but we do not feel obliged to adorn at any price. We shall use many semi-precious stones, especially in our jewellery, because in our eyes their manifold colours and ever-varying facets replace the sparkle of diamonds. We love silver and gold for their sheen and regard the lustre of copper as just as valid artistically. We feel that a silver brooch can have as much intrinsic worth as a jewel made of gold and precious stones. The merit of crafts-manship and artistic conception must be recognised once more and be valued accordingly. Handicrafts must be measured by the same standards as the work of a painter or sculptor.

We cannot and will not compete with cheap work, which has succeeded largely at the expense of the worker. We've made it our foremost duty to help the worker recover pleasure in his task and obtain humane conditions in which to carry it out, but this can only be achieved step by step.

In our leather-work and book-binding, just as in our other productions, we shall aim at providing good materials and technical finish. Decoration will obviously only be added when it doesn't conflict with the nature of the material and we shall make frequent and varied use of the different techniques of leather-inlay, embossing, hand gilding, plaiting and steeping.

The art of good binding has completely died out. Hollow backs, wire sewing, carelessly-cut, loosely-bound leaves and poor quality have become ineradicable. The manufactured so-called first edition, with its brightly printed jacket, is all that we've. The machines work away busily and swamp our bookshelves with faulty printed works and hold the record for cheapness. And yet any cultivated person ought to be ashamed of this material plenty, because he knows that on the one hand easy production means fewer responsibilities and on the other excess can only lead to superficiality. And how many of these books can we really call our own? Ought we not to possess them in their finest apparel, printed on the best paper and bound in the most beautiful leather? Have we so soon forgotten that the love with which a book is printed, put together and bound totally alters our relationship with it, that lasting acquaintance with beauty can only improve us? A book should be a work of art through and through and its merit be judged in those terms.

Our carpenters' workshops have always insisted upon the exactest and most reliable craftsmanship. But nowadays people have unfortunately grown so used to catch-penny trash that a piece of furniture executed even with a minimum of care seems quite out of reach. But it must be pointed out once and for all that we should have to assemble a pretty big house, not to mention everything inside it, if we were to equal the cost of building a railway sleeping-compartment, for example. This shows just how impossible it is to work out a sound basis for comparison. Only a hundred years ago, people were already paying hundreds of thousands for a period cabinet in a mansion, whereas today, when the most unexpected effects might be achieved if only the necessary commissions were forthcoming, they're inclined to reproach modern work with lacklustre inelegance. Reproductions of earlier styles can satisfy only the parvenu. The ordinary citizen of today, like the worker, must be proud and fully aware of his own worth and not seek to compete with other social stations which have accomplished their cultural task and are justified in looking back on an artistically splendid heritage. Our citizens have still far from carried out their artistic duties. Now it is their turn to do full justice to the new developments. Just striving to own pictures, however

magnificent, cannot possibly suffice. As long as our towns, houses, rooms, cupboards, utensils, clothes, jewellery, language and feelings fail to express the spirit of the times in a clear, simple and artistic manner, we shall remain indefinitely far behind our ancestors and no pretence will conceal our lack. We should also like to draw attention to the fact that we too are aware that, under certain circumstances, an acceptable article can be made by mechanical means, provided that it bears the stamp of manufacture3, but it isn't our purpose to pursue that aspect yet. We want to do what the Japanese have always done, and no one could imagine machine-made arts and crafts in Japan. We shall try to accomplish what lies within our power, but our progress will depend on the encouragement of all our friends. We aren't free to follow fancy. We stand with both feet in reality and await the commissions.

NOTES

1 Eduard F. Sekler, "Hoffmann, Josef," The Grove Dictionary of Art Online, ed. L. Macy, < http://www.groveart.com>, (accessed 18 December 2002).
2 Cynthia Prossinger, "Wiener Werkstätte," The Grove Dictionary of Art Online, ed. L. Macy, < http://www.groveart.com>, (accessed 22 December 2002).
3 Literally, "hand production" (as opposed to machinofacture).

Hoffman, Josef and Koloman Moser. "Katalog mit Arbeitsprogramm der Wiener Werkstätte," translated by Tim and Charlotte Benton. As appeared in *Form and Function: A Source Book for the History of Architecture and Design, 1890–1939*, edited by Tim and Charlotte Benton and Dennis Sharp, 1975. Reprinted by permission of Tim Benton.

Hoffmann, J., and Moser, K., ***The Work-Program of the Wiener Werkstätte***, in The Industrial Design Reader

Loos, A., *Ornament and Crime*, in The Industrial Design Reader

NOTE: As important as the Loos article is to design history, it is not readily accessible. At the date of publication of this book, the best site to access it was http://www2.gwu.edu/~art/Temporary_SL/177/pdfs/Loos.pdf

Bel Geddes, N., *Streamlining*, in The Industrial Design Reader

Norman Bvel Geddes, Streamlining

The American Norman Bel Geddes's (1893–1958) first claim to fame was as a designer of innovative stage sets; however, he also worked in the fields of illustration, interior design, exhibition design, and, most notably, industrial design. Like Buckminster Fuller, in the 1930s, Bel Geddes produced many plans and predictions for future products, transportation forms, and technologies, a number of which have been—albeit in slightly altered form—realized over the course of the twentieth century. In the 1930s, Bel Geddes was a major proponent of streamlining, and in these excerpts from his 1934 Atlantic Monthly article on that subject, he examined its origins, applications, and possibilities.

Excerpted from Norman Bel Geddes, "Streamlining," Atlantic Monthl†y (November 1934): 553, 556–8. Reprinted by permission of the Estate of Edith Luytens Bel Geddes.

Originally, the word 'streamline' was a term of hydrodynamics. About the year 1909 the science of aerodynamics borrowed it to describe smooth flow of air as well as the form of a body which would move through air with a minimum of resistance. For some years 'streamline' in its aerodynamic sense enjoyed honorable obscurity in the physics laboratory and the shop talk of engineers. Last year, however, advertising copy writers seized upon it as a handy synonym for the word 'new,' using it indiscriminately and often inexactly to describe automobiles and women's dresses, railroad trains and men's shoes. Into such general use has the word come that it is, perhaps, time to examine its meaning and its implications.

The truth of the matter is that very little is known about streamlining. Most of the popular explanations have treated it as though the facts were established and accepted, and in this respect some technical treatises have not been without fault. Streamlining as a science hasn't yet really been born. Its practical development in aeronautics has been highly effective, but not understood. In other fields, both in theory and in practice, it is still in embryo.

[...]

In spite of the hiatus here and there in the theory, parasite drag in the airplane has been eliminated to an amazing degree by the empirical method, and airplane streamlining can be considered to be approaching practical perfection. In 1918 a 400-horsepower motor drove a plane at 125 miles per hour. To-day the equivalent power in a comparable plane would produce a speed of perhaps 200 miles per hour.

In the scientific sense, streamlining, so highly developed in the airplane, has made but little progress in the motor car, the railroad train, and the steamship, all of which stand to gain in efficiency, riding comfort, and economy when drag is reduced. Though streamline attempts have been made in several trains and motor cars, their influence on drag is open to question. In the American mass-production automotive fields, only the Chrysler and De Soto can be considered as pointing toward authentic streamline form. Nevertheless the significance of these two cars lies not in their streamline efficiency but in the foresight and courage shown by Walter P. Chrysler in departing abruptly from traditional attitudes of appearance. What the scientifically streamlined automobile will look like can merely be assumed within fairly broad

Fig. 1 The boundary layer follows the form of a streamlined body

Fig. 2 The boundary layer breaks away from a non-streamlined body

Fig. 3 Airplane streamlining is very effective. There are few places where the flow pattern is uncertain

Fig. 4 The ground effect makes the flow pattern around a motor car a matter of conjecture at best
Kendall Hunt

limits, but it will certainly bear little resemblance to the car of to-day. The weaning of public taste from its illogical prejudices in the matter of appearance is paving the way for whatever form will best meet the automobile's requirements.

It has become fashionable of late to predict what streamlining will do for the motor car and the train. Unusually high speeds have been foreseen and practically no fuel consumption at all. While it is perfectly reasonable to expect a great deal from streamlining, the fact remains that its possibilities in the automobile and the train have been viewed through glasses made rose-color by the experience of aeronautics. Because of two factors not encountered in the free flight of an airplane, present knowledge doesn't assure us that the airplane's great success in overcoming parasite drag will be easily repeated in a vehicle moving in contact with the ground. [. . .]

[. . .]

From the technical point of view, then, streamlining of the motor car must reduce resistance to the air, both head-on and from the side, and must maintain present stability or improve it. The first and simplest step, and the one which is now under way, is the elimination of protuberances—headlights, fenders, door hinges, spare tires. Clean continuous lines from front to rear would aid in reaching all the objectives. The second and certainly equally important step is the development of the form. It is probable that this form will be a compromise, for it is extremely unlikely that any single solution can ideally satisfy all requirements. More than that cannot intelligently be said at the present time, nor can the form be foretold until the advent of sound data specific to the motor car, or until theory becomes more complete.

The technical requirements aren't the only ones, however, and it is to be expected that further compromises will be necessary to provide convenience and comfort—two factors that are becoming increasingly important as the car ceases to be an article of sporting equipment and takes its place with the stove and the toothbrush as a normal commodity. [. . .]

[. . .]

Bel Geddes, Norman. From "Streamlining" as appeared in *Atlantic Monthly*, November 1934. Reprinted by permission of The Edith Lutyens and Norman Bel Geddes Foundation.

BIBLIOGRAPHY

Alexander, C., 1964, *Notes on the Synthesis of Form*, Harvard University Press: Cambridge, MA

Banham, R., 1980, *Theory and Design in the First Machine Age*, MIT Press: Cambridge, MA

Giard, J., 2012, *Designing: A Journey Through Time*, Dorset Group: Phoenix, AZ

Gideon, S., 1969, *Mechanization Takes Command: A Contribution to Anonymous History*, W. W. Norton: New York

Greenough, H., 1947, *Form and Function: Remarks on Art, Design, and Architecture*, University of California Press: Berkeley, CA

Gorma, C., 2003, *The Industrial Design Reader*, Allworth Press: New York

Heskett, J., 1980, *Industrial Design*, Oxford University Press: New York

Loewy, R., 1979, *Industrial Design*, Overlook Press: Woodstock, New York

Martin, R., 2009, *The Design of Business: Why Design Thinking Is the Next Competitive Advantage*, Harvard Business Press: Boston

McKim, R., 1980, *Experiences in Visual Thinking*, Thomson Brookes/Cole: Monterrey, CA

Newton, E., 1967, *The Meaning of Beauty*, Penguin Books: Harmondsworth, UK

Papanek, V., 1985, *Design for the Real World*, Academy Chicago Publishers: Chicago

Rosen, W., 2010, *The Most Powerful Idea in the World*, Random House: New York

Simon, H., 1996, *The Sciences of the Artificial*, MIT Press: Cambridge, MA

Sparke, P., 1986, *An Introduction to Design & Culture in the Twentieth Century*, Allen & Unwin: London

Woodham, J., 1997, *Twentieth-Century Design*, Oxford University Press: Oxford

INDEX